welsh artists talking

to tony curtis

Foreword by
Oliver Fairclough

Portraits by
Bernard Mitchell

seren

seren is the book imprint of
Poetry Wales Press Ltd
Nolton Street, Bridgend, CF31 3BN, Wales
www.seren-books.com

ISBN 1-85411-286-4

A CIP record for this title is available from
the British Library

Welsh Artists Talking, an exhibition to coincide with this book, took place at the
National Museum & Gallery, Cardiff, from 28 October 2000 to 25 March 2001

*The publisher works with the financial assistance of the
Arts Council of Wales*

Printed in Plantin by Gomer Press, Llandysul

Contents

ACKNOWLEDGMENTS

Thanks are due to Oliver Fairclough, Keeper of Art at the National Museums and Galleries of Wales, Cardiff, and to Helen Waters in the Art Department there. We would also like to thank those collectors who have generously allowed the reproduction of the artwork. Photographs of the artists are by Bernard Mitchell; Lois Williams' work is photographed by Noel Brown, except 'Acid' which is by Martin Barlow; the paintings of Terry Setch were photographed by Graham Matthews. The conversations with Alfred Janes, David Garner and David Nash appeared in abbreviated form in *Planet*.

FOREWORD

Tony Curtis' first collection of conversations with artists, *Welsh Painters Talking*, was published in 1997. According to its compiler, it happened almost by accident, and with the pious hope that it would foster a greater interest in, and understanding of, contemporary art in Wales. It was the first book-length publication on this subject for ten years. This second volume follows just three years later. However, the gap between the two seems longer, as *Welsh Artists Talking* reflects a distinct change of mood, both among artists in Wales and among commentators. Certainly from the perspective of the National Museum & Gallery, there are more artists and a lot more art than there seemed to be in the mid 1990s – some of it of a strength and character to hold its own anywhere in the world. As Tony Curtis tells us in his Introduction, the extent to which the visual arts in Wales now attract an audience and commitment would have been unimaginable in the 1980s. Then there was still a lurking unease about the validity of our visual culture. What, after all, made Welsh art Welsh?

Today, as we enter the twenty first century the visual arts in Wales are studied by school students, whose emphasis, rightly, is on the last half century. The Visual Culture Project at the Centre for Advanced Welsh and Celtic Studies has drawn attention to a continuous but little-understood history of art and artists in Wales since the Tudor period. In the last year, there have been two fine BBC Cymru/Wales television series exploring Welsh art and artists. The first, Peter Lord's *The Big Picture*, placed our art in its social and cultural context. The second, Antony Jones' *Painting the Dragon*, celebrated the vitality of the contemporary scene, and brought to our TVs many of the artists who contributed to *Welsh Painters Talking* and *Welsh Artists Talking*. You can visit a dealer in historic Welsh art in London (or on the internet) and Sotheby's seem to have found a market for annual Welsh art sales at Margam, near Port Talbot. More to the point here, you can also buy fine contemporary work in at least three commercial galleries in Cardiff, as well as in exhibitions and arts centres all over Wales.

Whether all this represents a sea-change remains to be seen. It has been hailed as a renaissance, of the sort that transformed the Scottish art scene in the 1980s. Perhaps it is, and Devolution has brought both a confidence in identity and conversely an acceptance of diversity, which have brought visual artists in Wales more into the mainstream of cultural life. Nevertheless, many deep-seated difficulties remain. It is still extraordinarily hard to make art in Wales which commands international recognition. Some artists who should be in this book, or its predecessor, consequently live and work in Europe or North America, beyond the reach of Tony Curtis' tape recorder. Opportunities for public subsidy and private patronage remain depressingly inadequate. The great wash of Lottery money

which created Tate Modern, the Lowry, the New Art Gallery, Walsall and the Dean Gallery, Edinburgh, as well as transforming the exhibition and even the collection of contemporary art elsewhere in Britain, has raised barely a ripple in Wales. And we still lack a national centre for the display of modern and contemporary art. Perhaps not a renaissance then, but at least a new mood of confidence and even optimism.

This confidence is reflected in *Welsh Artists Talking*. What also comes over strongly is the diversity of the artists who agreed to talk to the microphone and to work with Tony Curtis to produce the imperceptibly edited conversations that make up its text. They include sculptors, installation artists, even painters. Among them are artists from outside Wales, like David Nash and Terry Setch, for whom the environment of Wales, the land and the sea, has become a creative mainspring. Others, such as Ivor Davies and Lois Williams, brought up in the language and culture of Wales, have moved to and fro, but Wales is an emotional and spiritual lodestone. The book includes conversations with very 'senior' artists like the late Alfred Janes (whose sparkling portrait of Dylan Thomas made back in 1934 is one of the treasures of the National Museum & Gallery) and the sculptor and calligrapher Jonah Jones, whose work somehow visualises the language. The book also records the experience of mid-career artists like Robert Harding, and of younger figures such as Brendan Burns. The ten artists are therefore an extraordinarily varied lot. Consequently, these conversations draw our attention to the range of contemporary practice in Wales today (and we need a volume three to take this further). Painting is alive and well here, but in this book it rubs shoulders with the 'found objects' beach works of Terry Setch, the reflective assemblages of Lois Williams and the politically uncompromising installation art of David Garner. Nearly all the artists in this book, and in its predecessor, are represented in the collections of the National Museum & Gallery, but lack of space means that only a few are on display at any one time. I am delighted that the publication of this book will be marked by an exhibition at the Museum. This will be held in the Oriel Celf yng Nghymru / Art in Wales Gallery, a newly-refurbished space used since October 1998 for a series of temporary exhibitions which explore the nature of art in Wales across time and media, and seek to provoke discussion and debate. *Welsh Artists Talking* is another significant element in that process.

<div align="right">Oliver Fairclough, June 2000</div>

INTRODUCTION

At the beginning of the twenty first century the words 'Wales' and 'art' may no longer be humorously juxtaposed. The artists, painters and makers of Wales have a confidence in their work and an audience for that work. The galleries of Wales, both public and commercial, are attracting wide patronage and healthy attendances. This strengthening of the visual arts has been steady throughout the final quarter of the twentieth century but has only recently been supported by publication.

This book is a companion volume to *Welsh Painters Talking* which appeared in 1997. It extends and complements that work by presenting another ten artists from Wales and allowing them, through conversation, to speak for themselves. These makers of art are either working in non-paint media, or their work does not fit easily into the category which 'painting' normally implies. For example, David Garner is a sculptor who works with the materials of the industrial and post-industrial world of south Wales; Christine Jones is a ceramicist making bowls and vessels and Terry Setch is a painter whose works often involve the detritus of the beach and suggest three-dimensional, sculptural movements off and beyond the conventional frame.

My first collection of conversations with painters grew out of my sense of the importance of art in my life and to my country, Wales. Some like Charles Burton and John Knapp-Fisher were already friends and colleagues; others, like Iwan Bala and Peter Prendergast, are new friends with whom I am pleased to continue to work. Sadly, two painters included in *Welsh Painters Talking* have died: Ernest Zobole at the end of 1999 and Will Roberts at the beginning of 2000. Alfred Janes also died in the year before this book was published. Those sad losses underline the importance of the attention we give to our artists. This book, again, listens and records for our contemporaries and the future.

Wales is a small country, ancient in myth and tradition and young in its sense of its own political entity. In 1985 I edited a collection of essays called *Wales: The Imagined Nation* which was influenced by the work of Gwyn Alf Williams and Eric Hobsbaum. That work was informed by the principle that a people coheres around ideas of shared experience and need and that those needs are often expressed, and often best expressed by narrative, metaphor and image. "The Welsh make and re-make Wales, day by day, year by year, if they want to", as Gwyn Alf Williams said.

The artists I talk with in my two visual arts books are all significant, gifted people; they do not, however, necessarily share a concern with Welsh

identity, nor an agreement concerning the purpose of their art. They are twenty-two remarkable individuals who are joined by their association with Wales, by birth, choice and/or an emotional commitment to its landscape, society and, yes, its weather.

David Nash is an Englishman who has lived in Gwynedd most of his adult life and who spent much of his childhood holidays in Wales. He is the foremost sculptor with wood in the world and is committed to growing and shaping living trees and re-working fallen trees in location from Blaenau Ffestiniog to Japan and the USA. His work is included in many major collections, both public and private, and is the subject of several books.

Lois Williams was born near St. Asaph and brought up there by her parents on a Welsh-speaking farm. Her sculptures and assemblages are often disturbing and ghostly workings of personal and shared experience. They challenge the spatial and emotional assumptions many of us have of the genre.

The late Alfred Janes worked for nearly seventy years as a painter and teacher. He was, famously, one of the 'Kardomah Boys' with Dylan Thomas, Vernon Watkins and the composer Daniel Jones. Fred Janes' posthumous retrospective at the Glynn Vivian Gallery in December 1999 brought back to Swansea an astonishing range of his work, from the jewel-like oils of the Thirties and Forties to the experiments with perspex, glass and marbles in the Sixties and Seventies.

Christine Jones is a maker of coiled vessels who is based in Swansea; she enters the new century with huge promise. Her work is in the National Museum of Wales and the Metropolitan Museum in New York. She has become a Recognised Maker by the Crafts Council of the UK. Her vessels are mute presences that suddenly sing to us and to each other.

Terry Setch is an Englishman who has made a major contribution to Welsh art through his teaching at Cardiff, and through the large, inspirational canvases loaded with paint and the detritus he finds on the beach in Penarth. For decades his work has stretched the boundaries of painting. It is included in the Tate Gallery, and the West of England Academy is preparing a substantial retrospective in 2001.

David Garner works in Gwent with the remnants of the dead coal industry and the leavings of more modern technologies. With wit, anger and political commitment he constantly progresses the possibilities of sculpture and challenges his audience to re-assess their perceptions at the interstices of art and real life.

Brendan Burns is a prize-winning painter whose work is currently focussed on the beaches of Pembrokeshire. His paintings, either very small or very large, are impressionistic and gestural, both addressing the wet light of rocks and pools and questioning the nature of painting as his paint holds and works off planes of board and perspex and wax.

Robert Harding lives and has his studio in Llantrisant with the Welsh

INTRODUCTION

wife who brought him to us. He works mainly in steel and largely to a domestic scale. That hard, resilient metal is wonderfully transformed by his vision and skill. For his students and audience he presents new possibilities through sculpture, which he calls 'the opera of the visual arts'.

Ivor Davies has been an important figure in the visual arts in Wales since his return in the late Seventies. His profession as an art historian is complemented by his passion as a Welshman and his vigour as an artist. From the heady, explosive days of Sixties experimentation through the political imperatives of the Seventies, when he joined Grwp Beca, he has produced work ranging from the provocative slogans on canvas to haunting still lifes on paper and canvas.

Jonah Jones is a Welsh Geordie by family ties and upbringing. Drawn to Wales after the war, he became fascinated by its landscape, myths and materials. Through public commissions, public service, the warmth of his personality and the strength of his vision he has made Wales a more interesting place for artists to work in. His enthusiasm for calligraphy has led to a number of notable collaborations with writers and publishers. Jonah Jones produced the memorials in Westminster Abbey for both Dylan Thomas and David Lloyd George.

In the last ten years the visual arts in Wales have strengthened in terms of audience and support. Profiles of artists have been produced for television; Peter Lord and Antony Jones have, through their television respective series, brought much of the twentieth century's work in Wales to a wider audience, while Peter Lord's books have excavated notable elements of our neglected art heritage. Iwan Bala, whose interview completed my first collection, has gone on to produce two books of his own. *Certain Welsh Artists* is a valuable collection of essays concerning contemporary art practices and artists. Iwan's concern to explore the nature of identity in contemporary art is manifested acutely in his own work; in the book which accompanied his *Offerings + Reinventions* exhibition this year he and others raise crucial questions about where we might go in terms of our need to express our Welsh identity.

Against this enriched context of historical and critical work new, young artists are developing. James Donovan in Hirwaun has already produced a compelling series of canvases which draw on his family's coal mining heritage and extend it imaginatively into fresh images. His work is the most exciting response in paint to our post-industrial society and ranks alongside the sculpture of David Garner in its power and originality. Two young women sculptors, Bethan Hughes Jones and Angharad Jones are building reputations both in Wales and Europe. The Ynys Mon-based painter Iwan Parry recently exhibited at CVA with Terry Setch and Brendan Burns and is clearly a fine painter of seascape, landscape and the dreamt topography of the Irish Sea; Peter Spriggs's Valleys scenes and plaintive 'Orthodox Candles' are also notable; Vivienne Williams's still lifes, less monumental

and more human than William Scott's, have the haunting presence of Christine Jones's vessels. All these artists will, I am sure, figure prominently in the first decade of this new century.

The state of the visual arts in Wales is strong and promises much; commercial and public galleries are attracting larger audiences, some of whom are themselves buying work and seeing Welsh art as part of their fuller life in Wales. They are taking works into their homes and their lives. Corporate offices and public administrative centres are acquiring art as a matter of course. People expect to see art in a wide variety of places – offices, hospitals, public buildings. If galleries are the new cathedrals and art the new religion, then there may well be another turn of the century Revival in Wales. I have a feeling that, like a hundred years ago it will be energising and non-conformist. This second collection of interviews, *Welsh Artists Talking*, points that way.

<div align="right">Tony Curtis</div>

ALFRED JANES

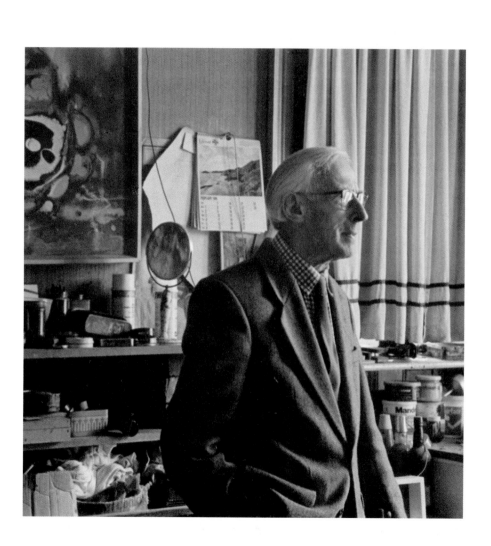

I visited Alfred and Mary Janes in their home close to the Dulwich picture gallery in January 1998. Alfred died in 1999. His home contained many of his works spanning a long and varied career; one of the bedrooms was effectively a store-room with many paintings from the 1960s and '70s.

That unique gathering of young talents in Swansea in the Thirties – Daniel Jones and Dylan Thomas and Vernon Watkins and Mervyn Levy and yourself – was one of those special periods in Welsh cultural history. It was a meeting of extraordinary talents, so was there a sense in which that coloured the rest of your life?

Yes, in a way. Daniel Jones was a real polymath – I miss him terribly; I miss them all terribly. But, no, that film BBC Wales made was a bit apocryphal, a bit romanticised. Showing us all going around together in a gang, that never happened. For one thing, for most of that period Dan Jones lived in London, because his parents had moved there. Dylan was an itinerant, moving around all the time. It was mainly a very small nucleus: Tom Warner, a composer who wasn't mentioned in that film, now he was a very close friend of all of us, particularly Daniel Jones, and I met him with Dan. He was a marvellous chap – he could go from the Uplands to the Tenby pub in a bus with one other person in it and come out with a dozen anecdotes. He had that sort of imagination.

Had you all been through Swansea Grammar School at one time?

No, Dan had been to Swansea Grammar School, and Dylan, of course, but I was older than the others and we met in 1931 when I was already a student at the art school.

But you were born in Swansea?

Yes, in Castle Square, right in the middle of Swansea. My father had a fruit shop there – hence one's heritage in painting still life.

When did you discover that you could draw and should go to the art school? Did somebody tell you, or did you know?

I think it was Macmillan the Prime Minister who when asked what really controlled his ideas and movements said, "Events, dear boy, events". And I thought it was the same with all of us. I must have thought at one time of joining and carrying on my father's business, but that didn't seem to fit. I could always draw as a child, particularly portraits, and I began to take evening classes at the art college after leaving school and then I got a scholarship.

Did you work in the family business?

No, never, I would have ruined it if I had. No, I've always tended to work alone, never being attached to a gallery even. Of course, in those days in Swansea there weren't the commercial galleries, only the Glynn Vivian.

There wasn't one in Wales before the Howard Roberts in Cardiff, I think. What did you and your contemporaries imagine you would do with your work – give them to the family? There wasn't any sense that this might be a career, was there?

I think you've answered your own question. What did you do? You survived

one way or another. I've taught all my life until 1971 or '72, at Swansea and for the last twenty years at Croydon. That was no chore, I got an immense feedback from students. It could be more learning than teaching, I think.

When you started attending evening classes in Swansea, presumably that was the traditional teaching of life class and still life? And then you enrolled full time at the college?

Yes, I was there for four years. The teaching was very traditional until we had a young man come down from the Royal College, George Cooper Mason, and he revolutionised the teaching there. He was wonderful. Up to then everything was sound enough, but really belonging to the the the last century. He brought along a totally new attitude of mind. I got a scholarship to the Royal Academy Schools to become an artist as distinct from a teacher. And one managed some way or another to survive.

Was it obvious that you couldn't go any further in Wales and so had to come to London, just like Dylan had to come up here to make his reputation?

It seemed, I suppose, the thing to do at the time. But it was very much to do with the arrival of George Cooper Mason.

Was it that 'Modern Art' was like a foreign language to be learned, because there wasn't much foreign art to be seen in Wales before the war?

It wasn't so much that Mason brought that to us but he did represent what was going on at the Royal College. Later at the Royal Academy I worked at all that drawing at a high level and then would go to the London galleries and the commercial galleries in Cork Street and so on, where the modern painters exhibited. From that point one never thought that painting was about anything else – representing things. Though I had learned to put down exactly what one saw. It was necessary because I had started out wanting to be a portrait painter; all my Swansea work was that, a lot of it commissioned. I started out painting pictures of my father's friends' motor cars. I've always been passionate about motor cars and other machines. There's never been any separation between painting and engineering.

And this was in Swansea in the Twenties, when motor cars were still fairly unusual?

My earliest memories were certainly of my sitting in my father's Model T Ford outside the shop in Castle Street. I learned on my father's lap and have been driving ever since – without an accident – seventy years!

So they would pay you for pencil drawings and paintings?

Yes, well it was also good for me as an artist because all the problems of perspective are there already with cars.

Was it a wrench for you to come up to London? Had you visited before?

Oh yes, Cooper Mason had brought us up for visits to the galleries. That was very enlightened. Unfortunately, he died a very young man.

Of course, the Glynn Vivian was at your doorstep.

Yes, and I was co-opted as a student to their purchasing committee. I was

on it for twenty-five years. My relationship with that gallery has been very close all my life.

And you painted the portrait of Vernon Watkins in its collection, and that of Dylan Thomas in the National Museum.

The one of Dylan was done in 1934. Vernon's, I think was shortly after coming out of the army, and the one of Daniel Jones was also around that time.

So you stayed in touch with Vernon and Daniel after the war?

Oh, yes, we were life-long friends.

I had classes with Vernon Watkins when I was a student in Swansea University in 1967, the year he died; I met him once a week for a term. I was very much in awe of him though I didn't really understand all he said. He kept insisting that Dylan Thomas was a Christian poet, which I though was a very odd thing to say as it didn't accord with what I'd heard and read about him. I don't think that Dylan was a Christian, was he?

Dylan a Christian poet! A friend of the Devil too! He was all of those things. If it was part of life then it was part of Dylan. He had an absolute breadth of outlook. Vernon was a Christian, of course.

[Mrs Mary Janes brings in tea.]

When did you marry?

Mary Janes: It was just before the war. We lived in Myrtle Grove in Sketty when the blitz happened. My mother was in Swansea hospital and died there on the third night of the blitz. I never saw her again. The radio broadcast that all the water pipes in Swansea were damaged. So on the third night

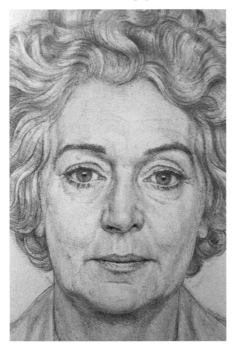

Mary Janes(detail)
1970 artist's collection

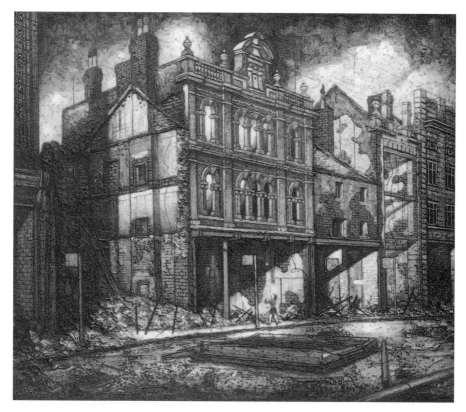

Castle Street, Swansea, after the Blitz oil on board, 51 x 61 cm, 1947, private collection

the Germans came over and dropped fire bombs.

Alfred Janes: Swansea disappeared overnight and after the bombing I was given compassionate leave. The centre of the town was devastated, including my studio. I had written some of my painting recipes on the wall, thinking that if I lost my notebooks they would be there!

For a while you lived in a flat in Earl's Court with Dylan, didn't you?

Yes, he shared a flat in Redcliffe Street, and then later in Coleherne Road in Kensington. But he was on the move the whole time. I think Dylan made that remark about being from the next county wherever he was.

I met John Pudney at a poetry reading in 1971. He told of Dylan staying with him one night and in the morning finding Dylan gone and his trousers missing. He saw Dylan in the Cafe Royal and sidled up to him, "Dylan – I think that when you stayed the other night you may have... that is, possibly you might have... by mistake, have taken my trousers," and Dylan rose up immediately and, starting to unbutton the trousers, said, "Do you want them now?" John Pudney, of course backed off, and Dylan kept his trousers.

I met John Pudney with Pamela Hansford Johnson – you know that Dylan and Pamela were engaged at one time. But I spent many an evening with

Pamela and her family; with Dylan not turning up. They were very kind to us. When Dylan and I had this flat it was totally unfurnished, but Pamela and her mother had moved to a smaller house and had furniture in store which they kindly lent us.

Was Dylan a distraction from your intention to become a serious artist?

That's difficult to say. When he was working he was a tremendously hard worker, and very diligent, dissatisfied with his own work and so on. But he was many sided and there are people who knew an entirely different Dylan from the one you knew yourself. He would sit in his overcoat in bed with that pork-pie hat and write poetry while I painted in the other corner.

So he didn't steal your trousers, then?

No – I was bigger than him, anyway! After a couple of years I went back to Swansea for the summer holiday and never came back. I left all my work there, four or five years of Academy work and lost the lot. Drawings and paintings. And that portrait of Dylan which is now in the National Museum of Wales, together with an entire exhibition's worth of work would have been lost too, except that Augustus John and Cedric Morris were organising an exhibition of Welsh painters in Cardiff and I went back to fetch those, otherwise I'd have lost even more work. It was from that exhibition that the National Museum of Wales bought the portrait of Dylan and the still life 'Bream'. I'd asked for thirty pounds each, and they gave me thirty pounds for the two. So they got that portrait of Dylan Thomas for fifteen quid!

You mentioned Augustus John; presumably he was for painters like Dylan Thomas was for poets of my generation: he was like this great mountain you had to go round or over to find yourself. Though, of course, John's best work was behind him by the Thirties. But was it encouraging for young Welsh painters to know that Augustus John was world famous? And was he an influence on you?

Yes, the early portraits very much so. Ceri Richards was important. He was a graphics student at the Royal College and I think that background enabled him to adjust to what was going on in this century in painting. The camera had hit painters and was a devastating event in the way that it usurped an enormous amount of the function of painting. Painters were no longer needed to document an event. The history of painting had been about that. When Henry VIII was being coerced into marrying one of the German princesses, I think, he hadn't the faintest idea what she looked like, so he said, "Send Holbein to bring me her likeness". That was the function to illustrate and portray.

Though the camera was readily available to many people at the turn of the century when John was doing some his best work. Perhaps painting took a time to catch up. It could be argued that both Augustus John and Ceri Richards were too open to influences – Richards being bowled over by Picasso and Matisse. And there's that large Augustus John fisher-boy in the National Museum of Wales that could be a Picasso, John had been so heavily influenced at that time. But John's old traditions were harder to bury

than they were for Ceri Richards.

Though Evan Walters certainly tried to experiment too, with this odd shimmering technique of double vision.

He tried a stereoscopic effect, or a three dimensional effect on a two dimensional canvas. Whereas it is the brain that must do that.

Although he had his brief moment of fame, taken up by London galleries and feted for a while.

A marvellous painter in his way. I thought his paintings of miners were terrific. He should have developed that forte, but he didn't.

So that was at least an attempt to pull painting away from the representational. Whereas Augustus John never found a different language. It was a nineteenth century language and he ended up churning out society portraits and often failed to finish work in his later years.

I think that the devastating blow that the camera dealt to painting accounts for the diversity and dynamism of twentieth century painting and the extremities to which it goes to express itself.

So you met John at the time of this Cardiff exhibition – was he an imposing figure, were you in awe of him?

Not really in awe of him because the painters one already regarded were so different. One admires a painting such as 'Madame Suggia' with its tremendous vigour and strength.

And Gwen John is now the painter better regarded.

She's too restrained for me, too refined. A good big 'un is better than a little 'un. John said that she would be a greater painter than himself in the final judgement, but that was in a way a sign of his own failing powers and insecurity towards the second half of his life.

So which painters did you admire and want to emulate? Which did you see when you were a student in London?

I liked a lot of painters – Braque and, of course Picasso was an incredible genius – and Paul Klee, Modigliani, Rouault. But I never wanted to do what they were doing.

You wanted to create your own magic. You knew Cedric Morris too, didn't you?

Oh, he was a close friend and was extremely helpful to a young painter. He spent a lot of time in Penclawdd when he came down to Swansea because he had close friends or relatives there. He's come back into fashion a bit and there was a lovely retrospective at the Tate a while ago. A beautiful flower painter. And if you look down the left hand side of our garden there you'll see some of the bulbs he gave us. He was a great iris grower. His bulbs still come up year by year. There was one lot which he gave us in 1963 when we first moved here and they've only just come up.

Mary Janes: He was from a famous family in Swansea, the Morrises of Sketty Hall: Cedric went off and painted and I think the title has faded out. The family moved away too and have dispersed. Though he was the most famous. It was one of his ancestors, Margaret Morris, who married the

ALFRED JANES

Frenchman Desenfans. Her dowry paid for many of the Dulwich Gallery paintings across the road from us here.

Alfred Janes: Morriston the town was named after that family, I believe.

Ceri Richards came from Dunvant. And he was at Swansea Art School in your time there. Then he went up to London. I'm looking at these constructions here and am reminded that Richards worked at wooden constructions back in the Thirties – 'The Variable Coster Woman' – with wood and metal, for example. Perhaps that was a sign that there was a dissatisfaction with conventional painting among art students at that time. Were you aware of what he was doing, and did you have any sympathy with that?

Yes, I did. I think he was the most creative and inventive British painter of this century. Perhaps one's prejudiced because one knew him well – an absolutely delightful person, for a start and restless, as one is oneself. If I can do something, then I want to go on and do something else.

I can see in his work and yours a determination to see things through. There are sweeps of concentration and focussing on certain things; repetitions and trying out almost obsessively certain ideas.

Searching for something, I suppose. You don't even know what you're looking for, but you'll know when you've found it.

When you are in a life class or with a still life you know where you are going; but in paintings of the imagination do you start making marks and then discover where it might be going?

Very much so at one period, yes. It might be said that I became an abstract painter, but I hate the word abstract, Hope is 'abstract' as it were. You can't go into a shop and buy a pound of hope. Take those constructions here in this room 'Regatta' and 'Vele al Vento' (Sails in the Wind); I had to go and buy every part of that – the wood and perspex and so on. It has ingredients, like a cake. But this thing isn't for eating, but for looking at. It entertains and instructs through the eye and brain. 'Regatta' was a purely abstract painting: I change the names if I want to. What I was interested in was obviously an arrangement of broken glass painted on the back. I called it 'Separate Compartments'. Because, if you notice, each piece of glass has been dropped, as it were, and jammed into these compartments. But it's interesting that so many people seeing the painting long after it was done said, "That reminds me of the yachts in Swansea Bay".

I didn't question that when you said it. I thought then it looked like Mumbles.

And there's a moon above and lights across the bay, so I thought 'Regatta' would be a better title. The one on the right here is 'Circle and Sign', one of my favourite paintings. That is an abstract: but you drop that on your toe and see how abstract it is! So there's no such thing as an abstract painting.

Charlie Burton said in Welsh Painters Talking *that all painting was abstract because it's a two dimensional thing trying to be three dimensional.*

But as far as I'm concerned, if 'Circle and Sign' is abstract then a cake is abstract. Because it doesn't represent anything else: it is what it is.

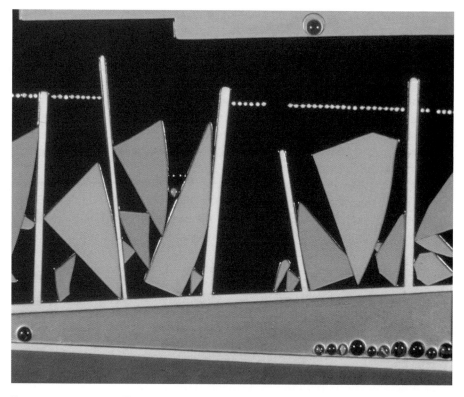

Regatta PVA, marbles, perspex on board, 59 x 74.5 cm, 1966, private collection

Coming across that painting out of this context and without its title 'Regatta', it seems to me that it is clearly about the sea and sky and sails. It has a deep, almost Mediterranean feel to it; it's summer.

And broken glass!

Maybe we've all been taught to accept abstract shapes and interpret them in certain ways. Colours have a representative force, don't they? To me, this is a very holiday mood – beach and sea. I do see sails there. Am I wrong to say that?

No, it's up to you.

But then where are you the artist in all this? Because if you create that work and you don't care where I go with my imagination, does the thing become detached from the artist? Does it have a life of its own? You don't want to own it?

I hope it does have a life of its own. I'm setting another mind in motion – the other person sees other experiences in it, or other images, other tunes, if you like. I've got a colossal interest in music and how it is made. And poetry, for that matter, except that in poetry and literature you have meaning, which is entirely different. That painting doesn't mean anything in the way that words mean something. It's very difficult to say the word 'table' and think of an orange, isn't it? So the meaning shapes literature.

Whereas blue and orange don't mean anything? Though one can talk about hot

and cold; soft, flowing shapes; sharp, angular shapes. One can talk in broad terms.
One can take a note on the piano – middle C – and there is nothing in the world like middle C. It is simply what it is. In 'Vele al Vento' there are at least six or seven tones of blue and they hold the thing together. Look right at that sort of eye in the middle, that's white. And you go from the deepest blue through a scale of blues, six or seven or eight tones of blue.

Yet that isn't a painting. 'Painting' doesn't convey its nature: it's a construction.
That's right – it's a thing.

If we reproduce this work in the book, readers are going to have a different impression of the piece from that which I'm having now, seeing that there are, in fact, pieces of perspex with a rather dangerous sharpness to them. I fear that if I touch it, it will cut me.
Good.

So that works against its being a joyful explosion of summer colours. As I angle round on the work I see that it has danger. It proves again that there is no substitute for living with a work of art and moving around it and moving it around in your space.
It is what is is. Nothing else.

But I've never seen it before and I have been in this house for about an hour and am already seeing it as susceptible to a number of interpretations. It is moving from my first impression. The sense of glass in the work is edgy and works against my feeling that glass is what protects the work I have in my house. I feel protective about my paintings. Whereas the glass here is incorporated and somewhat disturbing.
Would you like to come upstairs where I store a lot of the work? There's a lot of abstract work there.

<p style="text-align:center">★ ★ ★</p>

We've seen that you explored the Pollock drip technique in your 1960s abstract canvases and that there are a number of later painted construction pieces. Then on your stairs there are drawings done in the war. Was there a sense in which the war put a stop to everything, or did you manage to carry on with work? When I spoke to Will Roberts he said that he was posted in the RAF to East Anglia and managed to get to some life classes in Cambridge. He drew his fellow airmen too.
I did just a few drawings. I became very much involved with the army. I became a captain; I accepted it as very much a job that had to be done.

Where were you when the war broke out?
In Swansea. I was teaching part time there. I had gone back in 1934 or '35 from London. I was in the army for six years. We were in some disused cotton mills in Oldham during training. All we seemed to do was march all day. I got my first stripe by marching, but was commissioned in due course. I was posted to Egypt in 1943 and spend three years there with Italian prisoners

of war. Some became life-long friends of mine. It was an extraordinary story because when the Allies took back the Aegean Islands the Italians were totally fed up with German domination, and they turned round on the Germans and assisted in rounding them up. They claimed then that they had turned co-belligerents. We think we're anti-fascists, but, by god, you take a German or Italian anti-fascist! They lived with the bastards. You couldn't put them in the same cage: there were a lot of murders between the groups.

I was sent on a course to learn Swahili, because I was in charge of black troops in Egypt, but later I had the chance to work with these Italians. I made friends with their medical officer, Gianni Bernadini, and we walked each day in the desert and taught each other our language. He became a life-long friend and an excellent linguist.

People grew up quickly in the war; what did you do after demob?
I went back to Swansea in 1945. I had been teaching part-time in the art college and resumed there, doing a bit more teaching. I was married now with a son whom I had not seen until he was two and a half. I had a studio in my mother's house in Eden Avenue. It was there that I did the portrait of Vernon Watkins.

Who was the worst policeman ever put in an RAF uniform, apparently.
Yes, and he was in Bletchley of all places, where he met Gwen his wife. Daniel Jones was there as well, decoding from the Chinese – typical of Dan. He was working on the Enigma Project. The only one I saw in the war was Dylan. When I was on leave I would meet him in London often, in the Fitzroy in Soho. That's where I met Nina Hamnett too. Dylan introduced me to her. She was very interested in my paintings actually. But the war was a different part of one's life and very little to do with art, except for some drawings which I did.

Did Dylan and Vernon share their work with you?
Yes, they talked about their work an awful lot. I think Dan was a tremendous link between all of us. Except that Dan and Vernon didn't get on too well. Dylan and Dan had already been friends in school together. We had a wonderful time talking about our work. I have always played the piano and have an interest in the relationship between music and painting; they have so much in common yet are so different. I like to 'improvise' on the piano; I don't play the piano, I play with the piano, something quite different, experimenting.

You are having a conversation with the piano, listening to what it can tell you. Is that rather like the Pollock-like abstract paintings which we've looked at upstairs? Going where the paint takes you?
Very much so. That is the point which music and painting share.

That is what would distinguish your approach from that of Ceri Richards, who played the piano very well and who would take a piece by Debussy – 'La Cathedrale Engloutie' which was an established piece, with a structure, and would then work off that piece of music to develop images. He was, in a sense,

ALFRED JANES

honouring the composers, Beethoven, Debussy, that he admired so much.

I'm not sure that he was interested so much in so-called improvisation. I rather resent the word 'improvisation', I mean, why don't we say that we are improvising now, as we are talking? If you familiarise yourself with a musical instrument you just talk. I wouldn't consider myself a musician, but I get a lot of fun out of doing just that.

But you compose in paint, and other materials.

Yes, Painting is responsibility. I have no responsibility in music at all. I used to teach a lot on that basis; I taught a lot of part-time students and the great thing was to persuade them that there is no punishment for making mistakes. Like my piano, if you do something every day you do get better at it. I never met a student who couldn't make progress with proper encouragement. If they've got a human brain, they've got a conglomeration of miracles to start with.

And in both art and creative writing there is a lot of technique, a body of knowledge to be taught.

A lot can be taught in drawing and painting, and there's a lot which you can't teach.

It seems to me that looking at your abstract constructions here and in your store upstairs that there's the sea is still there; for example, there's that one 'Islands' upstairs. Here you are in Dulwich in south London, landlocked, but the sea is still there in memory and desire.

Oh, yes, no doubt about it. Ceri said that he saw the sea in my work.

When Dylan died in 1953 was it a surprise to you?

Not a tremendous surprise. He'd been having blackouts. We saw him two or three days before he left for America that last time. He'd never met Ceri,

Nineteen Marbles perspex relief, PVA on board, 43 x 76 cm, 1966, private collection

so Mary and I took him down to Dylan in the Boathouse in Laugharne. I had a lovely little Sunbeam Talbot drop-head coupé at that time and we drove down to Amroth and Pembroke and had a couple of drinks on the way. They would have been great friends, no doubt about it. They had a lot in common.

It seems strange that their paths had not crossed before, the strong links with Swansea and London. Because Dylan opened, or at least took part in, that 1936 Surreal Exhibition in London and went around offering people cups of boiled string. But presumably that was more for effect than any interest in the visual art. I don't think that Dylan was terribly well acquainted with Ceri's work. Dylan's was very much a word mind, one track brain. He was like the average person when it came to painting and other things. He had this tremendous drive when it came to words themselves. His father taught me at the Grammar School and he loved the words. The word as a real object.

Mary Janes: His mother used to say that when he was little, he was never a very strong child, and when she wanted to go out she would leave Dylan with his father. He had no children's books, so he read Shakespeare and the classics to him. His mother had a lovely voice too, a strong Welsh voice, very clear enunciation, a nice quality about it with a Welsh accent. She spoke with great clarity.

Fred Janes: He was a wonderful reader.

Was Dylan a good sitter for you, Fred?

No. I did the portraits of Mervyn Levy and Dylan together at that time in Chelsea. Mervyn joined Dylan and I at Coleherne Road. Dylan's parents were terribly worried about him coming to London. When he actually moved to London to live it was my father who brought us up in his car. He was itinerant, as I say, moving round and making contacts, but it was there in the flat that he did much of his work. I painted both of them as they went about their concerns. Mervyn himself had been at the Royal College and knew how to sit: Dylan was in and out like a cat in a tripe shop. Both Vernon and Dan Jones understood what was necessary. Dylan was impatient, but in a way I think it was the best of the portraits; it was a lively one.

Last week, prompted by the 'Kardomah Boys' film, I went to Cardiff Library to borrow some of Daniel Jones's music, and was dismayed to find that they had a couple of scratchy old lps and no cd of his work. It seems that we take no care and pay no regard to our own.

I think historically the Welsh have been a nation of employees, they went down the mines, they weren't the mine owners, and into the copper works. The capital was English capital. We've had that lower status and that is what the Devolution movement is all about now.

You've lived most of your life in England; do you still go back to Swansea?

Yes, I've lived here a good half of my life. Mary's sister in Swansea died three years ago, so we don't have that easy access now. The last time I was down was for the Attic Gallery exhibition in 1995. I still drive, but Mary

won't come on the motorway with me. I think that if you stick to the left hand lane, which is what I do now, it's like a private road, I let everything else pass me except bicycles and horse-drawn vehicles! I drive in London still.

Mary Janes: The funny thing was that Dan couldn't drive, Dylan couldn't drive, and Ceri and Vernon, Kingsley Amis couldn't drive – and who was the chauffeur for the lot of them? Fred, in his father's car.

How did you find Kingsley Amis?

Well, a very sad thing happened as far as Kingsley was concerned. I liked most of his work, it was extremely funny. We met him at many parties and got on well. But unfortunately there was terrible friction between him and Dan, because Amis pilloried Dylan and Dan in *That Uncertain Feeling* and they never forgave him. You had in Swansea the Amis crowd and the Dan Jones friends and they would never meet. Dylan was dead and gone, but he was pilloried in that book. Dan was called Stan Johns, so was hardly disguised even. This animosity made it very difficult for those people who were friendly with them both. It was very bitter.

Mary Janes: I thought he took the mickey out of a lot of Swansea people – enjoying their hospitality, spending time with them. As far as we were concerned he was always very good company.

Well, I discovered that Kingsley Amis did something positive for Welsh painting. He organised an exhibition of Welsh painters in the 1960s in Clare College, Cambridge, at which several works were sold.

Yes, I remember, I was in that. Three of my best paintings, actually; that nice one 'Pulse – Blue and White' was included. Amis became great friends with Stuart Thomas whose wife had, with two women friends, founded the Attic Gallery in Swansea. So there was a link between Kingsley Amis and that gallery. Stuart and Dan had been friends from Swansea Grammar School days and met for years afterwards at the Rock and Fountain pub, but then for some God-forsaken reason broke apart.

You say "for some God-forsaken reason". Some of the painters I've spoken to have said that there is a spiritual motivation to what they do — Peter Prendergast, Will Roberts and Kevin Sinnott, for example. Is there any religious dimension to any of the work you've done? I don't perceive that in an overt way; nor do I wish to impose that view. But isn't there a sense that whenever you paint a still life, or members of your family, there is a sense in which you are celebrating the world, paying homage to life or a creator?

I've got mixed feelings there. One thinks about that all of the time, it's not even at the back of one's mind – it's out there right in front. There is a statement by Bertrand Russell, for whom one has considerable respect, "When you realise that the world is a terrible, terrible place, you can begin to be happy". I think we are comfortable, we are warm and have plenty to eat, but there are millions for whom life is absolutely awful. They'd be better off not to live at all. Imagine being a child with flies crawling all over you. And old age is very sad; you gradually feel your powers going, there's

WELSH ARTISTS TALKING

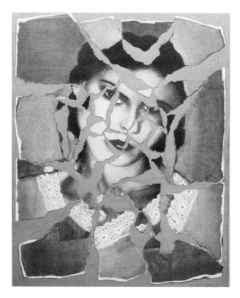

Francesca
mixed media, 1978
private collection

always something going, like an old car – if it's not the carburettor going, it's the gearbox, or the ignition, or the clutch – the end of life, the fag end of life is unhappy. You lose your powers. You go to lift a book and it weighs half a ton. Going upstairs is a torture.

Nevertheless, if you take life as a whole (and I've talked to Mary endlessly about this) it comes out, in a sense, neutral: being vigorous and healthy and feeling on top of the world balances out the pain of being born, and certainly of dying. Dying is never a very happy event. Every single living thing has to die. And dying for everything is pretty bloody awful. Though I think being dead is o.k. Last year's daffodils are in exactly the same place and if you can imagine those things going on, then your imagination is more vigorous than mine. Taking life as a whole I suppose the sadness is balanced. And in this sense you're glad to have been there.

The second half of this century, after the war, for most of us, hasn't been that bad a place to be – we are warm and fed, in western Europe, as you say. We have art. We have things, these chocolate biscuits.

I can see and touch this microphone and know that we are made of the same minerals, ashes. But it can't see me. I see it and for some sort of reason we are transformed so that this pile of molecules, me, can see that the chair is green, but it can't look at me and say that's human. I repeat, we are a conglomeration of miracles. It's taken countless millions of years to evolve me, so I might as well enjoy it. And I'm grateful when people are interested in my work.

CHRISTINE JONES

Christine Jones talked to me in her studio above the Dylan Thomas Theatre in the Maritime Quarter of Swansea in November 1999. She shares the space with the sculptor Martin Williams. We corresponded later about the interview.

I'd like to talk about that impressive show in Frome I saw a couple of weeks ago: how important that sort of solo show is for you, and how you feel about all those pots in that one room?

Taking on a solo show is an incredible amount of work for me, and I wouldn't have done it if I hadn't had stock here. It's just not possible for me to do it with a year and a half's notice.

A year and a half's notice?

Well, there's at least two years' work in there. At least. Having done it, I'm really glad I did it, it is a pleasure for me to transform a room with pots, to create an atmosphere, to create an environment, just with vessels, and I love that, and I will through the rest of my career do solo shows. But having just done one now, I feel that I don't want to do another one for at least five years.

Really?

No. It's such a lot of work, it's such a long period without any work going out of the studio, and basically no money coming in, so it's that financial part of it as well. But I loved doing it, I absolutely loved doing it. I think they were quite surprised that I'd gone up there, and insisted on setting it up myself, but that's the kind of pleasure…

But you would, wouldn't you? You wouldn't let anybody else do it, because that's part of what you do as an artist; that's like writing a play and wanting to direct it yourself.

Exactly, but I don't think they quite understood that. From previous experience I know it's just creating a rhythm, and placing pots together so they harmonise is important to me. It's lovely having that sort of show. The last one I did was Still Horizons over in the Arts Workshop, the Mission Gallery now, and it was just fantastic, having that very sympathetic but blank space, and just being able to fill it, designing everything, from shelving upwards.

Do your pots have to have a white background, a white space?

Not necessarily, because people take them home and put them in their living rooms.

You have no control over that though, do you? I mean, once they take the pot, they can…

Well, they can put peanuts in it! Well, white is a good colour to show them off, basically, isn't it? And it's just making the background….

You don't want anything that outshouts the pots, because they're quiet pots, aren't they?

Oh yes, very quiet. That's their purpose.

To be whispering pots?

Quiet, tranquil, just spacious, very much about time. They take a long time to make, and that's one very important aspect of them for me. Because of

the process, the length of time it takes to coil them up and then paring them down slowly, and the marks on the surface.

Do you play music when you work?

Radio Four. Radio Four fanatic. Can't work without Radio Four.

I thought there'd be some kind of very zen music going on.

No, I can't work to music.

There's not a kind of rhythm that you could pick up?

No, no, Radio Four, chattering away in the background.

You have several pots in progress here. How long have they been in the making, so far? They're far from finished, I guess.

That one's far from finished. Probably about ten days to get that ten inches. Probably about two weeks coiling to that level, and then the refining process starts.

What I'm seeing is grey matter. Does that mean it's going to be grey?

Well, I colour the clays, so no. Actually, that's going to be medium blue.

So you start off with the very base material of civilisation, which is kind of clay, a kind of mud. Stuff that you could find, if you knew where to look for it, like wood, like water. And then, you start building up. Can you describe what that process is. You're not using a potter's wheel, it's a coiling process. You've got a lump of clay – what happens?

Well, I've got a lump of clay, I wedge it up; but first off, I colour the clay. I don't put any surface colour on.

Right. So how is that going one to be blue?

Because I buy in white clay, then I dry it out, I weigh it out, and then I put in a percentage of oxide, which is the colouring.

So the blue is inherent in what I'm looking at now?

It's absolutely in it.

And when it's fired, it will be blue.

Yes, blue, with a subtlety of tone, and it doesn't allow the light to bounce off it. I like the idea of them absorbing light. Just being very gentle about that. And I don't like glazes, I like to keep everything to the absolute minimum.

So it's a matt, absorbing finish, rather than something that's going to have a sheen, off which light will bounce.

Yes. I've got nothing against glazed pots, but it's not for me. I like to keep everything to its absolute bare minimum. It's a discipline I've imposed on myself, I think, but...

Is it a discipline, or is it just a matter of taste?

I think it's a discipline I've imposed.

That seems terribly arbitrary, though.

Arbitrary? Why?

Well, accepting a discipline.

Yes, but it's me that's getting there. It doesn't come from anyone else, believe me! Discipline's not easily accepted from anybody else! Say, when you leave college. If you think about all the alternatives you could do within

one subject, same as writing, same as any creative thing, I often wonder why do I make these? Out of all the things. I do think I've got an imagination, and yet to some people, to keep on making these vessels in the same way, might seem terribly dull and repetitive, but I'm just absorbed by vessels.

Is that your chosen term? You'd rather they were called vessels than pots? 'Vessel' is more accurate, more all-embracing?

I think so, yes. They're containers. It's normally bowls and vessels. The more enclosed ones I call vessels, and the more open bowl shapes, obviously, bowls.

So you've got the clay. You must decide the colour before you start coiling it?

Oh yes.

Because that's inherent in the clay. Does your choice of colour dictate how the vessel, how the clay object, is going to develop? At what point do you decide which is going to be a bowl, which a vessel, which a pot?

As soon as I decide what colour I'm going to use.

So colour is the absolute key?

Oh yes, very much so.

And do you go in runs? Do you have your blue period, and your ochre period?

No, no.

Does that very positive 'no' mean that you like to switch colours around?

No. It's just a natural thing. Maybe I'd run out of a colour, or somebody

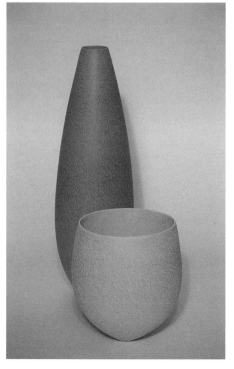

Vessels
grey blue earthenware (rear)
height 48 cm diameter 16 cm
ice pink earthenware (fore)
height 21 cm diameter 20 cm

will commission. For example, somebody's just rung me up, I'm working on all these pots here, and I haven't got one black one, I haven't got any black clay, so I've got to make some black clay, but that doesn't happen all that often. Say I've got a blue here, I might make it paler, I might add some white to it. But generally colour starts it off for me.

And your colours are subtle, and finite. You don't go wildly into colour, do you, in a very loud way, because that would militate against the shape of the pot, and your intention to create a quiet vessel. What are these things for?

What are they for? I suppose what I'd like to aim for is just, really, to make peaceful objects. Just a corner of tranquillity somewhere. That's what they're for. They're not functional. I do them much more to have a quiet, peaceful corner somewhere.

They're for looking at, aren't they? Are they for picking up, as well?

Yes, all pots are. But you can't to do that in an exhibition, otherwise people go in with their great big grubby hands. They are porous, and they do absorb everything. That's the only reason why, you can't allow touching in an exhibition. You have about five hundred people visiting an exhibition, and they all want to touch the same pot.... It's unfortunate, but there you are.

When someone buys the pot, and takes it to their home, how would you like them to treat it? They're obviously going to look at it. Every time I buy a painting, I know that I'm changing my surroundings. I'm going to change the place where

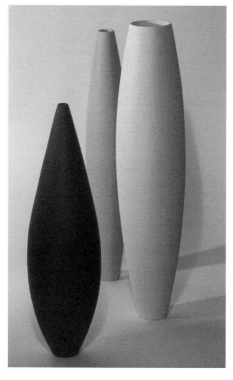

Vessels
yellow earthenware (rear)
height 45 cm diameter 10 cm
white earthenware (centre)
height 55 cm diameter 18 cm
black earthenware (fore)
height 40 cm diameter 16 cm

CHRISTINE JONES

I live in some way by adding that, by swapping something round. I feed off that, my eyes feed off that. Do you want people to move them around? Do you want them to touch it, to caress it?

Yes. Of course. I don't want them to stick it in a glass case. I want it to be a part of somebody else's environment.

They're not going to cook in it, but they're going to feed off it in a different way, in a visual way.

Of course. It's a visual thing.

Sure. And are they feeding off it in a spiritual way?

I hope so. But maybe I haven't quite go there yet.

Is that something you're moving towards? I'm not suggesting the object should be venerated, but it can emanate something, can't it? It can give off tranquillity.

Yes, that's what I mean. Not to be revered in any way whatsoever, no; but what I like the idea of is when I was talking about time, the process, the length of time that goes into the making, all those elements may be sensed. It's a rainy day here, it may be sunny tomorrow, maybe somebody else will visit, and all that kind of process that's been going on, all that life's been going on in this small square here in the studio, and then the pot is completed; it goes into the kiln, it's completely out of my hands, then. If it comes out in one piece, great. And then somebody will want to buy it. It's like a part of time, it's a part of something that's just gone on – ordinary daily life for me, coming into the studio every day – and the work goes off, and it becomes part of another life, in a way. That's terribly romantic, but I am romantic, anyway.

Well, as long as people keep coming along and buying them, then you can indulge your romanticism.

I have a reason to be here, yes.

So, you're making these wonderful objects for yourself. You're not making them for a market, for anyone else's expectation.

No.

But it's nice if there's a market there, because life is life, and you have to pay the bills.

My market is not fantastic, for everybody it's a struggle anyway, but people have wanted to buy them, and that's been fantastic. But I don't think I would have compromised. In fact I know I wouldn't have compromised. I've tried compromise, but I didn't last for very long, and as far as I'm concerned, you have to do what you want to do... but then, maybe I'm lucky.

Maybe you're good?

Maybe I've had some people looking after me.

Good quality work will emerge eventually, even Van Gogh. It comes a bit late in his case, but the work, if it's got real, intrinsic quality, whatever one's making; making hats, making pots, making pictures, making gardens, it'll come through. Somebody will see it. It will persuade people that there is intrinsic value there, which then sometimes becomes exclusive value. You know, the Old Master

work posthumously discovered, fetching a million in New York, or something. But the artist has got to believe in it. If you don't believe in it, nobody else is going to.

Absolutely.

Let's get back to the making of it. So you've starting building up your coil and you do, what, a handful of coils every day?

Three coils.

Do they look like little worms when you do them?

Yeah, and then I'll put three coils on, I'll dry it out, like this one here, keep that other one wet, that'll go off by tomorrow, add another three...

And obviously you started shaping, smoothing and incising, in a way, the pot on its way up.

Oh yeah, it gets worked on, I don't just coil it out. The process is there from the start.

And it's not to be rushed. The laws of physics dictate that it can't be rushed.

No, no, it's got a mind of its own, very much so.

Have you had ones that have flopped over?

No, not flopped. I've had just about everything else, though, but not flopping over, no. That tends to happen more on the wheel, really, I think, but as I said, if I tried to coil something like that in a day, it would fall over. You can't do it, it has to be taken very, very slowly.

When did you start coiling pots? You went to college late, didn't you?

Well, I sort of got convinced to go into teacher training college when I left school. I'm not knocking it, but I just hated it, and I'm afraid I dropped out. It just wasn't what I wanted to do. And when I went to the careers officer at school, he said, "Well, you're a woman, you're going to be a teacher." Art college wasn't something that was ever mentioned to me, though art was my main subject, that was all I wanted to do. They said, "You can do your art in your spare time, but you're going to have babies, and a family, anyway, so you don't need to worry about it really." It was very much that attitude.

So you were born in the Swansea area.

Yes. I was born in Ammanford, and we moved down here when I was about three, very young.

And did you go to Swansea Training College?

No, I went to Coventry, and I was very, very miserable there. Away from the sea, it was very industrial. I'm sure it's a lot nicer a place now, but I hated it, and I hated teacher training college with a vengeance.

Did you do art there?

Yes, I did, but not really, you know?

So what happened then? That must have been awful. Dropping out of college was pretty radical in those days, wasn't it? You were turning your back on a solid career.

So they told me. Everyone was absolutely appalled, in fact. So I came home

and got a job as a waitress. That was the start of many journeys, really. I just needed to take some time out.

To find yourself?

Well, not so much find myself, but to see what I wanted to do, really. I just knew I didn't want to be in teacher training college.

And you left Surrey College of Art in nineteen eighty?

Well, somebody said it was a really, really good college, but I was only twenty-four, something like that. I was a mature student.

And was that ceramics from the beginning, then?

Oh yeah, full-on ceramics. Fantastic. I couldn't believe this place existed.

At Coventry presumably you'd been a bit of a jack of all trades

Oh, you do a tiny bit of art and the rest is education. It just wasn't what I wanted to do.

What took you to Surrey?

I didn't know anything about it, and on my travels, I'd heard this name, Farnham, very, very well known for ceramics, and I thought I'd apply. They told me my portfolio was appalling, I should throw it in the bin. I hadn't done anything since A-level. I had been abroad; I went to Israel, I went to America, and Switzerland. I travelled around, doing this and that, worked in the civil service here, did lots of things, just experiencing life.

Were you drawing or potting at that same time?

No, nothing, no. So it was fantastic when I went back, it was heaven.

Because all those feelings inside of you wanted to come out.

Not only that, it was being with like-minded people, and that was just something I didn't think existed.

People don't know, unless you go to university or college, you don't understand that it's not about making a human vessel that's going to be filled with stuff, it's about being in a community. In its perfect state. That's what's so great about the Oxbridge idea and tradition; they all live together, play together, sing together, row together, and get drunk together. You can see how people are attracted by that, totally seduced by it and don't want to leave, which is dangerous because we have to come out into the real world. So you had three years there in Surrey?

Oh yeah, fantastic.

Were you always thinking about exhibiting? I mean, you had a solo show in eighty-five, so that's a sort of eighteen month, two year gap. Did you move back into a studio? Did you set yourself up straight away?

I came home, because I was broke, like any other student, and I had to live with my parents. All I wanted to do was find a studio, it didn't matter to me where it was, it could have been anywhere in Britain, I didn't care. All I wanted was a space to work, and then Martin Williams wanted to share this place, as a studio.

And you've been here ever since?

I've been here ever since, yeah. And as soon as I moved in here, I planned my exhibition over there in the Mission Gallery across the road. It was very

much a goal for me to work to. What you did in those days was you hired out, you looked after it, you did all the publicity, you did everything; it was just a space. It's quite different now. And I think I had a hundred and fifty pounds from the Arts Council to do it, and had to sit in there myself, and look after it, have the posters printed, and everything.

It was all consuming, then?

It was great, it was a fantastic experience, because I just learnt so much about actually doing things on the other side of it. Not just producing the work, but actually dealing with all that other....

Which is also a skill.

I'm still very heavily involved with the gallery over there, just as a volunteer.

You're almost above the shop in a way. So you sold at that first show, that was the first, that was encouraging.

Yeah, fantastically encouraging, absolutely.

Going back to eighty-five, would I recognise the pots and vessels as yours, from what I know now?

Probably, yeah. Similar, but different character. Perhaps not as strong, not as confident.

In terms of colour, or shape, or size, or...?

All of that. I'm still making the same forms. I can't let it go, I just haven't finished with it yet. Lots of people have said to me I should make something different, you know.

Something with birds on. Bit of gilt around the top.

Flowers.

Flowers is good, yeah

Feet, stick feet on them, make them stable!

Was there a sense when you started back here in Wales that you felt you were joining some kind of potters' brethren in Wales? Were things going on that you knew about or cared about, or admired in any way?

No.

I'm not surprised; I mean, when you go down to Pembrokeshire, for every filling station there's a pottery, but they're doing very much everyday, domestic ware and so on. A studio potter in Wales is a rarer beast.

Probably.

Who did you know about? This was just something you had to do — you had to do this, so you did it, without reference to a wider context — or thinking, "Who isn't doing this? Where might I fit into something?"

No.

Nothing as guileful or planned as that? I pot therefore I am.

Go for it. If it doesn't work, it doesn't work.

What was Plan B?

I don't think there was one, actually. Perhaps I would have compromised, I don't know. I did compromise: at one point I went back and did a post-graduate course, not something I want to boast about. I went back in

ninety-one, ninety-two, to Cardiff, for an art teacher's certificate. I was just so broke. The recession had come. I had been doing so well, but the recession had come, and overnight nobody was buying anything. This had been going on for about two years, and there was nothing coming in. It wasn't that I didn't want to work, I'd still come to the studio every day, working, but you just get to the stage where you just think 'God'... so my parents suggested it. They've always wanted me to have a nice job, and so they advised me to go back, and do this year course. Which I did, which nearly killed me.

But you didn't want to teach anyway, did you?

No. But I just thought I had to do something. So I did that for a year. It was great, very challenging. I mean, I hadn't written an essay for ten years or whatever, and it was good to get the brain cells moving again, in a different way. That was very stimulating. The course was absolutely fantastic. It was a PGATC; Postgraduate Art Teacher's Certificate. Bit of a mouthful. But I had a fantastic tutor up there, John O'Neill, who just wanted children to learn about art, and his enthusiasm was so great that you couldn't help but get involved in it.

Teaching is a very important job.

Oh God, don't get me wrong, I've got all the admiration in the world for teachers, but I can't hack it in a classroom. All the kids are much bigger than me, and they don't sit down and listen when you tell them to. I can't discipline people, and either you have that ability, or you don't.

So you did that, you felt good about it, it was basically a positive experience, but it wasn't a career move.

I went for about three interviews, and nobody wanted to employ me. Sad, isn't it? I thought, "They just know that I'm not serious." I couldn't just sit there. I was pretending, and they knew it. You don't have a studio for ten years and suddenly decide to be a teacher.

Well, times are bad if you do. Did you do any part-time? Do you do artists residencies, from time to time?

Oh, I've done residencies, but that's a different ball game altogether. I've done lots of residencies and things like that, and they're great fun, and enjoyable, but not teaching. No, can't do it.

So you're a maker of vessels and pots, and that's it. They can either take it or they can lump it. That's who you are, that's your identity. You have said these are recognisable pots. You say that from time to time people nudge you and say, "Well, why don't you try a teapot or something." Your vessels will only change when you want them to change, when you think you want to go somewhere else with them. No commercial or personal pressure will lead you to change?

Not after, what is it, fourteen years? No, don't think so.

Well, what about after twenty years? Twenty-five years?

I doubt if it ever will. I'll make these until I die. Because it's what motivates everybody, you never think you've made... it's never good enough.

So there's a sort of ideal, there is 'the pot'.
Well no, not 'the pot', it's not anything I'm ever going to make. I'll never be able to make it.
There isn't the perfect pot, there's only the idea of the perfect pot?
Yeah.
But you must finish some, you must pull some out of the kiln and say, "That's a good one"?
Yeah, not very often. But it doesn't last for long. The following day… I can pull it out and think that it's okay, it hasn't fallen apart, it hasn't got any cracks, it's not wonky.
That's very negative. Don't you say, "That one sings!" That it's the mother of pots, a humdinger that's going to resonate for you and other people?
I can't, because I haven't done it yet.
But I've seen a fair bit of your work now, and there were some gorgeous things in that last solo show, and the three pieces in the National Museum are very, very satisfying, to me. I mean, they're very pleasing works.
H'mm.
You know they are. Those are very fine pots, they're lovely vessels. There must be satisfaction there, tremendous satisfaction.
Of course it's satisfying, when you've made something you feel is half-way successful.
Half-way successful?
Yes.
I want to enthuse about them.
Well, I'm not going to, because I just don't feel that way about them.
If the mother of all pots came out of the kiln, would that be the end of it?
Perhaps it would, yes. You'd say, "That's it," then retire. But things move on and I am changing clays from time to time. I've only been working with this clay for three years. It's a much more textured clay, it allows the forms….
So there isn't simply clay, there are varieties of clays, just like any other artist's materials?
Oh yeah, lots of different types of clay.
So what clay are you using now, then?
Well, this is Y material. It's in the catalogue as simply that. You can get T material as well, if you like! You get earthenwares, stonewares, you can get different coloured clays; greeny clays, brown clays, red clays, so it's just up to your own personal thing, what you like. I like using a grogged clay. Bits of fired clay in the body, gives it texture. So whilst I'm working on it, and refining it, these little bits of fired clay make more texture on the surface.
So there are developments?
Oh yes, constant developments.
Although the pots seems to have unity and constancy, there are in fact shifts. The shift from one clay to another is a major shift.

And colour. Definitely, no doubt about that. I have changed. If you put a pot I was making now against a pot I made five years ago, eight years ago, ten years ago, they'd be very different. They'd still be similar, but have a different character.

Because there hasn't been a retrospective of your work, has there?

I'm too young to have a retrospective, for God's sake! I think I'm too young, anyway.

You think that's a moribund sign? "God, she's having a retrospective, she must be ill."

Yeah, "She's on her way out."

I don't know, you're in mid-career, aren't you?

Mid career? No! I'm in the early stages of my career. That's how I see it, anyway. Say I've been here for fourteen years. That's nothing, nothing. You look at somebody like Lucie Rie, who was still potting when she was ninety.

Yes, Rie, Coper and friends. How could one work as a ceramicist and not be influenced by those people?

Oh, I think that's quite easy. I don't think you have to be influenced by other....

But even if one is in reaction to them, there's an influence.

When you're working in art college, you're doing all sorts of stuff. When I came out of art college I realised that what I wanted to do was actually communicate through pots, I think. So instead of making obscure, self indulgent what-have-you, like great big mashed up spheres with things poking out, and God knows what, I really came out and thought, "Where can we start?" I just chose to work with bowls. And I'd always been a hand builder, I'd always been a coiler, I'd always loved coiling, so this is where I've stayed. I thought I'd do this for a couple of months, and see how it goes; but it just took over.

So there's still that satisfaction of that shape, that form.

Yeah. And something that people relate to, but is different. There's a way in for people. I don't want to...

You don't want to confront them with ugliness. You don't want to be confrontational.

Well, not only that, but I don't want to confront them with something that is completely self-indulgent. The pots aren't self-indulgent, are they? You can't say they are. It's not possible.

What do you mean? There's a classical ideal that you're working with, a classic form, do you see it as that? I mean, I can't pour my tea out of that. They're not utile, are they? And if they're not utile, they become objects to be looked at, rather than utilised, so that's a degree of self-indulgence.

Okay, maybe.

You're not doing any use in the world, are you? You're as useless as a poet!

Okay then. What I was trying to say in that statement, in fact, and I take on board exactly what you're saying, but what I was trying to say is that I

don't see them as fashionable things. I like to think that they go a little bit deeper, that's what I'm trying to say. I don't want to be....

Fashionable. But you want people to buy them for their intrinsic worth, not just because you've had a big show, and you're popular at the moment.

It's got to go a lot deeper than that for me.

Your kiln is rather modest. I was expecting some great oven of a thing.

No, it's very straightforward. Electric. I don't do any fancy firing. I get enough failures just doing it in a straightforward way.

So you fire a few pieces at a time?

Normally about five or six pieces at a time. These are from the Frome show, I've just put them in there for storage. They're going up to London. That's very, very dark grey. I get a terrible failure rate with black. Major, major, major. They warp.

So you've got cracks and warps that are potential problems.

Cracks no, warping yes. Warping is my big one.

So opening the door is the moment of truth. What sort of failure rate do you get? Too much, obviously.

Well, it is when you've spent three weeks making a piece, but I've learnt to live with it. I have to. I've just got to say, you know, that's part of the process. I give all my warped ones to friends, and the house is full of them. But if I didn't push myself to make that particular piece, I'd be playing it safe all the time. I've got to take it further.

Presumably the higher you build the vessel, the more problems you have? These look astonishingly delicate.

They're not, though; they're quite hardy. You pick that up.

Bloody hell! It's like picking up an artillery shell.

My partner Martin calls them bombs.

It's really like an artillery shell. Are they all heavy, then?

Yeah, they're all weighted.

Well, that is a surprise. So they're pretty stable, even the tall ones.

What I wanted to talk about is the way in which they work in groups, because they do work in groups. If there are two pots, you get more than the accumulation of one pot's effect and another pot's effect. Something else happens. There's a kind of dialogue that goes on, isn't there?

I hope so. I like that idea. I think they work just as well singly, but I like to complement pieces. They do feed off each other, very much so.

So, Martin Tinney is going to take them up to London for his Christmas Cork Street show, but you won't supervise their presentation there, obviously.

Oh no, no. But I will be the only ceramicist, it's all painters. I think he'd discovered that he'd got an alcove there, with a lot of shelves in it, and rang me up and asked me. It just so happened that I knew Frome was finishing, and I knew I wasn't going to sell in Frome...

It was tremendous, seeing a sweep of them in a room. It was like a congregation of vessels, if you like.

CHRISTINE JONES

One day I'll do a show that I'll be satisfied with. I'm never satisfied. What I'd like would be for somebody to pay me for about five years to produce an exhibition and then I'd be able to do what's been on my mind for years, but life's not like that.

It's only some London or New York gallery which would put you under that kind of contract, but then sell the lot at the end, or something.

Oh, no.

Well, that's the only way it'll happen.

If I had enough money to support myself to do it. I wouldn't want to be controlled by anyone else, really.

No, no. But what if someone came along and said you could do what you like, on trust for, say, three years, and that they'd take what you'd done, and show in their gallery what you'd done at the end of three years, and then bill you for the expenses and advances? I know that's happened with painters.

Doesn't happen with potters.

What about potting in Wales generally? I was born here, but I came back in seventy-four, after teaching in England, and there were few people I was aware of then. I can remember buying a couple of things from Albany Road. I recall Betty Blandino was the leading name. I know she included you in her book, I didn't really know anyone else at that stage who was a studio, arty potter. By the time you came back in eighty-five, started to show in eighty-five, there didn't seem to be any club or context that you were joining then, did there? You were just doing your own thing, there was no sense of anything else going on.

Yes. The only thing was that I came into this building, and it was amazingly supportive to work with people who were already established in whatever field they were in; painters, sculptors, weavers, stained glass artists, that was incredible. To have that range when starting out meant an awful lot, so a great amount of support.

How did you get there? Did you just apply to the council, or...

No, this building was here, and Martin Williams was here already. I'd gone, I think, down to the Mission, and then came over here. I was just looking for studio space and I just came in, the door was open, and then got chatting to Martin, and he wanted to share. This actually used to be our kiln room in here, because we were going to build a big gas kiln, but eventually we worked out it was just too expensive, but that was the initial reason I moved in. And then over the years Martin's gone on to much bigger projects.

In terms of influence, if anything, do you feel in reaction to Rie and Coper?

Well, no, not at all.

That's the impression I got.

I try to be part of that tradition, absolutely. I'm very traditional, really. Everybody says who your influences are, but I don't really, honestly, ever think that it was Lucie Rie or Hans Coper, I really don't.

What about Leach and that whole ethical pot movement – you're making an unflattering facial response to that!

No. Well, you get it shoved down your throat, don't you, when you're at college, and you just rebel, basically.

Good solid pots though, and jugs and mugs and tea pots...

Oh no, they're brown!

You hate brown, don't you? Everything about you is un-brown.

Definitely.

But it became a kind of moral imperative, that these things in the Leach school, these things were utile. They were plain, brown, and were some use in the world as well.

It was a whole different time. I just don't want to know about it, really.

The Leach school of pots doesn't attract you.

Yeah, yeah. I mean with Lucie Rie, it's taken me a long time to appreciate her work. Hans Coper I actually discovered well after college, and I'd not seen any of his work in the flesh, and I actually saw some pieces in a craft centre. I was in a studio then, it must have been three years into being here, and I saw them and I thought they were absolutely fantastic. It was a personal experience, it wasn't like somebody saying that I'd got to like Hans Coper. The quality, the presence, these tiny, beautiful pots. That was a real discovery for me, as a potter.

That doesn't say much for your college experience. How didn't you know about these people?

I knew about them, but you know, I was an art student – you don't want to see Hans Coper, he's old, he's dead.

We were in New York and saw a Coper show. An astonishing show, just amazing, wonderful stuff, but that's the antidote to Leach, and the brown jars.

Whenever people ask you who you're influenced by, we're all influenced all the time, aren't we? It's just I don't feel that I was directly influenced by anyone in that way. I wish I had been.

But there was a moment there when you saw this Coper work...

Yeah, but that was discovering the quality of his work.

Which must feed into what you're doing, mustn't it?

Well, yes, of course it must. But to say, "Oh Gosh, I admire this work".

But you sound like the kind of person to which that doesn't happen all that often.

No, it doesn't.

Do you keep up? Do you go to shows, do you seek out things?

I don't often get the chance. To be honest with you, since about June I haven't been out of the studio. It's just been absolutely hectic, and so I haven't had a chance. I'm hoping to go up to London, maybe mid-December, and that will be the first time I've been to London for about two years. I just don't get much of an opportunity. But with the Mission across the road, I'm always going to keep in touch with what's going on in the craft world, because obviously I'm incredibly interested in it. I find it fascinating, what people are coming up with. Go to somewhere like the London Craft Fair these days, and the work people are producing, it's good. Not

particularly the field of ceramics, but certainly with jewellery....

There are a lot of talented people in this country, certainly.

Absolutely. And very good quality, really good quality stuff.

I suppose the people really making waves in ceramics since Betty Blandino, are Walter Keeler and Michael Casson. Casson's on the border, or thereabouts. But he's a brown man.

Don't talk brown pots to me!

I've got a Michael Casson on my mantelpiece. It's a lovely jug.

Yeah, I'm sure. I'm not being critical, it's purely personal taste. And I'm sure he wouldn't like my work either. It's just different schools.

You're suggesting there that they're mutually exclusive. Maybe they are. And there's Keeler. He's not brown.

He's not brown, no. Great stuff.

And there's Frith. He's in the same case as you in the National Museum.

Right. I know the name, I can't...

And Morgen Hall I mentioned. I just love the sort of tricks she plays, and the humour of that.

Oh yeah, absolutely.

It's different, it's like the two masks of comedy and tragedy. Your pots are very serious, you want them to be. These pots demand to be taken seriously, they demand to be looked at seriously, not to be walked past. They demand to be

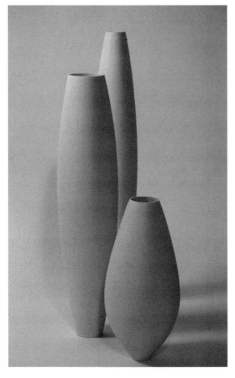

Vessels
white earthenware
height 66 cm diameter 15 cm (rear)
height 55 cm diameter 18 cm (centre)
height 30 cm diameter 18 cm (fore)

engaged with.

Well, I hope so. They are serious. I'm probably not that serious about myself, but I'm certainly very serious about my work. You often wonder why you've done one thing and not another thing, in a particular field.

If you're lucky you find out.

Yeah.

Some people don't find out. Serious people do find out why that is, they work it out for themselves. Are you on a journey with these pots, in a way? We talked about the 'perfect pot', that's never going to appear.

I hate that phrase, 'perfect pot'.

Right. Too scary? Too simplistic?

Too simplistic. Yeah, maybe that's what it is. Of course I'm on a journey.

And are they accompanying you, or are there places where they're stopping off?

That's very poetic. They are accompanying me, definitely.

Literally, are there pots that you think 'I'm not selling that one, I'm keeping that one, I'm keeping that for a while, anyway'?

I keep things for a while, often. Not through any sort of preciousness. Often through doubt, but I do keep things when I want to think about them a little bit longer. I keep them around as reference, maybe.

So you want to learn more about what you've done there? To carry on into your work.

Yeah, because very often they come out of the kiln, they're into a box and they're off.

You don't really want that?

Well, for the last six months it's been like that...

Your bank manager wants that, but ideally you don't want that.

It's nice to have work here. It's very frightening not to have any work here. I like to have some of my work around just because people demand sometimes, and often I get failures, maybe it's that bit of security as well.

The pressure to produce.

Yeah, and I don't like pressure at all. No, I don't respond to pressure, I go totally the opposite way. I have to be very well organised, or try to be very well organised. I do try not to take on things that I can't fulfil.

I mean there are five works in progress here today.

Actually I've got a lot here. I've just been coiling like mad. Normally after an exhibition I fall into a heap, but because I had commitments, I couldn't stop and take a break, which normally then takes about two months for me to get back in. This time I haven't taken a break. I'm still going at top speed.

Perhaps it's Millennium anxiety?

It's something, because normally it doesn't happen. I can't stop. Once I stop, I'll probably have about two months off, where I'll just be recycling clays and doing this and that.

Everyday, background stuff.

Yeah. But at the moment I'm just producing at full pelt, and have been for

about the past six months.

But the way you work is not to produce a pot and then to start another pot. It's ongoing because each pot has to occupy a different stage of production.

If I only had one pot on the go, I wouldn't have anything to do. I could put the three coils on and I could sit here all day and contemplate. There's a rhythm, but once you stop that rhythm it takes a long time to get back into it, to start all that process going again so you have this lovely flow going, and all you've got to do is walk in and your work presents itself to you. You're like an instrument, almost, tending to the needs of each thing that's going on.

I'm trying to make parallels with what I do. I'm putting a selection of poems together for Italy, and there's nothing to stop me taking a poem I wrote twenty years ago, and published twenty years ago, and changing it. I can do that. Like you, I keep things going. I'm working on a collection of poems, and I'll put a comma in in the morning and take it out in the afternoon, that's what writers do. You're doing that in a way, but then for you comes the firing point, beyond which there's no recall. It either works, or it doesn't, and that's such a dramatic thing, really.

I love it, though.

You like that?

Oh, yeah.

And the better you get, the fewer failures you have, presumably?

No.

No? There's always going to be that one pot...

There's always going to be that time when you've been in the studio and you're not concentrating, and you make an error. That's human, isn't it? There'll always be failures. But over the years, you learn to live with it. But it doesn't distress me any more, I take it as par for the course, I take that as part of a good pot. I used to be distressed by it, but now I just take it as part of the working day, really.

I'm very loath to give up on a poem, it can always be sorted. When a pot fails, you can't recycle the clay once its been fired, obviously. It has to be binned. But if something happens while it's still malleable it becomes recycled, so there's a parallel there.

And you also learn... whilst you're working, you know when something's not right, and then you...

You can feel it as well as see it?

Yeah, and you just say put it in the bin. And you'll work on it for maybe another day, and you say again that it's got to go in the bin. But you don't waste the clay, you recycle it. But obviously if you think there's a little bit of hope there...

We've said your pots are more meditative than narrative. What's the relationship between the pots and real life for you? Does what you're going through in your life feed into the pots? Does it reflect? Obviously, when we have to deal with

the day to day business of life, affairs of the bank and affairs of the heart, then that effects the way creative people work. I write about things that happen to me. I've been ill, I'm going to write about that. Is there a way in which what happens in your life is echoed, is reflected in any way, in the vessels that you make?

No. What I see effects what I do. Without wanting to sound too romantic. I see a fair amount of the sky, and as I say colour is a very important thing. If I see a winter sunset, and some gorgeous grey and pink comes into the sky, what I see influences what I do. What happens to my life doesn't influence my work. I don't think it does.

There's no 'confessional pot'?

No, not as such, no. That seems very cold and calculating, doesn't it? Not doing that. I feel like they're part of who I am, and what I do, and there I am, just by the very nature of making them. If I was a painter, then I would be, probably, expressing what happens to me.

Though not necessarily, of course. If you were a poet, it would be difficult to keep your life out of the poem. It is a very confessional medium. Would it be insulting or intrusive to say that the pots are the place where you are really in control of things in your life?

You sound like a psychiatrist!

I mean, they are meant for something.

No.

What you produce, when they're fired, they're very meditative, they're very zen.

Yeah, but they're not... I hope they're not the only place of control in my life!

But of absolute control in your life.

But I'm not in absolute control at all...

Because the bloody kiln has this awkward relationship with you.

Yeah, and I have to be... I have to communicate with the clay, the clay is my partner in this. I have to work with it. I don't sit here and talk to it, but it's what I work with. If I wasn't sensitive to the material, I wouldn't be able to make anything. It's alive, it's a great, wonderful thing to work with. It has its limits, and you have to find out where those are. I like to push them, but I know when to take a step back, and let things be.

Because as the pot gets higher, as the pot gets more adventurous... I mean, I'm surprised at the low centre of gravity of those pots, and I'm delighted that they have, because I feel so insecure around them.

Well, lots of people do.

So it's kind of a risky business, for the viewer.

Yeah. It's about being vulnerable. It's about vulnerability, but at the same time it's about strength and stability. They unnerve some people dreadfully.

Oh, I can understand.

Some people won't breathe in front of them. Strange, just as a reaction to a pot that's made out of clay.

You are creating a beautiful thing that has its own space: the pot changes the

space; the vessel encloses, but takes up space; there's a dialogue going on between the vessels; there's a dialogue going on between you, the maker, and us the viewers, the recipients of these things. Yet there's this awful feeling that it might go over. It's something that needs to be protected in some way. I feel much happier having lifted and handled a vessel. I mean I feel insecure here, because I like pictures, with frames around them. I like the rectangle, that's why I like poems. A poem is some black stuff in the middle of a white page, and I like a picture with a frame around. The pot is really dangerous, it's really wild, because in a sense things emanate from it. Your pots are designed to absorb light, but there's still a presence of the pot, and I don't want to get too close.

That's the difference between being a two-dimensional person and a three-dimensional person, isn't it?

Is that what I am?

You're two-dimensional. I'm afraid so! With what you do being two-dimensional. But I'm three-dimensional. I'm real, you see!

And yet one of the problems of showing the pots is to decide whether they're on ledges. You have this format of presenting them as a coloured shape in front of a white background, or the possibility of walking around the object, completely circumventing it; that's a tension. So in a sense, your three-dimensional objects in some situations become almost two-dimensional. The few ceramics we own by other people are usually on mantelpieces or window ledges, or on the piano, and you can't walk around them.

Yes, but you can pick them up, can't you?

Yes, but one tends not to.

You use them, don't you?

No.

Why not?

They cost too much! I've got a coffee pot from the school of Leach which we use on special occasions. We use our Morgen Hall plate to serve quiche. That's the difference, isn't it? You don't want people to pick these up, do you?

Of course I do.

But not in exhibitions. Once people own them they can pick them up.

Yeah, not in exhibitions, it's just a practical thing. Of course I want people to pick them up. I pick them up and move them around all the time.

Handling those pieces, I now know they are much more substantial objects than I thought.

They are. I have to admit when I first started I made them like egg shells all the way through; when you picked them up they almost flew out of your hands. But over the years they've become something different, so there's the illusion of fineness and fragility there, but they're actually substantial.

That's a great tension, really, because the colours that they are and the shapes that they are belie their mass in a way. That's interesting, that they seem to be these quiet, contemplative things, but they're tough little buggers, aren't they? They're chunky, much chunkier than I thought. And in an exhibition, because

you don't touch, you don't realise that. I think there should be an exhibition, no kids allowed, where you encourage people to handle them.

Well, I wouldn't mind, in an ideal world. But when you get people with kids in, it's not just worth it. The gallery would have to pay for anything that breaks. I know it's horrible, but that's the way it goes, unfortunate as it is.

That's the most surprising thing you've said, because these really are things to look at, I think, and having lifted one up I now begin to see these are also things that are portable and...

Stable, weighted, rounded.

In 1991 there was a Total Oil commission for your work, a series of vessels for an office in Kensington, and that's interesting. In a way, that's what artists want, they need patrons.

Of course they do.

That was a considerable commission. Is there any kind of compromise involved in that? If somebody came along and said that they wanted six blue ones, would you do six blue ones?

Of course I would. Making six blue pots isn't a compromise.

And if they said they didn't like the blues you've been using, they wanted a different blue.

M'mm... well, I mightn't be able to make it. If I could make the colour. What I've done at the moment is make a new sampler, I'm making some new colours, I make my little recipes.

So you're mixing as a painter would on a palette, but you're recording the mixing.

Yeah, and it's much more time consuming, and I often don't have the time. I've been meaning to do those for about eight months, but I only got around to them about two weeks ago. In fact, I haven't made any colours for about two years now.

But they'll be colours in nature rather than...

Very much colours in nature, yeah.

So the forms are not exactly organic, but they're round and sensual, and again there's the tension between the apparent fragility which the colours lend to them, I think, and the solidity of the actual pot. And there's a tension between the fact that they're artificial, but your colours tend towards the natural. There are no bright reds, there's no postbox red.

No. You'd have difficulty in doing that, unless you were using different materials, like enamels and things like that. There are ways of achieving that in ceramics, but they are not colours I choose.

So the colours are predicated by the clays that you choose, the clay you're happy working with?

The clay and the oxides. You can achieve very, very bright colours in ceramics, but I much prefer the more subtle tones.

So again, it's a matter of choice, it's not just the practicality of the thing. You have a palette, and you're about to nudge that palette a little further. But you don't, you can't, conceive of the idea that you could be pushed into a very radical

angular shapes, or very loud colours, that's simply not what you're about.
No.
Even if someone came along from Shell Oil and said they wanted some really radical sharp bright colours?
They'd have to pay me a lot of money! It wouldn't be what I do. I'd much prefer to send them to someone else.
And if you come to me, you must have come to me because you like what you've seen, so why would you expect me to be radically different now? That probably wouldn't happen, anyway.
No. It wouldn't happen.
Are you at all religious?
No.
Because there's a spiritual quality to your work. I'm sure people are responding to a contemplative quietude. People who are purchasing your work are not just buying a pot. They're buying something that's going to resonate in a space that they think is important. I mean, you're a front room artist. This is going to go on the mantelpiece, or that very special table. The pot is going to change its surroundings. That's the expectation, I would think. Purchasers want to bring something extra into their personal space.
M'mm. You've gone from one question to another to another there, now. Ask me one question, and then I'll answer it.
This idea of the pot somehow completing their peace of mind, or completing their sense of where they are and their surroundings, you know, "I must have a Christine Jones vessel, because"...
I could never take that on board, no. I hope people buy my work and enjoy it. It's really as simple as that. I hope it's generous, honest, spacious...
What you see is what you get?
Yeah.
But they may be seeing a bit more.
Great.
Right. "I'm happy for you," you might say?
No. I like the idea that I just make something that involves a lot of time...
And skill...
...and energy...
...and vision...
...and passion, and that somebody else is going to enjoy it too, you know. Why not share it? I'm very lucky. I know the rain's pouring in, and it's freezing cold, you've got soaked here indoors today, but I love it. I'm very lucky.
Because you're doing what you want to do.
Yeah, absolutely.
And just about staving off pneumonia!
No, I've got my thermals on! I'm not good at talking about myself and my work. For me, it's a very private thing, and at the end of the day, what goes out of the studio, what happens in here, I don't feel the need to talk about

it. Some people like to talk about their work. I just do it.

This is what I do, and this is, partly, who I am.

Yes.

You're going to do this whether the vessels go out of the studio, and people want them, or not, I guess, aren't you?

I have to. This is my work. My worth, maybe. I don't know whether that's the right thing to say. My value as a human being. It's what I have to contribute. It's certainly not teaching.

If you're a maker of things, and teaching isn't what comes naturally to you, what you're happy doing, then you just have to make those things and hope for the best, really.

I'm not knocking teaching at all.

No, no you're just saying it's not for you. You've talked about a specific person in Cardiff who you found inspirational, a valued working relationship.

Oh, totally. Another person I could mention is Nigel Williams. He trained as a painter, but got into adult education, more as a freelance thing. He's been running this Opt for Art scheme, where artists go into schools. He does tremendous work, really getting to the core of things. I'm just glad there's someone out there doing these things. The point is, when you're teaching, you know that some kids are losing out, because of the discipline problems.

About the texture. These vessels seem to be smooth, perfect, and have this quietude about them. But as you get closer, they're marked. They're not perfect, they're not unmarked, they carry the marks of the making. What makes those lines?

The clay's grogged, it's got those fired bits of clay in it, which I use purposefully. Sometimes it's fine, like a silica sand, and other times it's large pieces of grog, like this new clay I'm working with now. And so whilst I'm working on it, I'll refine it and I'll work on it with these tools; scraping the surface then, would bring out those bits of clay, and drag them across the surface, and of course you're working, and working, and working, refining away, so you're building up this whole texture. I've got no control over it, it just happens in the making.

The control is you determine when to stop, presumably?

Yes, but it's bringing these onto the surface, and making that texture. That's a narrative, in a sense.

Is it?

Yes. It's like writing to me, all those marks on the surface that are random, that I don't have control over, but that's par for the course.

Except the choice to leave them there or to keep working and eradicate them.

Oh, you won't eradicate them, no. I'd use the clay without grog in, if I didn't want them. That's very much part of the piece as well.

There are sweeps and swirls on the black pearl-shaped vessel that we're looking at. Are you ever seduced by the possibility of figuration? You could sweep those into foliage, or grass, or…

No.

CHRISTINE JONES

Clearly you haven't in the past, but have you ever, with the door locked, been tempted to draw a cat or something?

No, no. It's as it is. It's myself working with the clay.

In order to get that, what already appears to me to be a wonderful curving and shape, the marks are a necessary means of achieving the shape. That's you working the shape. It isn't?

No. I've only just started refining this now. Those marls aren't finished. Then I use a smooth kidney, and take all those serrated marks away and I start working with the grog in the body, and dragging that over the surface to create these marks that will actually be left there. That's within the pot itself.

You've determined the shape by then, so this is decoration, this is not construction.

In a sense. But it would happen anyway. If I didn't want that surface texture, I wouldn't use that clay. I use it because I want that texture on the surface.

Does that lead to the absorption of light?

I don't think so, no.

What controls the absorption of light? Is that the colour?

It's not being glazed. Otherwise it would be very reflective. I've only just started refining this now. I continue to carve it down until I think I've gone far enough, and then I'll start working on the surface, and bringing out that texture that creates those lines.

It's almost like a beautiful person's skin. And when you get closer you realise that nothing is flawless. It can't be flawless.

Now that's good. I've never thought of that before, but that's a lovely way to describe it, yes.

The glossy models appear to be Goddesses, flawless. But nothing is flawless. If it were flawless it would be almost non-human, wouldn't it?

That's why I don't like the word perfection associated with my work, because it's not perfect. Perfection is not something I strive towards.

But you want the rightness of shape, the right curve to it, the right height to it.

Oh yes, but that's harmony. That's being harmonious. Perfection doesn't come into it.

Because it's clay, for goodness' sake. How could that be…

Yeah, exactly. And it doesn't want to be perfect.

Like porcelain's perfect? That's a different aesthetic, isn't it?

I don't know, I can't use porcelain at all.

No, but you wouldn't want that.

No. That's why I make fine forms in a heavily grogged clay. Maybe the contradiction's there. Nothing's perfect.

That's why I respond to more contemporary work, and in this instance to your work, and I'm not interested in the Nantgarw and the Swansea, because it's too pretty.

It's industrial, isn't it? It's a different thing. It's made through an industrial process.

And then decorated with great skill and some individuality.

It's different, it's an industrial process. You're talking one-off pieces, as opposed to mass production.

And one can spot a Christine Jones piece. You are recognisable. You want to be distinct. You have your own aesthetic, and once one has seen one, two, three of your pieces, then you'll spot another one. There's no-one else doing this, is there? These are yours. You must be very proud of that. That's what you're about, isn't it? Getting there.

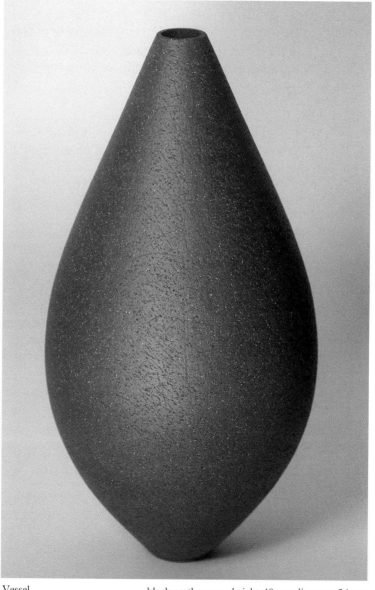

Vessel black earthenware height 40 cm diameter 24 cm

TERRY SETCH

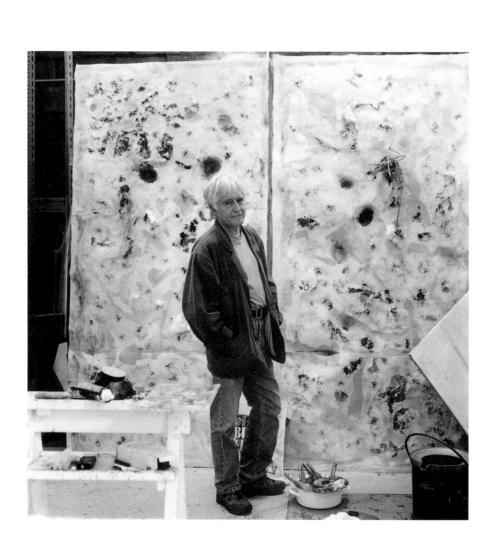

Terry Setch invited me to his home and studio in Penarth in 1999. He lives in a large Victorian house in the same road as the painter Charlie Burton. Terry has had a studio in the Bute Street building in Cardiff in which Iwan Bala, Susan Williams, Phil Nicol and Jan Beeney work. He has been an original studio member since 1979. We talked again at Terry's exhibition in the CVA in Cardiff at the beginning of 2000.

We know you for the beach work at Penarth particularly, but you were born in Lewisham, miles from the sea and in another time. Was there a moment when you realised or determined to become a painter?

I was born in Lewisham in 1936. During the war a landmine fell in our street and we had to move out. At first the Salvation Army took us in and we were homeless for a quite few years. Then we were deposited by the council with a snobby family in Ewall in Surrey. I was obviously not an artist at that stage! We were moved constantly and ended up in a rest centre near Sutton. My father was a boiler-maker and had to travel from Surrey into work in the Isle of Dogs everyday. We were really working class: there were no books at home and it was by chance that I went to art school in Sutton.

That happened because my mother worked in the first school canteens after the war and I was a kid at the same school. As soon as lessons finished I went over to meet Mum where they were peeling spuds and preparing for the next day. I used to love drawing, so she'd give me pencils and paper and a pastry board to rest on. One of the other dinner ladies was the sister of a teacher at Wimbledon Art School and she said her brother would like to see my drawings. She took some off to show him and the message came back that I should go to art school. I was only twelve, but he said that I could go to his Saturday morning art classes. When I was fourteen I applied for a junior art award and went to Sutton and Cheam Art School. My parents supported me for years and never complained, though they didn't really deal with it or ever brag about me, even when I had work hung in the Tate.

How good was that course as an initial art education?

At the age of fifteen I was working in my own personal way, doing small watercolours, not attaching much to the curriculum, we had to do typography and other things which I found boring. But at fifteen I went to the big Munch exhibition at the Tate. Because I was an introverted kid and a bit of a dreamer the emotions were quickly aroused by Munch's paintings. I wanted to be a painter from that moment.

You were already practising, as it were, but it was the emotional charge, the size and importance of the painting that made you realise that.

I didn't paint like Munch – I was painting small watercolours which I suppose now fit with the British Neo-Romantics of the mid-century. And that took me to Sutherland and then on to Bacon. I would distress the paper,

worry it until it holed and then this revealed new images in a new context. I am still doing this in my large paintings.

So you were breaking through the surface and realising that might not be accidental, that it might be part of making the work?

Yes, the edge became frayed and took on a shape, although the interior of the painting might be a woodland or a saturated landscape.

And then you went to the Slade?

At seventeen, but it was pointed out that I'd have to do my National Service first. I served mainly in Germany on the Rhine. I did do sort of commercial art in the Army, including the design of dinner place settings for regimental dinners and the address of welcome scroll presented to the Princess Royal, on her visit. I was supposed to be a clerk, work which included filing the VD records!

Was that two wasted years?

Well, I did see some art in Germany, including Picasso's 'Guernica' on one of the few occasions that it travelled outside the USA. That would have been 1955 or '56. And I did see some wonderful German paintings in Hamburg and Hanover – Casper Friedrich especially.

Then you returned to begin at the Slade with your army short back and sides.

I went in with my blue denim overalls alongside the mainly public school boys in their blazers. They'd started a new four year course. Someone pointed to me and said, "That's what we all should be wearing!"

And you studied under Andrew Forge and William Coldstream?

Forge and Coldstream, the Professor, were very encouraging. I became interested straight away in the avant garde, I was searching for ways of doing things differently. Some students had worked with Bomberg, Dorothy Mead and others. But it was too uniform there and I had to reject the schoolism.

Was that a problem – you'd come out of regimented, uniform existence for two years, so were you bound to kick against the traces?

Well, my art school at Sutton didn't encourage painting; for instance, Sickert never appeared in my register of artists. Slade students came through the Cézanne-Sickert mode of instruction, a very structured approach to painting. Mine was more a romantic wandering. I picked up on Expressionist painting when, in 1959, the American tour of thirteen artists hit London. I was bowled over by the scale, the brashness of it all – Pollock, de Kooning, Rothko and so forth. For a brief time I painted like the Americans. I rejected it after leaving the Slade.

And then you got a job in Leicester?

Yes, I got a job for a couple of days a week. Tom Hudson was on the look out for new staff for the Foundation course in Leicester. There were a couple of very good people that Tom got together – Mike Chilton, Mike Sandle the sculptor, and Victor Newsome. We had a very formal course to teach and worked hard at that. We all shared a big rented Georgian house for which we paid seven quid a week and had massive studio spaces. Later, the

course itself started to mutate into something else.

I'd always painted, but at Leicester they used lots of different materials – plastics, wood, metal – I used those too, and it was an eye opener. The work I made there was a bit crazy, but it does underline my curiosity in materials. I did three-dimensional things in leather – personal things, figurative, made of brightly coloured leather I'd got from the boot and shoe factories. I bought myself a leather sewing machine so that I could stitch and draw freely with it. I'd pack them solidly, not like an Oldenburg, and find a way of stitching them closed. They'd be supported by metal or plastic tubes. The work was appreciated and featured in *The Observer*. So it seemed that I could have been a sculptor.

And there are the roots, obviously, for what you have done over the last thirty years.
Yes. Then the group's work started to get noticed. Jaisa Reichardt, who was organising a lot of shows, including the British Pop Art shows thought she saw a new 'ism' appearing in Leicester and she called it *The Inner Image* and put us on show at the Grabowski Gallery in London. That followed a show in Leicester. I had some good press notices which got my career started.

When Tom Hudson moved to Cardiff to be course director, he invited you down to teach. But the move to Cardiff was most significant because you came to live in Penarth, within walking distance of the beach. This house must have attracted you because of its size, but was it also because of the closeness of the sea?
All my work up to that stage, from about 1962, had been home-bound: the leather things I did in Leicester were partly to do with the leather industry – boots and shoes. The work shifts when I moved out to Penarth.

I painted walls in Cardiff – I was astonished by the walls in Cardiff made by the Corporation. They're unlike anywhere else. For example, the bricks of the prison – there's a style and handwriting in the way they're laid. I just had to work with that beach at Penarth, but I had also to find a way of doing something related to my thoughts previously. I had to deal with the openness of the beach, in the context of high art, i.e. landscape painting.

The obvious thing to do at first was to reflect what you saw, to represent the beach, the view. So presumably you did something conventional to start with?
No, nothing conventional, because of the link to things I'd done previously. It was like finding an outside studio. The place where I could mark out my territory on the sand – a large space, forty or fifty feet. I walked along towards St. Mary's Well Bay and established a territory. Ultimately it meant my taking down some fabric and saying, "This is where I am". I had tarpaulins made by a canvas and cordage firm, who had been making sails and tarpaulins for a hundred years or more. I could roll them together, panels stitched together, rolled or tied, put on my shoulder and with my other apparatus I could take them to the beach and establish a studio there.

Did you feel very proprietorial about that space?
I am a kind of introverted person, the loner if you like, and I suppose I perpetuated that by moving on to the beach. So I'd look for a place where you

wouldn't find other people. However, there's always fishermen. On one occasion I tried to nail the canvas to the cliff. No-one was there, it was winter and cold. The next day there were four fishermen. They had their privacy and I had mine. Them looking round to see what the hell I was doing washing out paints in their water. Eventually one saying, "What the fuck are you doing?" I said, "I'm just painting" – and that answer seemed to be enough reason to be there.

Well, painting's no more stupid than fishing – they're both excuses for males to be alone and spiritual. So the work immediately becomes other than a mimetic representation of the beach, the sea, the sky, but is made up of the elements, the beach, the water and what it brings in.

Yes, a place full of contradictions. It is a stunning view, the light is constantly changing, a big open sky; the tide on the move. If I'm working on the beach six hours isn't very long; you have to keep your mind on things all the time.

This Channel has the second highest tide rise in the world.

Yes, fifty foot or more, depositing its spoils on the shore. Just twenty years ago it was a busy shipping lane, so you'd often see a ship coming very close to the shore; it was magic, because if it was rough and misty you'd hear it before you could see it.

So you go down in all weathers?

I would enjoy best the winter months. People walk the beach along that tide line – the fag packet, the beer bottle, whatever, the newspaper, a settee that's been sat in to fish from. That same settee then burned to keep someone warm a day later, and you get springs and stuffing littered all over the place. I'm not making a judgement: you could say that all those things are pleasurable to me, because I'm scavenging the place.

There's that exciting beachcombing pleasure, the sense of finding something that's been given.

It's very exciting. We'd agree on fifty per cent of the things I pick up, but I overstep the mark and pick up things which aren't agreeable. A plastic bottle – say it's got some yellow liquid in it, it's wonderful when the light catches it and it glows, but what is it, piss?

When you involve that detritus, those givens, those discarded things, in the body of your work, it must be stressed that you are not using them in some Duchamp trickery way, you are not like Picasso taking the seat and handlebars of a bike and pretending it's the horns of a bull. In your work the can remains the can and it refuses to be used artistically. It's not mimetic; it is what it is. Though you may paint around it, so there's always that tension between the made thing and the found thing.

I could easily have turned these things into that made thing, it doesn't take much to do that, but I do provide a new context for them where my materials become metaphors for light or other elemental conditions.

But they are not just metaphors because the egg-box, the can actually changes

TERRY SETCH

the light illusion of the piece.

Well, yes, in a gallery it throws back the light of the gallery. And that's how it does it on the beach.

So the sense of its being an intrusion, at odds with the natural surroundings, you keep in the piece. It's at odds with the gallery viewer's assumptions about what a work of art should be. And this is not the sort of art that fits into somebody's personal collection. It's not beautiful, or even attractive.

Certainly, it would be at odds very much with the home, because the basic characteristic of it is that it's torn, shattered, ravaged.

But it is attractive in the sense that it engages with the intellect and subverts one's assumptions about art. It's disturbing; though they're not just propaganda pieces, are they? You have a polemical view in them, you are against such things in one sense, but you're glorying in them too.

I have had instances where it does clearly enter into the ecological question. I've written for *Waste Management* when they asked me to talk about waste, its distribution and re-cycling. But my work is not overtly political; I'm not saying aren't we behaving badly, isn't life dreadful. There are different kinds of messages attached to these things that integrate with nature. Some are very violent, like the car that's pushed over the cliff, it's smashed up. The discarded paper bag, however, while it might be non-caring just to toss it away, isn't born of the same kind of violence.

I live on a busy road and am furious at the amount of litter I have to pick off my lawn and drive.

If I'm sitting on the train and there's paper and cans discarded, rolling under my feet, that angers me. But on the beach, I have a different response. I may just be walking along the beach like anyone else, but I am also trying the establish my route as an artist. I have used political subject-matter; images from my visits to Greenham Common, for instance, which were shown in London. The National Museum has a large painting called 'Night Watch'.

Just across the water in England you have a nuclear reactor ticking away at Hinkley Point.

I have a big painting done at the time of Chernobyl. The Hayward Gallery commissioned nine painters, including myself, to make large paintings related to contemporary society. Welsh sheep were being irradiated with fall-out. I put sheep in the painting roaming the beach. Again, the Tate picture 'Once Upon a time there was OIL' immediately pulls you into the question of our over-use of oil. Some people said, "Do you mean once upon a time there was oil painting?"

But I do also infer that once upon a time thirty years ago I was on the beach and picking up a can and writing OIL on it. Ten years later the oil issue comes and the meaning changes, it is politicised.

You don't mind that intentions are overtaken by events and meanings change?

No, I like that. I am now as an artist looking at the things changing in Cardiff Bay. I love the mudflats, they're extremely beautiful, but I will be

looking at what happens after the barrage and whether they will deposit somewhere else.

The beach plays an extremely important role in the British psyche, doesn't it? Many of your paintings, and you insist that they are paintings even when they come right off the wall, are juxtaposing the British family on the beach with all the rubbish washed up or dumped.

I love the way we behave on the beach, the dogs, sports activities, or a family just sitting there while the sun's out, only seeing what they want to see. From the Seventies to the mid-Eighties I was working with an absence of people. The painting 'Sisley, Marconi were also present' refers to that near missed meeting of the two who were here within a few months of each other. Would they have recognised each other? Whatever mad thing Marconi was doing wouldn't have been comprehended. Wherever you go you might find a piece of territory where history has been marked.

The fishermen would have been really perplexed by him as well.

The fishermen certainly would have been there. Now I like looking at my age group – the Saga age group on the beach.

My problem with this coast is that I think of Pembrokeshire where there are real beaches – I don't really believe in beaches over here in the east. I struggle to be moved by the sea. In Barry where I've lived for twenty-five years, there used to be these wonderful banana boats coming in weekly from the West Indies. They've gone, the coal's gone and now the town's lost its way. But in Penarth there has always been a solid bourgeois confidence in where it was and that was reflected

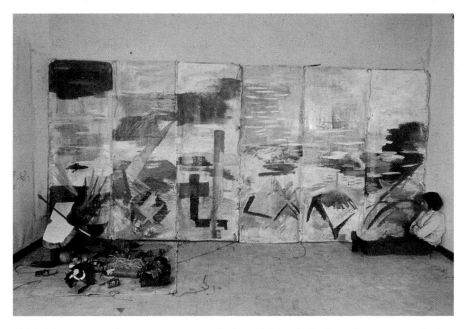

Sisley, Marconi were also present wall piece with beach detritus, 1973, private collection

TERRY SETCH

in the houses they built, and the shops, the pier and the Turner House Gallery.
They would have had their large yachts and gone out and socialised and gambled.

And now there are power boats and those awful water-bikes.
I've painted those. Men standing up in the sea, surrounded by foam. You think, "How can they do that?" All activities on the beach are sort of mindless. You are supposed to do nothing there.

But for you it's not a place to relax or escape, because people intrude, because the cars come over the cliffs, because the sea washes in the ugliness of the world. We shouldn't be surprised that you are not creating the sort of clean beach scenes we find in the work of someone like Kevin Sinnott.
As I'm getting more and more involved in the games that people play and images of themselves I'm putting less of the rubbish into the pictures. Or the left-overs which are becoming just one or two things, it's not a great mulch of stuff any more.

The paintings have not been, strictly speaking, made of paint for a while, anyway. You've developed over the years this use of encaustic wax, first cold and then hot, which acts as a binding agent.
I had used a wax back in 1971 and very rapidly employed that again when I started going down to the beach in the mid-Seventies. It slows the action, soft wax, mixed with turpentine, giving a pasty quality to the oil paint. I don't take just a little bit with me; I've taken a bucket full, or I've started a fire on the beach to melt the wax in a saucepan in a brew-up. The encaustic technique is very traditional, though there are few true encaustic painters around. Jasper Johns used it hot onto the surface of his paintings. Mine could go from very sloppy, like melted butter to being like solid butter out of the freezer. The turpentine evaporates, leaving the wax. Often I would use hot-air blowlamps to evaporate the turps and melt the wax; it's a very dangerous activity, highly volatile. I had to wear masks and other protection like an industrial worker. That painting activity excited me. With the ladles and spatulas, it's more like cooking or building than the polite practice of painting.

And in 'Spillage' from that period, you include fruit locked into the wax on the canvas or board in the wax.
I used apples and other fruit; I encased the fruit in wax and when it went on a two-year tour entitled *Tree of Life* or something, the apple shrank and began to look like a wax thing, rattling like a bullet in its casing. I like that process of change going on.

At the same time, you've never ceased to be a more conventional painter. Many of those pieces have still got painterly, figurative elements in them, haven't they? Paul Moorhouse, in his catalogue essay for your 1992-3 exhibition, points out that this is a very notable contribution which you are making – that conflict of aesthetics which you don't want to resolve. The avoidance of resolution is what you intend.
Yes, I can bring these conflicting elements together in one image, but they

will be seen as opposites in the painting coming from two different styles. That's why I hold on to the term 'painting' so much. If it were sculpture the weight and kinds of materials I could bring back from the beach and re-assemble and store would be entirely different. When I put disparate things together in one painting it becomes a new image. Though a lot of my smaller pictures can be seen as traditional, landscape paintings in hot wax. You can see what the function of a figure or yacht is, how it denotes a space and provides a story around the incident.

The Monet exhibition at the Royal Academy attracted record crowds and blanket media attention. That's about visiting an art cathedral, a very positive experience, but essentially reassuring in its confirmation of the audience's expectation of painting. What do you want an audience to experience when they visit an exhibition of your work? Are you trying to shock people?

It's interesting that you should mention the Monet, because I had an absurd title for paintings made in the landscape in the early Seventies titled 'Monet's carpet is Nature's floor'. Dreadful! It was intended as tongue in cheek. I went to the Orangery in Paris years ago and saw the large water lily paintings. He called them paintings. As you walk along the thirty feet of it you are tempted to run your hands along the surface to be reassured that it's only a painting. It's not a great illusory thing, you are not transported into the water garden, but it is such a big, absorbing landscape.

I agree, there is an initial face to my painting and it must startle when you first enter the gallery. My painting has always been about landscape, the figure, and my surroundings. But what also interests me is how you bodily approach a painting. The working of the big paintings is for me extremely physical, like the building of a house.

On the evening of the talk which you gave at the CVA show in Cardiff recently you began your session by taking hold of the plastic bags of rubbish at the foot of your 'Eclipsing Sisley' painting and throwing the contents across the floor in front of the audience and said that you'd been longing to do that since the exhibition opened.

If I include rubbish in painting, am I rubbishing painting or elevating rubbish to the cultural condition of painting? I always intended to include a floor piece, as I did in the 1973 work 'Sisley, Marconi were also present' and the 1979 'Penarth Beach Car Wreck'. Both had beach rubbish in front of them. By throwing the contents of the plastic bags out in front of the audience, I demonstrated that painting has a performance aspect to it; remarkably the contents fell into a kind of order.

It's the issue of fact and fiction, which runs through my work. Here we have stuff which people recognise and can arrange for themselves, if they wish. Someone, for example, has taken this paper plate and has re-arranged this old string and stuff to make a sort of small hat out of it. I didn't do that, or see that on the evening. The morning after I came back and one side of the rubbish was in a straight line, with three new cans at one end

TERRY SETCH

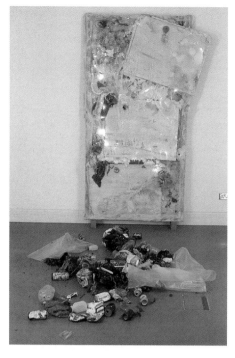

Eclipsing Sisley
wall piece with beach detritus, 1999
private collection

and three old cans at the other.

Perhaps the cleaner tidied it up.

They may have. Embedded under layers of polythene are three squashed paintings, one of which replicates the Sisley painting in the National Museum; here in Cardiff. The other two are of differing views made during the eclipse last year. Both Sisley and Marconi came to Penarth in 1897 and did their thing. Each is included in the picture of Lavernock Point, Sisley looking towards it, Marconi sending radio waves from the Point. My house would have been built within two years of that. The Museum acquired the Sisley about three years ago and when they removed it from its frame they discovered two figures concealed, walking along the cliff-top. These figures had been hidden for about one hundred years: they are also missing from my painting.

And neither would have experienced the rubbish that is part of your beach experience.

When I first went to the beach in 1969 I was looking for new ways of painting. I am still concerned to relate my bit of the Severn estuary to the rest of the world. The Severn has a huge tidal rise and fall every six hours; it's both beautiful and frightening.

And the rubbish you find spoils everything.

Well, I picked up that heap of rubbish in about ten minutes. It's the evidence of life that attracted me – like Schwitters and Rauschenberg – they're attracted to what we leave behind us.

WELSH ARTISTS TALKING

You are not just interested in the moral issues of rubbish and the environment, it's the art of rubbish that interests you.

It has its own beauty, like everything else, just like paint.

You like the viscosity of paint, the thick, clotted texture.

I celebrate the use of paint in its viscosity as much as rubbish in all its coarseness.

In fact, 'Eclipsing Sisley' always wanted to be a sculpture and when you threw the rubbish down in front of it it became a sculpture.

Yes. But I call them thrown objects in the conceptual framework of the painting.

So for a number of years your pieces have been sculptural 3-D assemblages of junk held together by cling-film, bubble-wrap, whatever.

And held together by painting concepts. I've always loved painting, I've always seen my development through the history of painting, cultural questions through painting. I have even insisted that the frame be a constituent in the work itself, other than a boundary.

But unlike Howard Hodgkin, it's not an extension of the painting qua paint, it's an extension of the idea of the work.

How else can we read painting?

The plastic bag surrounds subvert the idea of a frame which marks out the hallowed space of the art. In that series of six of large works 'In the Picture/Out of the Picture' you have a picture within a picture.

Yes, pictures within pictures tell a bigger story.

In the Picture/Out of the Picture (detail)
mixed media, six panels each 260 x 76 cm,
1995/99
private collection

TERRY SETCH

Along the Shore (detail)
mixed media, five panels each 240 x 120 cm,
1992/99
private collection

That series of six panels were placed on the wall, but then one came to 'Along the Shore' from 1996 which was set into the wall itself at CVA, so that only its uneven surface of enclosed, chaotic beach detritus and paint held in place by plastic obtruded. And that garish red – cosmetic and confectionery.

That was to be one of six pieces panels, begun in 1992 for the Camden show. It has a pristine surface under the layers of which are contained bits of beach rubbish. You have it all held together in the refracted light coming off the polythene.

If that is to be one of five panels then it again raises the question of how the effect is changed by context. In the context of traditional art practice, it is a very provocative, ugly, garish assemblage, but coming to it after the six panels of 'In the Picture/Out of the Picture' it seems like a progression of degeneration.

Yes, but in the natural context all this rubbish is in various stages of decomposition, some so mulched into a kind of compost, some recently discarded and it all exists in a unified way unless we ask the question, "Why is this rubbish here?" I'm trying to use those mixtures of things in one place and at one time in the works. I am very involved with chance, because that is the way happens on the beach. I've used a Tesco bag as the windsurfer's sail in a very simple way. But when things go into pictures they become mythologised. The reason why I work in panels is to do with the lateral aspect of painting which is more to do with sculpture in that you move yourself across the field of action. I was intrigued by Monet's water-lilies paintings in the Orangery: you do walk as if around this lake, you don't sit down.

'Along the Shore' is almost pointing the way to sculpture; why not pull it completely off the wall and let people walk around it?

In the first place my work could have been installational. It could been left on the beach to rest there. But that panel of 'Along the Shore' is now like looking into a rock-pool, you see it, you don't see it – an old tin can, a coke bottle or something glistening. Then when you put your hand in the water it ripples and there's another sort of engagement. But I can't put my piece on the floor, like a pool, because I'm still debating the issue of painting.

At present I am engaged in a research project on the internet through UWIC. It invites people to scan or digitally photograph beach finds, rubbish or whatever rich findings, and I will work with what they, as it were, send in.

They will be your Atlantic beach-combers.

Well, at least they will be clearing the beaches, won't they?

Ethical art indeed. I'm still worried by your use of the Tesco bags wrapped over the frames of what are reasonably clear paintings.

But these bags are extremely efficient, you buy your bags and use them for the goods you've bought and then often re-use the bags for other things. I was really interested in the logo and chopping it about.

It's the logo that really annoys me. It's an icon, and, god knows, I go there shopping every day. And around 'In the Picture/Out of the Picture' you've got the Millennium Man from the bags and the 'Millennium Experience' slogan.

Framing is difficult. Matisse's frames are beautiful, but the Monet frames are bloody awful and kill the painting. Frames were expensive then and matched your picture. Remember, for many years since the war we've had the fashion of no frames.

You've got a big exhibition in the Royal West of England Academy in 2001. What is the effect on your work of that imperative of a show?

Artists do need a time scale, a demand. Knowing that there is a demand for your work certainly energises you. But you mustn't take shortcuts. My whole life has been about finding a way of dealing with it, because I'm not a full-time artist, I have to grab moments and energise those moments, so I think deadlines are very good.

A lot of writers and artists have to balance the demands of teaching and their own work. Is it possible for you to say what is the relationship between teaching and your work?

When I was in my twenties and started teaching a really exciting course, there was a correlation. Now, as the demands in education grow and as I get older there is a dividing line. You now give out a lot when you're teaching, solving people's personal problems. Also, as a reputation grows, certainly it was the case for me in the Eighties, a lot is asked of you – interviews, theses on my work, and so on. I fit into a specific category for some people. It's very hard to be like Soutine going from one shed to another, eating it and painting it at the same time!

TERRY SETCH

The recent work in your studio is a series of conventional 18x21 inch landscapes of the beach and sea views in frames carefully made by yourself, behind perspex; then the whole thing is completely subverted by each frame being covered by Tesco bags and plastic wrappings, obviously stapled to the frame. Do you think people will buy those?

Well, I do provide a different context. The frames in the Monet show are very worrying; they are killing the paintings. I understand that in people's private collections those frames provided the aesthetic context; they mediated between painting and style of living. What I am doing is putting another context around the painting: homes are not full of old Tesco bags so I am providing a new context and that context has got to be conceptualised if it is to be accepted.

And in the recent show of yours I saw in the Washington Gallery in Penarth the landscapes were framed in rather roughly taped silver tape.

I suppose I was trying to replicate silver-leafed frames. There's something antiquated about a gold or silver-leafed frame, it looks distressed. So I covered those frames with silver insulating tape, very distressing.

And some of the paintings themselves were on metal and then mounted on a silver-taped background.

Well, there's a long tradition of painting on metal – copper and tin is a good surface to paint on – small amounts of pigment added to the wax medium. I use conventional brushes, though occasionally the bristles are removed by the hot wax! Traditionally one would use a variety of painting tools.

That was evident in that wonderful Egyptian mummy paintings exhibited in the British Museum a year ago.

It's a very permanent medium; the only thing it would be suspect to would be heat. That's why I put my my small works under glass. It can be buffed up like shoes for a richness of colour. Those funeral paintings of Romans in the British Museum were done very systematically, a number of strokes of colour were applied and then single stroke cross-hatching the wax. It can also be translucent like a glaze.

How do you see the state of painting in Wales?

The artists who were established when I arrived have all gone, but I like the recent influx of newer artists. The students I teach seem to stay in Wales, they like Cardiff especially. There's growing studio space; and you do need the context of others. I need to have other artists around me, that camaraderie of studios. Charlie Burton and Ivor Davies live close by in Penarth, but we don't see each other often. And for two years I have been without a studio outside the house while my studio is being renovated.

Is there a sense in which you might exhaust the possibilities of Penarth?

I don't know when or whether we'll move from Penarth, but I might extend my territory, say, moving to Cardiff Bay. I'd still be on the beach though – there's some wonderful areas, bits of ships and detritus in the Bay. There's plenty of work there.

WELSH ARTISTS TALKING

*Although it is convenient to have such a large house with room for studio space.
How do you manage to carry your stuff around, you don't drive, so are you like
Stanley Spencer with his old pram?*

Funnily, I do like the idea of an artist going to work. Stanley Spencer with
his pram attracts me as an idea. When I started those big works in the
Seventies I would roll canvases of nine foot and put them on my shoulder
with a bucket on the end of the cardboard tube of wrapped canvas,
saucepan, matches and other stuff. Often I'd find useful stuff, another lad-
der or whatever on the beach, and I'd be bringing back more than I'd taken.

*Apart from that series of drawings and watercolours of your daughter's dance
classes in the early Seventies, your art seems to exclusively address public issues.
Should we be more perceptive in reading the personal ideas and experiences locat-
ed in your work? Are the beach paintings, large and small, expressions of your
personal life too?*

My art addresses what I am interested in. I get very excited when looking
at superb painting, sculpture, architecture and design. I have a catholic taste
and can enjoy art from cave painting to old and modern masters, but I also
enjoy amateur art and mad art. When I see visually exciting colour and form
in a mess or in a gutter, the absurdity of the excitement that it can cause,
is interesting. Maybe I see things in a 'heightened' way, visually powerful
objects or experiences can upset my balance. My beach paintings are about
my observations within a chosen subject matter which is on my doorstep.
That is important, it is where I live, about the place I live; romantic, geo-
graphically, historically interesting. If one were to analyse the psychological
elements of a painting, almost certainly aspects of the artist's personal life
and history would be there. So yes, personal ideas and experiences are locat-
ed in my work.

*Do you know where your art is going next? Are the smaller polythene bag
encased works pointing to a new development, or are they to be seen as a re-
working of your established themes?*

The theme was established thirty years ago, I just continually observe and
reinterpret what we do to the landscape. How we use it interests me. The
kinds of activities carried out on the beach are timeless, but what we take
there is new, like polythene, polystyrene. How a painting ends, where is its
edge, has always concerned me. The polythene wrapped frame puts the
painting back into a bag.

*Given the confrontational nature of much of your work, and your use of the dis-
carded bits of the human world, would it be fair to assume that your vision of the
end of our century and the beginning of the new century was a pessimistic one?*

Consumerism proliferates. It has caused the landscape to change, it looks
different from previous centuries yet we still cling to the romantic, pre-
twentieth century notions of beauty, peace and tranquillity. I just record it
the way I see it. If that is pessimism, then so be it.

DAVID GARNER

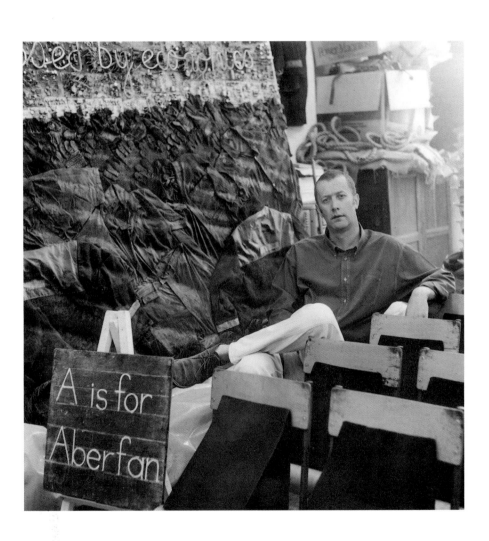

I interviewed David Garner in his studio near Pontypool in the summer of 1998. He has a large space at the rear of a community centre where he constructs and stores his often very bulky works.

When you returned to Wales after your time at the Royal College was what you started to do in your work in response to an anger and disappointment at what had happened to the community you'd left?

The shock was in the scale of the destruction – things that I knew had disappeared. I'd been in London for three years, coming back of course from time to time, but moving back I could see pit-heads being ripped down, bulldozed and flattened – shops closing in villages and smaller businesses going under. It's not just the mine closing, but the knock-on effect. I got involved in the tail end of the 1984 strike, printing posters and so on, but it was over. I started making work out of the anger at what was happening – Thatcher and all that. There was a lot of aggression around, particularly music – Einsturzende Neubauten, Test Dept – who used industrial tools and machinery to create sound. Angry times!

Was it the coincidence of your return being at a time when the coal conflict was coming to a head, or was it that the contrast with London would have led you to react anyway?

I'd never really looked at the Welsh landscape until I moved to London. It looked so dramatic and I actually started to paint the Welsh landscape when I returned. Like Kyffin Williams, I was painting Wales while in London. Things were so expensive in London that I felt I could set up a studio back in Wales much more cheaply. There were practical reasons.

That's what happened to Peter Prendergast and, more recently, Kevin Sinnott.

I was lucky because I had a studio in an old chapel, which was free, and I had an old school in this village and used it rent-free for seven years until it was pulled down.

Was there any sense of guilt, in that you'd got away to London leaving all this behind you?

No, except that there's always a kind of roots thing, especially with south Walians, feeling more comfortable with your sort of people. But, no, the main reason for returning was practical.

At the Royal College you began as a painter, but didn't finish as a painter?

I got involved with many things – book-binding, print-making; more than anything I drew. I got a scholarship to Paris and spent my time doing Welsh landscapes. I remember bringing them back and people were amazed; they were bleak works – I was reading Beckett at the time! There were things that I didn't appreciate when I was in Wales.

Your father was a coal miner?

Yes, he's still alive after fifty years in the industry. He's eighty-five now and going strong; he went underground when he was fourteen. He was made redundant at the age of sixty-four. He worked in three collieries, finishing

in Bargoed. He gave me great support and said I could do anything I wanted, "But don't go down the mine, son". He gave me great support and along with my mother encouraged me to pursue the interest I had in art. My background has given me a strong sense of belonging and identity which has helped shape the work I'm making. Coal, with all its associations, has played an important part in my life.

The installation piece 'History Lesson', is re-creating the back door of our house as I remember it from my childhood. My father worked nights for twenty years because it paid an extra £10 per week. At times I would only see him on a weekend. But there was always this jacket with the flask still in and a muffler hanging on the back door. When I was a young kid we did lots of things together. He had very little education, starting work at such a young age, but he was good at making things, resolving three dimensional problems.

The industry was good for him, wasn't it, in that he was always employed?
Yes, it was a job for life. Obviously the industry wasn't the safest, but these people had a choice and there were plenty of jobs.

But did they really have a choice? In most of the valleys, if you didn't have a good education, you knew that you were going down the mine.
What I mean is that they had a choice of doing the job then, it's been taken away from people now. Though a single industry community is always vulnerable.

When I talked to Charlie Burton for the Welsh Painters Talking *book he said that each day his father went to work he was in fear of his father being killed. Every day. Because you saw injuries and deaths constantly.*
It was different after the war. My dad started in 1927. When I first came back I used him as a model for some things. I don't know that he understood fully what I was trying to do in my work. What he wanted was for me to get a full-time teaching job.

That's the classic south Wales working class escape. Presumably, when you stopped working on canvas in a conventional way, the idea of your being an artist is harder to accept.
It is a difficult practice, particularly if you are producing stuff that isn't obviously saleable. I made the things because I have a need to do it; secondly, I'd like to show them to people; the income is just a bonus. I've only sold one since I came back. I've made small things as gifts for people, and I suppose that I could do more of that, but that's not what it's about for me.

Do you feel less respect for those artists who do that?
The problem I have with such people is how they cannot seem to develop as an artist. I suppose it could become quite easy to have a conveyor belt where you were producing things because you know you can sell them, and you are not developing your language as an artist. It becomes a job. I find that difficult to understand. When they have enough money to support themselves then why not develop the work?

DAVID GARNER

When does style become cliché?
For a lot of that kind of art one of the main considerations is who's going to buy it.
And before that, who's going to exhibit the work?
I don't even consider that. I remember being asked when the Oriel show was being set up what prices the works were. I needed help, because I had no idea. I do them for myself and hopefully to show them to people to communicate and get a response.
You do them for yourself, but do you also do them for the community you've returned to, like a bard's role?
To an extent, and particularly with some of the earlier things. But first and foremost the work comes from self-motivation. There is a need to make the work. A combination of wanting to be involved in a creative process and as a release of tension or anger.

I want to communicate, this I feel strongly about. I believe art should reflect the time in which it was made. Relate to the times in which we live. So I suppose I see art as a witness, sometimes a witness to events before they occur. If we want to understand society, then perhaps we should look at society's artists.

I'd like to think that a neighbour or someone down the street could read something into the pieces. That's why I use text and that's why the titles are very important. When you are developing an artistic language not everyone will be able to read it immediately. But you can't compromise on that.
Using words on the images, you could be accused of not trusting your audience. I mean, it's obvious when one looks at that big work, where you've got the jackets, gloves and NCB stuff and wire circuitry what your point is. Do I need to be told by the wire message, "Politics eclipsed by economics"? Isn't there a danger of closing the work down by articulating the message in the work itself?
It's not the case that I don't trust the audience; I want to use more than one avenue to communicate. The title is usually an aid to interpreting an artwork. With this piece the title is part of the work. The incorporation of text in this piece adds further layers of meaning and, hopefully, avoids any misinterpretation. I like using text and I've a great interest in graphic design and things like bill-posters. I like the attention-grabbing quality of those things you can't walk away from. The desire is to engage in dialogue with the spectator.
But how could there be misinterpretation, because you have the interface between the traditional materials of the production industry, and then you've got the circuitry of the new technology?
There's always a possibility for misinterpretation; the viewer reads an image via their background and culture. It goes back to my previous point about wanting to communicate with members of the community. So a title like that with those words included is an aid. I wanted to put an added political message, because the top industry could be seen to dominate the bottom,

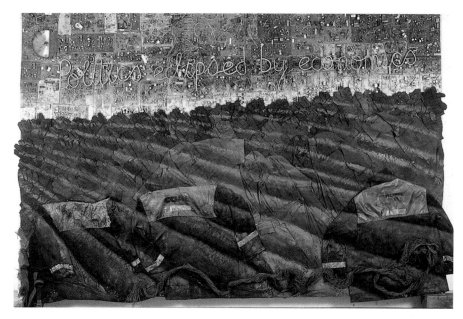

Politics eclipsed by economics industrial garments, electronic circuitry, electric cable, oil paint, tarpaulin, 300 x 200 cm, 1997, artist's collection

and they have been discarded as well.

Yes, they have, and that has a particular resonance in that the modern will soon be as redundant. But I don't want to be told. I think that there is a difference between a message and a slogan. It's a really powerful image and I think anyone would get that point.

I certainly don't think the title 'Politics eclipsed by economics' is in any way sloganeering. In fact, in conjunction with the symbolic eclipse of the industrial cutting disc, it becomes quite poetic.

Yes, you've got that yellow and green element now. And on the 'i' of 'eclipse' you've got the wire stripped to dot that letter. It's not random. So it's not about communicating an idea solely, but also a message?

Yes, this one behind us – 'The State of Play' from 1997, deals with the point when the Labour Party dropped Clause 4. It's again about the two industries; I've used two factory tannoy speakers and am playing around with the metaphor of the voice; the old voice has become a rubbish bin almost, while this new voice can be muffled. I've included the OXO symbols which refer back to the Coal Board jackets I'd used in 'Political Games I'. I've gone back to that idea of using games.

And you've included a metronome with a Japanese bank-note attached; then there's a toy donkey on wheels.

That goes back to what my father used to say about the Labour man always getting in and that they could have put up a donkey with a red rosette in the election.

DAVID GARNER

In that situation the significance of voting is dubious, but you have no choice. Then the tv screen is showing a text: the dictionary definition of 'subsidy'.

Yes, it was making the point about how money was made available for certain industries, but not for the traditional ones. I'm not making an ogre out of technology, but the lack of fairness annoyed me.

It's Cool Britannia, isn't it? Nice clean new low-level factories and no slag heaps.

No slag heaps, but open-cast mining ripping up the environment, imported coal from Columbia mined by eight year old boys. Cool Britannia – clean, low level, heavily-subsidised electronic industries paying low wages and allowing no unions in the work place. It's not the answer.

David, where did your art start? Was there a point where your mind was changed?

It was in the primary school, having paintings and drawings displayed on the walls. In the third year I had a very encouraging teacher, who died tragically in a rugby accident. He was keen on art and held a competition, which I won. I remember him saying to me, "You really like art, don't you, David? Would you like to be an artist?"

My reply was that if it meant being able to draw and paint all the time, then yes. He said, "Promise me you'll go to art school." I was eight or nine, but from that point my mind was made up. I remember having money for birthdays and buying books on Rubens and da Vinci's inventions.

Where did you see art? Did they take you down to Cardiff to the Museum?

No, it was just in books.

But art must have seemed exclusively to be dead, foreign and from hotter, exotic places. So how could some one from south Wales be an artist?

All kids have ambitions and I just pursued mine.

Were you aware of anything going on in Wales, even later?

When I attended the Foundation course at Newport Art College, I discovered the work of Josef Herman and Constant Permeke, through books and seeing the odd painting in the Museum. Those huge chiselled figures with massive hands and boots.

Who taught you at Newport?

On the Foundation course I had Peter Nicholas. He was inspiring; it was my first encounter with someone who was a practising artist. I went on to the degree course at Cardiff with Terry Setch and Glyn Jones as my teachers. At that time in the early Eighties there was a figurative revival – the Scottish school. I did very figurative work at that time. Terry Setch was enjoying a lot of exposure and probably doing some of his strongest work.

But Terry Setch would have been producing those big works with beach detritus as well as paint – the work coming off the canvas as three-dimensional art.

He was doing the wax encaustic paintings, yes; but he incorporated the bits of rubbish later. I realised that painting didn't have to be presented as canvas over a stretcher with a frame. His use of tarpaulins hanging down from eyelets together with that monumental scale left a lasting impression.

After Cardiff and your degree, was it a natural step to think about going on and

applying for an MA?

I suppose around half the students put in an application for something. I remember there was a postal delay, a strike or something, and nothing came through from the Royal College for about five weeks. There was some problem with limited bursaries. They asked me on the phone if I would be able to fund myself if offered a place. I just laughed and said it was impossible. About five days later the letter came through with the offer of a bursary. My father was so angry with them that he wanted to just throw it on the fire unopened. I saw it as being another step on the road to being an artist. It was my first time living away from home. I met so many people from other places and other walks of life, that was the biggest experience. My tutors were Alistair Grant, Chris Orr, and Paul Astley.

So you had a working space and were left to start working or continuing from your previous college. At least in London you could see the actual sculpture in a context, in space where you could walk around it. Was there a moment in your student days in London, in the Tate or the National Gallery or Whitechapel or a commercial gallery which made you gasp, made you see what you might do?

There are many times when that happens. I remember when I was doing figurative work seeing a Stanley Spencer retrospective at the Academy which I thought was fantastic. And a Beckman show of triptychs at the Whitechapel. When I was working on the tarpaulin pieces – 'Many Idle Hands' with the gloves and things – I saw Anselm Kiefer's work on loan at the Tate. He works on a large scale, sometimes enormous, and uses a very limited pallet of earth colours, mixing in ash and objects and lead. I was bowled over when I first saw those. He uses text in the work as well, bits of poetry, titles, German mythology, etcetera.

Are you in some way adding to a Welsh mythology, an immediate post-industrial mythology? Mining wasn't all good, was it?

I wouldn't say mythology, that implies something fictitious or unproven. The one constant in my work is that it depicts a truth. It's no myth that the coal industry was brutally destroyed, tens of thousands of men put on a scrap-heap and communities destroyed. Coal mining had far more to offer than the inward investment industries like LG where you have a quarter of a billion pounds thrown at a single company. If that sort of money had been made available for coal there could have been a very healthy industry, Tower on a grand scale. Many of these foreign electronics companies are only offering short-term commitment – Hala in Merthyr is a classic example. The LG situation in Newport is looking very shaky. It's like I said, "Art as a witness – sometimes a witness before things occur"!

I think I'm drawing on things that I know about, and feel confident about handling those issues. I'm working on some pieces now called 'History Lessons, One, Two and Three'; this one, which isn't finished yet is dealing with Tryweryn, the valley flooded in 1963.

It's made out of a tin bath with a circuit of water going nowhere, a

DAVID GARNER

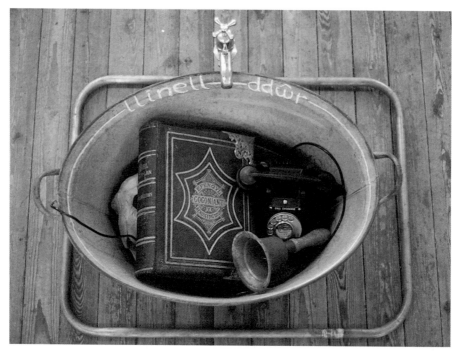

History Lesson 2 (Tryweryn) table, copper-pipe, tap, tin bath, telephone, Welsh bible, school
bell, sheep skull, 137 x 110 x 76 cm, 1998, artist's collection

school bell, a disconnected telephone with the name of the village, Capel
Celyn, a family Bible – no connection. The awful thing is that it is an
impressive lake now.

I'm working on another one about Aberfan with that desk, chair and a
bit of school floor. And that is a Welsh-Not. My children go to a Welsh
school.

You are a brave man to take on Aberfan as a subject.

I know it's a sensitive subject and I hope the piece doesn't offend anyone
– that certainly isn't the intention.

I remember being in the school yard and the noise of these NCB lorries
pouring through the village on their way to help. The kids whose fathers
were lorry drivers for the Coal Board were heroes. I was eight at the time
and remember that everyone had a news book for daily use. I drew a pic-
ture that day about the disaster. This Aberfan piece is perhaps a continua-
tion from that news book from primary school. There was a monstrous tip
towering over the school that I attended, which seemed to be the landscape
of the time. It's only when you are able to comprehend what happened that
you realise that it could have been me. Artists have dealt with the Holocaust
and that's about as tragic as it gets. The Aberfan incident is part of my his-
tory and therefore I feel justified in dealing with it.

You are a governor of your children's Welsh-medium school; did you learn Welsh?

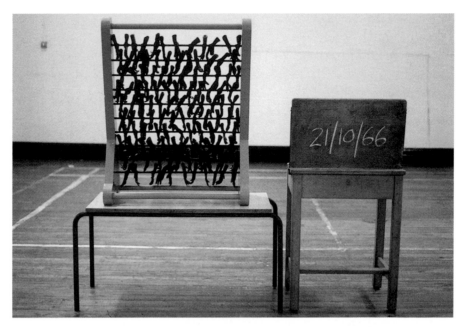

21/10/66 abacus, children's gloves, school desk, table, 160 x 142 x 42 cm, 1998, artist's collection

I've tried to learn, but it's tough and time-consuming. I feel strongly that I've been deprived of the language. My wife and I decided to send our children and I've become involved in the school. My father's mother was Welsh-speaking but it got lost then; my father occasionally comes out with phrases.

The language is doing very well in the valleys now. My eldest daughter is ten and the school intake has doubled in her time there. There is a new comprehensive school planned in 2001.

So it's not just the middle-classes banking up sand against the tide?

There may be mixed reasons for some people sending their children.

You are using the noughts and crosses idea again. I saw David Carpanini's recent paintings and he had one which showed lost youths leaning against a wall and looking at chalked street games of chance on the pavement.

The games theme started for me with the 'Political Games' series – politicians playing games with people's lives. The idea of using games stems from there being numerous games around the house with my children. The theme has been continued with the see-saw in 'Unlevel Playing Field' and most recently with a piece about Aberfan, where I've made a huge three-foot abacus. A large percentage of my time is spent with my four young children so it's inevitable that some of that experience feeds into the work. As to painting – I feel that painting's been done to death.

But you are painting on the materials of some of your constructions.

I've done painting and I don't see where else you can take it.

DAVID GARNER

Was there a moment, a painting you were working on, when you decided that?
I clearly remember making reference to boots for a painting that I was
working on. I saw that the dirt impregnated leather with a glimmer of steel
in the toe of the boots was more powerful and evocative than anything I
was attempting with paint. I emptied sackfuls of boots, jackets and gloves
over the studio floor and just scrutinised them. I started arranging certain
groups of garments which eventually led to the Political Games series. I was
still using some paint with a piece like 'Many Idle Hands', but the paint has
disappeared completely now. The objects I use have such strong associa-
tions before they are assembled or manipulated. I feel confident with this
way of working at present, painting just seems irrelevant. I am fascinated
with objects, discarded objects, and I just think that combining objects is
the way for me at the moment. I can't see me returning to paint.
*You are taking rubbish, the detritus of the industry, and recycling them, privileg-
ing them by putting those objects in the context of gallery space. You are creating
art, but also working as a kind of archivist, aren't you?*
I don't see it like that. I'm fascinated with discarded objects; they have
strong associations, a previous history. I like the idea that I'm resurrecting
these clothes or shoes – giving them a new life. We live in a throw-away
society; rubbish or detritus is an appropriate material to be working with.
Art reflecting the time in which it was made. I certainly didn't see myself
as an archivist – collecting and cataloguing objects. I specifically look for
pieces, they are not just found. I spent ages looking for that toy donkey –

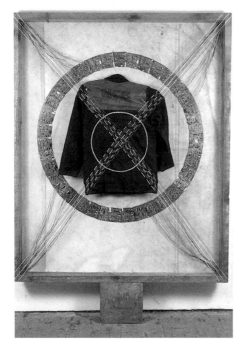

Post Industrial Icon 1
industrial jacket, electronic circuitry, electric
wire, wood, tarpaulin, 183 x 152 cm, 1997
artist's collection

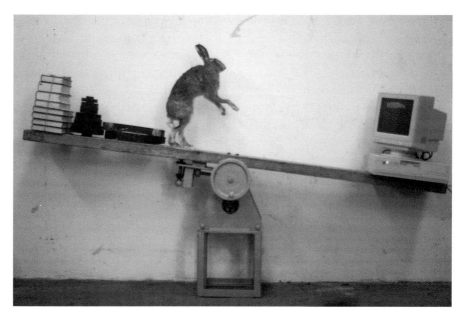

Unlevel Playing Field

steel and wood see-saw, hare, industrial cogs/gears, marxist ideology/mining practice books, computer/monitor, 242 x 140 x 40 cm, 1998, private collection

in junk-shops, car boot sales. I remember seeing one when I was a kid and knew what I wanted. Like the Welsh family Bible I'm looking for now.

I met this amazing character, a self-taught taxidermist who works nights, twelve hour shifts in a factory, and does the stuffing in his spare time. I've had an Arts Council grant to commission things from him. This piece 'Unlevel Playing Field' uses a stuffed hare he did for me. It's a see-saw. The idea goes back to 'Political Games' and came from games around the house. This construction has a pile of books at one end of the balanced plank and a pc screen at the other. If I switch it on you will see the message.

> Negotiating from weakness. When the hares addressed a public meeting and claimed that all should have fair shares the lions answered, "A good speech, hairy feet. It lacks claws and teeth such as we have."

This is playing around with the idea of imbalance again. I spent ages on this piece.
You've got the very weighty books – Coal Mining Practice, Karl Marx, Nationalised Industry and Public Ownership, Bolshevism – Theory and Practice, *and old cogs being outweighed by quite a light pc. And why the hare?* It's one of Aesop's fables; and I've been looking at the work of Joseph Beuys. He's used a hare. I saw an amazing show of his work in London. The things that the hare represents – madness. The same taxidermist has

done a sheep for me too. There will be a computer involved in that new work too.

You are dealing with certain Welsh icons – the mining practice books, the sheep, the miner's donkey jackets. And here's one caught in a giant mouse-trap that must be five or six feet long. What's that one called?

It's called 'The Broken Back of Socialism'. It's another wall-piece so that the jacket dangles from the trap. I will silk-screen "Socialism" on the back of the jacket. It has a wreath below it of plastic roses. It's about the demise of socialism. The date on the grave-marker referring to the date that Blair's Labour was elected. An engineer friend made it to my design in a local factory unit. And the trap snaps shut. [Demonstrates, springing it with a pole at arm's length: the trap thunders shut alarmingly.] It works.

I suppose some of the objects I use could be termed icons or symbols. Perhaps some of the objects that I assemble will become new icons.

You mention a friend's help and then the taxidermist; it seems that a lot of people are useful to you. Almost like a theatre director, you are pulling together a set of, if not the talent, then at least the skills of others, in your work.

Mostly I don't have a problem with utilising other people's skills – it's the concept that's important, although I do enjoy getting my hands dirty. It's just impossible to acquire all the skills necessary, such as taxidermy. I probably could have made the steel trap, but it would have taken more time and required hiring equipment. The objective is to obtain the finished product necessary to complete the art work. Damien Hirst, for example, does that too.

And Henry Moore, who never worked directly on the big public pieces, but had them enlarged from his maquettes.

I visited Moore's studio when I was a student at the Royal College, and it was so disappointing. We came away so deflated. It was a couple of years before he died. He still had this routine he felt he had to go through, going to his hut and doing these Fifties drawings. It was a bit like a catalogue; he could go through it and pick out a number 54, and pull out a maquette and give it to the guys to do the business. A bit like mail order. There was this huge pot-bellied stove in one of the studios and that for me was the most interesting thing I saw there.

If you look at any contemporary artists, like Damien Hirst, he comes up with the concept, but others make it. I like to be involved with the actual making of the work, but some things I can't do.

Like the stuffing of the hare. And the Japanese bank note, is that like a work shirt from the factory?

Yes, that's Aiwa. I went along to the factory to see if I could get some old circuit boards. It's just down the road at Newbridge. But I made the awful mistake of asking if they'd got any faulty circuit boards I could have: "I'm sorry, sir, we don't have any faulty things here at all." The shirts with Aiwa on you see everywhere around here. They've taken over from the mining donkey jackets.

You use both shirts and donkey jackets in these two pieces 'Post Industrial Icon I & II'. One is the NCB jacket with electrical wires stitched through the frame and jacket wired up to a circuit which is going nowhere. The Aiwa shirt is crucified by the wires.

No, I didn't intend a crucifixion. It's more a simple Japanese image of a circle; they have a red circle of the rising sun, but this is green one. The electronics factory shirt has replaced the donkey jacket as a symbol of work. But where there was a sense of belonging and security and even pride associated with the donkey jacket, I don't think the same can be said in the wearing of the shirt.

I wanted to present them as icons – the donkey jacket has been cancelled out with electric wire, hanging across a frame – lifeless. While the factory shirt has its arms out-stretched, robotic. It's celebrating the new technology. There's the underlying message warning of the influx of foreign electronics industries into Wales offering low wages, instability and an erosion of workers' rights. My concern is not based on xenophobia or a racist view-point, but out of a concern to avoid any further injury to an already damaged region.

I can understand that. But it must seem like shouting into the cave sometimes. I mean, these new pieces with the sheep and the hare are not destined for a particular exhibition, are they? You continue to work in the studio though.

I've got ten pieces on the go at the moment. I'm enjoying these three-dimensional pieces. Like this one – 'History Lesson One' – it connects with

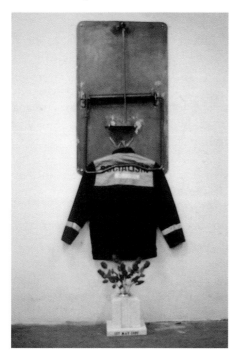

Broken Back of Socialism
steel trap, industrial jacket, marble grave
marker, plastic roses, 220 x 70 x 30 cm, 1998
private collection

the desk and chair; I'm going to make a cross of ashes beneath that stretcher, one bath is filled with coal and the other empty; the desk has a book open at a page "I want to be a Coal Miner". And there's a wreath on the window sill. So this piece is harking back to childhood.

"We cannot get along without coal," says Jack's father, "Or the coal miner," says Jack. This is an ambitious work which will stretch across a whole room in a gallery. You will need space to walk around them. Is your work getting bigger?

It just seems a natural progression – these pieces started to come off the wall, especially last year when I made 'State of Play' for the Newport show.

Were pieces made specifically for that space?

No, I was making them anyway, but once I'd been offered the show which was in nine month's time, that gave me more of a drive. The work you see here, I have no idea where it will be shown.

And the huge spike with helmets and jackets held on it?

That one is 'Statistics Column' and was shown at Newport. I also did a show in an old drift mine, just after the Oriel show. It was the Taff Bargoed development where they have the largest climbing wall in Europe. There was a lot of development money so the community bought the old mine buildings which they've turned into a leisure and conference centre which has created about fifty jobs. There's a wild-life centre too. Well, when they had gutted the area and before they started the new building they invited me to show my work there. Tyrone O'Sullivan opened it. There were organised discussions and talks.

What are the economics of showing at the drift mine like that? These are such big pieces.

People just took them over for me. There was no money in it.

But these big pieces and their assembly require a lot of work each time they are shown. Is there a fear that if you get too big in scale or complexity that no-one will show them? After all that time and effort a piece may only be shown once. Are there times when you think: The gas bill's due and I've spent the last six weeks putting gloves and paint on a ten by fifteen foot canvas and who's going to show it?

I just have to do it. At the moment I'm just happy that I've got a good space to work in. Perhaps in fifteen years time I'll have a studio full of stuff that isn't going anywhere.

How do you work – are there preparatory drawings?

Yes, I have a ring-bind folder of small ink drawings, little ideas. I start collecting the materials I think I'll need and then start playing around with them, putting them together.

So there's the feeling, the idea, the visualisation and then the challenge of getting the mechanics to work – particularly with a piece such as 'Unlevel Playing Field' – where you need that stuffed hare to turn round. Do you want people at an exhibition to turn it?

Yes, I'm just adding a stencilled instruction 'Turn Slowly' for people to do

that. I wanted that audience involvement with the metronome at the Newport show; we wound the metronome up but it only lasted for an hour or so. Whereas on another occasion there was a child who triggered it back off again.

I've always thought that metronomes were very sinister. And you've got the thousand yen note on your piece as well. So there's a Japanese face looking at you.
In the art historical context I was thinking of Man Ray's famous piece of the metronome with the eye on it.

So your book of ideas is like Bob Monkhouse's joke book – with more ideas than you can deal with.
There are a few things which I've not started but it tends to be that once I've worked through one idea it triggers off something else.

So you see a progression in your work?
Yes. I think that most of the new things have come from this piece, in literally coming off the wall; and in having a more complicated involvement – moving parts and so on.

They are remarkable. You want to go up and play with 'An Uneven Playground'. And it's resilient enough for that.
During the six week show at Newport the gallery contacted me and asked whether a group of blind people could come and touch the works. I went down to meet them and they thought it was wonderful to touch art works.

In a recent television programme on Henry Moore, Michael Foot's wife Jill Craigie, talked of Moore working and passing his hands over her hips and it was incredibly sexy and profound about that sense of getting to the essence of something by experiencing the bulk and substance of that thing, an object, a person's limb. There is something very arm's length about painting. As a sculptor you must love the textures of what you work with. Do you want visitors to your exhibitions to be shifted in their attitude, because your art is not about celebrating your feelings about your family life or your feelings about landscape is it?
I'm not sure that art can have that command.

But something like 'Political Games 2' is very disturbing, with its collection of shoes which reminds one of piles of shoes in Auschwitz, and those laces hanging down, are sinister and suggestive loose ends. You want to make people uncomfortable, don't you?
The work is about asking questions. Then, hopefully, people viewing the work will be drawn in to ask questions. I don't think art has any power – not the sort of power to change anything. But I would want my work to have the power to touch or move people. I hope it might leave a lasting impression, that it's not easily forgotten, makes them uneasy or uncomfortable; then that's positive.

Certainly that's different from many commercial exhibitions in which people want to find that which they expect and recognise.
Ideally, people should be provoked by something which isn't so comfortable and easily forgettable.

DAVID GARNER

What about the general public? Might the more conservative not find your work feeding their prejudices about 'modern art'? Is there a sense in which committed art such as yours is probably always preaching to the converted?

Well, I like to think that I could change things, but, realistically, I don't think that art has that kind of power.

But you said that at Newbridge people are walking round with the Aiwa shirt like miners used to wear the NCB donkey jacket. That's good for them – they're in work, it's clean, nobody dies in that industry; but by juxtaposing the two worlds aren't you reminding them of where they've come from and what they've escaped. You may not be turning them into revolutionaries, but that's not what you want anyway, is it? I mean, father of four, governor of the local primary school.

It's difficult, it depends who the audience is.

But the dilemma is that your work is often placed in art galleries, which many people still find intimidating.

That's why I got involved in the Trelewis Old Drift Mine project and fly-postered the villages and tried to get as many people to come as possible. Not a great deal, no. It's intimidating, as you say. That's one criticism of the show in Oriel in Cardiff with the windows blacked out so you couldn't tempt people to look in and go in.

We've got to have a glass wall through which people can look and feel that they can enter. Especially in those communities from where the work derives and for whom the work is initially intended. Not just showing it in the prestige galleries in Cardiff, or London or New York.

They're opening a gallery in Ystrad Mynach in the old NCB offices, with a lovely glass dome. But one of the criticisms they are sure to get because of the Lottery money is that it's a waste of that money. The other thing I like doing is going into school, following up on exhibitions which the children have visited and then asking them to collect things that we can then construct together.

And how do you regard Gormley and Whiteread and Hirst, the younger Brit sculptors?

I saw the *Sensation* show in London and thought it was dreadful. The Hirst and Whiteread things stood out, perhaps because they had the money to set their things up impressively. I was fascinated by the mechanics of the Hirst piece – the pig sliced in half, two thin cases of formaldehyde which sliced past each other so that the pig became whole again at certain points.

Of the other people working in Wales, are these people you feed off?

Tim Davies has interesting work. It would be good if we could exhibit together – Lois Williams and Tim Davies. We are involved in the same sort of thing but we never meet up. I've met Lois once, but not Tim. I've got a really nice video on David Nash and use it with students. He's got a good attitude in involving local people in what he does. The local haulage man and so on.

It must be difficult to move your work. For example that large banner of a piece

which says it's made of "Tea towels, electronic circuitry, emulsion, car-paint".
Yes, but exhibitors organise that for exhibitions. Though recently that big piece 'Identity Crisis' went to Cardiff. They took slides of it and decided to show it at the European Summit in Cardiff. They collected it in a van and took it down, but when they saw it they said that they couldn't show it – it was politically unsound. So that was an exercise in just moving art work around the country.

Your work has been growing in size, and the current pieces are practically room-size installations. You will need a warehouse if the work continues in that way. Isn't there a problem looming in that you could end up with a collection of works unseen, as most of the major museums have unseen works?
It could be a problem, but there's no point in worrying about it. The boots and the gloves from the *Political Games* exhibition are rolled up and stored.

There's maybe a fear that ten or fifteen years on I'll have a studio full of stuff that no-one wants. At the moment I'm really happy that I have a space to work in.

BRENDAN STUART BURNS

Brendan Burns was living and painting in his terraced house in the Adamsdown area of Cardiff when I visited him in October 1999. His wife Sarah also has a studio in the house where she makes embroidered jewellery and pictures.

A year ago you'd just won the Gold medal at the Eisteddfod – again, for the second time in five years. You must have felt that secured your reputation in Wales?
The second win came as a complete surprise. I entered to support the Eisteddfod, because it represents a showcase in Wales, and if you're not part of that, then I think that's a great crime; there are many winners of the past that do not contribute or exhibit, because they've already won a prize, which is a shame, really. So I entered again and will continue to show at the Eisteddfod. But as regards to reputation. When is that ever secured? I'm never sure.
It wasn't a fluke the first time, really.
No, that's right, it becomes a reality again, and it slows down everything you did the first time, as regards the publicity, gearing yourself up, getting a postcard printed, approaching galleries and generating media interest, it kind of slows down and the second time you're able to re-live it.
This is a significant event in Wales, isn't it? Winning the Gold medal means something.
It does. This time, the prize money is quite significantly larger, it's something like five thousand pounds now, and when I first won it was two and a half, which is still a fair prize. But it goes beyond just the money, it goes beyond financial gain. It's about the position, it's being part of that lineage of medal winners and the platform to show your work.
And it's always nice to be recognised and rewarded by one's peers.
Of course it is, especially when the selection panel includes respected artists, writers and critics. One can't help being touched by their commendation.
Do you speak Welsh?
No I don't, unfortunately.
But the competition also pulls you into that other Wales, doesn't it?
It does, both occasions on winning I made a commitment to be there for the week. I don't speak Welsh, so at times it was very much like being abroad for the week. And being on the field day in, day out, for the whole seven days, not being able to understand the discussions people were having in front of 'my language', the language of paint, a language that supposedly is universal, was an interesting and challenging experience.
Most people in Wales, don't inhabit that Welsh language world, and those Eisteddfodic traditions and so on.
No. It touched a nerve, no doubt about it. I wasn't brought up with those Welsh traditions. I had a primary school education which touched only briefly on the Welsh language and what it meant to be Welsh. But once I got to secondary school it got worse. Now, of course, things are reversed,

learning Welsh is compulsory in many schools, which is fantastic. So I did feel slightly uneasy being on the field and not knowing really what was going on. But I think I gave it my best, to be there to answer questions and be part of the whole thing.

And it's good to have the work. The work being visual art communicates anyway, but that was perhaps finding another audience.

Yes, and it's important to see it as that and to remember that it is a visual stimuli, it's not just a word. And the work is about Wales, its landscape, its climate.

I was going to ask you that, because I thought your first submission was feeding off the New York experience that you had the previous year in ninety-three.

The first one, yes of course.

So that's a double irony in a way, isn't it? Here's this non-Welsh speaker, coming along with images of New York and carrying it off at the National Eisteddfod. Wonderful.

Yes, that was very interesting. There were a couple of paintings there from the Ascension Series, very abstract, quite large. But there were three or four, the main prize-winners, from a New York series; skyscrapers, January light, foggy, snowy days, on the top of skyscrapers looking across Manhattan. The second win was completely different, obviously; the work was all about Pembrokeshire, the landscape of Wales.

Which is also to do with light and water.

Yes, so the lineage is the same. It's the common denominator, perhaps.

The Pembrokeshire series continued of course, and won the University of Glamorgan Prize, and that series of works continues to this day. We'll come back to that later. The New York Experience was a Welsh Arts Council travel scholarship. Did they decide that you went to New York, or was it your decision to go to New York?

It was my decision. I desperately wanted to go to Mexico, to visit 'The Day of the Dead', held in early November, the festival of the dead. I was working at that time with the Ascension Series. I have a religious background, a Catholic school upbringing, and my interest in renaissance art, crucifixions and depositions, alongside a death in the family, deaths of friends, began to provoke me to use this as an armature, really, to try and understand and question what happens to the soul when it moves on. So I began to put this application together to visit 'The Day of the Dead'. I wanted desperately to go to Mexico. I think I wrote about five or six pages of application, and I thought, "This is not going to work, it doesn't have the bite to it". At that time on Radio Four there was a feature on the big Matisse retrospective at the Museum of Modern Art in New York, so I quickly wrote down an application to go for the weekend. I intended going to New York, see the show, and come back. I needed £250 from the Arts Council for the air fare. I had a relative that I could stay with, I just wanted to see the show. It was never going to happen again, they were never going to get that many works

together again – four, five hundred paintings in one space. So that was what I was going to do. Not Mexico, but Matisse in New York. Though I wanted to see the city, of course. And it stemmed from there. I drew constantly, I took many photographs while I was there, never anticipating that it would filter through and produce a large series of works on my return, but it did.

Did the city in a way seduce you, you thought, "God, I'm here, this is just visually amazing"?

Completely, and I fell in love with it. I was romanticised by it.

Did you just spend a long weekend there?

No, I stayed for about three weeks in all, and that gave me the chance to see many other shows as well as the obvious sights. The Metropolitan was fantastic, not to mention New York in general. It was an incredible injection of energy and confidence.

So you had an introduction to the city, began to get to know it, but you also made a lot of notes, did a lot of sketching?

Yes. I drew, I photographed. I did all the tourist things as well, and lived the city, really. I probably filled two or three sketchbooks and god knows how many slide films I shot; it was an intense and prolific period really.

So, when they said "go for two weeks", did you think "I'm being offered a project here"? Or was it when you got to New York, and it's just as it is in the movies, that you decided "I have to respond to this, this is the next bit of work for me"?

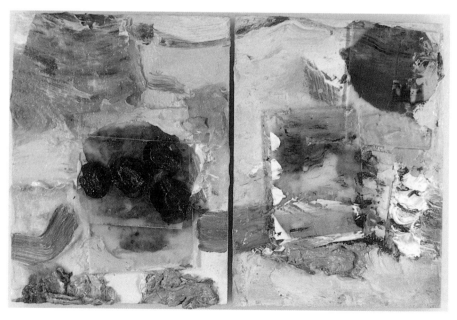

West Shadow oil, wax and perspex on board, 21 x 36 cm, 1999–00, private collection

It was probably a bit of both. Again, that Catholic guilt – here I am, I've been given two weeks in New York with this money, I must come up with something – so I drew constantly. I went to Florence a few years later. Again, I just filled sketch books. I lived through drawing, lived through looking and experiencing. I never come back thinking "this will provide for a series or body of work". I just enjoyed it, I revelled in New York through the artist's eyes, and that meant drawing and taking photographs.

And so it was that work that went first to the Eisteddfod?

Yes, that was the work that first went to the Eisteddfod, some two or three years after the trip. It provided a prolific period for me.

You quote Kandinsky in your catalogue, "Painting is an Art, and Art is not vague production, transitory and isolated, but a power which must be directed to the improvement and refinement of the human soul"; that sense of spiritual response and purpose is central to your art, isn't it?

Without a doubt. I believe very strongly that painting is the most primitive and central of responses I can make to the world around me. The 'spiritual' within what I do as a painter is the common denominator within my creativity. It doesn't matter, on reflection, whether the work is concerned with the urban, New York, or the rural, Pembrokeshire, these subject matters are just one of many reasons for making paintings. There has to be another response to these works – other than a simple recognition of time and place. They have to be more primeval than that, they have to 'touch' you. I aspire to a painting which communicates to everyone, whether you know Pembrokeshire or not. It's our genetic make-up, it's being human, being alive to the world, that I wish to tap into. If these paintings were to be exhibited in Kansas or central America, how would they be read or experienced? The nearest coastline is 1500km away. They have to work as paintings in their own right first, then split seconds behind that, the source of imagery may kick in. They're about being human, and the act of creativity. They have to be sensed as well as experienced, they're physical paintings, they embody human presence. The 'spiritual' response and purpose is central.

So the three instances of significant projects over the last decade have been responses first of all, as you say, to loss, to personal loss, the loss of friends and so on, then the trip to New York, but why did Pembrokeshire next absorb you?

Family, really. I married into Pembrokeshire, so I have been visiting Pembrokeshire over the last fifteen years. Obviously I was working on the New York Series and the Ascension Series while I was visiting Pembrokeshire, visiting family and friends, walking the beaches.

And were the beaches getting to you? Were they seducing you at the same time, perhaps in a more subtle way?

I think they must have been. They weren't as obvious as New York.

Nothing is as obvious as New York!

No. There it is, here it is, this is what you get.

BRENDAN STUART BURNS

In your face.

Yes, and that kind of made me respond. But Pembrokeshire has been more seductive than that and obviously more subtle. It's been working its magic quite slowly over the years, and maybe I know it better because of that now.

Your response to what you've been seeing over the years in north Pembrokeshire could hardly be further away from someone like John Knapp-Fisher, who's lived there for thirty years, who is not doing exactly conventional watercolours, but still produces fairly accessible landscapes. Your works are much less convention- al in the impressionistic, expressionistic approach. This continued commitment and series of responses to, in a sense, the minutiae of the beach life.

It's the microcosm, in many respects.

Yes, whereas with Knapp-Fisher you might get the solitary nature of a Pembrokeshire cottage, but you'll get a lot of sky, a lot of landscape, to go with that cottage, or that boat, or that harbour.

Yes, I'm very aware of the sky. The sky feeds Pembrokeshire, it's the light, it's the space, it's the fact that there's so much sky.

It's like the American mid-west, only with sea! There's a lot of space up there above you.

That's right. I worry about that sky in my paintings though, and maybe that's what sets us apart. I find that one of the most traditional pieces that I have got sitting in front of us is the triptych over there, because the horizon is two-thirds of the way up the painting in a traditional landscape format, and that's as near as we get. In the rest, there are glimpses of horizons that suddenly become edges to other forms, and so you're teased more, rather than becoming the one space.

You said you're worried by the sky. You're concerned by the sky.

I am concerned. In many respects I don't see myself as a landscape painter. I'm a painter who happens to be dealing with Pembrokeshire. I worry that by putting two bands of colour together I've got an edge: I've got an hori- zon, I've got a sky, I've got land, or I've got sea, and it becomes a landscape, it becomes a space all too easily. And that doesn't tease me, that doesn't interest me as much as finding other horizons and other spaces, that are per- haps more demanding to the eye. I fear the space, the more recognisable spaces, and I suppose that's why I fear the sky.

So the eyes come down from there, and you may be concerned with a sort of microcosm of the whole county's experience, the coastline's experience. But then you do leave the viewer, the audience, to interpret that as they may. I mean, the microcosm is open to interpretation as a macrocosm.

That's right, without a doubt. What is happening in the microcosm is ulti- mately what's happening out there in the macrocosm.

And not just in terms of reflections in water and so on.

No, far from it. The ability to draw an edge, or work with an edge in a rock pool is exactly the same as working with the physical edge of a distant hori- zon. What's happening down there is happening out there. I think I'm

drawn to the small, for some reason. I'm drawn to plans. I don't know whether it's an interest in geography or what, but I'm interested in what's happening around my feet.

And in our tradition of painting, there are four edges; traditionally in landscape the sky and the ground under your feet define the possibilities of what can be done. But your take on what you're looking at is, if I'm understanding correctly, more of a God's-eye view down?

It is. I just find myself, certainly on the beach, and walking the coastal path, I'm very conscious that I'm looking down. If it's just simply to avoid falling over. But it's my interest in what's happening down there, all that texture, all that colour, it avoids the picture – should I say picturesque. I find myself looking down, ninety percent of the time.

And not too near a cliff!

And not too near a cliff. But that is reflected in the works, and they all do have an element, or a glimpse, or a hint of the horizon, but the percentage area on the paintings for that sky is minimal. It locates the space of the painting too quickly.

The problem is then, regardless of the size of the paintings, that when someone looks at a painting, framed and on a wall, the natural assumption is that one is looking at the world the right way up, that the bottom is the earth, and somewhere at the top there is going to be a sky or something that immediately precedes the sky, the top of a tree, the top of a building, or whatever.

Certainly the small works are produced on table tops, or on floors, so they are actually painted on a level surface, on a horizontal surface, and then they are taken and exhibited, because that is the nature of a gallery, that is the nature of framing, that is the nature of seeing. But as you've encountered

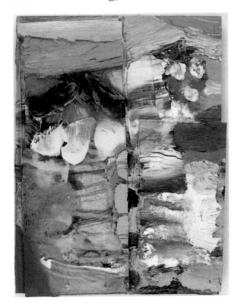

Clear Green/Blue Clear
Oil, wax and perspex on board, 21 x 17 cm,
1999–00
private collection

in the studio, as they're drying they're sitting on tin cans horizontally, you can walk around them, and so there is no definite orientation.

In fact, when we went up there ten or fifteen minutes ago, there was a temptation to see it as a kind of installation piece, wasn't there?

It can become that.

That these are a kind of mosaic around which, as you said yourself, you're tempted to ask viewers to step, as it were, through a pool.

They are almost stepping stones. They happen to be on different size tins, so they have alternating layers within the space. That becomes quite interesting, because that is exactly what's going on in the paintings anyway, they are building out with layers of board, or building out with layers of perspex. So I'm playing physically with layers, as well as illusionistically with layers, in the image: but having them in the studio like that as well is very interesting.

And why not, for goodness sake, break away from our culture's tradition of framing and presenting in that very conventional, very sensible way? Why not take it down to the floor? I think we've got the seeds of an exhibition here!

Well, yes, it is an interesting idea, one that I have already seriously considered. *"Tread carefully, or you'll tread on my paintings!"*

I am challenged by it. I imagine a huge space with paintings that are placed on small plinths.

Which may or may not be complemented by paintings traditionally hung on the walls of the gallery.

Yes, that's right. Neither one nor the other, but both. So you've got many spaces opening themselves up. The physical space of what's on the floor as well as the illusionistic space, when it's hanging on the wall, of looking through and into.

I think that would make a really interesting exhibition.

It would. I do worry about it though, in terms of a distraction from what is going on in the work, what it is that I'm about. It is too easy to get caught up in alternative ways of presentation, which may just dilute...

Maybe this is something that you just do as a one-off thing, and have the paintings then revert to a more traditional presentation format after the exhibition?

That's right. It is challenging. I'd certainly like the opportunity to test it out.

It certainly is a challenge, and worth exploring.

Perhaps they don't actually sit on the floor. Maybe they sit on a plinth that is waist high, more traditionally in terms of sculpture, small bronzes, for example, in that way, so they're horizontal, and you can walk around them.

The fact that we're talking without smirking about this is interesting. The flat surface is something you've become dissatisfied with. How many years has that been going on? The last three or four years, maybe?

It's the last perhaps two, three years that I've been building off, either with layers of MDF or perspex. It started initially because it became an edge, an inner edge, a literal edge. I walk constantly with a camera, I take hundreds

of photographs, so this inner edge placed onto the painting surface became a way of being able to focus, and to work within. It was like taking an aspect of the whole composition out of context and working in a slightly different way.

Is it almost like a close-up?

Yes, it can work in that way. It either plays within focus or out of focus, or actually plays on the level of importance, but it can also represent layers on the beach. There is a physical layering here, and the illusion within colour and tone wasn't enough for me. I needed to work with that physical depth, too.

And the perspex and the plastic that you incorporate from time to time isn't covering up the paint entirely, it's working as a refraction.

It does. They initially started as a physical membrane, or a surface to a rock pool, the layer of water, the dividing line between interior and exterior of that rock pool. Squashing the perspex against the paint forced a similar kind of response, or sensation, as one looked at the image, similar to the way seaweed is forced against the membrane of the water in a pool. Again it gives me layers, it gives me the ability to build up transparent layers. A number of perspex sheets laid one on top of the other with wax between them drying and cooling, continuing the drawing process, continuing to dry and shrink, which almost echoed exactly what was happening in the landscape anyway, so it was drawing itself, the paint was becoming the landscape.

And you're casting the paint as a hostage to fortune there, because once you start playing with the properties of wax and perspex and these other materials, in a sense you're changing the surface of the painting, but you're allowing it to go the way it wants to go.

Yes. In the conversation so far we've talked about the landscape being very important, about New York being very important, about a meaningful Catholic upbringing and the Ascension Series, but one of the main factors that has driven me is my love of paint, the material itself. A kind of affair, really, one can have with a physical substance itself. The paint finds the landscape, the paint enables me to find images and find spaces and find textures, surfaces and colours that perhaps I haven't realised before in the landscape.

In the way that every non-naturalistic painting is making a pronouncement about the act of painting as well as anything that might be, incidentally or essentially, represented in it. The painting is about painting.

The painting is about painting. So there is always this balance: to be about paint, to be about painting, this process of making itself, as well as the process of having something to deal with, rather than just within me, about my experience of walking in the landscape.

You've used the word 'edge' quite a lot, and of course a painting, like a photograph, like the cinema, is always false. It always has an authoritative edge to it. It isn't the whole world, it doesn't wrap around the viewer.

BRENDAN STUART BURNS

No, it doesn't. And that edge is the painting's most vulnerable aspect. It's where the real world takes over, and that edge can break down that illusion, because at the end of the day, it's the balance between illusion and reality. It is only ever going to be paint, it is only every going to be MDF. When you're standing in front of a Turner, it is still only paint, but it instils this amazing sensation.

It says you have the border, you have the frame, and most of your works, more recently, are boxed in a sense; but just like a television or a movie screen say, you can come into this world, and I'm not pretending that this is the real world, but it is a take on the world. It's an edited version, and you can stand in front of this and choose to come into it.

In some ways the box frames help that. They deny access in many ways, because they make you more sensitive to their tactile qualities. You frame them to protect the surfaces as well as presentation, but sealing them off, putting them into this vacuum, has almost heightened their stillness, their quietness, and their tactile qualities. A sense of touch, and a sense of touch within painting is very important. Not physical touch, reaching out and touching with your fingertips, but touching with your eyes, physically touching with your eyes, being able to feel around the painting with your eyes. I think that's something that's very important to me both there in the landscape and back in the studio.

What about the titles? Because one needs the titles in such non-figurative work. Many of these paintings need the context of being within a solo exhibition, so that one knows they have a cumulative effect, they play against and with each other, they gain effect by the context in which they are being viewed.

They need their friends, they need their neighbours to play off, one against

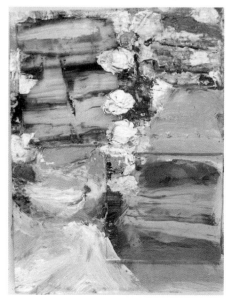

White Light Flicker
Oil, wax and perspex on board,
21 x 17 cm, 2000
private collection

the other. Also the titles you're right, are important, because many of them are quite emotive; often they give a clue to what goes on in the painting itself, the process of making that image, as well as actually what's going on at the beach, the shore, so the painting titles 'Blur Blend Rush', for instance, is a play of what's actually happening there on the coastline but actually what's happened on the surface of the painting too, to create it.

So there are a number of elements here. First of all, there is the size of the object of the painting, and in your work as a whole, one tends to see relatively small – ten by eight, twelve by nine, something like that, relatively small paintings, or very large paintings, like six foot by six, seven foot by six.

Extremes, isn't it? They're spaces really, in terms of your identity and relationship with them. So when you stand by a six by six, or eight by eight foot canvas, you're in it. You're faced with a physical space, and then, as you say, these eight inches, these ten inches, are playing on that, they're pulling on you, you have to approach and scrutinise them to see them clearly. They're microcosms of what's happening out there. It's the middle size that's always caused the problems, not just in this series, but also the New York Series. Maybe the New York paintings are more successful, working with the middle size. In terms of the use of architecture and urban spaces, anyway.

So there's the size, then there's the decision not to be straightforwardly representative. These are impressions of the beach, and they are expressions of your feelings about the Pembrokeshire coastline and being out there, which is so different from where we both live as urban dwellers.

That's right. It's a conglomerate of all of those things, of sensations, the smell of fresh cut grass, blowing off the land, mixing with the smell of seaweed, the sensation of the sun on your cheek, or wind in your hair, the sound of barnacles crackling and drying off at low tide, all physical aspects of touching and being part of the shore.

The constant clock of the waves as well, that just keep ticking away, that keep

Blur - Blend - Rush
Oil on canvas
230 x 230 cm, 1998
private collection

rolling in all the time.

The force that recreates. What happens with the tide is what I try to make happen with the paintings. The tide is recreating. It's destroying, but it's reconstructing at the same time. It's a simultaneous process, construction and destruction. And that is what exciting painting is to me, pushing paint around, wiping it off, layering it on again, wiping it off, until it finds the image, it discovers a space, it finds a landscape. It reveals itself.

Because the paintings certainly retain a fluidity. It's almost like they're still moving, they're still wet.

They do have that quality, and I think it's quite important that they do look fresh, they do look as though they took minutes to produce, they were intuitive and found themselves. They don't – I hope that they don't – look hard won, and reworked again and again, and yet they are. They're wiped back, sanded back, scraped off, turned upside down, turned over, sandwiched together, and constantly reworked, over many, many hours, even though they're small.

So we've got size, we've got the non-representational aesthetic, but then you've added, more recently the fact that they're not just paintings, but paintings with things intruding, extruding from them, and yet at the same time being integrated, because the perspex, the plastic, the various things that have appeared, the layers of board that overlap and create a 3-D perspective are themselves painted, and you've got the tension of that. So one can't forget, no matter how persuasively one is drawn into the idea of beach, pool, light, moss, seaweed, one can't forget that one is looking at something that is very much a construct. It's an intellectualisation of the physical reality.

Definitely. You have limpet trails, you have seaweed, you have definite formations of the rocks of Pembrokeshire, the geology, the layering down, the sediments, as well as aspects of light, weather, movement, alongside smells and sounds. You have the hint of tectonic plates in the use of two boards placed together which has a gully running through them; the movement of the land, which is constantly shifting, constantly reforming, constantly being destroyed. The paintings try to deal with all of those things, simultaneously.

From detail to massive structure.

Yes. I think that's very important. The most successful images are those that have that balance, they try to deal with it all.

So, if one were facing these works for the first time, one could be excused for not realising precisely what was going on. That ambiguity is part of your intention, there is an ambiguity. Would it be fair to say that?

There is. I enjoy this ambiguity. I mean, I know the rock pools very well, because I've spent many hours with them, and I've spent many hours on the beach in many aspects of climate and light. There will be areas of the beach that I know very well, but, the viewer may look at these paintings and dismiss them as painterly tack, because the colours, surfaces, shapes, and forms, the aspect of light, are unknown. So they become abstract, they

become just paint because that person doesn't really know the land, doesn't recognise the light, or doesn't know the contrasts of colour that can be found in wet or dry rocks. So it worries me that maybe I'm using a language here, I'm dealing with a subject, that isn't accessible, and isn't registered as a real sequence of spaces and sensations.

Also, the majority of images, as I understand it, are produced in the centre of Cardiff, a hundred miles away from the coast, and so in a sense these are memory paintings.

They are, most importantly, about memory. This is exactly what 'distills' these experiences. Distance is a crucial factor in my working process, whether it be Pembrokeshire or New York.

Whereas somebody living down there, like John Knapp-Fisher or David Tress, who I suppose works in the same way, will be setting up something in the landscape.

That's right. The work will be produced there and then in the space, in the landscape itself.

And if not, the studies will tend to hold the painting to a more specific 'view' as opposed to a conglomerate of spaces. So in a sense it's almost certainly going to be more about the fact of the landscape, or the particular camera angle one's taken of the landscape. Whereas what you're doing is about memory, and paint, and the feelings that memory evokes.

Precisely. This 'one view' doesn't interest me. Although, saying that, I am comfortable with this 'one view' in the photographs that I take.

But you never paint directly from a photograph?

I never physically work from a photograph in my hand. I do not hold a photograph and paint from it. The act of taking a photograph is almost enough: the act of walking the beach or walking the coastal path with a camera, being able to put the camera to my eye, to section off areas, to zoom in, to pull out, to play with those compositions. Whether I get the photographs back or not is secondary in some ways. It's the process, the experience, that's important, it intensifies my observation. The camera acts as the experience – and drawing. I'll draw and I'll write, but again I won't paint from those drawings upon my return to the studio. They act as catalysts, they take me back to the memories.

I wanted to come to the words in a minute, let's deal with the photography first. So at some point, in going, through family commitments, to the Pembrokeshire landscape, you started to take photographs of landscape rather than relatives, and at that point, were actually beginning an editing process, because taking a photograph is always an act of editorial choice.

It is. It's interesting you mentioned photographing the landscape, not the people. I avoid people. The figure tends to locate the space too literally for me. That's also true of the New York Series.

It's tough to avoid them there!

It is very tough to avoid them, because obviously the shapes of buildings,

the architecture infers that those buildings are for people, but I'm not interested in people. If I walk a beach, and somebody walks across towards me, I'll walk up the other way. I won't include them in the painting, I won't include them in the photographs.

You're a miserable bugger, aren't you?

Completely. No footsteps, no debris, no human presence, just myself.

Britain being Britain, the Nineties being the Nineties, and the coast being the coast, there must be debris, there's a lot of junk floating in.

There is.

But you edit that out?

I turn the other way. I have to look at what's happening in the pools, in the land and its climate or weather.

You want pools that don't have the ship's detritus.

I'm not interested in the squeezy bottles that have been washed up, or the colours within them. They're fantastic objects, and I know that artists such as Terry Setch will use them as source material, but I'm more interested in the land; the colour of the rock, the light, the sea. The ship on the sea destroys the image for me. The ship on the horizon completely destroys it.

So you're a pre-lapsarian artist, whereas Terry Setch journeys back into hell every time he goes on the beach. He is an obvious point of comparison. You live within ten, fifteen miles of each other.

You could say that. He taught me when I was studying for my degree in Cardiff.

And Terry Setch has been devoted to, or fascinated by, the very soiled experience of the Bristol Channel beach at Penarth.

Very much. I mean, no doubt about it, Terry's had a very profound influence on me, on the way I think and the way I work, and not just my subject matter. I certainly wouldn't have chosen Pembrokeshire because Terry's worked with the coast, but certainly in his teaching, I think his aspiration and his passion for the physicality of the substance, of paint, of materials, inspired me more so than the subject itself.

Terry Setch's commitment to an approach, and his commercial and critical success certainly validates a lot of these aesthetic principles that you share.

Yes, without a doubt.

Large pieces of his, like the ones in the National Museum in Cardiff are... what are they? Paintings, or collage, they're certainly coming off the canvas. Or the canvas is including all kinds of detritus, all kinds of junk, whereas you're using a very controlled perspex or wax rectangle, to rise off the surface, and create another surface. As you've already said, you don't want to take the old plastic bottles and whatever...

And make those part of the image.

...and ram them onto the canvas.

I'm not interested in that reality, because as soon as you put a squeezy bottle onto the canvas, it is a real squeezy bottle, and it has that kind of obvious

meaning. I would find it just as problematic to include seaweed or real stones. *You find that a distraction then, do you?*

Yes. I'm still more interested in the illusion. So even though I've put the perspex, or the board, onto the image, and it has a physical edge, it's still part of the painting. You don't recognise it as an object. It's just layers of an image, layers of space.

And you certainly can in some Setch's work, although some of it blends in, and there's the shock of realisation that it's an old squeezy bottle. But his very recent work, which we've probably both seen in St David's Hall, you've got almost impressionistic seascapes, beachscapes, reasonably conventionally framed, and then the frame covered with a Tesco's supermarket bag, which is certainly "in your face", isn't it?

He never ceases to amaze me. He comes up with something different. Recently he used very heavy aluminium, silver frames, which did help the image, I think, tremendously. Gave a physical weight to them, a history almost.

There was a kind of sci-fi effect; they really did look like they were aluminium, and you don't normally associate that with oil painting, the context of oil painting in galleries.

No. He joked with me at the beginning, when we were talking about his frames, he said, "Look, they haven't even been unwrapped!" And you never quite know with Terry, there's that kind of tongue-in-cheek...

But your paintings still play by the rules, and are not concerned to tease as much as Terry's are.

No. I would worry that they would distract from the real image.

And he's concerned that they should distract.

They become part of it, in many respects. That edge is taken outside into the frame, almost like Howard Hodgkin.

I don't think you need to, because your paintings have that quality of being paintings, they couldn't be anything else, but they are also, and the titles persuade one that they are also, moments from a beach experience.

Yes.

Let's move on to the titles and the words. Because it struck me that, in your solo show at Turner House, that David Alston introduced he very interestingly included extracts from your notes. My notes on your notes say, "the notes seem to reach for the state of poetry". There's a sense in which 'poetic', although it's a sort of dilettante term, is not irrelevant as a way of approaching what you're doing.

There are visual similarities, aren't there?

There are, and one's looking not so much for symbols or similes, but for more a quality of suggestibility. Grey doesn't mean the same thing in every painting and neither does green. It's not as crude as that, but there is a strong element of the poetic about them.

Well. That's a compliment. I'm aware that I don't write well. I write in

BRENDAN STUART BURNS

sketch books privately, as I draw. The drawings rarely get shown, let alone the writings, but we decided to take some excerpts from the writings, phrases such as "having to squint" describe so many sensations. They became in-roads, really, the starting points to look and experience the paintings.

You've talked about the importance of photographs as a prompt for memory. Are the notes the same?

They are. They perhaps prepare or predetermine an emotional charge or response.

Do you stride around the studio, proclaiming in Dylanic tones?

Oh completely. I will sit and re-read the notes before painting. And they will be quite coarsely written words, describing the scene around; the smells, the sensations, the sounds, the mixing of the senses. Trying to include all information, really. The written word can be very powerful. I do find it very difficult to work directly with colour on my walks, other than, obviously, working with colour photographs, but to describe the colour in note form in the sketchbooks, that's different. I can more readily locate a specific colour via a written description of it.

So your sketches are with charcoal, or pencil?

With charcoal and graphite. But to actually describe the colour, to write the colour, to describe how to mix the colour once back in the studio, seems to be far more accurate for me. It takes me back. It puts me back firmly in the landscape, and obviously reconstitutes that memory.

I'm looking at 'Stone Bright Place' here, where your notes go "Remember scale, marks which are so delicate, contrasted with force and power. Light is crucial, the pulse of light, to be in the space of the painting. Not viewing a plane. To experience the landscape is to experience the painting". Which is strange, sort of inverted. I would have thought what you're aiming for, surely, conventionally, would be "to experience the painting is to experience the landscape"?

Misty Wet with Rain
Oil on canvas, 204 x 178 cm, 1998
private collection

It's interesting, isn't it? Yes, conventionally it's the other way around. But this is where the balance between 'paint' or 'painting' and communication of the landscape is questioned.

You go to the landscape for the painting inspiration, for the fact of the painting, for the impulse to paint, but then for the viewer, it must be the other way around, mustn't it?

I don't know. When I'm back in the studio, all I have is the paintings. And the paintings are far more important to me, in many respects, than the landscape. It's what I do, and how I respond, and my reaction to it. The strange thing is standing in the studio and mixing coloured earths, and placing them, very primeval, placing them on a surface, on a canvas or a board. There is nothing more challenging, and that seems to be the most important thing for me, not so much the landscape.

So it would be ludicrously romantic to say you make these pilgrimages to the Pembrokeshire coast, or previously to New York, and you come back and celebrate the landscape?

I celebrate the painting. I'm a painter. Romantically, being a painter has always enticed me, more than the landscape. Influences, or affinities with, I should say, de Kooning, Gillian Ayers, Hodgkin. Painterly painters. They are the images that make the hair stand up on the back of my neck.

But when you're there, the landscape might also have that effect.

Of course, the landscape becomes the excuse to make paintings, in many ways. And also, let's not forget that painting is communication, it's about sharing, it's about communication of feelings, as well as sensations, spaces, or views, so to an extent of course they must communicate the landscape. To be successful, they must communicate those things. One of the nicest compliments at Bridgend's Eisteddfod was a lady who came up to me and said, "They're Pembrokeshire colours. I don't really understand them, but they are Pembrokeshire colours". And that sealed it, that was one of the greatest compliments of the week. I knew I was doing the right thing, and making connections.

The painting 'In Sunless Days': you have a comment under that, "paint reveals the landscape more clearly, I see the landscape through the painting". So there's a sense in which the painting, for you, at least, and for some viewers, completes the landscape.

Yes, definitely. When I'm painting, I certainly do not start with the idea of a particular composition. The last thing I want is to start a new canvas, or start a new panel, and know exactly what I'm going to do. I have a starting point, but I want that painting to take me somewhere different. I want it to take me on a different journey. I want to arrive somewhere else within the landscape. I want to find a different aspect to space, light, colour and tone.

Although when one sees them all grouped, or in a show, the paintings, of Pembrokeshire or New York, are clearly making a whole. They are of one range

of colours, the colour is the connection.

Colour is the connection. The palette is the connection.

And also the uniformity of size.

Yes.

So in a sense you do know, within certain parameters, while you're working on responses to New York, or Pembrokeshire beaches, you know pretty well where you're going to go, don't you?

Yes, you do. It's interesting when you mention size. Many of them have dimensions which work with the golden section. They have a geometry about them, so they can be arranged, I can be working with diptychs and triptychs together quite easily, and so there's a common denominator. I've been working with a common format for the three years, and I feel very comfortable. I know that area, that arena with which I have to play. So it's not just the palette that is common, it's the format, it's the scale, it's the geometry within that arena, that follows through from image to image as well.

When a single painting goes to a collection, or into somebody's house, do you feel as though a finger has been taken away? That something has been removed?

Yes. Obviously, some are more important than others. Some take great strides forward, and reveal aspects of painting and spaces and Pembrokeshire that I'm challenged by, perhaps twelve months after they've been produced, and so I would deeply miss those images. Others perhaps not so, but all of them are very special. They're part of my surroundings. I grow and I learn with them. They are around me, they feed me.

You have works by other people. Do you occasionally crave the works of other artists, you must go to a lot of exhibitions, and think, "My God, I need to have that".

Oh yeah. Financially, that's the restriction. Peter Prendergast. I crave a big Peter Prendergast. I've got a small painting of his, and we have promised that we would, one day, swap, but we never seem to quite get it together.

Is there a sense in which you don't want too many examples of other people's visions, other people's languages, in the house? Would that get to you?

It's an interesting one, isn't it? I would obviously like to be in a financial position to surround myself with works that really challenge me.

The odd Van Dyck in the kitchen...

That wouldn't go amiss, obviously, would it? But at the same time, I can't imagine myself being surrounded by other people's work. Art is quite a selfish activity, in many ways. These are my friends, these are my paintings, the stimuli, they're constantly around. I catch a glimpse out of the corner of my eye, and it takes you somewhere else. You can see them in different lights, you can grow with them. And obviously that's the best thing with buying art, surrounding yourself, because you've always got it there. Walking from one room in the house to the next, doing mundane household chores, this is when you sometimes drop your guard, and 'see'

something new in these paintings.

Though you stop looking at them. I move things around in our house. And also, recently with being ill for a couple of months, when I came back from hospital, it was great. It was great walking in the house anyway, but coming back, I really looked at our collection afresh. That was a sort of re-learning of the work.

That's what it's about, that's what collecting is about, that's what surrounding yourself with art is about.

I think one has to keep things fresh, and move things around.

They're friends. They're friends and neighbours. They speak many languages. They infer new meanings with new relationships and contrasts.

In the same way though, the Pembrokeshire Series. New York in a way came out of the blue. You went there for another reason, and as anyone who has been to New York would have told you, the city's going to knock you out.

It was always going to do that, wasn't it?

The Pembrokeshire beach also crept up on you. You didn't know when it was going to start. Do you know when it's going to finish? Do you say "another five or six, and I'll have done with this"?

No. It constantly burns. I know it so little. I know it less, perhaps, than when I first started. The more I try to reveal what it's all about, and what painting's about, the more enticing it gets. You think you get there. I do it no service. As you said, I live a hundred miles away from it. Maybe that's the best way, I'm not sure.

Maybe you've got to. For the sort of paintings you're doing, you've got to.

Exactly. Maybe if I lived with it, and I visited the same beach every day and I had that luxury of painting every day, then maybe the work would change, the imagery would change.

But that's why, of necessity, but of choice as well, you are doing something different from David Tress, John Knapp Fisher, Arthur Giardelli, people who are down there.

Yes. It's not a question of liking or disliking a particular way of describing a landscape. It's about circumstances. And so the circumstances you find yourself with in life dictate a particular way of working, and experiencing.

For the last decade at least, what you've been concerned with is place, light, a moment or moments of time, and the absorption of place, specific place, and particular moments or collections of moments of light. Where are the people?

There are no people.

Have you ever drawn, have you ever painted a person?

Yes. There was a period when I was working in college, when I was at the Slade in London, the work was about people. It was very politically driven. It was about being Catholic or Protestant in Northern Ireland. It was about having a family that was both Catholic and Protestant, one living in Wales, the other living in Belfast, and it was this childhood upbringing of working and living between the two. So there were people. There were the Orange Day marches, the parades, the confrontations.

BRENDAN STUART BURNS

And you were living through that; you were born in sixty-three, so the Troubles have always been there.

The Troubles were at their height. We were protected from it, as children, of course, but we were aware of what was going on. Certainly being brought up in a Catholic school, having a Protestant father who was in the Forces, who had a very different viewpoint to my own. The one way of dealing with that was perhaps through the work, becoming interested in the political strife of Ireland.

So the work in the Slade, in the second half of the Eighties, and perhaps afterwards, was both confessional and political?

Definitely. It always had that confessional aspect to it. And it filtered into the Wapping riots and the Toxteth riots. It was combat, there was conflict.

So you were painting people in conflict?

Yes, very literally. And making sculptures as well. Making bronze castings of the Bobby Sands hunger strike, Union Jack soldiers in visors, protected by the State, and the miners' marches, and the crucifixions – then going back to early college, the degree – certainly very figurative; suicides and crucifixions, Christ figures. Very figurative indeed. So it's been a gradual process, looking back over those twenty years, of working away from the figure.

And being more reflective about...

Perhaps realising that it's back to being about paint. That's the common denominator. If I had to hold onto one thing over these last twenty years, it is about the physical substance itself, maybe more importantly than what I'm painting, and maybe I find the landscape the most appropriate subject to do that.

Although, if you look at Lucien Freud, you have both. You have a tremendous sense of person, personality, relationships, but these are painted things.

Yes. And they are 'pictures', as well. They are 'pictures' of people. And you see the image, you see the symbol first, and that is not what these are about. These are about sensations first, rather than recognising particular spaces, or urban environments, or rooms with figures. Almost being there, really.

Although the political situation and your own personal background hasn't changed. You can opt to bring those in or out of focus, can't you?

That's right. I find it more difficult, though, when I was dealing with a subject that was big and grand, like nationalist politics in Ireland. That came first, the painting came second. It was the message, it was the communication, it was the image.

It was a way of carrying a message.

That's right. And it almost became propagandist imagery. And that's perhaps why they worked themselves into small bronzes, I could become even more literal. I could paint a soldier standing with a gun about to knee-cap a man off the street, or tar and feather. It could become so literal, like tin soldiers, bronze soldiers, whereas paintings of those situations always felt

uncomfortable for me. Those spaces were too still, too static, too pre-
scribed, too stiff. And they didn't allow me to enjoy what I enjoy, and that's
using paint.

*Whereas what you're doing now, particularly when you involve wax and you
press perspex, you press layer upon layer, you're also expressing, there's the
release of your control, you're not entirely sure how it's going to work.*

The most exciting aspect of painting is about losing that control. It's letting
the reins out, allowing the materials to find certain forms and particular sur-
faces, but at the same time being able to pull the reins back when you find
that form, to recognise it and to recognise the accident. It's creating the envi-
ronment on canvas, or within the arena, to allow those things to happen.

*And as you said earlier when we went up to the studio, if it doesn't work, you
abandon it, you rework it.*

It gets scraped off, sanded down, or it's allowed to dry and it's turned
upside-down and gives a great key, or a great surface to work back into,
and then you can wipe it back to earlier imagery, or earlier colouring, and
that again is in some way like a landscape; the erosion of cliff faces, reveal-
ing time, working back through time.

*So you work layer on layer, different materials layering and giving perspective.
You're in a sense creating an object, which is then mounted and boxed and
becomes another sort of object, or becomes objectified.*

Yes, it's sealed, isn't it? It's vacuumed. As you say, we go back to that touch
element within looking. They become sculptural, they become objects as
well as paintings, curiously.

*And that was underlined when we went upstairs to the studio, by the drying
process.*

Having to be kept horizontal, having to sit on tin cans. The latter pieces are
not painted on MDF at all. They are painted directly onto wax tablets, so I'm
actually starting to cast a surface to work onto and into, casting molten wax
into sheets, actually making the surface as well, and then bedding the paint
and the perspex within the molten wax. That's a new departure, really.

*It's the making of the object and the making of the painting coming together. And
you're obviously getting a lot of satisfaction from it.*

Oh yes. There's so much more mileage in it.

So at the moment you're mid-series?

I'm scratching the surface, literally.

*Let's pick up on a number of those points. The last point is very interesting.
Because the photographs are important for you in stimulating, or reminding you
of what it is you're about in these paintings, the idea of a show, of an exhibi-
tion which involved some of those photographs – can we talk about that?*

Yes. That has begun to interest me more. Certainly with the Turner House
show, in the National Museum back in February, I was a bit worried. I
talked to David Alston about including perhaps some of the photographs,
or even possibly some of the drawings, to give people a link in, a hint to

BRENDAN STUART BURNS

where the stimuli were coming from. Anyway, we decided not to, the paintings should hold their ground. But with the forthcoming show, in 2002, we've talked about the possibilities, again. I take hundreds and hundreds of photographs. Photographs are, in their own right, as strong as some of the paintings, so maybe there is a way to include them.

That's a dangerous thing to say, isn't it?

It is, because I'm a painter, not a photographer, and I never take the photograph with the intention of it becoming a finished piece of work in its own right. However, the photographs deserve to be shown and they may well reveal and prompt, as another aspect of the paintings, to give an in-road.

Because these are very personal responses, and they are very sophisticated in terms of current art practice, and past art practice, and those are not languages, approaches to art, that everybody in our society can have. You're not in the business of being obscure, or indulging your personal vision. You want people to understand what you're doing.

I do. Maybe the photographs actually take them to an aspect of the beach that they haven't experienced before, and they take, and point, them in the direction that I sat and watched a shimmering rock pool filtering out after low tide; sat for an hour watching the sand being deposited and moved through a rock pool. I could possibly deal with the moving image as well, a short film, or a short video sequence, where it simply holds, it doesn't try to give too much, but it at least points people in the right direction, as a starting point only.

And this, you feel, wouldn't reduce the effect of the paintings, it would open up...

I don't think so. I hope that it would open up, I hope that it wouldn't simply illustrate the paintings. I hope it wouldn't put the paintings into second position. I would hope that the paintings are more important in the exhibition as such, and they become an access, a way into the work, similar to the use of titles.

Because the problem is currently people, whatever they're doing, will follow a moving image, will have television on when they're doing other things.

They will be constantly drawn. You can imagine walking into a space, a room full of fifty paintings, but there's a TV monitor. Where are they going to go? They're going to go to the TV monitor, they're going to go for the quick fix, the moving image, and I worry also with the written word, the labels, what's been written about the show. The public will read that first before they go and stand, look and experience. So maybe we've got to be very careful about the layout of a show like that.

So it might be a video booth?

As long as it's not the first and foremost things that you access. I want people to work at it, and that's why these paintings are like they are, because they will continually work on the senses. They're not one glimpse, one view. They continually change, you see alternatives, you see different things each day, as you walk past them, they reveal themselves slowly, they change, very

much like the landscape. They are still changing, because I'm still changing, and I'm seeing new things in the landscape. I'll come back from a walk on the beach, and I'll see an aspect of two colours, placed together that perhaps failed to resonate or register at the time.

So looking at paintings around the room from a year ago, sends you back upstairs to work on.

Yeah, it continually fuels, re-ignites that flame, really, that creativity.

You showed me your sketchbook just now, and to a large extent that work predicates the paintings. You are dealing with that view down onto rocks and water. But it also contains much more conventional landscapes of Pembrokeshire, seascapes of Pembrokeshire, but you always resist the temptation to push that into paint. Will you continue to resist that?

I think so, because they don't challenge me. They challenge me when I'm there, when I'm working in the environment, perhaps with a more traditional use of horizon, but the drawings just take me through that learning process. They act as a catalyst for learning the landscape, learning the experience, and I come away with that. The drawings are there, they're collected in a sketch book, but I don't, like I said about the photographs earlier, I don't hold them open and draw from them. They act as catalysts, they're reminders.

Would it also make sense, in a forthcoming exhibition, to include the sketchbook?

Possibly, yes, but possibly more in terms of taking slides of individual pages, or videoing the turning pages of a sketchbook, so again it gives a flavour of where this information is coming from.

It's not going to compromise the paintings.

I wouldn't have thought. If they're good paintings, no they won't. If they're not good paintings, maybe then it destroys the illusion, and maybe there was nothing there in the beginning. But I'm confident that they are decent paintings, they work with me, I'm confident with them.

You've discarded the ones that you weren't happy with anyway, of course, by the time you get to exhibition.

Exactly. They've been vetted, anyway. They've been turned, or painted over, or included in other paintings in some way. To produce five that work, I would have to produce perhaps twenty, and fifteen get binned, or turned around and drawn on again, so they get recycled. So yes, it's prolific, but there are a lot more that don't work. I suppose that's the very nature of working in this way.

So, when you're actually producing paintings, which generally tend to be a small size anyway, you can work quite quickly. You have to work with some energy and excitement about you.

Yes, you do. I read the note books, I'll flick through the sketch books, I'll take myself back to force an almost meditative state for painting. It's finding that through painting, that's the most exciting sensation, to find yourself within, where the painting starts teaching you something as well. Sometimes

that doesn't happen, so you'll be painting, you think you're painting, but nothing's really being produced, you're not actually getting anywhere. You'll be physically moving the pigment around on the surface, but it's not actually doing anything, you could spend days doing that, thinking you're painting, but actually nothing is being produced from it.

What is your work pattern? You've got 'a proper job', you teach five days a week. Presumably you need to paint, you need to be physically involved in producing a painting, or developing a painting, every week, or every day?

I need to paint as often as I can. But obviously there are the practicalities of having to pay the mortgage, so I lecture on a foundation course. I'll paint, obviously, when I'm teaching. I'll paint weekends and evenings, but perhaps there isn't the intensity there of a summer period, where I know I've got eight weeks at a stretch in the studio, and the intensity that comes with that, that knowing confidence, that consistency.

And when you can pop down to Pembrokeshire.

And being able to pop down to Pembrokeshire whenever I want. I try to get down there most weekends. We certainly go there once or twice a month, right through the year. But out of term time we're down there more often than not. I do need to maintain a close relationship with it.

The Pembrokeshire connection, as you've said, is through your wife, Ruth. Ruth is also in this house, also working in this house. How does that working relationship affect things?

For instance, the contrast between the painstakingly detailed stitching, and my more energetic and perhaps immediate, sometimes intuitive process of painting. But we're both artists, we both create, and we both respect each other's disciplines. I find it more difficult to work with interruption than she does. But Ruth completely understands this and completely appreciates my rhythms of work.

Presumably each of you is the primary audience for anything the other does?

Yes. She's the first person who will see what I've done, and likewise. I trust her comments. She knows my work, she knows Pembrokeshire, and that's a great audience to test it out on, first and foremost: someone who has been born and brought up there.

It strikes me, you haven't had a show in Pembrokeshire, have you?

No. The only work that's been seen, really, is work with Myles Pepper, in West Wales Arts, in Fishguard.

But you haven't had a solo show?

Not a solo show. It's been a selection, really, a selection of images. Part of group shows.

Not that there's much choice of venue down there, to be honest.

There isn't, actually. Certainly when David Alston was here at the Museum he had ambitions and ideas, of perhaps a National Museum of West Wales, in Fishguard or in St Davids. There was talk about the possibilities of taking these works back to Pembrokeshire, and showing them there alongside

Sutherland's. Maybe even in Picton Castle. It's a shame the Sutherland Gallery was closed, it's a crying shame.

It is a great shame, and they were losing money on it. But isn't that what arts funding is there to protect?

Exactly, the work is still sitting in an RAF hanger; what a waste.

Perhaps the future holds a gallery, a gallery in Pembrokeshire that would have travelling shows, but would also have examples of responses to Pembrokeshire.

It's needed, it is needed.

There's plenty of stuff. We've mentioned Sutherland, Piper, obviously, and then moving up to people like Giardelli and Tress and Knapp-Fisher.

It's interesting, Pembrokeshire is rich in work that is strong, pushing, and challenging. But it's also plentiful with work that's geared towards the tourist industry.

More immediately accessible.

More "immediately accessible". Let's be politically correct.

We need a Tate Gallery in Haverfordwest!

Why not? Wales needs at the very least, a gallery completely devoted to contemporary work produced in Wales on an international stage.

The one in St. Ives manages to be both international and very specific and loyal to the immediate surroundings, a wonderful place.

That's what we need. That's what Wales needs. Yes, we've got a Millennium Stadium, but we have to have a museum of modern art in Wales, without a doubt.

Grey – Green – Glimpse
Oil, wax and perspex on board,
21 x 17 cm, 1999–00
private collection

ROBERT HARDING

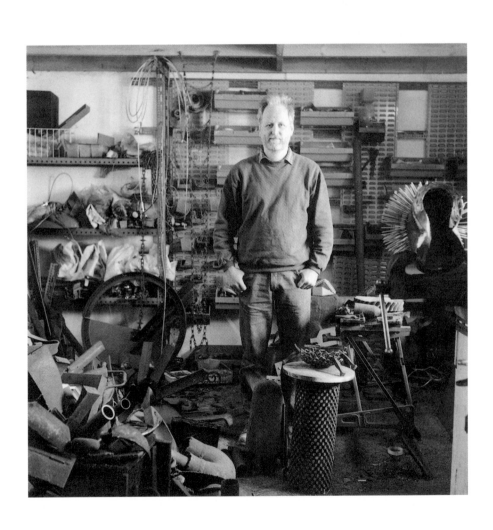

I have known Robert Harding and his work for many years. He lives in Llantrisant, near Cardiff, where he has converted outbuildings into his studio and workshop spaces. Much of his work is in the house and its grounds. We met several times in February 2000.

A good place to start talking would be for you to respond to what I'm actually looking at at the moment, in your front room. It is a great crescent of steel, sticking out, called 'Tusk', and I'm also looking at three animal-like objects on the wall, right up to ceiling height. They again are steel. What is it about steel?
It's moderately easy to manipulate it when it's hot, it's available, it's relatively cheap, it's universal. It's just wonderful stuff.
'Tusk' is large and very curvaceous. You can see that that is steel, and it's black. Is that painted black?
Painted black, yes.
This is a nice big room and it will take that piece. But it is intrusive, isn't it? It seems to me that a lot of your pieces, whilst clearly intended for domestic situations, intrude into those situations, come at you from the wall.
I don't want people to treat my work as visual musak, or glorified wallpaper. I want them to actually take notice of the sculptures. I mean, all art demands that you look at it. As a sculptor, you don't have the conventions of having a nice, rectangular frame, a window, if you like, a highlighted space with a painting in it. There are various tricks to get attention: scale is obviously one, but you can do it much more subtly than that. 'Tusk' isn't a subtle piece of work. The three animals climbing up the wall are much more subtle. You could come into the room and then suddenly notice them. You can't miss 'Tusk' – especially when you are sitting there in the chair.
You do feel that there's something hanging over you, because when you look up there is something hanging over you.
In a way, that is a much safer piece of sculpture than the part of the animal triptych that looks like a woodlouse, because that piece touches the surface of the wall on metal balls, and you wonder how the hell that grips. It is very important that the fixings are hidden, because it adds to that sense of the sculpture penetrating through the wall, hovering on the wall, crawling up the wall, floating. That sort of feeling, about how the object is relating to gravity, is a very important part of the sculpture, part of the idea.
In your house, like a lot of artists, you've got a collection of art, and I'm looking at a lovely work by Ivor Davies. You are attracted to the idea of something framed, but as an artist you find it much more exciting to come out from the wall, off the flat surface, because you're a sculptor.
Because I'm a sculptor, flatness is just one thing to be used.
A painting gives the illusion of three-dimensionality.
But a sculptor is not particularly interested in illusion. Allusion, maybe, but not illusion, because we're dealing with real stuff. We might play games with the fact that you don't see the fixings, so there is the illusion that this

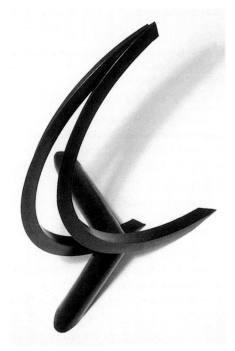

Tusk
painted steel, height 70 cm, 1986
artist's collection

thing is climbing up the wall; but it becomes part of the intellectual game, in a way I suppose like perspective does.

You want some puzzlement in the response?

Oh yes. All my work has elements of ambiguity, some of them quite strongly, some of them less so, but I want people to question the work; it's not to be just accepted.

A tusk is something that an animal grows, an elephant or a mammoth grows. It's ivory, it has a certain quality, yet your tusk is clearly metallic.

But it still relates to the trophy form of display, and in fact friends who have no knowledge of art have referred to the pieces as "your trophies on the wall".

Without any sense of irony?

Without any sense of irony, because three-dimensional things that come out of walls to them are sort of like hunting trophies, or the sort of trophies that you might have for winning a sports event.

That would be the only point of reference for them, wouldn't it? Because what conventional visual art does, what the Ivor Davies painting over there does, is decorate, largely in a two-dimensional way, a space of wall.

The equivalent for sculpture would be the relief form, which is usually of narrow or shallow depth, usually recto-linear; it plays with levels and surfaces, one in front of the other, and it often does have perspective. In a way, that is a convention I don't want to be involved with at the moment, because I feel there is just so much to do with freedom of space that the

conventional relief restricts.

There's a tension between the physical weight, the gravity, of what you're using, a very heavy, very hard, in a sense unyielding material, steel, and its various forms. You are playing, in a very serious sense, with the tension between the material and the organic forms that you're implying or representing.

A lot of people who work in steel tend to make steel almost like spaghetti. When you get it hot, you can manipulate it in all sorts of different directions; I don't want that softness all over. Quite frequently I will play with it in parts, but the overall piece is still steel to me, and as you say, it has that sort of intractability, that slight mechanical feel, a slight edginess, sharpness, precision to it. I want to play about with that mix between these two characteristics of hot and cold steel.

Where does your art start? You are fully and formally trained, you went through the academic mill, didn't you?

Yes, but I didn't start working in steel until I left college. I was playing with mirrors and rope and installations, and much more ephemeral things. It was partly the *zeitgeist* of the time, which is very similar to now; there weren't many people making objects. I was taught by people who were minimalists in their way, and they certainly influenced me a great deal, but the students were reacting, obviously, against all that at the time, and like them I went in for piles of sand and rope and things. It was great fun, I enjoyed it, but when you leave college – I found anyway – it's more difficult to operate like that as a sculptor, because you need galleries to say, "We want you to do something in this space". However, I soon realised that galleries don't make such offers to recently graduated students. I then wanted something that I could work on at home, privately, if you like, and I therefore got into the realm of making objects. But that sense of placing, that sense of siting work is still there, and that's partly this reaction to placing something over a chair, or the relationship of the work to a flat surface, or to a wall. Or that sense of tension you get by suspending things on wire.

So you started off with the sort of art that's site-specific, but 'Tusk' and 'Three Beasts on a Wall' are not site-specific, although it's absolutely crucial that they be sited with some sensitivity. They won't work as effectively anywhere.

No. They have to go on a vertical wall, for one thing. That wall has to be flat. That wall needs to be plain; on flock wallpaper I don't think they would work very well. This is on mildly textured wallpaper at the moment, there's a slight weave in it.

From my point of view, as someone who always dreamt of owning a house with art in it, and wants to be a collector, there's a sense in which where I live becomes a display area. It becomes a display area for things that I value, but also it becomes, in the most profoundly banal, bourgeois way, a way of exhibiting one's material wealth, and taste, one's personality, isn't it?

But for a practising artist, it's also a place where you actually get to sell some work off your own walls! Let's face it, there's an element of that.

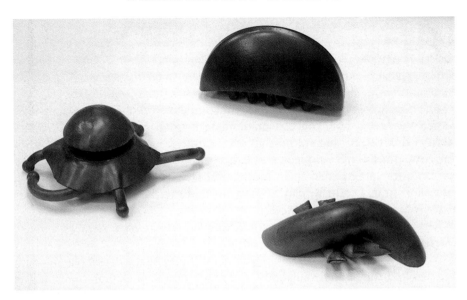

Three Beasts on a Wall steel, 35 x 23 x 14 cm, 44 x 19 x 24 cm, 48 x 41 x 20 cm,
1994, artist's collection

This looks great in my house – it could look great in your house?
Exactly, and I'm amazed that sometimes, when you go around to artists' houses to interview them, some have very little of their own work displayed. They have a lot of their friends' work. It maybe because I'm thinking of well-known artists, who work on big pieces. In fact it's one of the things I've learnt from them, people like Philip King, Bill Pye, Tony Caro, people like that, that they have clean space in their workshops, and in a way they use that space, like I do now with the clean space I've just created, as a place to think about work, to photograph the work, to on occasion sell the work, and therefore possibly their houses are less important. And also they are artists who work on a vast scale, and so the chance of their work being exhibitable in domestic space is much smaller.
You mention Caro, and he is clearly an influence and a reference point for any-body working in the sort of field that you do.
Yes, but curiously enough, as a student I really didn't like his work at all. I didn't understand it, because in a way I was so involved in playing with the idea of site and the dimensions of sites and the feel of particular sites, that I wasn't involved in the abstract language that Tony Caro was using. But I've really grown to appreciate his work, I suppose, in the last twenty years.
That's another tension in your work, that tension between the organic and the abstract, between the readily recognisable and the challenge of the abstract forms that you're dealing with.
Yes, I would agree. I mean, there's a wonderful little Tony Caro floor piece called 'C53', and it's exactly the same scale as the two bar electric fires that I had as a student, with a silvery background and a grid over it, exactly that

size, but it's made out of huge, thick steel which has been melted and crushed in the middle. He's obviously making references to an electric fire, because of the scale, and the way it sits on the floor. He is often dealing with doorways, and windows, and that sort of architectural form. And chairs, recently.

Again, taking the banal and rendering it, if not surreal, then certainly ironic.

To a certain extent, but he's also dealing in the world of objects. Like all sculptors, we make objects that have to work in the realm of objects, and therefore you're often making references across to reality, to that sense of real objects.

So Ivor Davies, on that painted piece of paper, that lovely framed, painted urn on your wall, is playing with perspective, whereas you are realising perspective, you are very three dimensional: your things have gravity, weight, occupy a space, can be tripped over. Whatever they are, whatever ideas and references they're making in an ironic, post-modern or kitsch way, they are taking up space, they are demanding attention because they're there.

Yes. They should be. I don't want them to be like the zapper for the television, a sort of discrete thing that's grey and flat.

I'm looking across at one of your rear windows, and on the window ledge inside, there's a pretty substantial steel piece which has a mesh cone, like a lorry exhaust, and a circular disk. You were saying that when that was in the front window, somebody knocked the door and asked you if it was a Land Rover part, because he needed one, and could he buy it off you. That's an amusing anecdote, but what sort of insight does that give into what you're doing?

I don't think it gives insights into what I'm doing; it gives insights into how people react to things. You might have noticed on our porch, we've got some ridge tiles made in the shape of birds. I asked a friend of ours, Wendy Earle, to make those for us, and it's amazing the number of people who walk past, and then suddenly notice these ceramic birds on our ridge tiles. I like that sense of surprising people, and you get various reactions to it, usually a sense of humour – they laugh, smile and point. We have a house that's right on the road, so obviously things in our windows attract attention.

I mentioned before we started recording, I'm currently reading an article in the London Review of Books *concerning kitsch, which is an interesting concept. We say, "Oh, that's kitsch," but do we really know what that means? It's got something to do with a totally predictable response to an object, an easy emotion, that isn't really earned at all. You, as a sculptor, are in the business of maybe at times skirting with the kitsch, but never succumbing to the easy response. For example your chromed doorstop, which is a kind of knotted, large spanner.*

A 'King Dick' spanner.

The prongs of which are, as it happens, I guess, beautifully organised to hold the door and be a door stop. But of course, it's subverting the idea of the utile.

But it's still making it useful.

Yes, it is. It's turning the spanner usefulness into something else: a spanner that

has been bent back on itself seems to have been rendered useless, but in fact offers itself up to a different sort of use.

But there's so much in art, and design, about the changing of context; for example, the classic Marcel Duchamp interventions, that are changing the context of things. You think of recent design – the egg cup made from a spiral spring, the lemon squeezer made from a Tintin rocket design. You're just very simply taking something from one context and shifting it into another; it's the 'bricks in the Tate' syndrome. There's so much twentieth century art and design that is about that shifting context. You can call it kitsch, to a certain extent there's a little bit of pop art in it, too; this sense of the recognition factor of popular culture, that everybody understands the imagery being used. But we've lived through all that, that's part of our make-up, therefore, as artists, we will play with it.

You're post-kitsch?

We're post-everything, and that's what's so wonderful, it's such a freedom. *The whole business of the new century is terribly kitsch, isn't it? We're in it, now, we've got to get on with it, we're going to die in it, the dates on our grave-stones will cross over.*

Yes. That sense of time, when you look back to the beginning of the last century, and you see what people were doing, sculptors in particular. You go back to the nineteen hundreds, and you look at Epstein, at Brancusi, and they were all making things to do with the new-born; children, egg shapes. You know, it's bound to affect us and, in fact, I've started making something that has that egg feel to it, because it's something about a new era. The new Anthony Gormley by the Millennium Dome is also a spiky egg.

No matter how much we argue that the date numbers are insignificant, they are unavoidable, aren't they? On the tape for this interview I put 00 down. I still feel that's very strange, putting the two eggs, putting the 00 there.

It's important, I think, that we are aware – sculptors in particular are aware – of the culture we're living in. I always think sculptors are much more sociable than painters. We have to be – you have to ask people off the road to help move stuff occasionally, you know, you've got to be dealing with many more people. I have maybe twenty, thirty places I would go to for stuff to make art. A painter possibly only has to go up to Atlantis in London, or somewhere. They don't have to talk to people, I don't think, in the same sort of way. I'm having to ask people, occasionally, about how to do things.

I notice on your CV that part of your education was City and Guilds welding. I've never interviewed anybody who had a City and Guilds before.

Well, you've had a sheltered life! It was great fun. There I was, at Pontypridd Tech for two years of one day a week, with people coming from garages, quarries and engineering companies who had to learn how to weld, for particular reasons. You learn a lot in that sort of context, and I had to do it, curiously enough, after I did a piece for the Garden Festival at Ebbw

ROBERT HARDING

Vale, which was very big. The organisers were really worried about it, and they called in structural engineers; because I was welding on site, the health and safety people wanted to see my welding certificates. Of course, as an artist you don't have welding certificates, and they called in these engineers, who did no more than I would do – they shook it. They looked at the welds, and they shook the piece to see if it would actually stand up or not; exactly what an artist does. It seemed to me a complete waste of money to call in these experts. But it did make me think that I should get some sort of qualification in all this. When you put a piece of sculpture above somebody's head as they sit drinking their coffee, you want to know that that piece of sculpture is actually going to stay on the wall.

I think that certificate ought to be right next to 'Tusk', not hidden away, with a big arrow saying "The likelihood is this is not going to drop on your head"! You've got an MPhil as well, haven't you?

In Lancaster University I did academic research on the use of contemporary sculpture in urban environments. This was before all these percentage schemes started to hit Britain, so it was quite interesting. I looked at what had been done through various schemes, Art Council schemes up to that point – Festival of Britain, the development of cathedrals, university campuses, all those quasi-urban spaces – I saw how they'd used sculpture, plus the use of art in new towns, the problems they'd had, and then compared that situation with America, in particular. They started their percentage schemes in the USA in the early Sixties, so they'd had, at that point, nearly twenty years of experience of these schemes. I learned a lot. It made me

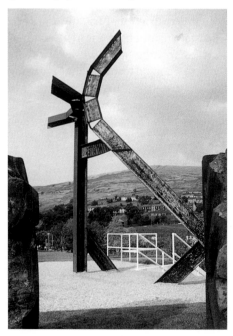

Testimony Garden (detail)
cast iron and steel, site installation,
1992 (now destroyed)

very enthusiastic for public sculpture, and when I came here I joined Art Works Wales/Cywaith Cymru, which in those days the Welsh Sculpture Trust. It is important to have sculpture out there, as Henry Moore said, otherwise we'd just be living in bathrooms. We need to decorate our spaces.

And because sculpture helps to define space.

Yes. You think of Milton Keynes, you think of concrete cows. You think of Florence, say, and you think of Michaelangelo's 'David'. Or Venice, the St. Mark's horses, or Gateshead, 'The Angel of the North'. There's a sense of identity that can be built up.

You think of Cardiff Central Station, and you think of something that was vandalised as soon as it was put there. That's the other problem, isn't it?

Exactly. I mean, you think of the redevelopment of Cardiff, and you will think of that roundabout, with all the road signs on it. That's got immediate appeal. It works in the location, it's absolutely right for the site; it's a very good piece of public art. I know that for some people it is known as the 'Magic Roundabout'. But it can make one angry that, as you say, there are pieces that get vandalised out there. I walk frequently through an underpass between here and Tesco, that was decorated by The Pioneers and two local primary schools with mosaic, and that has been vandalised. It can make one very cynical, and very worried about how people react to public art.

At least using steel it's unlikely that someone is going to irrevocably damage a work of yours.

Well, to be honest, I'm not so interested now in making pieces for outside, for public spaces, because there are so many restrictions, usually imposed by the commissioning body or the architects, so much of the risk factor is taken out of it. And the other thing is, they're judged at the level of the maquette, and the drawing. They've got no capacity to be changed during the making process, and that's where half the fun of sculpture is. It's not in the predictable, planned thing.

If you submitted for public commission, and your plans were accepted, would you sort of lose interest at that point. Would you think, "I've just got to make it now"?

To a certain extent, yes. I've done some sub-contracting work for other artists who've had commissions, and it's fine; it makes money, but it does tend to be a boring thing to do, because there are no decisions to be made, it's just an exercise. That's why there are companies out there who specialise now in making these public works of art, and that's fine, but it's just fabrication at that stage.

You've got a very striking situation in this house in Llantrisant, in a corner spot with a long, interestingly-shaped garden. You've got old pig sties, which you use as your studio, with lifting gear, with an anvil, with drills and presses, and that part of this property is like most of the other artists' studios I've been to: a complete

bloody mess. But it's an incredibly interesting and creative mess. In a sense, it's the sort of mess you will walk into and find yourself distracted by, because the juxtapositions of the scrap metal, of the half-finished objects, will throw up ideas. That's what draws you back to creating things, presumably.

Absolutely. I want to be surprised. It's a bit like cooking. I don't know any really good chefs, but I imagine they have the same sort of reaction. They've got all these ingredients, that they mix and they play with, and they create something, and the taste is out of this world. It must be a bit like that, to be a great chef, and that's possibly why they call them artists in France. It's a very ephemeral product, but it must be a bit like that, and accident obviously plays a big part.

In your studio there is quite a large, eight-foot tall, sculpture which you've said you will scrap, re-cycle, because you're not happy with it. Does that happen a lot?

Yes, of course it does. You've got to be your own worst critic, you must be. And therefore I actually create as much scrap now, probably, as I get from the scrap yard. You have to revisit things. Sometimes it's easy to be too self-satisfied with things. It's not too difficult to get exhibitions, to put your work out there. Galleries have waiting lists, all right, but you put your name down. You produce work sometimes that's exhibited, and you bring it home and you think, "I shouldn't have done that". Sometimes it's the first time you really see the work too, because you have a big clear space you can actually put the work up in, and it's sometimes the first time you actually really look at it, because otherwise it's so close to you. You're working on it so close physically, you're so involved with it, with all the decisions you are making, that you're really not looking at it objectively.

Maybe it's like a publisher's deadline. You've committed yourself to an exhibition, and something has to go there, but as long as people realise that's going to be work in progress, that's okay.

I mean, have you ever changed your poems after they've been published? By the time they get to book form?

That's a perfectly understandable thing to do, yes.

I mean, I know R.S. Thomas changes them sometimes.

I think that's the difference between magazine publication and book publication. You really ought to have sorted them out by the book stage, most poets would collect work every four or five years.

When I get to the one-person show I would agree with you, because most of the pieces will have been shown in other venues, and that sculpture you're referring to, that I'm planning to scrap, was only shown in one mixed show, and not in a one-person show.

At what point did you realise that it was wrong? On opening night?

I realised it was wrong probably when I went back to see the show when there was nobody around, and then I brought it back here after the show and I thought about it, stuck in a corner there.

It is a big work. There's a lot of physical work involved in that, it's a commit-ment of space, it's a substantial piece, eight or nine feet tall.

Yes, but there are bits of angle iron that are still straight, so I can re-use those. There are other bits that will get chopped up into, I suppose, four or five different pieces, initially. Then they'll join the rest of the stuff in the pile. And later I shall come across them. It's almost like archaeology, going through that pile, because I discover things in there, bits of pieces of sculp-ture that I might have made twenty years ago. And yet I can remember the germ, I can remember why they were made, what it was I was looking at. But then I've got to try and rethink, and treat these bits almost as if I'd found them in the scrap yard, without the history of my involvement with them yesterday.

The artist I've most recently interviewed is Ivor Davies, who's interested in cul-tural politics, and you mentioned archaeology there. He talks about archaeology as being all political; that when you dig something up, the use that it's put to is so important. Is what you produce essentially a matter of personal exploration, personal expression, or is there any wider agenda, as there would be with some-one like Iwan Bala, who is now making objects out of very specific, Welsh cul-tural artefacts? You're clearly not in the business of doing that, are you?

I'm not in the business of making political statements with a capital "P". I think that is the difference, possibly, between Iwan Bala, Ivor and myself; I'm interested in the personal response. It's my identity that is important to me. I'm not making any grand claims for Welsh identity or anything else, because I've not got that sense of place that those two artists have. My upbringing was being moved by my parents from place to place.

Why was that?

Because my father was an engineer. Moving from factory to factory, you don't get that sense of identity with a particular place. There is a graveyard outside Stoke-on-Trent, a place called Maerhat is full of Harding graves, because up to the eighteenth and nineteenth centuries, the family were farmers, and stayed put. But come the industrial revolution, most of the Harding family went off and worked for potteries, the steel industry and the mining industry, around Stoke, because that's where the money was. So this sense of identity with a place certainly petered out in my father's genera-tion, because they kept moving.

What sort of an engineer was he?

He was a mechanical and electrical engineer, who worked for English Electric for years. It's one of the reasons I think I became an artist. He was made redundant when English Electric was taken over by GEC, and it was exactly that sort of time, I was about fifteen or sixteen, when I was making decisions about what to do in life, and I swore to myself I wouldn't work for anybody else, except myself.

Really? You didn't want to be a company man.

My father hadn't sold his soul, he really enjoyed it. But he was in his fifties,

and suddenly redundant. I remember the months he spent writing letters to old colleagues, application forms, trying to get work – in the Seventies, it was around the time of the three-day week. It was very difficult and affected all the family.

So you thought, "Well, being a one-firm person doesn't necessarily guarantee you security. I'm going to strike out on my own."

It doesn't guarantee security, but at least your destiny is, to a certain extent, in your own hands. All right, a lot of accidents go on, a lot of opportunities are missed. There's a lot of chance, but effectively it's my decision about how much I put into a pension scheme, for instance; it's more control. I think control is important: you'll notice it, actually, in the sculpture itself, this sense that I like to be in control of the work. There are elements of pure chance in the genesis of the work, but, by the time I'm crystallising it all together, at that time, I want control.

And when you walk into your studio, sometimes you want – well, as often as possible – you want the unpredictable to happen. You don't want the predictability, going into your working space.

Not at the beginning, no. There is a moment, in all sculpture, of grind. This is why I never have just one piece on the go at any one time, because there are repetitive operations that can be mind-numbing, so you need to have something else to go against that. You need the excitement of generation of ideas, generation of form at the beginning to offset that against the repetitive working.

Each piece has a plodding aspect, "I've simply got to cut through this metal, I've got to heat it, I've got to bend it. That's simply got to be done."

[The interview was interrupted, of necessity, by Jane Phillips from Glynn Vivian Art Gallery in Swansea collecting some pieces.]

What show is that for?

They bought some pieces – a metal bowl, and a wall-mounted sculpture.

Right. So, did she come around and look at the work, or was this something she'd seen at an exhibition, or...

No. Jenni Spencer Davies, Glenys Cour and Peter Wakelin came around about two weeks ago. There's been an award, Peter Wakelin's parents left money to the Glynn Vivian to buy works of art from contemporary artists. I think there's going to be an award for five years, presumably while the money lasts.

Well, that's very satisfying, isn't it? Are you already in their collection?

I think there is a small piece: it was bought a long time ago, in the early Eighties. At the time I was doing pieces about redundant steelworks, or steelworks that were being demolished and I did a piece called 'Shotton' that they bought. It's quite interesting; it links back to what you were saying about being political. There are times, obviously, when in a way I do

make political things.

Because you live in the real world; and have opinions and feelings like everybody else?

Exactly. You've seen on the staircase some pieces made of money, and there's one outside. You can't actually make a piece of sculpture with money, with coins, or with notes, without making a political, or at least cultural point.

It's also illegal, I think, isn't it? Defacing the Queen's image. And you live very close to the Royal Mint, so there's a kind of irony in that. They're minting it, and you're turning it into a fish, or a bowl, or...

They've also played a very fast one on us; they changed the coinage in the mid-Nineties to steel-based, as opposed to copper-based. I discovered this by having a magnet in my pocket and it attracted all the pennies and two-pences.

So at that point, you thought this is good raw material for you?

Yes. What you say about defacing the coinage, I'm actually very careful. I don't actually ever weld on the face, I weld on the edge.

So the O.B.E. is still possible?

I doubt it! The one that's hanging, as one goes upstairs, the fish made out of pennies is all edges. However, I did actually drill one of them for the eye.

The Glynn Vivian has just taken two pieces, then, so it's a nice day for you. The trouble with being in collections is that, particularly in large collections, something like the National Museum collection in Cardiff...

I'm not yet in there.

No. Is that, for some of the time, anyway, they'll shove you away in the basement. They've probably got ten times as much, fifty times as much stuff in the basement of most museums than they have on show. If your work isn't being seen by someone, even if it's only people who come to your house, then that's terribly frustrating, isn't it?

Not really, when you consider how much artists produce. I would agree with you if your whole work was like that, but two pieces, three pieces in the Glynn Vivian collection. All right, most of the time they might be in store, but when you think about it, that's a tiny fraction of the amount of work that I've produced.

Is there a different feeling, if somebody comes along, and buys something for their house or their office? I don't know how much corporate business you do.

I haven't managed to crack the corporate market!

Is there more satisfaction in thinking that somebody is going to live with this thing, than that it's going into a collection, and being subsumed into the mass?

You win some, you lose some. Private buyers need confidence in the work. They don't want to feel that they're spending two hundred pounds, or two thousand pounds, on something that nobody else wants! And that's why, on CVs, you get all this business of collections. It's a sort of assurance: "Well, they've bought it, it's all right."

ROBERT HARDING

It's like a kite mark.

Exactly. It's an odd business.

I mean nobody, essentially, needs any work of art. We only think we do. It's rather like the drug addict. I mean, I've got art like some people have cocaine, you know.

The drug addict analogy works for the artist too: there are a lot of lows, too, but there are enough highs to make it worthwhile.

You have to do this, even if the stuff just accumulates in your shed in your garden, then you're still going to do it, aren't you?

Oh yes, of course.

You don't need a commission, you don't need an audience.

Not really. Obviously, my first audience is myself, my second audience is my wife, and I think that's very important. The other thing that's very important is to have one or two friends in the art world whose reaction you can trust. There is a need for some audience, but it doesn't need to be huge.

You mentioned earlier the Ebbw Vale festival, back in the Eighties, and that was a big audience. That was a high-profile thing to be involved in, wasn't it?

Yes, but it was anonymous at the same time. In my case, deliberately anonymous, because of the stuff I was using – it was materials from the old steel works, from the site before they landscaped it, bits of stuff I found on site.

Do you mean anonymous in the sense that there wasn't a plaque saying "This is Robert Harding's work"?

There was a plaque, but Testimony Garden didn't read as a 'typical' Robert Harding, because I was dealing with some very big stuff, some of which I hardly touched; I just presented, or re-presented it in different ways. Big gear wheels from the old rolling mills they had there, beautiful things that had a certain sense of Roman columns about them. In another context they would have been in a museum. These great, huge things that had been dynamited.

This is the Marcel Duchamp principle again, isn't it? That art may not be substantially involved in changing the physical structure of something. It may be involved in changing the context of that thing – Carl Andre's bricks, which outraged people.

But it doesn't just change the materials; it changes, hopefully, the viewer's mental attitude. So it's not just huge cast rolling mill pieces. It becomes something else, because of the way you present it.

And it goes from industrial – from the utile, industrial use – to the essentially more meditative quality of art.

Yes, and very definitely meditative because of the way I've structured it on the site.

That's not a surprising commission in terms of what you do, because what you're taking is a universally utile substance, steel, and you're changing it, you're making it non-functional.

Sometimes. I make bowls, and things to keep the door open. What is utile?

Yes, your King Dick *spanner certainly keeps the door open, albeit in an unintended way. I have a large Pembrokeshire beach stone which has the same function, but not the same resonance and humour, of course.*

But there again, if you covered your whole sitting room floor with pebbles from the beach, you would be, in a way, creating a context.

Making a floor, an uneven floor. But you are deliberately subverting, distorting, the functional quality of that very large steel spanner, because it has been bent into an almost forget-me-not, keepsake shape. And again, the bowls that you make out of steel are working against the natural assumptions and tendencies of the metal.

Yes, but there again, it's not the metal as much as the functionality of a spanner that needs to be straight to get the leverage to do the job.

In almost the same way, at the group show in Llantarnam Grange, you had a triptych of wall pieces which involved the cutting edge of saws.

Those play with the same transference of purpose; the saw blades are no longer functional as saw blades, yet aesthetically they are doing a cutting motion within the sculptures. In that respect, it's exactly the same as the door stop. The door stop is no longer a spanner, but at the same time it grabs something which is, in a way, part of the function.

But saws are potentially aggressive things, aren't they? It's a controlled weaponry, really, for cutting through wood or metal. So something that you might well use in a different context to cut metal becomes involved in the sculpture itself

Yes, and lots of sculptors use tools: tools become a part of their vocabulary of form. David Smith used tools; Caro's work uses tools. Lots of the metal sculptors have used tools.

And so that's a kind of self-referentiality, isn't it?

Yes, you're surrounded by them the whole time. It's why, for instance, Claes Oldenburg used clothes pegs, made sculptures out of clothes pegs, because his studio was full of clothes pegs because he made soft sculpture. When you're surrounded by stuff, it feeds into the art.

What state is sculpture in at the moment? In Britain first of all, and then specifically Wales?

I think it's very good. I think a lot is owed to Henry Moore. Not only did he make British sculpture acceptable all over the world, but he left all his money to the support of British sculpture, and I think that's fantastic. I think we should all take time off and drink to his memory. He was one of those people, you'll be interested to know, who never accepted an honour, except the OM. He turned down the offer of a peerage by Harold Wilson.

What about Barbara Hepworth?

Well, Hepworth was odd. One of her assistants, Roger Leigh, was one of my lecturers at college, and he said she was a real tyrant to work for. But her sense of ambition wasn't the same as Moore's at all. Her sculpture was quieter; there's a more meditative, more poetic sort of vision in a way there, and sometimes it works and sometimes it doesn't. I think her garden and

her studio are just wonderful places to go, in St Ives, and I think her 'Family of Man' – they used to have it in Hyde Park, I don't know whether it's still there – when it's all together, the complete family, is a major work of art. But she wasn't into making 'masterpieces' in the same way as Moore was. *The piece that the National Museum in Cardiff has is made of ancient African wood, which is quite remarkable. We were talking about the new century in an egg shape, it plays with the idea of 'egg' in a wonderful way, I think.*

Yes. There are so many similarities between that piece and some of Moore's pieces. There's always the problem of who made the first hole, who used the first bit of string, and all that. In a way, it was a very incestuous, very small art world at the time, so it's very difficult to make those sort of judgements. But I liked her bravery in colouring work, certainly a thing that Henry Moore never did. The white interiors of hers, and there are some lovely blue interiors.

Again, the Cardiff piece is a very good example of that.

I think that was quite brave, in its way, especially in the light of the prevailing orthodoxy of the time, 'Truth to Materials'.

I notice one of the pieces in your hall has stripes. I don't think it's painted; but the cone part of it has stripes. How do you get your effects on the raw steel?

This is the one that looks like a humbug. That was very deliberate; that was rust, non-rust. It was masked, lacquered, and then the masking taken away so the raw steel rusted, so you've got that stripey effect.

So it's actually in the process of changing as it's in the hall?

No, because the whole thing has now been lacquered, but it was very deliberate to make that humbug quality of the shape much stronger, so you've got that reference, and then it's clamped by a sort of mouth. I was doing three sculptures at the time. This one is called 'Silenced'; there's one called 'Blinded', and another called 'Deafened'. That sort of process of our senses being blocked off.

So just as a painter might fix the medium with varnish, you can fix the steel at the point at which you want it?

You can, yes. This striped quality is one of the things I'm going to go back to in the near future, because I've discovered that you can weld stainless steel to mild steel, to bronze, so you can get all those different effects; polished, to rust, to green patinated or blue patinated bronze. There's so much I want to try.

It sounds exciting. There's a great body of work here already, and you've been working very seriously, and almost a full time artist for a couple of decades, haven't you?

Yes. I teach a day a week regularly, sometimes two. In a couple of weeks time, I'm working all week, teaching at Carmarthen, and I'm also doing a stint of teaching at UWIC, in Llandaff – not sculpture, interestingly, but textiles.

Is that important to you, to get out and meet students, or is it just a practical

necessity? You have to keep the balance right, presumably.

I enjoy teaching. I really enjoy teaching: I don't want to influence students to make Robert Hardings, that would be the last thing I want to do, but it's to try and instil that enjoyment of the three-dimensional world, really. So much art is taught two-dimensionally, and there's a huge, huge potential still untapped out there, in the three-dimensional world. There's so much we've yet to do, and discover. I can feel it, I know it's there.

Is there a lack in society? Would you say that we need to experience more, publicly, as citizens, in terms of three-dimensional space as mediated through an artist's vision?

Yes, to a certain extent, but we do actually live in a three-dimensional world. I think the trouble is we take it all for granted. I have done sessions with students before now, where you get two children's periscopes, and you put them horizontally – not vertically – over your eyes so that, effectively, you then have your eyes about three foot apart, and it's the closest I think you can get to a sort of LSD reaction, legally. It's mind-blowing to see the world like that. We're just so used to our eyes being an inch, two inches apart. To actually separate them that way, your sense of depth is just incredible. And then to get the students to negotiate with these things, spaces they're used to, to try and walk along a corridor, to try and turn a corner, to try and sit down.

I suppose if the visual arts have a function, it is to provoke us into seeing the world for what it is and could be, but also to provoke us into appreciating the wonderful things around us, by de-contextualising them, by altering the context.

To a certain extent, yes, by altering context.

And sculpture probably does that more obviously than anything else. More obviously than painting does. In those terms, painting is comparatively safe, isn't it?

It is. I absolutely agree with you. It is safe; it's confined to its frame.

It doesn't obtrude. Your stuff does obtrude.

It's what I like about the paintings you'll see around here. Although they are framed, they are disturbing in their way. The Ivor Davies because of its perspective, the Ceri Richards because of the animal forms and the skull, and the dead hare by Paul Edwards.

Ivor Davies often plays with a trickery of perception, doesn't he? What's in focus, out of focus. Until you told me that was his urn, and then suddenly I see it for what it is, that could be a cave, it could be... it's an ambiguous image. It's interesting that the two-dimensional work you have is ambiguous.

Ambiguous, but at the same time strong enough, as an image, to actually arrest you.

You're also friendly with, and enthusiastic about, Vivienne Williams, whose paintings interest me.

She's a lovely person, first of all, and I admire what she's achieved. She studied English at University, and Philosophy, not practical art, and therefore to a certain extent I think her work has been about discovery and struggle.

ROBERT HARDING

What she depicts in her paintings are clearly playing with the idea of three-dimensionality. They're kind of flattened in that way. They tend to be still-lifes of fruit and kitchen utensils.

Yes, we've got one upstairs in our bedroom and it took me years to realise what was going on in that painting. I've been looking for so long. There are bees inside the red poppies, the oriental poppies. It took me ages to realise that.

That's the great thing about living with a work of art. Going to exhibitions can be wonderful – and intimidating for a lot of people – but owning something, possessing something that can still surprise you, years afterwards, is astonishing, isn't it?

Exactly. You move them around, you re-contextualise them. In a way, absence is also very important. It's amazing when I go down to the bottom of my scrap pile. Life has moved on, attitudes have changed to certain things, you are going to look at it differently.

Some of these big sculptures are enormous.

Exactly. And then you get the engulfing sense, you get the drama. It is very much more difficult dealing with life size.

But the recent Ann Maria Pacheco show was interesting. I went back four times. I'd gone to London to see the Van Dyck show particularly, but I thought her 'Martyrdom of St. Sebastian' work was wonderful. It was a subdued room, and it was late in the afternoon, some of the other people in the exhibition became part of the assemblage, you joined the onlookers, and so you'd catch them from the corner of your eye and think, "Oh God; that's not part of it, that's a real person", and they were probably looking at you in that way. I thought it was fascinating.

How carefully carved and modelled were they?

They weren't caricatures, but they weren't life-like. They were just too big.

Have you ever seen any of the Duane Hanson shows?

I saw The Tourists *in Edinburgh, it was wonderful.*

Exactly, because there you have that sudden take of who is real and who isn't.

You don't use figures, do you? You use animal forms, like the trio of creatures crawling up your wall, but you don't use the human figure, particularly.

Not the complete figure. I use allusions to figures, obviously; to navels, to sexual organs, there are allusions to figures, yes. If you're dealing in a metal, as most of these are metal, that is quite intractable in a way, it's still metal at the end of the day. It can't do that imitation of flesh thing.

You're not casting, are you?

I do cast, but I don't tend to cast huge pieces. I tend to cast elements of pieces of sculpture, constituent parts. I make things in wax, and usually I cast at college, in Carmarthen, because they do a lot of casting there. It's expensive, yes, but most of the expense is taken up with making something in plaster or clay and getting moulds taken of that into which you can then

put the wax. I always work directly in wax. If I'm going to make anything in bronze, it's always directly made in wax or plastic; it's a one-off, it's not an edition. It's just the old fashioned lost wax process. It's all the moulding and the finishing at the end, it's the polishing, patinating and chasing back that makes it expensive, but a lot of that I can do myself.

The advantage of casting is the convention that one could have an edition of six.
Yes but I'm not interested in that, only in some of the complex shapes achievable and its possibilities of mimicry.

When I spoke to Jonah Jones, he had a bust of John Cowper Powys, from way back, in his little studio in Cardiff and he said he originally couldn't afford to do the six; and I said we really ought to get together and either get some Cowper Powys fans and we should commission another casting of that. He didn't have the extra fifty quid at that stage, which was a lot of money then.

It's how the Rodin Museum survives. The Rodin Museum inherited all his stuff, but they don't get enough money from the state to run it. They sell casts of the work. There are at least twelve versions of the 'Balzac' now, all over the world. I know of at least five versions of 'The Gates of Hell', and that's a massive casting, over a hundred separate castings.

What about 'The Burghers'?

I only know the one in London and the one in Calais, but I've seen the separate figures in all sorts of different locations, and they don't work when they're separated out nearly so well, because they elongate the legs and arms. It works as an ensemble, beautifully, because you get that sense of movement and circular motion, but at the same time always coming forward; it's a very clever composition.

But if suddenly, say 'Tusk' won a big, major prize, and half a dozen people wanted it?

It wouldn't interest me to reproduce it. It's manufacture, then, to me, and it's what I came to art to avoid. I came to art to make one-off things.

You make a piece, then you make another piece, then you move on to another piece.

Yes, that is where the interest lies.

And if there is any sense of sequence, or theme, or if there's a signature piece, it's because you're still interested in doing that kind of thing again, not because you're replicating.

No. You create shapes, which you can see all sorts of possibilities with. You can see a juxtaposition of a soft form and a hard edge, that could lead in all sorts of different ways, and you get this obsession for a time, and you work through it, and then it goes. I've had obsessions with the eye form, I've had obsessions with balls, with rough edges with vessels and containment.

These on the window ledges are very jagged pieces. You could cut yourself on this, couldn't you?

It's very heavy, and only balanced on three points. Don't push it through the window! But yes, it has that ball in the centre as a sort of calming

influence, in a way.

And it has its own legs, but they're precarious. It's twisted out of what you might call a kind of organic form, essentially, and it's a sort of container, but not utile again at all. It's playing with the idea, I would think, of the figure, but also the vessel, isn't it?

Yes. Also, in pure sculptural terms, of weight up in the air.

And counterbalancing, the curve of it... what's that called?

It's got a name. It was done at the time when Sellafield was changing its name. Now, what was it called before Sellafield? Windscale. It's 'Windscale Flower'.

So it's a political, ecological...

Slightly.

What do you mean, 'slightly'? It's a protest piece. Accept the label.

All right. The steel has got 'England', or part of 'England', written on it. There, upside-down. But it's ripped; it's that sense of ripping, but there's a sort of sense of containment, as well. I was thinking very much at the time of the implications of that sort of plant on the Irish Sea. However, it is not a polemical piece of sculpture.

When you do something, when you work on a piece, and we've established that these are unique, one-off: they're not stepping stones toward something, there's no continuous road. What is there by the way of preparation? Do you have drawings?

Not often, because that presupposes a plan for something. And anyway drawings on paper wouldn't last five minutes in my workshop without

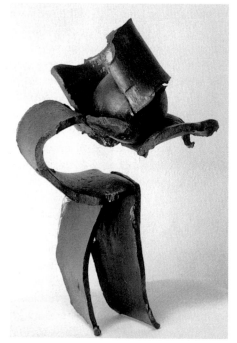

Windscale Flower
steel, height 48 cm, 1992
artist's collection

catching fire or getting too dirty to read! What happens though, frequently, is that I will draw on the metal itself, to know where to cut, to know how to bend something. I've got chalk in the workshop, and there's some four-foot square sheets of steel there, and I'll often draw on those, to think about ideas and solve problems. I don't like that planning of every step, because I want to be surprised by the process.

You want each day that you go in there, each time you go in there, to have something of the unexpected.

As much as I can. Though obviously, you get to a certain stage, and you know every step that's going to happen to the end of the piece by then, because otherwise it's not going to work. But then as I say, sometimes I finish it, live with it for a bit, and scrap it, because it's actually not quite working as it should do.

A lot of people who aren't really serious or thoughtful about art will have something in a frame on their wall, a photographic reproduction, a David Shepherd Charging Elephant, or whatever, Not many people have sculpture, or think they've got sculpture, do they?

No.

It's more than a normal framed work on the wall, it announces in one's house a commitment to the art of...

Sculpture can so easily become the opera of the art world; the preciousness, the expense, the over-the-top theatricality of it sometimes, and it's why I don't really play on bronze as much as some artists do, or marble, or, if you like, any of the operatic materials. I want to use stuff that everybody has around them, not these precious, wonderful things that you associate with Italy rather than associating with Wales.

What I'm leading up to is to get your response to something that we both supported out of our wallet, and that is the Sainsbury Homebase commission of contemporary 3-D artists to produce something affordable. Behind you is the Anish Kapoor lamp, and you have the Richard Wentworth plate in your kitchen with his impressed fingerprints in gold on that lovely white plate, For me, that was a marvellous way for the century to end itself and announce another beginning, Whatever you think, here was an attempt, a successful attempt, to commission relatively small-scale original objects, which played with the idea of usefulness – Anthony Gormley produced coat hooks – which were affordable, and were in Homebase, for goodness sake!

Yes, I think that's great, that's brilliant, and obviously the whole time I'm using stuff that everybody's familiar with screws, metal, all sorts of different things, tools of various sorts, and I agree with you. But as an artist, if I was put in the same sort of position as those, invariably London-based artists, the problem for me would be that they were made by manufacturing outlets, not hands-on: they only made the prototypes. And even then Anish Kapoor, for instance, who is well known for not being very good with his hands, uses lots of assistants – some of them have been my ex-students!

It's his vision, but somebody else does the graft?
A lot of it, yes. But he knows exactly when it's right and when it's wrong.
When you buy a Robert Harding, you get his blood, sweat and tears.
Exactly. I've made it. That is why I think the ones that work best from the Homebase range are the simple ideas, simply executed, because if it's out in the manufacturing world, you've got no real control over it after a bit, and therefore you need to make it pretty easy for the manufactures not to make an absolute balls of it.
As you know, I bought the Richard Deacon cast aluminium sculpture, which I guess is completely quality controlled.
Yes. It's mass-produced.
A mass-produced cast, inspired by an oil spillage from a car. But it becomes a beautifully shiny, almost glitzy piece which looks great propped against the closed keyboard of my piano.
It will be very interesting to see what it looks like in twenty or thirty years time, because cast aluminium goes a sort of powdery grey. And don't take it to Russia, because if you take aluminium to really cold climates it is destroyed.
But in a central-heated, boring old house in Barry it should be all right.
But it'll lose that glitzyness, because cast aluminium does.
I wonder whether it's a limited edition of two-hundred thousand, or whatever...
I don't know, but for any casting the moulds or patterns have a limited life.
I've encountered Richard Deacon's work in the Tate in Liverpool, in Warwick University and other places, and he interests me. It's marvellous that for thirty-nine quid I can acquire something, albeit a multiple. In a way that if it really works, and I guess that was what the Sainsbury project was about, it will feed people's enthusiasm, and perhaps fire some enthusiasm. There really isn't any reason why anyone can't have an object from one of those artists.
I hope so. I just have this feeling, though, that in a way it's probably preaching to the converted.
Yes. Even members of my immediate family thought that I was off my rocker spending thirty-nine quid on this lump of aluminium which, unless you turn it the right way, does have swastika implications, which I hadn't realised at the time.
But of course, the swastika is an old form from Indian art.
To be fair to him, it's much more organic than that. It's an odd thing, but the moment I saw it in my local Homebase, I just wanted to put it on a polished wood table. Because the aluminium has got an over-the-top glint to it and I just wanted that contrast. And in fact the cleaner moved it, from the top of the piano, to an upright position, it's resting on the keyboard ridge, and that's interesting. I haven't talked to her about why she did that...
Your cleaner is taking aesthetic decisions for you!
And I'm going with it, I'm leaving it there, yes.
Or is it because she is more used to seeing pictures in your house, and

things on a vertical surface?

No, there's ceramics there as well. I'd like to feel that something really exciting and almost democratic was involved in the Homebase project. I don't think people should give things away. Thirty-nine quid is not a lot of money, but it's a lot of money for some people, and the lamp is what? Fifty? Fifty-five?

Fifty something. It was my Christmas present to myself.

It's affordable, but it's not a give-away. It does encourage people to say, "Look, this is a famous artist person, I've read about him in my Observer supplement, and I can have something by him, albeit completed by other hands." But you didn't buy the Richard Deacon, for the very reason that I did.

Exactly. Because it is non-functional, and I want that sort of play on functionality which relates to the bowls and things I make. But the thing about the Richard Deacon, for me, is the obsession. It's the obsession of the way he glues things together, or screws things together, and it's repeated and repeated and repeated.

The curves of wood and metal.

Yes, and the riveting. It's almost Victorian in its sense of patterning you get with all those rivets plus the mix of the material, so you get the lovely, soft materials moving into the hard. I've done that occasionally, with things like feathers and steel, leather, rubber, polyester and materials of various sorts.

What's the one in the garden room?

There's one out there with pan scourers and steel, I don't know whether you noticed that one. The feathers and steel piece is called 'Breaking the Mould'. I've done quite a lot of those, playing with soft/hard things.

I think what Deacon is doing in that Homebase piece is playing with the idea of decorative objects, but it is aluminium, it could be out of a car bumper, so it's about the infinitely repeatable industrial object, like a car bumper.

Actually, you're more likely to get aluminium engines than you are bumpers, these days.

I'm a child of the Fifties.

You wouldn't get aluminium bumpers; they are too soft, far too soft.

But it refers to the mass production of cars. It wouldn't work in steel. It would be saying something entirely different.

Yes. And the other thing about aluminium is it is a low melt metal, therefore you can get that sort of dribbly-ness. Deacon's got that sense that you can almost experiment, like you can with lead. I melt lead in a saucepan in the workshop. You can melt aluminium quite easily, without serious equipment. It's moderately cheap, and moderately easy to manipulate and throw around. He probably did a hundred different versions, and just chose one. He could have done that on his studio floor, on sand.

He said it was from an oil drip from a wrecked car, just an interesting shape.

Yes, but then, in the sculpture world, there is this huge tradition of having a workshop, where you have the master, the maestro, and all his minions. This has been going on since the Renaissance.

ROBERT HARDING

Well, painters as well, of course.

Yes, but even more so in sculpture. It's why, for instance, Henry Moore could give so much time to the National Gallery and the Arts Council, and the same reason why, now, Anish Kapoor and Anthony Gormley can give time to the Arts Council, because they can go into their studios in the morning and say, "Do this, this and this," and then they go off to do something else. I know people who were assistants to Henry Moore. Henry would make really small pieces, and say, "Right, enlarge that to six foot."

So he was making the maquette, but the object was made by someone else.

Yes, and he would come back when it had been made up to full scale, in polystyrene or whatever. He'd come along with his chisel and rub it up a bit, get his hands on it, and then it would be sent off for casting. Yesterday, after I'd finished teaching, I was doing some bronze welding for another sculptor. It is a tradition that we help each other in some way.

That's interesting. Ivor Davies and other Beca, Beca-sympathetic artists, shall we say, worked on a collaborative project to produce a book, for the Glynn Vivian book exhibition. So somebody sent him something, and then he completed it, or...

I love that sort of idea; it's like playing 'consequences' with art. I like that. You have to have an artist who works along some similar lines, but obviously not identical, and I think you could make something really interesting that would become a sort of performance, in a way, especially if it was done publicly, or filmed, where you'd have a day with this material, in a workshop, and then the other artists would come in, modify it, change it, play with it, and you'd have a day at a time on the same material. It would be a lovely sort of project, because every time you would have to be thinking about the decision making that was going on.

So you are clearly open to this collaborative possibility?

As long as I am collaborating with artists, and not administrators.

"The councillors have looked at your sculpture, and I want you to take it down."

I can do without that. But there are a lot of good artists out there.

Yes, there are. There's a hell of a lot in Wales. That's the message of my doing these two books; I've interviewed twenty-two people over the last five years, and there's another book's worth of people, who I haven't got around to seeing, young artists, as well as more established artists. There's a lot of people doing things. It's really vibrant at the moment, I think.

I think it's been vibrant for a long time, actually. People don't realise it. I know somebody who went from Aberystwyth to run the sculpture trust in Hampshire, and she said there was more going on in Aberystwyth than ever was going on in Winchester and Hampshire. It's partly because I think we have to, in a way, because we can't just go up to London easily and acquire our cultural fix. We have to do it ourselves.

I think perhaps art in Wales needs something of the, albeit shallow, hype that the pop groups have had. I mean, Welsh rock now doesn't raise a titter. It's not

a stand-up comic's quick laugh. Welsh art still is. I mean, you talk to the sophisticated English dealers of wherever, and it is not something that is necessarily taken seriously.

The problem is, I think, our ambition as artists, and the scale at which we can work, and the size of our studios and the size of the venues we can show in easily. There's not that much encouragement to actually go wild. There are economic necessities and bureaucracies.

Well, Cardiff Bay has generated some commissions; there are some marvellous things. I know you're not drawn towards public commissions particularly at the moment, but I think the merchant seaman's head and ship is an effective one: I have witnessed people being very struck by that.

It is, without doubt, very popular. I think there are a whole series of postcards of the art in Cardiff Bay; I would be very interested to know which postcard sells the most, because that is a very good indication of a popular piece of sculpture.

And the man looking at the globe, by Kevin Atherton, which is difficult. You only see it as a blur, the way I drive, and I keep meaning to walk over and...

But in a way, and I don't like to be derogatory, but some of them are 'cultural shrubbery'. They are not that inventive. I like the merchant seaman piece and one or two others, which are really quite clever. To a certain extent the Kevin Atherton piece relies on its particular location on that bridge.

It causes a double-take. We are talking about a life-size figure, aren't we?

It's a life-size figure just cast from a model into bronze.

But it's site-specifically wonderful.

Exactly, but to me half the problem of site-specific sculpture is that it doesn't have some of the universality that art should. All right, you can look at the figure of a man looking into this globe, plus its reflection, and say this is looking onto the world. Are you part of the world; are you real or is the world real? That sort of dislocation thing. But art has the potential to deal with some bigger issues than that.

The merchant seaman memorial in the old Customs House is a one-trick pony, in a sense. Here is a wrecked ship which, when you approach it, becomes the sunken face of a seaman. But one doesn't want any more subtlety than that. It's a public piece that's got to be accessible to a vast number of people.

Yes, I know, and I think that's my problem with a lot of public sculpture at the moment. In a way, that sort of advertising hit that you get through the manipulation of those images is part of the zeitgeist, isn't it?

So your pieces, which are becoming more and more relevant to, directed at, internal spaces, maybe domestic spaces, reflect a personal vision, rather than a public pronouncement.

Yes, and also I think... you've talked to David Nash: I don't know whether you've gone into the issues of life and death with him.

I'm a poet, I think of nothing else!

Good. In a way, so much art is about life and death.

And he grows art, doesn't he?

It isn't just the growing ones. It's his use of carbonising, the cracking and the slicing.

You can see the weather breaking down those, as you look through the glass, and that's clearly a matter of art that is designed to deteriorate, to age.

That sense of life of death, of cycles, is important. Nash is dealing with a material that was alive, I've never dealt with a material that was alive in that sense.

And yours are made to last, 'Tusk' is, on an internal wall, it's going to last as long as any human being wanted it to.

Yes. But at the same time, it's about death. It's about, to a certain extent, the trophy, the problems of elephants, but at the same time the problems of the time when I was making it, particularly the steel industry. There are always these sort of connotations at the back of things. We live at a particular time of history, therefore what goes on around us feeds into the work.

Recently I was talking to Ivor Davies about the political act, I was talking about still lifes and how they could be political, the application of paint and doing a still life of oranges on a table, The whole business of painting is political, the whole business of art is political. Is it only possible when you have a peaceful civilisation?

No, I don't think that's true. You can think of Gaudier-Brzeska, things that he made in the trenches. I think the fact that they survive, is significant.

So the curating of art is one of the most civilised things we can do?

I think so, yes. At the same time, curation can be a very deadening thing, too.

Oh, surely it can, I mean, the acquisition of works by national institutions which are then shoved in their basements we've already referred to, If it's not being looked at, who gives a damn?

Exactly. It's the cleverness of curation that really needs boosting. I've been quite impressed with what the Tate has done. The juxtaposition of work is absolutely critical.

Have you been to the Sainsbury Gallery at the UEA campus?

No, I haven't.

It's quite remarkable, the way that, without regard to nationality or medium, they've juxtaposed things: African carvings with Modigliani.

Of course, that's been done right from the beginning of the last century, when Picasso and Gauguin, and others started acquiring African and oriental art.

But to say this is a university and public gallery where we're going to let the juxtaposition of images set up their own relationship, it's not been organised in any kind of colonial or proprietorial way.

Well, is it or isn't it? I wonder. Some people have referred to Picasso's use of African imagery in particular as cultural colonialism, because he's taking these images completely out of context.

But when Picasso does that, and when Gauguin does that, he may be appropri-

ating them into European culture, but he's also drawing attention to them, and legitimising them, using them specifically because they are what we would characterise as native and savage. He's bringing them into the body of Western Civilisation, isn't he? You can't have it both ways.

No. I think to a certain extent Freud, Jung and others had a huge influence on artists at the beginning of the last century. I think using African art gave the artists of that time a wonderful excuse for dealing with some of those issues, too.

This raises, maybe this can be the final point: some of the people I've talked to, particularly Beca artists like Ivor Davies and Iwan Bala, are articulating quite specifically a sense of being in a certain place, Wales, and a certain identity, Welsh. What brought you to Wales?

I fell in love with and married a Welsh girl. What better reason is there?

You've been here for nearly two decades, and in both your teaching and your exhibiting, you have made, and are continuing to make, a contribution to whatever is perceived as art in Wales, or Welsh art. How does that make you feel?

I've lived in Wales longer than I've lived anywhere else. I'm a product very much of the late twentieth century move of people not being based in one place for their childhood and upbringing. I've kept moving. In that respect, I don't belong anywhere, as I've said before.

Oh, we want you to stay here, Robert.

I'm very happy here. When we first moved to Swansea, and I lived in a row of terraced houses in Swansea, the sense of welcome, by my neighbours, was remarkable to someone who was English, was an artist, and made noise – not just an artist who painted quietly in a corner. My neighbours used to knock on my studio door, and bring me coffee and cakes and stop for a chat, and help me unload steel and load up vehicles with sculptures. That sense of being welcomed for whatever one was...

You were a maker then.

Before, I was a student in England. I often had to lie about what I was actually studying in order to get accommodation.

I wouldn't want you next door, that's for sure!

I avoided saying I was an art student. I used to go around saying I was an engineering student, or something else to get accommodation.

Again, I think that's to do with people's perception, quite legitimate perception of arts students...

Maybe in the Seventies. But that sense of the 'welcome in the hillside' when I moved to Swansea in the early Eighties, was definitely there. And that's why I feel at home here. It's a very inclusive sort of place, Wales. It's very good here.

IVOR DAVIES

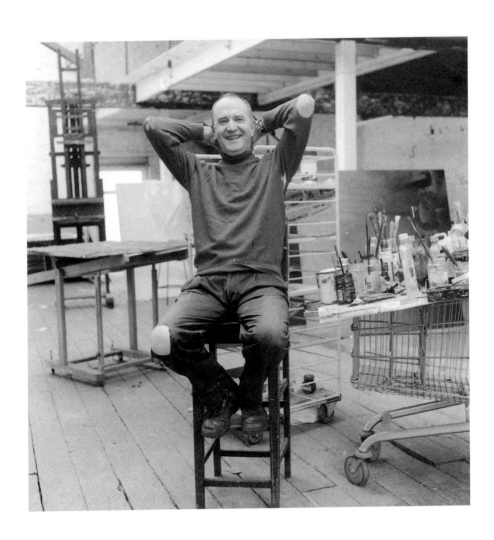

I visited Ivor Davies on several occasions at the beginning of 2000, both at his house and his studio in Penarth.

In your contribution to Certain Welsh Artists *there's a quotation that struck me: "much of my work is about the memory of an ancient culture". Visiting your house and looking at your paintings, it's clear to me that even when the paint is still we things are partaking of an ancient culture, you feel yourself to be part of a continuum.*

Yes, it would. I'm interested in the sources of things. I happen to be Welsh and therefore am interested in the sources of everything Welsh I've absorbed; that has led me to look at archaeology. That is always political. I was talking recently to an Israeli general who said that there were no such people as the Palestinians; he said there were only 'arabs'. And the Turks do not recognise the Armenians or the Kurds. We need to resist official interpretations.

I'm interested in the Celtic gods, divine heroes and myths which we find extensively in carvings and objects which have been dug up from Asia Minor to Provence and Spain, which are by Celtic-speaking peoples, as well as those which crop up in Irish and Welsh mythology. In school we had something called 'Welsh History', as if this wasn't proper history, because History was about the Kings and Queens of England.

Let's stick with archaeology for a moment and talk about one of the canvasses on which you're currently working. In this studio there are five or six on the go, your working practice is to move from canvas to canvas and keep things alive and to keep working at them over a number of weeks or months or years, even. But there's one where you've adhered earth to gesso. You're actually painting with earth; not a pigment, extracted from the ground, but the ground itself. That's a kind of archaeology, isn't it?

It is. Of course many pigments are earth. The oldest pigments are ochres of various sorts, and this is an iron oxide.

Where's that earth from?

It's from near Eppynt where the British government cleared people off their land, from their villages to make firing ranges for the army. It had been a large peaceful Welsh-speaking community.

So you went there and brought back a bit of earth?

Yes, I dug it out. A red flag flies there, which shows when they're firing, but you can dig this earth out. It's wonderful; I think it's about the reddest earth in Wales, certainly, if not in Britain. And of course red earth has tremendous significance, going back to the Palaeolithic period in Wales. The skeleton discovered in a cave on the Gower peninsula, the Paviland Man, was painted with red earth about twenty thousand years ago; in Africa 150,000 years ago red earths were used to decorate the body for funeral rituals, according to recent archeological research.

Politics interprets archaeology
loose earth on oil, gesso and hessian,
110 x 110 cm, 1995
private collection

This particular red earth has a superb texture, and I've resisted the idea of making it stick totally to the canvas. I'm very interested in permanence in painting, and I've studied permanence, and how to keep paint from cracking and how to keep it on the canvas, but I'm also interested in impermanence, and destruction and change, and the alteration of the world, so I'm going to resist fixing this earth permanently to the canvas. I want it to fall down at will into a tray-like frame I hope to make for this. At the middle is a part of a plaster cast I made of a figure, or rather I made it from a copy of a figure, which is a bull with three women on its back. Nobody really knows what it is; it's sometimes called a Tavos Trigaranos, a bull with three cranes on its back. There's a similar one in the St. Germain crypt in Paris. This particular figure is a mystery. I notice that bulls and cattle are not mentioned in the *Mabinogion*. Only one man, called Gwarthegyr, even suggests by his name a person who looks after cattle. But in Irish mythology, Cuchulain was hunting a bull, and three maidens are supposed to have warned the bull of this hunt; they turned into birds and this might be the explanation for the figure.

What you're describing there, really, is a Celtic existence that goes from Asia Minor through to Ireland, that most of us have forgotten about. Although you can't see it on a map, you can't see it as you drive along, if you go to the artefacts, both literary and physically, if you go to the art, there's a commonality, there's a shared, perhaps distorted memory, a shared need for the mystery of the women who turned into cranes. You're interested in that, and excavating that, and making it fresh.

Exactly. And I'm also interested in how this is an extremely modern thing too. Not only the concept of this disintegrating image, but the idea of the ancient in our presence. We live with anachronisms, you know, our houses are built of stone, they could be made of plastic, but we prefer stone, stone is really stone age building earlier than the Celts. The very existence,

say, of Wales owes something to these remote roots, so that Wales is modern, in that it exists now, and there are political events occurring even now in Wales, which are only existing because of the long strands of history and of thought, that go back to these sorts of things.

I'm reminded of Gwyn Alf Williams, "We make and remake Wales over and over, day after day, week after week, if we want to". But it seems to me that you have wanted to do that, in your activities and in your art, particularly in the last twenty-five years. You want to take whatever Wales is, reiterate ancient Wales, and you see that as part of whatever it is that Wales is now. Because Wales is only a construct, a series of accidents, political and otherwise, like all countries.

In a way, though, I think it's the opposite of re-inventing Wales, or remaking Wales, whatever the opposite is.

Excavating what is there.

Yes, finding out what it really is, showing, excavating, rediscovering, often retrieving from cultural theft such as the Arthurian stories.

But excavation is political, and what you find is then subject to interpretation and distortion... What we thought was Roman may not be; what we thought was Celtic may not be.

Exactly.

So really, what you're doing can't be objective. It's always going to be subjective, isn't it?

Well history is the most subjective art. It isn't a science, any more than psychology is a science. Africans would not be so interested in the history of the Kings and Queens of England which was imposed on them with a disregard for their own cultures and histories. In many of the university institutions in Wales, including your own, the art history of Wales is absent, except for the Centre for Advanced Welsh and Celtic Studies at Aber.

We must address that, certainly. In that context Africans probably wouldn't know they were Africans, until recently.

They would have a history of art which would be connected with Egypt, perhaps, and with the manufacture of bronze objects in the west of Africa. History has been distorted by the winners up to now. Archaeologists were often military men who explored and collected what were regarded as ethnographic specimens: masks, carved wood figures and objects of utility. To the European usurpers the naturalistic bronzes of Nigeria would have been impressive, but imperialists destroyed cities of considerable sophistication there.

History has always been written by the winners.

It is written by the winners.

But art is always exhibited by the winners, isn't it? The national galleries, are what determine 'good' art. They give art a sense of quality, and that's been a contentious issue in Wales, and that's why there's a strong argument for a museum of modern art in Wales.

Yes. I'd like to see a modern collection and a historical collection. I think

things are improving now, considerably, in the museum, but the whole lay out of the Museum, so that nothing can be changed, was a mistake. The Tate Gallery has a more intelligent way of constantly changing displays. It should, as Peter Lord says, be centred on Welsh Art, or at least organised and presented from a Welsh perspective. Friends of mine come from all over the world, and they're really disappointed at not seeing that much Welsh art in our National Gallery, because so much of it is in storage. I think things will change though.

But visitors are very surprised to see very good impressionist art, thanks to the Davies sisters, of course.

Yes, that's wonderful. The Davies Collection has been an inspiration to me since the day it was donated. We do need to support that with new loans and acquisitions, like the Sisley view of Penarth. A few years ago there was a fine view of Swansea by him at Sotheby's and we missed it. It was unsold and later went to Japan. We shouldn't miss things like that. I think things are really improving a bit, now at the Museum.

And Peter Lord's done excellent work, in a way, in excavating, no doubt in a politicised way, in excavating a Welsh heritage.

He's influenced me quite a lot. Some artists are afraid to admit who's influenced them, but there are a very large number of people who have influenced me, over the years, from Gwyn Daniel, who taught me at Primary School. He was sacked because he wouldn't join the army during the war, he was a conscientious objector. He made me realise that Wales had a culture, at a very early age. My grandfathers, my parents, of course, each individually and collectively brought me up.

Let's talk about your roots, because you are very much rooted in Wales. Your family is Welsh, and Welsh, back through generations.

My maternal grandfather was from Penarth. His grandfather was born in Wick, but my maternal grandmother came from Carmarthenshire, and that's the kind of Welsh that I speak. I was brought up bilingually, to speak English and Welsh, in Penarth.

You have become much more international in a sense – your time in Lausanne, and your academic interest in Russian art, which began during your time professionally in Edinburgh. Could we trace some of that?

I was taught by the same teachers who taught my father in Penarth County School, and they used to refer to him. One of them, the chemistry master, even knew that I was named after one of my grandfathers, he used to call me John Phillips, he got it the wrong way round. I was fanatically interested in art in school. We had a stimulating, if rather unusual art master, who taught woodwork and art. I thought the most interesting people in Cardiff were art students, so I dropped my higher certificate work in French and Welsh to do that, I was going to do A level Art but there was no facility to do advanced level art in school, I didn't have much help with it, and so I went to art college a couple of months before my sixteenth birthday.

IVOR DAVIES

Was that with the support of your family, or was that a great disappointment to them?

Oh no, they supported it. They assumed that I would be a teacher – which was something I later did. Of course those were the days when there were fewer galleries than there are now and fewer publications and reproductions.

This is nineteen fifty-two to fifty-six?

That's right. There was the Howard Roberts Gallery, that was quite alluring, in its way. You'd walk along St. Mary's Street, and get a rickety lift up to the top of this building, and you'd emerge on this huge space with floorboards, and there were Augustus and Gwen John, Ceri Richards and David Jones.

I'd have thought Ceri Richards would have been an influence on you, if one were looking for clues, rather than either of the Johns.

Well, I don't think any of them were really much of an influence, on me. When I was at art college, to me the most enlightened teacher I had was David Tinker, and he was about the youngest. He had a bright red beard. I was interested in surrealism – the first thing I ever wrote was in school. I remember Bobi Jones, who was a student teacher when I was in school, he said "You're interested in Salvador Dali, write something for *Baner ac Amserau Cymru* and get it published. So I wrote a little piece, I never kept a copy of it, but it was published there. I was fifteen.

I remember him saying I had an inferiority complex, so I went to the library to look for books. I found a book on Freud's *Interpretation of Dreams*, but there was nothing about inferiority complexes in it. It was so fascinating, though, and I forgot I had an inferiority complex. Years later I found an article by Bobi Jones on the Welsh inferiority complex and the Act of Union.

I then went to art college, and it was all a bit disappointing. I thought everything would be explained to me in art college. That's why I had been a bit disappointed with the rugby at school, because nobody explained all the rules. It took me years to realise that nobody knows all the rules of rugby. In art college, nobody explained anything, which I thought was appalling. I always wanted explanations; but at least life drawing, perspective and other old-fashioned devices were taught to a certain degree!

There's a serious academic side to Ivor Davies, isn't there? I mean, plainly it's there on your CV, you made your living as an art historian, but you are interested in ideas, and in articulating ideas, not just painting them, but also articulating them, and arguing.

I was an academic, I think, because of not having the answers given to me in art college, if I had the answers given me I wouldn't have bothered to do any art history, I wouldn't have worried about it, but in our college Philip Barlow gave an extra-mural course of evening lectures in art history. In those days there were only black-and-white slides, so we had Monet in black and white, but I learnt a lot from that.

Black and white slides?

Yes. When I started lecturing, they were black and white. We used to send to the V&A for them, glass slides about three inches by three inches would come in a heavy box.

This is astonishing, isn't it? This sounds like the Ark.

Yes. Some of the architectural ones were superb. Later on I realised that Edinburgh had slides by Alinari of the Uffizi in Florence without any traffic, with people standing in front of a horse and cart. They were thrown out when they got colour slides in. They were invaluable objects by then. But they were the slides I would see, so any discussion of Seurat was without any colour at all, they were all black and white slides, and Claude Monet in black and white, but it was enough. And there were also Skira Books. They were some of the few publications which had very over glossy reproductions of modern art, and used to go to the library and look at these. I think it was probably David Tinker, later on, who introduced me to the paintings of Paul Klee and to the idea of combining writing with painting later on. And I did one or two texts like that. But in art college, I had expected the world of adult art or adult education, the world of grown ups, to be carefully run, and carefully organised, and everybody doing it, but they were a bit haphazard.

And in any case, what you learned about was European art, there wasn't a sense of art being something that Wales had grown itself, because I suppose it hadn't grown that much, had it? Peter Lord, as you say, is trying to fill those gaps for us now, but you couldn't have known anything of a Welsh tradition at that stage.

I think it's the same with all British art, unfortunately. The tradition of British art in general is relatively recent – for example, I went to see an exhibition of the art of the Plantagenet era at the Royal Academy several years ago. They really had to scrape around to get some good stuff, although there were some manuscripts and the Mappa Mundi and so on. But when you think about Italy, France and Germany there is no comparison. I remember those talks by Pevsner after the war, in the Fifties, called 'The Englishness of English Art'. It gave more confidence to English people about art, that they had it, it wasn't foreign stuff. But the whole concept of art is foreign to the English language, and it wasn't until the eighteenth century that the English really began to adopt cultural and artistic nomenclatures, you know; and then, in the early nineteenth century, the term 'avant-garde' was coined after the French revolution, to describe the advanced art that would break through; and of course the concept of the avant-garde was totally foreign anyway, in Britain. Painting, state painting and sculpture, was a way of recording people, essentially.

Yes, I suppose it was.

It was originally an adjunct of a religious need, the need of the church, and then it became secularised into the recording of people, and then of those peoples' possessions, horses and whatever. It's only relatively recent in what

we would call the standard of Western civilisation, that art as painting as a thing of value as itself, has come into being. That's quite radical, you make marks on canvas with pigment, water-colour or whatever, and that in itself, the marks are interesting.

Let's talk about your other life, in a sense. Your professional life has been, really, as an art historian, and through a set of happy accidents, you find yourself in a major university in Edinburgh, and then have the time and the encouragement to do a PhD. Why was that on Russian art? And do you regret that? Should it have been on Welsh art? Would that have been acceptable at that time, we're talking about the Seventies now, aren't we?

Yes, I began it in the Sixties. I suppose I could have written on anything I liked. I think it's connected to the fact that when I was in art school there was very little about the history of art. There was a very small number of publications relative to the big boom of the Sixties, and I used to go to the Central Library in Cardiff, and there were the Skira books which I could consult. And in the library when I went to art college, I could find a few more, and the disappointment I had in not being able to be provided with any art history in art college caused me to look elsewhere for art history. So I was craving to find out all these things; I attended extramural classes. Then when I came back from Switzerland, I didn't have any money, I was selling *Encyclopaedia Britannica*, and I bumped into a man whose psychology classes I attended, a very interesting man called Frederick Salter, and I'd gone to his class when I was in college. And he said, "Why are you doing this?" and I told him I was just trying to make some money. "Look, we'll get a group together, and you come and teach us with WEA, Workers Education; you'll have to contact the WEA."

So I contacted the University extramural department, and I started to teach this group of his friends. I taught them art history, because I'd been to Lausanne for two years, and I'd attended art history lectures, very serious and a very extensive range of study – a whole year on Courbet and a whole year on Cézanne, for example, and that was mostly bibliography. I'd got some clue now as to what art historical method was. So I started to teach the history of the modern period, but maybe going back a bit too far into the nineteenth century, trying to delve into the roots of these things. I kept having to get more and more people to come to the class, you know, as the winter came on, but they were a wonderfully interesting group of people. I remember a dentist called Goodman in Whitchurch, and he had a specialist knowledge of Hieronymous Bosch

You came back, and you felt a bit more European, and you felt more rounded; you had a few clues about this.

Indeed. And then I applied to Edinburgh University for the post of assistant lecturer, in the history of art in the modern period. I was naïve. But I was invited to be interviewed, to my surprise, and they'd all gone home when I got there, they had to recall the committee, because my real reason

for going to Edinburgh was partly that I could look at the galleries, the museums there and in Glasgow. I'd gone to see a friend in Doncaster along the way, and so I went to Glasgow first. I looked at the museums there, then I stayed overnight, looked at the museums in Edinburgh and then I went to the interview. And indeed they asked me about the museums, and I was so successful in discussing my favourite paintings there.

Because you were excited about what you had just seen anyway! You had done your homework.

Exactly. So they appointed me, over the head of a lot of people who had done degrees and so on. It was a fluke, really. Maybe I shouldn't have been the person to get the job, when I think about it, people who had done post-graduate degrees, and knew things, knew more about art historical method at that time than I did. But anyway, I didn't really want the job, and I said to the Dean, "Will I able to get out of this within a year?" He said, "You'll never get a better job than this again." And being there for a period of time as an assistant was great, I really enjoyed it, I was tremendously confident. Then suddenly my confidence collapsed when I realised I had to go through a sort of bar to be a lecturer, a full lecturer, that was the career, full lecturer, and the wind was taken out of my sails. I did get through it, but I began to get an inferiority complex about not having an academic degree like all the others, so I thought I'd better do a Ph.D.

So you were giving classes on Russian art? And this had been an interest of yours.

The classes I was giving were meant to be called 'Sources of the Modern Movements', which was the whole of the twentieth century, and late nineteenth century, right up to Pop Art, which was the latest movement in those days.

Of which you became a kind of part, in a sense, of the Sixties, with the destructive, explosive end of that.

Well I was doing that as well, you see, before doing this PhD. I gave up the destructive art and did a PhD. instead. But I wanted to do it on some subject which was unobtainable, you know, and in those days Russian art was difficult to see. I sat these exams, my colleagues were kind to me and let me through, and then I went to Russia for four months on my own, in 1968.

But you don't speak Russian?

I didn't speak it when I went there, but when you get hungry, you do! But I did study a bit of Russian for Scientists, so I knew all about what sulphur was in Russian and all that, but that was the only course that was suitable for me at the university. And this period in Russia was fascinating, because you realised what blatant lies we were told, and were written about Russia, and the things that were really wrong with Russia didn't get reported.

They didn't have to tell lies, because the Russian system was a failed one, and re-patched up anyway.

Well, this is what they tell us now. But at that time, I lost my spectacles in Leningrad, and I did the eye test in a clinic. I could read and speak some

Russian, but I couldn't name the alphabet. Anyway, they made me a perfect pair of spectacles and, on the National Health, and they reached me a week later in Moscow. So there was nothing wrong with their National Health Service, at least nothing wrong with it that wasn't wrong with our National Health Service. The communism wasn't just the politics, it was an infrastructure, which would be for us like the National Health. The road systems, the sewerage, education, everything, was held up by this system of communism which was actually based on the idea of equal opportunities for everybody.

Just like Blair's Britain, of course.

Yes, in a way, but I don't really believe in equal opportunities.

You don't?

What it led to in Russia was inequality, because some people are better at getting on than others.

Surely equal opportunity is fine. Equal results is impossible. There has to be the gold medal winner, the Oxbridge First, there has to be that, we're not all going to get those.

But I don't really agree with equal opportunities. It leads to competition, in a way, and in a political world, I don't believe in competition. I believe in co-operation and the sort of collectivism that you had in China, where people worked together. I don't believe in it purely, exclusively; you can't believe purely in something because competition does take place, people do compete, and some people are better than others, and they will come out of it. But in Russia I did notice that it did lead to inequality. Inequalities were already there, there were people there who spoke the Russian of the aristocrats, influenced by French, and there were peasants, who were totally different. There was an intelligentsia which was sometimes snobbish. However, I liked and admired the Russian people, their warmth and their soul.

But that time when you went there, there was surely a distinct absence of interesting art? Art was interesting for the first twenty-five years of this century in Russia, and less so once this great communist motherhood system came into being.

To some extent, yes. During the first twenty-five years of this century, there was a lot of interesting art going on, but it was a kind of minority art. It was the first time that it had been made official, Russia was the first place to actually make abstract and experimental art official.

In the sense that it was in the public galleries?

Well, not only that, they reformed all the schools and appointed these artists as the professors. But then, the majority of artists were not avant-garde, the majority were anything but experimental. Maybe they were thinking back to the nineteenth century, some of them, the mid-nineteenth century, rather, what they call 'The Travellers', who were taking radical realism all over Russia, because realism was radical then. There was a message, and the message was more important than the niceties of paint. And this is what

was revived, to some extent, in the early Twenties in Russia. It's not black-and-white, they were there all the time. And of course, coming back from the front they increased the number of old-guard artists.

How could you know in a Cold War situation what was going on there? Were you surprised, by the vibrancy? Was there, despite the communist system, a sense of individual flair?

Oh yes there was, a tremendous number of interesting artists, but the difference between Russia and Western Europe is that artists were then, not now, respected as professionals, the same as poets were.

We've got that in common, then, nobody takes any notice of either of us!

I wouldn't put it that way, but in Russia you, for example, as a poet would have been paid a salary. I met poets, they could recite the whole of Robert Burns to me, in Russian, and they were marvellous poets. Artists, too, they were paid, but then the idea was you had to paint a certain amount which was public consumption, which they could use, maybe as posters if you were into that sort of thing, or which people would enjoy, common people. But I found Russians much more cultivated than anybody I'd met, say in Western Europe, with regard to experimental art, the art of the experimental period, the poetry. I met atomic scientists in Germany who could recite the poetry of some of the Russian symbolist poets of the beginning of the century and who were followers of Rimbaud. I don't know how many scientists here could recite Rimbaud. But you see, Russia wasn't quite what it was painted in the West, and they said they're all overweight and all that – it wasn't true, they were handsome people, not like social realism heroes either, real bon viveurs.

So the Russian experience you then brought back to Scotland, and then ultimately to Wales. Was that a matter of encouragement in what would appear, what we were told was the most unhealthy context for individual flair and experimentation and so on; if that could happen in Russia, then why the hell couldn't it happen in Wales, where there didn't appear to be any official acknowledgement of imagination or vibrancy of art anyway?

There were some parallels, really, between Wales then and Russia in the nineteenth century. In the early nineteenth century, the Russian language had no status. I mean, the French language had status, the aristocracy tried to speak French to one another, and they used French words. You read Russian novels and you see the parody of using French words in certain contexts. It was the novelists that really brought the status, I think, to a great extent, as well as great poets like Pushkin, of course.

But Wales didn't have that either, did it? There were no great nineteenth century Welsh novels, and there were no great nineteenth century Welsh poets, were there?

There were a lot of Welsh poets in the nineteenth century, but Wales did have respect for its language. What I mean to say was the status of the language itself in Russia was very low, and the status of Welsh was low until relatively recent times. I remember someone in Edinburgh saying that the

IVOR DAVIES

Welsh language could die out – it was the first time it had ever occurred to me, in the Sixties, that this was possible. I thought, how can it? It then became a reality, and it then became something, the nature of the Welsh language was different, in the eyes of a lot of people.

So then you got involved in political work. Certainly your art reflected the issues of the Sixties and the Seventies, particularly the politicised issues of language and territory and the drowning of the valleys and so on, but earlier than that, you'd started off by being quite international, hadn't you? Destructive art, meeting with Yoko Ono – you couldn't get more trendy and international than that in the Sixties, could you?

I'd met people who are perhaps more, directly influential on me, like Marcel Duchamp, for example. I spent two afternoons talking with him, which was very interesting. And I met Man Ray, not for very long, for about an hour or so, and Victor Vasarely and Sonia Delaunay, totally different sorts of artist. But the presence of those sorts of artists, who were like modern great masters, were certainly influential. Of course, I did work with a lot of artists during that Destruction in Art symposium, which only lasted a week, which included Yoko Ono, who stayed on in London then. I was certainly the first person to systematically use explosives in art, destroying things, this was before I wrote my thesis.

You'd been at the cutting edge of a kind of transatlantic experimentation, and then when you had the chance, to undertake serious academic work, you went off in almost the completely opposite direction, geographically to Russia. Presumably, you were attracted by the cutting edge art of the beginning of the century there?

Yes. I didn't make it easy for myself because I didn't know Russian when I started it, and it was inaccessible and difficult to do research. Britain made it difficult to go to Russia at that time.

You were probably bugged while you were there, and they kept an eye on you.

Well everybody said that. Sometimes it got so lonely that I hoped somebody was! Nevertheless, it was a wonderful experience, and yes, it was difficult to see the works there. I failed to gain access to a lot of work, to see it, but it's come out since.

And we know that they have all sorts of treasures that they had looted from the Nazis, who had looted them from other people, an enormous back catalogue of great western European art that they had secreted.

The Hermitage Museum – I probably spent almost a solid week just walking around looking at the most wonderful collection of European art.

So when you came back to Wales at the end of the Seventies, you come back with a rich map of art, a rich set of experiences; the people you've met, going from that transatlantic cutting edge experimental art, thorough to serious academic research in, and about, Russia. You came back to Wales with a heightened sense of a political moment in Wales, and you get immediately involved in Beca and other artists who are concerned with the matter of Wales. Not simply with

Destruction in Art event installation work, Edinburgh 1966

personal expression, but feeling that they have a duty to who they are and their community.

There weren't many then, though. It was just the Davieses, really, and later Tim Davies. But I never really came back to Wales, and I never really left Wales, you see, because I used to come and see my parents during the vacations, especially the long vacations, some of the times during that five years I used to write up my thesis, at home, in their house, and I never left it, you see. And my international activities are still just about as extensive as they were at any other time. I travel to see as many important exhibitions as I can, in Paris particularly. I try to keep up with history, art history.

Art History has been an important aspect of your work, hasn't it?

There isn't a strong British tradition in thinking about art, but it has been political. I went to a private view of an exhibition of late Celtic metalwork, in 1989 at the British Museum – the catalogue included a message from Margaret Thatcher! I could hear this terrible outbreak of competitive discussion, or rowing, about the origination of some of the things. The Irish were suddenly being told that it was really the Saxons who had done this manuscript, it wasn't the Irish. There was, of course, a good deal of dispute about it. Nobody knows, really, but there's no doubt that it derived mainly from Ireland, and there it is again, the political. The British Museum is particularly political in its attitude.

And at that time, perhaps, that was a particularly charged thing anyway.

To some extent, but I think it always has been and always will be. It's almost impossible to say for certain if a manuscript is by an Anglo-Saxon

who learned how to paint from somebody in Ireland. Or an Englishman. It's the trend I'm interested in, and it's predominantly Celtic, until later, then there were continental influences.

But you said, I'll quote you again, "We discover our life as part of an historical sequence and archaeological strata". Your art, your painting and the other things that you've done, seem to be particularly politicised, very consciously part of something. Your involvement in the Eighties with Paul Davies, the Tryweryn protests, later paintings which deal with that, and so on, they were a personal expression, but you want to get involved in public issues. You want the politicised, you want to work within the political arena, don't you?

Yes I do, for several reasons. First of all, because I want to influence politics in that direction myself.

How can a painting influence politics? How can art influence politics?

It's a good question, if I wanted to go entirely in that direction, I ought to be doing posters, or working on the Internet.

But what would you do, the battles have been won. The battle for the Welsh language has been won, the battle for a sense of confidence and self-regarding Wales, these are battles of the Sixties and Seventies and prior to that, but they've been won, haven't they? You can't be an angry young man still, surely? There's nothing to be angry about.

The Welsh language battle has not been won yet. It still needs to be fought. I think it was a Spaniard who pointed out to me that tourism creates poverty. Huge numbers of well-off English people settle in Wales, create a second economy, a second community, they don't want to have anything to do with Welsh culture, which most of them despise. In some cases they have forbidden their employees to speak Welsh to one another. It sets up the price of the houses, local people are poor, so this battle still has to be fought, I think.

How do the visual arts pertain to that? Some of your paintings have specifically celebrated or, at the very least, remembranced, acts of protest, historical protest.

These are historical, these are people. I wanted to celebrate, in a number of pictures, people to whom you don't find figurative monuments in the middle of towns, like you find statues of people like Winston Churchill and Oliver Cromwell in front of the House of Commons. Well, when you think of their record of destruction, it's considerably more than somebody like John Jenkins.

Winston preserved Western civilisation.

He did a lot of damage, too.

Can't make an omelette without breaking eggs.

Perhaps that is what I am trying to say. So I'd like to put up statues to these people who've broken a few eggs, though on a much smaller scale. Funny, I use eggs to paint them with, too. And these are recent history. I don't want to be an antiquarian altogether. I like the combination of antiquity and modern, there's nothing new in that; Max Jacob, the poet, in Paris used to

combine ancient and modern imagery; it's rather exciting to have both as subjects. And there are a number of those who deserve to be remembered, I think. Whatever one thinks of them, they are part of a history that has been suppressed.

Only if someone writes the name down somewhere, uses the picture. In the studio at the moment, you've got a painting in progress, which again uses The Mabinogion, *and then just upstairs you've got a painting which has embodied in it a photograph of the most recent Welsh terrorist, I suppose one might characterise him, Sion Aubrey Roberts.*

Well, yes. He's a part of the struggle. What the Nazis called the 'terrorists' the Allies called the 'Resistance'. If you could list the number of people who've suffered imprisonment for Welsh causes, whatever they did, I think there could be a very interesting gallery of paintings. I've never thought of painting them systematically. I've painted certain ones which have drawn my attention, but there are a number of others.

Perhaps that's a project for you, or would that just be too schematic and too crude to say "Right, I'm going to do, from the Second World War to now, I'm going to have a gallery of heroes, rogues, whatever"?

I'd like to do that, eventually. Maybe have an exhibition of portraits of Welsh people.

Welsh activists. Welsh 'terrorists'.

Well, not necessarily people who have done anything, or have been in prison. Ideological interest are involved in constructing the past by both sides.

People who are part of the making of Wales.

Yes. It's an interesting thing, I think, to do. I think all painting is political, actually. We don't live in a vacuum, immune from the State – state censorship, state counter-subversion – we belong to a community even if it's a global village. Even when trying to be oneself, a painter speaks for the community. Everything.

Even the still life with – and you've done, you've a lovely set of oranges – in fact, there is a collection of oranges on the table out there, so this is an ongoing thing – even that's political?

Yes, I think so. I think it's political.

How can a Cézanne be political?

A good question.

How can a bowl of fruit be political?

Oh, easily. In the way it's painted, it's partly political. And the subject matter.

It's very polemical, certainly, I suppose, the method of painting, the method of construction, not as in one of your recent works, where you're actually pressing a photograph of an activist into the surface of the oil that you're using. But the brush stroke could be a gesture, polemical at least, if not directly. We're talking about an argument, the brush could be argumentative, couldn't it?

Absolutely. But more than that, the symbols in it are also political very often. There was an exhibition, the catalogue of which proved extremely

unpopular in London because it sought a political element in Claude Monet's subjects, of the haystacks and the poplars, as being symbols of France, at a time when France had been recently unified. Also at first I was sceptical about that, but the more I read that, the more I became convinced, because a number of scholars in, particularly, Chicago, in the 1990s, have been getting together and analysing paintings from a sociological and political point of view. Particularly English watercolourists, for example. I'd draw your attention to books by Paul Hayes Tucker and W.J.T. Mitchell on Monet and Landscape respectively.

That seems anathema, doesn't it, at first sight?

It does at first sight, but when you think that the Duke of Cumberland employed one or two on his campaigns, for Scotland, to draw up the landscape very precisely, they went with map makers, and the map makers' duty was to actually get a real picture of reconnaissance. Paul Sandby, of course, was one. Landscape is very political, ever since then.

Because landscape is always distorted. I mean, all painting is distortion. When we look at a painting, it's not what we would see looking at the oranges out there. Your painting of the oranges is not going to be my perception of the orange, and when you get to landscape, it is political, the way the landscape of Wales has been used. What Peter Lord has done, looking at the Builth Wells group is to say that our country, Wales, is, like many other countries, subject to usage and abusage by visitors. Not just in buying the cottages, actually coming and looking at it, taking something away, taking a distortion away, they're affecting what they leave behind. There's a lot of valuable work in that sense, but every painter; J.D. Innes, Augustus John, in what they were doing in the teens of the last century, changes Wales. Peter Prendergast, I think he's changing Wales in the way that he paints it. Catrin Williams has a version of Wales, which is clearly acceptable to a lot of people. You don't do landscapes in quite that way, do you? Your paintings would tend to be more timeless, more myth specific.

Yes, but I've also done a lot of straight landscapes, a lot of landscapes of places as well, everywhere. I was doing some last autumn, for example, in Mid Wales.

But that isn't enough. You want to go back, you want to create a Wales that is peopled by everyone from Lleu, through to your recently-released so-called terrorist.

Yes, but I feel as though I'm not really saying quite what I want to say, both in my paintings and in the interview, as though there is some point which I can't quite reach. When you paint, you might start to bring in something of mythology, you might start to bring in something of recent politics, and something of something else, yet in a way it's all in the paint, it's all in the actual paint anyway, and if people are not the least bit interested in the history, the mythology, or in the politics, they can be interested in the paint. It's enough.

You don't mind if they don't get it? Because that was where my question was leading. When you want to affect change, when you want to address a nation's

identity, which we've agreed is something we make up as we go along, and we have to make up, if we're serious about it, as we go along, you don't care if people don't get all the mythological references, don't get the recent political references.
Well, I don't have any choice, really, because it's like the poetry of Dafydd ap Gwilym, Shakespeare or Victor Hugo, for example. People have been reading it for centuries without fully understanding it. Or the poetry of Baudelaire, or Shakespeare. Businessmen haven't got the time to sit down and really read the critical texts about these poets. They enjoy it, and we don't know why they enjoy it, so it's the same with paintings, if we are to be realistic.

People in 'the real world' are attracted by Shakespeare because it is about power. I mean, there are many plays that are about love, and about power. Everyone's interested in love and power.
Yes, that's true.

They may not be specifically interested in Wales, but I mean, do you follow up the purchases of your paintings? Are there occasions when you think a painting's gone to that person but I'm not quite sure they know what they're getting, what they're taking home with them.
Most of them do, most of them really know. But you see, even if they didn't know, I'd sort of tell them. If they weren't interested, then I wouldn't hammer it into them. You don't really have the choice, in the end. If someone is just not at all interested in history and not at all interested in modern Welsh issues.

But they're interested in the figuration, without really understanding the significance, so be it.
In the mid-century certain Russian painters were only interested in the message and did not care about the qualities of painting, glazes and impastoes. We can't have everything. We can't convert the world. We can't change the world really, but I think that if there is an element of these sorts that I've put into the paintings; mythology, politics, history, surrealistic juxtaposition, a general feeling comes out of it. It's the same as Baudelaire's remark about Delacroix's paintings that even at a great distance you get the spirit of the painting from the forms. Something goes into it which hits you, and you don't know quite what it is. So somebody who isn't the least bit interested in these things will see the painting, and they'll get this curious sensation.

And of course, they're going to live with it. The thing about, you know, you buy a book, you read it, you may read it again, but when you take a painting, I always feel when I acquire a work of art, I'm kind of getting into bed with it, I'm taking it home, my home is very important, I'm surrounded by things, and what I'm surrounded by, most of the time, doesn't affect me on a day-to-day basis. But every now and again, when I move things around. When I was ill recently, and went back to my home, I discovered what I had there again. I think a painting isn't for Christmas, it's for life. There's an obligation, to look after it in the physical sense, and to keep looking at it, to open yourself up to it. So buying pictures

Alfred Janes: Two Lobsters
oil on board, 39 x 59.5 cm, 1937, private collection

Alfred Janes: Rude Breath
oil on board, 95 x 116 cm, 1960/1988, private collection

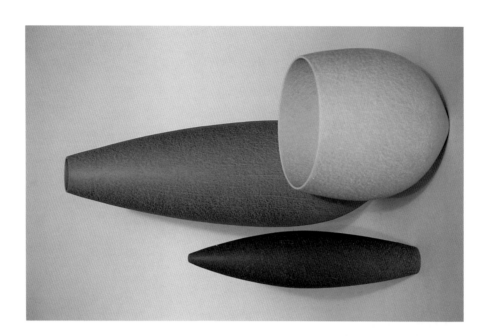

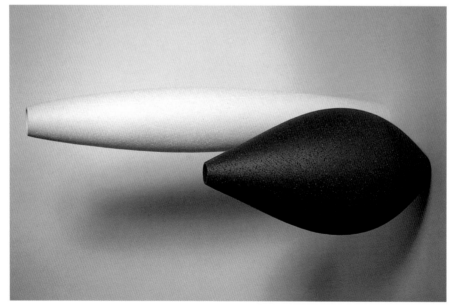

Christine Jones: Vessels
grey blue earthenware height 48 cm diameter 16 cm
dark blue earthenware height 33 cm diameter 9 cm
ice pink earthenware height 21 cm diameter 20 cm
white earthenware height 66 cm diameter 15 cm
black earthenware height 40 cm diameter 24cm

Terry Setch: Nice beach Penarth beach (panel two)
mixed media, two panels, each 305 x 183 cm, 1999, artist's collection

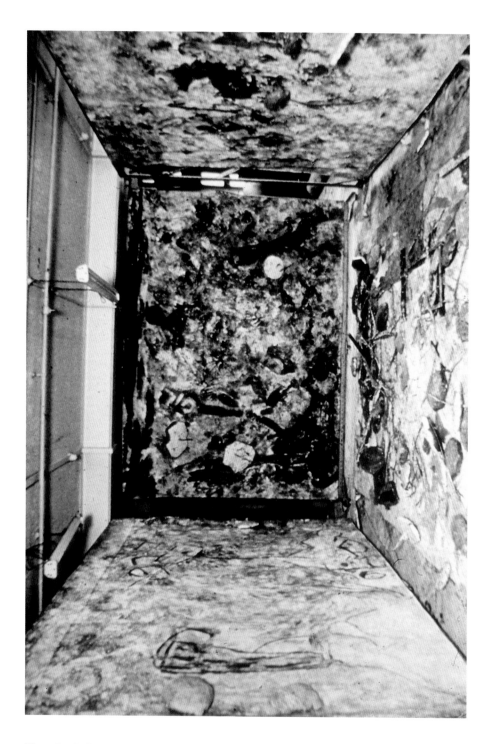

Terry Setch: Penarth beach car wreck
mixed media, studio installation, 1979, artist's collection

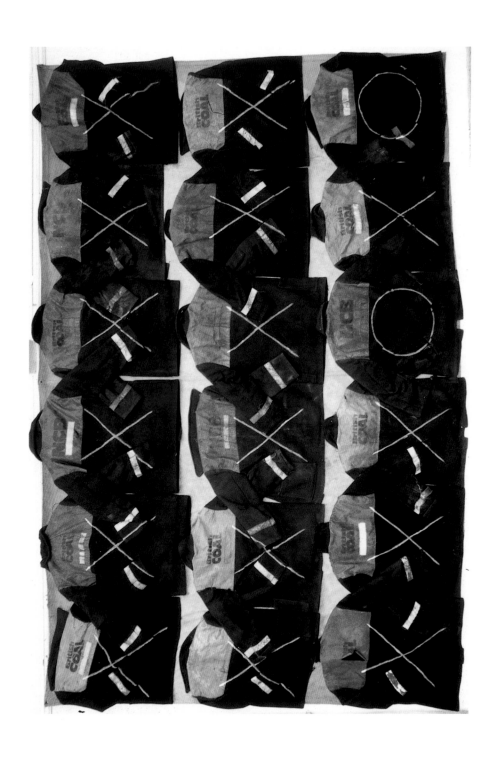

David Garner: Political Games 1
industrial jackets, oil paint, tarpaulin, 480 x 240 cm, 1995, artist's collection

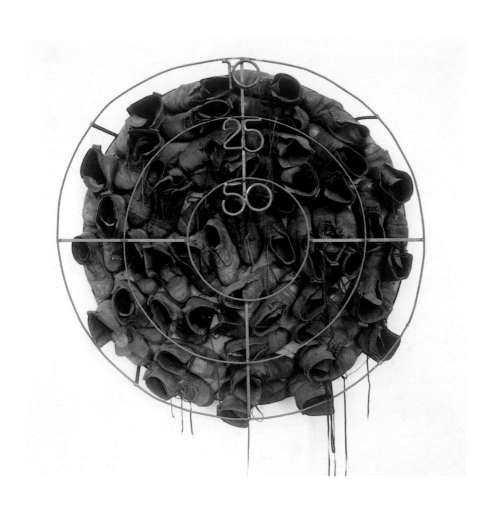

David Garner: Political Games 2
industrial boots, steel, wood, 152 x 152 x 30 cm, 1995, artist's collection

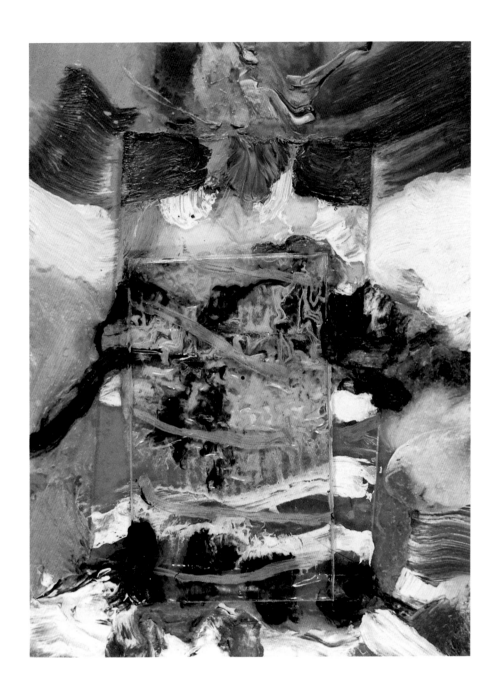

Brendan Stuart Burns: Blur – Blend – Rush
oil, wax and perspex on board, 21 x 17 cm, 2000, private collection

Brendan Stuart Burns: Green Grey
oil, wax and perspex on board, 16 x 37 cm, 2000, private collection

Robert Harding: King Dick Doorstop
chrome steel, height 14 cm, 1999, artist's collection

Robert Harding: Tree Ring
2p coins and ash tree, height 36 cm, 1997, artist's collection

Ivor Davies: Caethiant
tempera, oil, oilgesso on hessian, 127 x 86 cm, 2000, private collection

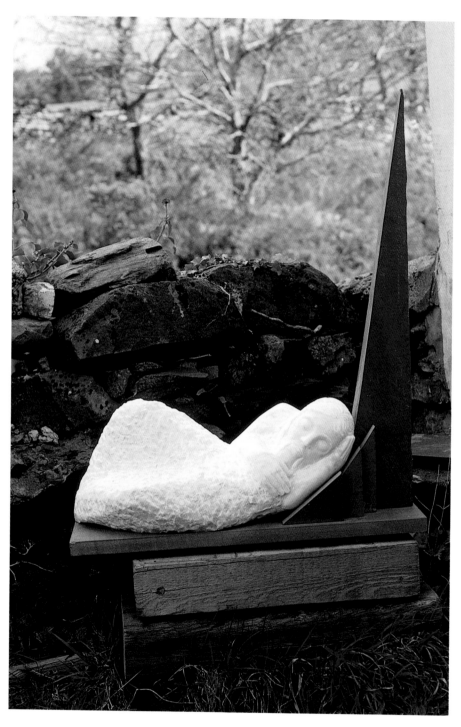

Jonah Jones: Jacob at Peniel
Carrara marble, Aberllefeni slate, 56 cm high, 1979, collection: Naomi Jones

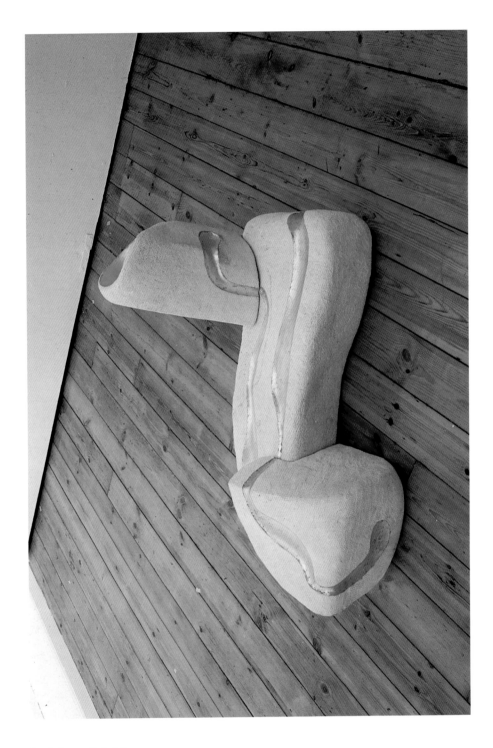

Jonah Jones: Bethel II
Portland stone and gilt, 30 cm high, 1979, collection: David Townsend Jones

David Nash: Wooden Boulder
Vale of Ffestiniog, 1978

Lois Williams: Red
used object, felt, embroidery cotton, 259 x 50 x 55 cm, 1995, author's collection

is a very important thing, it's not just a decorative. I know a lot of art is being shifted, to put it crudely, in Cardiff at the moment, in a corporate sense. People are decorating their offices, and their homes. Paintings are status symbols after all, aren't they?

For me paintings are the embodiment of ideas, and the embodiment of applied philosophy in a way. So I wouldn't even necessarily have a painting on a wall, so long as I had it, and the actual process of producing a painting is so complex. It's an avoidance of clichés, it's an avoidance of the obvious, it's trying to make things gradually emerge and be discovered. It isn't something that comes all of a piece. The imagination doesn't have any real, physical substance in reality, there's no translating of a kind of idea in the mind onto a canvas. Something mysterious happens between the material of the paint and one's pushing it in a direction where one wants it to go. It's impossible to articulate, why and how the painting arrives.

Is each one – it sounds almost clichéd and I hesitate upon saying this – but is each work, or sequence of work, an act of discovery? If you knew where you were going, you probably wouldn't go there, there's no need to go there.

That's right. The biggest luxury is like what I did with 'Caethiwed', I did that in ninety-one. I tried to make an exact copy of it for this exhibition in Llantarnam Grange recently, and it was extremely difficult, but it's a kind of luxury to have done something and to do a second one of it, knowing that I have a ready-made thing, beyond which you can explore new territory. But each painting ought to be different from the last. It doesn't go down too well, perhaps, with collectors, who like consistency.

Yes. Your career as an artist so far, and it's only mid-way, has been all over the place. What was this destruction-in-art thing you got involved with in the Sixties? That sounds like a contradiction of terms, art being, after all, a way of preserving things.

I don't know if I showed you the things I did in the late Fifties, early Sixties, of great areas of oil, gesso, plaster, and paint, with a process of disintegration on them, which were inspired partly by visits to Sicily and Italy and observing the stones in the villages there, and also by artists at the time, in the late Fifties, like Tapies and other Catalan artists, there were a number of Italian artists too – Burri, Crippioto – they were not really that well know, at the time the American abstract expressionists were so well known. I was more sceptical of American art, and much more attracted to this European art with those great massive surfaces and textures. This is what I was doing then, and it had this element of destructiveness and even before then in the earlier Fifties, the mid-Fifties, I was doing paintings of cities disintegrating. In the early Sixties Jean Tinguely was destroying machines in performances in America, and I also met a very interesting artist called Gustav Metzner. A former student of mine, and friend, called Peter Halliday, suggested a small symposium in his college in Ravensborne, so he, Gustav and I, and a number of other people, read papers about a destructive performance.

Disintegrating oil and metal on hardboard, 91 x 60 cm, 1955–56, artist's collection

Gustav had painted on nylon with acid. I was using explosives to transform objects, and very controlled explosions, so that one part would go off, and another part would blow off, and so on. Gustav had the idea of extending this to an international destruction in art symposium, which we did in nineteen sixty-six. It lasted a week, and it was not written up by any critic, or in a book. The press covered it a lot, because it was sensational, but it wasn't taken that seriously until relatively recently. In the 1980s when people started writing PhD's, one in America, one in Belgium, about it, and being fascinated by this Sixties phenomenon which they now see as the epitome of the Sixties opposition to Uncle Sam's Superman, Coca-Cola culture, which extended all over the world.

But even the American artists in the Sixties were reacting against that. I mean, Warhol's multiples and repetitions, the Campbells cans, the newness, images of Marilyn and so on, which have now been assimilated onto every students' wall by posters again.

That's interesting, too, and pop art is fascinating. But pop art was really, it's been proved since, but I was saying so at the time, it was really a government art. It was sponsored by a political element in America.

I thought the argument was that abstract expressionism had been supported by the CIA, as a purely American reaction to state art, communism's art.

That has been proved, yes. But the representations of America in, for example, the Venice Biennale was with Pop Art, and of course, the number of American pop artists who dreamt of the stars and stripes before painting them, I can't remember altogether now how many, but certainly

IVOR DAVIES

Jasper Johns was one, and Tom Wesselmann.

Johns' 'Stars and Stripes' is very anti-authoritarian, isn't it. It's almost sacrilegious, isn't it?

If it had been against the state, it wouldn't have been exhibited so internationally and it may not have been allowed to be shown. It wasn't burning the flag as much as promoting an America which was far more liberal.

Isn't it rather like Jimi Hendrix playing 'The Star Spangled Banner' in a distorted, feedback, electric-guitar way? Johns' flag is a bit like that, isn't it? Perhaps they didn't understand what he was doing, perhaps they didn't get it. That's what's marvellous – you can be subversive, and in the galleries, perhaps, at the same point in history.

There are a number of other American things like the 'Great American Nude' by Wesselmann, where you get this very flattened out, pop-art, faintly pornographic nude, the American stars and stripes are in it somewhere, you get a lot of pop art with stars and stripes on. I mean, if it had really been anti-American, the Americans would not have exhibited it in the Biennale, or promoted it the way they did. It was the social realism of America, of an America which was colonising culturally and economically. The biggest colonisation, of course, is through radio, television and Coca-Cola, that sort of kitsch culture, but this was a more...

So, in the broad intellectual spectrum of Wales, why should we be so self-conscious about making up Wales, when the Americans have spent all this century not only doing it, but selling it to the rest of us.

That is a very good point. It's purely economic. The Americans have had, and still have, more money and independence than Wales. They've colonised the most remote parts of the Pacific with Coca-Cola, and hamburgers, and so on, and radio stations, and GIs, and goodness knows what. But Wales has been in the position of one of those Pacific islands that's had the Coca-Cola and hasn't had the power to do anything; people have been too busy earning a living, scraping a living or not scraping a living to buy a work of art.

But since the war, with the establishment of a Welsh Arts Council, the importance of culture, in its broadest sense, high culture, arts, low culture, sport, entertainment, Wales is finding its feet, isn't it? There's room for us, because there's such a broad spectrum, there's so many radio channels, there's so many TV channels, so many galleries now, there's room for us. It's a good time, isn't it?

It's a good time now, quite a good time. But the Welsh Arts Council, when Peter Jones was first there, was copied and admired by all the other arts councils in Britain. But it only supported a few artists, none of whom were Welsh, it never really did any serious research into what Welsh artists were doing, or who they really were, it had to be, everything had to be in Wales, it mustn't be Welsh. Anything that's in Wales is always suspect, I notice, because it denies the existence of Welsh, like the Wales Tourist Board, so the Welsh Arts Council really, failed in its efforts, I think.

Perhaps it wasn't its effort, perhaps as you say the wrong people were there, the wrong notions were there. But again, although in a sense you've rowed your own course as an individualistic artist, someone who deals with paint, who would be involved in events, the explosives, who has made objects, who has made paintings that are not just paintings but also objects – I'm thinking particularly of 'History Curriculum' – although you've struck out your own course, you're also a joiner, you're very much involved with Beca, you've put your canvas where your mouth is, really. Can we talk about Beca, and the importance of that?

Well, I think that's very important, that's one of the most important things in Welsh art, and I think Paul Davies, whose sad, premature death in his forties, was, and still is, the most radical artist, maybe in Britain, certainly in Wales, no question about that, because to be radical, it means going to the root of things, it means doing an art which is disgusting, in the original sense, that is not in the taste of the particular time. The taste of the time when Paul Davies and his brother Peter Davies started this effort in the late Seventies, was certainly not Welsh subjects. That was like a joke in art. English jokes about the Irish, you notice, have died out now, because the Irish have considerable prosperity. Nobody jokes about Jews any more, because of the terrible things that happened, but people were still joking about the Welsh, and still are joking about the Welsh, in the nineteen-seventies, and Welsh art – there would be a nervous laugh, because there was a mixture of a deep-rooted racism, and a self-consciousness about something which was hidden, which hadn't come out in any way. Paul Davies deliberately, and his brother Peter – who was an ideas person, Paul was an activist, perhaps more than his brother – worked on the subjects which were Welsh. Peter Davies had been all over the world, it was he who introduced the *Chicago Who* exhibition; weird, weird paintings from Chicago. He'd seen a lot of stuff all over the world, and he was open to many influences. This hit me first when I went to the Eisteddfod in Wrexham, and saw Paul doing this performance, which I wrote up immediately in *Link*. I realised then that he was a real presence.

And you'd just come back to Wales in 1978 anyway, from Edinburgh, so that was a very pertinent moment for you to realise that something exciting was going on in Wales. Had you been aware of that from Edinburgh? Edinburgh being one of the major provincial cities – provincial in the best sense – national capitals, perhaps in Europe. Were you aware of what was happening back in Wales? You were visiting family, obviously.

Oh yes, I knew quite a lot of what was happening, because I used to come here, to the Eisteddfod. Because that was something very unusual, out of the ordinary, at the time, because the Arts Council had its own internationalistic kind of performance, which was tame compared with Paul's. I was determined, seeing this, to support him, because I thought who else will, at that time, and so I wrote, I was editor of *Link* for two years, and did a lot of things which some people didn't like at all, published absolute-

ly everything. I didn't censor it. I actually supported him in further copies of the magazine, because I felt that this work was living history, valuable elements of history which must be recorded.

I suppose most of us think of Paul Davies as the man who did the map of Wales using rubbish, mud, and paint, and I suppose that's pretty radical, in a sense. It's still radical, for a lot of people. It's still quite offensive, perhaps, for some people. Including the Wales Tourist Board, perhaps.

Exactly. Paul and I used to argue a lot about politics, and it seemed to me that a lot of his ideas about politics weren't that radical, but there was something amazingly radical in his art and what it embodied. It was concentrated into the art. I think he was also radical because he didn't care about pleasing with his paint. He didn't care whether the paint was respectable or tidy. He'd trained as a sculptor at St. Martins, and he'd done a lot of things there. He was marginally involved in the destruction of art symposium, and he had a bit of that element about his work, and he was putting into reality many ideas which Peter, his brother, had talked about. And I said to him, after a bit, "The Beca group, that's just you and your brother, isn't it?" He said, "Yes", and I said, "I'd like to join that group". So he asked his brother, and I became a third Davies in that group.

Things weren't necessarily distinguished as individual works?

Both, you could do both, and I felt there was a certain kind of impetus, even release, in painting Beca pictures which we painted jointly, in some cases. I wish I'd painted jointly with him even more. I used to go up to Bangor, and stay there, and we'd work jointly on a piece sometimes, not very often. Other times he'd post unfinished works to me, and I'd post it back with alterations. It'd go back and forth, so you'd get this extraordinary anarchistic kind of, not that kind personality at all, but something jointly done like that, and I think that was a great release, in many ways, of artistic energy, of restraint. Of course, the self-censorship which goes on in painting, creating something, is enormous, I'm sure it's the same in writing, the self-censorship, you think to yourself "Well, now I mustn't paint this in order to please anybody, if it's going to be real". So I'd be careful not to please anybody. "I mustn't do this because so-and-so's done it, because he has done it already". There's a lot of self-censorship like that going on, I think. The biggest of all, of course, is you don't paint people wearing Welsh hats, but if you do if it works.

An entire exhibition of work, including some by Paul, was censored as being too political. Individual works by him such as 'Burning Cottage' were censored elsewhere in Wales. I remember Magritte's painting 'Nocturne', a picture of a picture of a burning cottage. It was, of course, not censored from that Belgian artist's exhibition at the Tate. But in the end censorship encourages that which it seeks to suppress.

Because you're playing with a cliché, of course. And that's Johns' 'Stars and Stripes', isn't it? The Welsh Mam.

Those things which are self-censorship were lifted in the Beca group. When Paul died, I think that his widow wanted the group to go on, but it couldn't go on in the same way, because in a sense he was Beca. What happens after he dies? Do you go on with Beca or not? Well, we decided yes, and so, by then Tim Davies had joined, and so had Pete Telfer. He called himself Bob Davies, actually, a pseudonym. It was a kind of a joke, you had to be called Davies to belong to this group. So we met once or twice, and decided to do a performance at the Eisteddfod. I proposed the idea of the Welsh alphabet in sound and materials. I thought of Beca then not so much then as a group but as a movement, because by then, everybody wanted to belong to it, and that means we'd have to get a treasurer, become an institution. Paul had done a hand-written newsletter and he suggested membership fees, which I opposed.

So it wasn't going to be a Welsh Group, or a Fifty-Six Group. Because the trouble is, the moment two people get together, you've got a committee, haven't you? Instead of a revolution, you've got a committee: it returns to its bourgeois roots again.

There's no other way, really. Because if there were, say thirty members of the Beca group in Wales, how do you do it? Do you put on an exhibition, just asking a few people, or all of them, or, how do you do it? There's no way out of it, so I thought the best way was to call it a movement, rather than a group, and everybody is a member in a way, if they want to be. Everybody is Beca. But I don't think this really caught on, because people like to be members and know where they stand; but in my mind, it became a movement, so that if a few people wanted to come up to the surface, and put on a performance at the Eisteddfod, or do something else under the name of Beca, that's it. They don't have to submit an idea to a committee.

They have to be called Davies, though! I wanted to talk about David Jones, you're interested in the various facets of him as an artist, as well as his desperate, and awkward, need to be Welsh.

I don't think his art has influenced me really, in any way that I can think of. Possibly his lettering. I think his greatest achievement was his inscriptions. I think he's a writer, a visual artist, and I think his inscriptions have got it all; they're intense, the lettering isn't derived from Eric Gill as a lot of people assume, if you look at it and compare the two, they're worlds apart. A lot of it is derived from some of the stones in Cardiff for example, and from that Romano-British lettering, which evolved.

He was taking the old and making it very new and very individualistic, wasn't he?

Yes, he was. And he was very much a person of his time in his writing, if you compare it to, say, T.S. Eliot, it's even more annotated, even more obscure, and even more intriguing; though I do like T.S. Eliot, and I think I feel that about my work a bit, that there are a lot of footnotes, but you don't have to read them. I think that his writing is fascinating in that way,

IVOR DAVIES

and I think to really understand David Jones, you've got to know the writing, you've got to know the inscriptions, and you've got to know the visual things. That's different from T.S. Eliot.

He's difficult. You can't pigeonhole Jones at all, can you? But he was driven by a sense of Welshness, which he had to opt into, but also there was this overwhelming Catholicism. Are you a religious person?

I'm lapsed, I suppose. From Welsh non-conformist, to Welsh non-conformist.

I mean, we're talking about mark-making, we're talking about painting, art, as a politicised activity, but there's an equally powerful argument, thesis, to be worked through, which says that art is almost always a celebration and partakes of a religious need in people.

I think it probably does.

But that fits easier, not only with the tradition of Catholicism, that Jones embraced, but Welsh conformity, which might be characterised as having a falsity of visual art.

Well, to me, the paucity comes in British culture generally, from the seventeenth century, in that respect.

Post-Cromwell? Knock it down, break it, smash it.

That's it. Because even now, you see, the British attitude towards art is like that, and the people I respect like William Morris, who are useful arts, you know, you see a William Morris exhibition and the V&A, and it's packed. It's the applied arts. There is a conservative nervousness which hampers the visual arts in Britain. There isn't a gallery in London, on the scale of any of the continental galleries. The Hayward Gallery is the biggest, admittedly, and the Royal Academy is domestic size. But you take the Grand Palais in Paris, for example, that's a huge place. I'm so bored of hearing of the Millennium Dome now, but one simple exhibition like that could have gone in there.

Peter Lord has shown that there is non-conformist art. One of my students at Newport did as well, John Harvey, who's now Professor at Aberystwyth, wrote a very good thesis which I did my best to encourage when he was there, on Welsh non-conformist art in the ninth century.

But David Jones is quite specifically dealing in that Catholic iconography. And you, in a sense, are raising eyebrows, not to false gods, but to Welsh gods, aren't you? You do seem to want to paint, to come back to, those Welsh myths. The characters, the figures are very much implicated in what you're doing.

I think they are archetypal figures, many of them. You could probably find similar myths in Japan, or in South America, or anywhere else like that, because myths are international.

You find similar or parallel narratives, but the land mass of Europe would seem to have something specific to itself, wouldn't it?

The Anne Thompson *Index of Myths*, collected myths from all over the world, as did Frasier, and found remarkable similarities between them all. The roots go down to a much deeper humanity.

WELSH ARTISTS TALKING

Blodeuwedd
oil on canvas, 127 x 102 cm, 2000
artist's collection

*There is re-occurring imagery in your own work. Lots of drawers with imple-
ments, or cutlery, in them. Bowls of fruit. The stuff of traditional domestic still
life. But your drawers are often mysterious, and if one were more critical, one
might say indistinct; there's a mystery. It's not a finished, polished, absolutely
photographically defined sense of person, or circumstance, is it? You want an
ambiguity in your work, don't you?*

I don't discourage alternative images appearing in the work.

Or contrary readings of those images.

An open drawer with objects inside it reminds me of certain of the twenti-
eth century French poets who listed a number of objects, in the lines of the
poem, one after the other. And if you actually open a drawer, and you're
going to write something, and you write a list of the contents of that draw-
er, or if you make a film, about one or two objects, and their sources and
their origins, these little objects have a personal fascination, and they are the
personal objects of each individual – they don't find their way into the draw-
er by accident. So to open somebody's drawer on a table, is really a slight-
ly voyeuristic intrusion into somebody else's mind, I suppose my mind in
this case. It's a privileged view, as through you've pulled out a drawer from
the painting. It would be interesting to do a painting where you pull out a
drawer, perhaps – but I think it's more interesting to depict the drawer.

*You're revealing something but it's also intriguing. Your house is a wonderful
artefact in itself. I get the impression you've never thrown anything away.*

That's the trouble, I know.

IVOR DAVIES

It's an astonishingly complex jumble of marvellous things.

That's my complex, actually, I can't throw anything away, either in terms of my history, personal history, linguistic history or anything else. Some people are hoarders. Some people are wonderful at throwing away old junk but I've tons of junk in my house.

You've even got a box here of stuff about which you say you may collage some day.

And all of the stuff for images, which I may never use, but it's a bit like recording something, a film, from the television; once you've recorded it, you don't really have to watch it.

But you could if you wanted to, you might. We're looking at an oil painting of oranges?

Quinces, actually.

Fifteen Quinces, from nineteen eighty-seven, and one might say that's fourteen years ago, but the still-life is still something that you find a valid genre.

Yes. It's almost like getting down to pure painting. Purely painting, in one way, because I'm very interested in painting, and despite the fact that I'd done things that were the opposite, the death of painting, the destruction of painting, I'm very interested in painting, and the agony of painting, the struggle of painting and so on. It's all there, in the still-life. That is a basic struggle. The arena is the still-life, and of course, still-life has a history of meaning and of the idea of the ephemeral and the memento mori, whatever you like to call it.

In its simplest and crudest, it's a celebration of the fruits of the world.

Yes, but also the passing away, vanitas, the vanity of everything. So very often, you found still life with a skull, particularly in the seventeenth century the skull, an hour glass, and fruit with flies standing on it, and so on.

So there again, art is the stepping stone between legitimate religious art and a more secular art, in terms of issues without specifically religious iconography.

I think there's something in that. I mean, seventeenth-century Holland, there were many still-lifes painted there, and of course it was extensively Catholic, with the Protestants a growing minority. I think it's still over fifty percent Catholic now. There was that quality about it, I think. But these were bought by merchants, even people who kept pubs. They were philosophical objects, also interesting still-lifes, Roman wall paintings of objects, very simple, clear objects. I think the still-lifes which are the most exciting to a lot of artists are the Zurbarari and other seventeenth-century Spanish paintings of objects which are very simple; vegetables and fruits, that are very clearly painted in a crystal clear light. Different from the Dutch ones, they've got a more earthy quality about them, and they appeal to me, but I think it was Roy Powell in college, in the early Fifties who drew my attention to the still-lifes of Cézanne.

Was he a contemporary of yours? Because he's had a late blooming really, hasn't he? We've started to see shows by Roy Powell, and he has this extensive vanitas series, where he's doing exactly that.

Fifteen Quinces on a Table oil on board, 30 x 55 cm, 1987, artist's collection

It was he, really, who introduced me to Cézanne. I've really gone into Cézanne since then, and looked carefully at his work.

Perhaps I'm being rude, but it seems like 'Fifteen Quinces', is an homage to Cézanne.

It is, in a way. But when you do still-life like this, you've got to observe, it's just observing. It isn't painting from the imagination. You've got to look, and you've got to translate what you see into paint. And you've got to decide what language you're using, you've got to know whether it's going to be this or that, whether it's going to be, like chiaroscuro, light and shade, or whether you could add colour later. And then the materials you use are significant. I see materials, I don't know what they are. I buy them and look up what they're used for, and use them, try them out. That way round is the wrong way. The actual physical materiality of painting, and the chemistry of paint, is fascinating. I find it very interesting to realise that all these substances come from some kind of natural source.

Does that validate the activity of painting for you? That you're dealing with earth, you're taking the earth and you're making something out of it. I've just interviewed Christine Jones the ceramicist. Ceramicists take clay, mud, and turn it into beautiful objects. And in a way, that's what a painter does.

Yes, it is. Yellow ochre is purely earth. Up in Gwaelod y Garth there are caves, that I explored when I was about sixteen, vast caverns, wonderful places, and there is the most wonderful yellow ochre there, yellow earth. You can just pick it up, take it away, you can wash it, wash the stones out of it, if you want to, and there you've got a beautiful yellow ochre paint,

mixed with a medium, whatever medium you want to use. And the same goes for the red earth that I use, and the charcoal, or soot. You can use anything.

Is it more satisfying to do that, to take, in that case, a piece of Wales, and work with it, than buy the tubes?

It is more interesting, but again I started the other way around. I was a student, looking for cheap ways of getting paint, so I went to chemistry laboratory suppliers, or I'd mine it myself; you get better quality stuff, because when you buy a tube, a large proportion of that tube is linseed oil, to keep it from drying out, waxed filler, like pipe clay, or whiting, there's very little pigment there. So if you get the thing yourself, you've got a dense pigment, you know, really dense, wonderful, truly earthy thing. I regret there's no green around here. There is in Germany. And the terres verts are all different, you get different sorts of greens from different places.

You are very interested in taking things that present themselves, taking the found object. We've just looked at that marvellous, strange construct of a book that you, Iwan Bala, Peter Davies and others did, for the Glynn Vivian book exhibition. You like the idea of taking things and transforming them, and that's very much a Beca thing anyway, isn't it?

Well that book started off accidentally. A painting by Paul which he sent to me, and asked me to finish. It was chalk on a blue oil paint ground.

He started a painting, and sent it to you and said, "Finish that one off"? A kind of a co-operative?

Exactly. We used to post them. But he actually handed me that one, rather than post it. But we used to post things extensively, work on them, post them back, transform them, so you got total release from all the self-censorship of painting which an artist in isolation has, when you think, "Oh, I'd better not do that, it'll look too much like Cézanne or a Morandi", or whatever. You just do it, it doesn't matter. You push out into new places, because you know it may be transformed again, by Paul, or it comes back to you again, and change it. A very exciting way of working. And the intention was, of course, that a number of artists would work on it.

And the finished thing is really two framed paintings as the covers of the book, held together with string, net, and then contributions of various types within the book.

When Paul sent me that painting, it wasn't intended for a book, just a painting. I couldn't work on it straight away, because it looked interesting in itself and I thought, "That's it, it's even got a frame round it", painted bright blue. And when this idea of a book came up, I also had done a painting of a conventionalised figure of the Welsh bard, with a harp, and I made it look very salty, by covering it over with marble dust, and fixing it so that it would look as though it has just been pulled out of the sea. I thought these two would make good covers for a book. When I saw this competition in the Glynn Vivian in 1996, I thought we'll do a Beca book. And so I wrote

to everybody I could think of, not just Beca people. I wrote to about twenty-five people, and a lot of them sent things that I could actually put into this book. And I used a lot of coloured papers like sugar papers, which I happened to have kept from the Fifties, actually. I liked them, because they were gradually fading, and I added ephemera from three Beca groups; one in Taiwan, one in Abergavenny, none of whom knew about each other. I tied it up, with very crude, netted string, into a net, and fixed it so that it would have to be cut in order to be opened, and this is what the judges did. The exhibition was a wonderful idea, I think. I don't think it was that well displayed, but even as Fauves among Donatelloes the Beca book was highly commended. There were some wonderful books there.

I saw that exhibition. Beautifully tooled leather, fine art, the book as objet. But yours subverted that. As long as you bind something together, and it's got pages, it is a book, and if you want to call this a book, it is a book, it's a Beca book. And it was also a book, ostensibly, which could be opened. I liked the idea that it was tied up, that it wasn't opened, but you could cut these strings and find things inside it, quite surprisingly. But not just easily opened, you'd have to cut the string. And of course you can easily tie up string again, it's not a valuable material like a lead seal. And Christine Kinsey sent something, Iwan sent something of course, and Jeff Nuttall, Roy Powell sent a beautiful piece of lettering, and Ogwyn Davies contributed. A whole list of them is inside.

So Beca continues to this day, and is there if anybody wants it. If two or three like-minded people say they want a Beca event, you're up for it.
I think so. I haven't thought about it lately, whether Beca still exists or not. *But the idea of the micro-political is still strong. In the 1960s utopian beliefs were to come to the top of the social pyramid; now our micro-political structure will grow, not being authoritarian, but from individuals' talk and action. We need to encourage collective creativity too.*

Is it perhaps as Wales discovers itself as a vibrant cultural, visual arts, music place, and is more assured of its identity, that there's less need for Beca? Is the ideal state of Wales one in which there is no need for a Beca group of self-styled outsiders, raising issues about Welsh identity and the nature of Welsh art when nobody else is?
I hope that Beca will disappear, but there are so many things that need subverting, still. A lot of people think that the Assembly is suddenly the end of everything, but things go on, destruction goes on, destruction of communities goes on, destruction of language goes on in a different way, despite its more official status. Certainly the physical destruction of towns, with the supermarkets outside, and the destruction which seems too trivial a subject to represent, but it is symbolically represented, I think in general, with the kind of work, whether one calls oneself Beca or not. Beca was a big release. Maybe Beca shouldn't go on for ever. But even as we speak, as house prices increase in London and the bigger English cities, second homes are bought

in Wales, destroying communities. So Beca, Cymdeithas yr Iaith and others are still badly needed.

Daughter of Beca is the next one, perhaps? So you're a stronger Welshman, Welsh artist because the lines are still open to you, through a sense of international activity.

It's difficult to keep up with everything. I subscribe to certain magazines, the *Burlington Magazine*, which is the classic, and *Art History*, but I don't have time to read them. I take the *Art Newspaper* and *Barn*, and I read whenever I can. There's a lot of rubbish to read too. I think most of the books in the world are rubbish. There's such a sense of morality about reading. You go to any railway station, or any of these shops, full of pulp. Ephemera gives you a good idea about the place you are in, however. The junk publications of any city can tell you what the place is about.

It's pulp, it's pulp fiction. But people might say that about art as well, that the paintings, the works of art that are distinguished – it's not even the test of time, because the works of the previous generation are often consigned to the basements of the museums – maybe we're all pathetically struggling against the inevitability of obscurity. Most of us are, aren't we?

Well, I don't know. Obscurity. I've come to look at it in a different way.

Well, what we do is to win against time. We don't want to be forgotten. We make marks because we don't want to be forgotten.

I suppose not. But I think it's other people who prevent us being forgotten. *And the system – that's why there are universities, and art history, and galleries and archives. Your house and your studio together are an astonishing archive of your life, and the interception of your life with other movements and other artists. It's quite astonishing. We make marks and we keep them, and we use a medium that, if we're lucky enough and clever enough, can preserve the moment, the feeling, the instant of the light falling is there for your lifetime and mine, so we do that. But also, what's interesting about your career as an artist, it seems to me, is that you have responded to the instant, to the political moment, to the moment of national need, national identity, as well as painting for eternity. You don't mind the fact that the book you made for the Glynn Vivian Gallery is, by its very nature, becoming tired and worn, and showing its age – that's the nature of that particular artwork. That's not a failure, that's a part of what it's doing.*

Well you're right, it's disintegrating in a way. The actual artworks, I must say, that people sent for it are not disintegrating, they're carefully preserved inside it, but as a bound book, it is disintegrating, just as the painting using earth is disintegrating, the earth is falling down into what I hope to be a wide tray-like frame to catch it. And I think that fame is the same, you see. It needs one or two people to stop somebody being forgotten. Very often, they go to extremes – there are people who have devoted their whole life to writing about Matisse, or Picasso, or writing about somebody else who we've never heard of. It's one person giving up his life for somebody else's life.

And that could have been your life. You could have been the art historian. But you've managed, quite remarkably, to be a number of different things; political activist, art historian, successful painter, successful creator of objects.

It's a bit like getting out of heroin, actually, not becoming an art historian, because as you say, I could have done that and it's very seductive, a good living, and there's also the competitive spirit in it of being able to find new things and publish them before somebody else does. There's all that, which is resistible, really. You can dry out of it.

Can we round things off by talking about this century now. We've got two or three very successful commercial galleries in Wales, we've got the Centre for Visual Arts in Cardiff, we've got a sense in the museum of, at least acknowledging and doing something for, specifically for, contemporary Welsh art. Are you happier? Have some of the battles been won?

I can't quite tell. I think some of them have, but they're not so much like battles. They're a bit like the way that ancient Egypt was dug up; if you turn your back, the sand can gradually slip back over it again.

That's like the language issue, isn't it? The language battles have been won, but the vigilance has to be maintained.

And that's what happened with Egypt, of course, until the authorities actually de-colonised themselves, pulled themselves together, learned something from the colonisation, and didn't allow supermarkets or anything to be built on archaeological sites. If an archaeological site is discovered there, everything stops. And I'm sorry to say, it isn't the same here. Not far from here, a multinational bought what is ostensibly the seventh-century graveyard at Llandough, quickly dug up a few graves, covered them over and built ugly little houses on it. It happens all the time.

So it's good that the Victorian library in the centre of Cardiff, no longer functioning as a library, at least now is the Centre of Visual Arts.

Yes. I hope it works. The struggles are never over, really. You can't go round, changing the whole world, you can't stop people from putting replacement windows in, knock at people's doors, and say "keep the sash windows", you can't do everything. But I am for keeping things, if there's nothing wrong with them.

Well, you can't talk personally, you can't throw anything away! This incredible edifice of stuff that you live in and work in.

All this junk. I'm haunted by something if I throw it away.

JONAH JONES

Jonah Jones has a studio in his daughter's film production office in Llandaff. Jonah and his wife Judith live a short walk away. His constant companion is an elegant whippet. We talked in December 1999.

There's a point in your 1999 contribution to the journal Matrix *where you talk about doing the Dylan Thomas memorial stone, and this lovely phrase, you said you did the stone, you painted letters on paper, did a bit of printing, wrote words in books, and all told, kept faith with the word. And that's a key phrase, whether taken in context or out of context, which sums up a lot of what your working life had been about. You've kept faith with the word.*

Yes I have. As a boy at school, I won an essay writing competition, which is every boy's ambition, every girl's ambition, and I remember appearing at the local cinema, having to walk up onto the platform to receive the fiver. And I suppose that was the beginning of my writing, anyway. But I was more interested in the image of writing, the letters themselves from an early time. So although the word is normally used in a Christian sense, or a biblical sense, I like to think, really, the word has been central to my working life in many ways. Even when I try to paint, or do free sculpture, somewhere behind it would be the word. A lot of my sculpture, and I can't do any more because of arthritis, a lot of it is biblical. So that in the end, it would be reading about Jacob, the great, flawed character who I love very much, and it would be about him. But the source of that would be reading the Bible.

Another source was a man who influenced me greatly in the deprived days of the Depression, a man called Leonard Evetts, who wrote the classical work, *An Analysis of the Trajan Alphabet*. That was a terrific book. It went through nine reprints, which every author would love. He taught at the King Edward College of Art in Newcastle in those days, which later became part of Newcastle University. It was marvellous for me to go back there in nineteen eighty-one, as a Fellow. They wanted me to stay on, but I like to be free, and that's another thing about my work, much to my father's regret I never had a proper job. I've always been free, to work around the word, and I've made a living at it. I had a brief period in academia, but I've worked as a sculptor, an artist and a craftsman.

And that was the marvellous thing. It's interesting, the word. It's vocational, the word. It enabled me to earn a living, as an artist. The origin of the verb to write is from ancient German, and it means to scratch something. So, from the beginning, the idea of writing is perhaps an incision, originally, leaving your mark. So although now we have a sophisticated distinction between the written word and the image, and the written word seems to convey ideas in the abstract in an encoded way, that perhaps people think is obvious – if you can't read or write you're illiterate. But if you can't paint or sculpt, that's just something that you can't do. But the two were joined at one point. Articulating meant making a mark.

Yes. The word 'poem': you're a poet, and the word 'poem' derives from the Greek word 'poiema' – a thing made. So yes, I've never seen these distinctions. It's very important all the time, I think, for artists and craftsmen not to think in categories, but to cross these divides.

And you've certainly done that, haven't you?

I have, yes. I don't mean it should dilute your work, its inspiration, in any way, but you should not be tightly bound to one way of making. I couldn't write a poem. Naturally I've had a go, everybody has a go at writing a poem. But the word, that's it, and carving them has been a great joy, all my life.

One of the sources of your inspiration, of your art, has been the poem, has been other people's poetry, and both the carving of that, and what it suggests to you, has been a very fertile area, hasn't it?

Yes, that's right. There was a marvellous commission I had, for the University of Western Illinois, it really was wonderful to be asked, to write out, paint out, fourteen poems by Welsh poets. I enjoyed that enormously, it was just the sort of thing I wanted to do, and do freely myself sometimes. There's one there on the studio wall of Charlotte Mew, one of my favourite poems, and then the *Mabinogi* that I've always worked from. For example, when I work on that landscape, I start off with the words about Gwynedd, and end up with an actual image.

We first came together in a professional sense over that Western Illinois project, which was initiated by Fred Jones of Llanymynach, and more lately of Macomb, Illinois. What was marvellous about that was you had been asked to do the calligraphy, strictly speaking, but you couldn't just do that, could you? When you got involved in that, images started to appear, and what you created was both calligraphic representation of the poem, but then a visual interpretation of the poem as well.

I've always painted letters on paper, and I have to say again that, although I deny categories, I've never thought of myself as a calligrapher. I want the freedom to be awful! To be vernacular, demotic, and I'm much more influenced, I suppose, by letters from the Roman Catacombs, where people scratched – the word you've already used – on the walls of the catacombs in praise of the dead, perhaps, commemoration, what for me are beautiful demotic letters, untutored, to somebody unheralded and unsung. And that has been a great influence on me, as well as the Trajan alphabet, which of course is the great source.

Right. It strikes me that in the Western world, and particularly in the urban western world in the last twenty-five years, the scratched word, the scratched name, has become really quite important, it's become almost an art form. Thinking of the disadvantaged and disenfranchised black kids in America, and Hispanic kids, writing their names on the train. There's a wonderful book called Watching My Name Go By. *The graffiti, the vandalism of taking a subway train and painting it, is now being seen as really a sort of democratic act. That*

it was art mobilising, in every sense, the identity of otherwise unempowered kids.
Yes. I love that. It seems to me if we'd had that in the Depression, which
was a very black mark in my life, I'd have done the same, with pleasure and
joy.

You didn't have the spray cans available, that was the thing!
No, and of course you had a great fear of railways, whereas now anything
can happen. Yes, that sounds marvellous to me, because they are disen-
franchised. We were, you might say in the Twenties and the Thirties, and
nowhere, no way the means of expression people have now. I disapprove a
lot of graffiti, perhaps the defacing of a fine building. But on the other hand
I do understand it. "I want to leave my mark, and I want to see it as a
stamp, there, on the wall".

*It's that tension constantly of between order and discipline, people knowing their
own place, and the undoubtedly healthy human feeling that one ought to over-
turn order, one ought to deface things, one is entitled to make one's mark,
although I'm seriously pissed off by the kids who've just written 'Y2K' on my
gatepost outside my house, as if I didn't know the bloody thing was happening!
Why would you do that?*
That's meaningless.

*You grew up in the north-east, but your roots, you're Welsh. At what point did
you realise that? At what point was there a tension between being a Geordie and
yet feeling those Welsh roots?*
I had one moment, which I can remember very particularly. Being called
up, and I was stationed at Exmoor. For me, that was the first time I'd been
in foreign parts, so to speak, because you didn't travel beyond what you
could do on a bicycle. And that's very true. You might think that's pathet-
ic, that you'd never been to London, that you'd never been outside your
county, but that was what the Depression was like. If you could get an old
bone shaker bike, then you could travel fourteen miles to see Durham
cathedral, and that was about the limit, and it would take all day. So the
army, in a way, was a great liberation, and I was stationed on Exmoor,
above Minehead I think it was, and there I was, on the heights, on a free
weekend, walking the Moors, loving it, with a real Taffy, and I use the word
advisedly – he obviously came from the Taff vale, and he looked over and
he said, "There it is, that's where I come from", and he used the word
'hwyl', and I asked him what that meant, and... what's the other word for
exile? 'Hiraeth'. He spoke of that very strongly, it was almost visible in his
face. And when I looked across the Bristol Channel, there was a green and
pleasant land. It has to be remembered, the collieries were still working
then, so there must have been a bit of smoke about, but from Exmoor, it
looked a green and pleasant land. You could almost see the delineation of
the valleys from there.

I'd never been back, perhaps it was an exalted moment, I don't know,
but that was when I realised I had to get back to Wales. My grandfather

had come from the Caerphilly valley, Senghennydd, very early on, and he was a shaft sinker, that is, he used to work on developing pits, sinking the shaft that gave access to the coal, one, two or three thousand feet below the surface. Once done he moved on to the next 'commission'. So he was itinerant, like the people who build atomic power stations now have to move on to the next one. And he moved right across. Married in Somerset, in Midsomer Norton, which had a colliery then, up through the Midlands; Staffordshire, Yorkshire, and ended up in Durham, by which time he could retire. He bought a little bit of property in Washington. So that's how I came to be there. The sight of Wales, from Exmoor, was what determined me to get back somehow. That wasn't easy. The army, which I hated, was a great facilitator in moves in life. First of all, you *did* travel. For the first time, it opened my eyes to the world: Europe, the Middle East, and so on, but I came back from the war with John Petts, because we'd started a press in the army, a private press, in which we could print a little book about parachute operations, the medical services of parachute operations. That was my job in the war.

You pursued Petts, in fact, didn't you?

Yes, I did.

You wangled postings, chasing him almost…

That's right, yes. That was a daft thing to do, of course. I went up to the usual training camp, where you do squad drill and all that, and then you have an interview at the end of the month, and they're obviously searching for particular people, otherwise the dross goes where they push them. But you never know how the army thinks: 'We might have a hero here, who'll volunteer for something daft'. Well, what I was interested in was joining Petts. I'd seen this illustration of his of a Dylan Thomas short story in *The Listener*, and I'd torn it out as I'd rushed off to the training camp, to read it later. And as I was recovering from my jabs, another fellow called Wilson saw me reading this, and saw the name, and said, "That's a bloke left just a week ago; he went to some parachute training course". And so it came to mind. I was really interested in this artist. I thought his view of the Swansea Strand illustrated in the Dylan Thomas story was superb. I liked the blackness of it, and the contrast with the white sky and the sea. And so when I was asked did I have any idea of any particular career in the army, I said, "Yes, I'd like to go for parachute medical duties," because that's what Petts had done. It was a very short interview, that was that, and I was off to Ringway to learn how to parachute. Which was terrifying. There was no lamer parachutist than me, I was no hero. But I did it, and I joined the unit, and it was a marvellous unit, and very instrumental in my subsequent career, in a sense.

You weren't a pacifist, were you?

Yes, I was.

You were? I mean, the point was you were happy to wear uniform, but you

weren't prepared to carry arms.

No. Never carried arms. Only a Red Cross armband in actual operations.

That wasn't Petts's position, was it?

Yes it was. And indeed, all the idiots… not all, but half the idiots there were pacifists. Because the army had great difficulty finding medical personnel to parachute. And these chaps were willing to do that, but not to carry arms. Looking back, it seemed a very odd position to take. I have written an essay about that.

Parachuting is one of the most adventurous, dangerous and as you say stupid things to do in the war. To do that as an unarmed person was a level of courage, or insanity, barely equalled!

Yes. I wouldn't say courage, but it was insanity. If you were a pacifist, you still had to justify yourself in the face of an enemy like Germany. It was a very difficult position to take. My father had been badly wounded in the First World War, and had the horror of it all.

Was he working, in a mining sense, at the front? Because his expertise would lend itself to that.

I've never known what he did, because he talked very little about it.

Ah, they didn't want to, did they?

No, no. He was wounded at Vimy Ridge. It's quite possible he was engaged in mining under the German lines, because before the war he was a coal hewer. My grandfather had fourteen children, I think, and many sons. They all went into the mines, of course, in Washington – there were two mines in Washington. All I knew was he hated it all, and he preached at me, and it was horrible. So I was a pacifist, that was it.

Being a pacifist in the Thirties, as Glyn Jones was, it wasn't that uncommon, was it?

No. The 224 Parachute Field Ambulance, that was the name of the unit, was made up principally of pacifists, and I'm still in touch. We met again on the fiftieth anniversary of D-Day, in a National Trust pub in Southwark, The George, and celebrated. What was left of us.

So where did you parachute?

It was Normandy and Wesel, not Arnhem. The last parachute operation was Wesel, on the Rhine, and that's when the Germans really began to fold. We jumped behind them, and they could no longer defend the line.

A very hazardous thing to do, really.

Well, yes, it was. I got off scot free, but a lot didn't, of course. For instance, we lost a key member. There was always one dentist and anaesthetist in a field ambulance, and he was killed instantly, so any mouth operations were very, very difficult. The surgeons carried on, they had to do it. We had two surgeons. One of these men was Dr Nathaniel Miller who operated on appalling wounds in a trench we were holding – at Wesel he was lucky to find a shelled church and the altar proved perfect as an operating table. He was involved in tending to the victims of Belsen too.

One accepts that, in the Thirties, being a pacifist was a natural product of that nightmare that was still continuing, of the First World War memories, the trench memories. But at the end of the war, you awfully came across one of the reasons for perhaps not being a pacifist, and that is you went into Belsen.

Yes, that's right.

Was your sense of being a pacifist shaken at that point? Did you think, "I will take a gun to these bastards"?

Yes, I did, yes. That is why I have written somewhere that, looking back, I find the position untenable. But I know that people like John Ormond and me are torn about it still, that if you see something like the camps, it was unbelievable. And I see it again, in Kosovo, in Chechnya. What happens to civilians? What happens to people who you dislike, or hate, or are apart from you; colour, race, religion, it's an appalling thing.

And the only thing that can defend them is the gun, unfortunately.

That's right, yes. It is. Really, I've come to think it was an untenable thing, but I held it then. It was a hard principle.

Everything has to be judged in its context, doesn't it?

In its time, yes.

And so you met John Petts? At what point did you catch up with him?

After that interview I went to Ringway, and you do eight jumps, for a start, to get used to it, but you never get used to it.

I can't believe that!

I can't, looking back! It's crazy. The first two, of course, are even crazier, because you go up in a balloon, and you're sitting in a basket with a hole in the floor, and to sit with your feet dangling in that hole and then to be told to jump out of it, is unbelievable! Oh dear, no, it was mad, mad, mad! But it was done, and one or two jumps, of course, once you joined your unit. They were very expensive things to organise, of course, so we didn't have many. But we had one jump, I remember, over the Thames, and that was obviously a rehearsal for getting behind a line. I went back there recently because I have a son who lives near there, and it seemed very odd to see this place. I've never been back to Germany, I wouldn't go back.

But you and Petts were involved in this little booklet that was produced during the war?

That's right, yes. I was very much at the centre of that, because Petts was quite a bit older than me, and he was demobilised before me, and John Ryder, the typographer, he was older, he left early, and so I was left behind.

So you kind of had an apprenticeship by default, in a way?

That's right, I did, yes. This was the word, again, I was assembling type into a composing stick as printers call it, on a little flat bed press which we could carry around with us, and printing a page at a time, assembling the type again, a page at a time, and there were about seventy pages, I think. And we got through it and printed it. Petts had had the Caseg Broadsheet experience, of course. They had been established before the war by John

and Brenda Chamberlain, and Alun Lewis. Alun Lewis himself was a pacifist, who eventually gave way in the face of what was happening, and died at the end of the war, in tragic circumstances. So John and I link up very much. Also one or two writers. There were one or two intellectuals in the unit. I wouldn't count myself as one. They were a remarkable group of companions, and we got on very well. We organised various things to get away from the harshness of army life. We were in barracks on Salisbury plain, and would get on the troop train into Salisbury Plain, and Salisbury Cathedral.

So it was a further education, and possibly the beginning of a higher education for you.

Yes that's right. It was very much so. The Depression had deprived me of all that, anyway. I had no studentship, and no art school. It just wasn't on.

After the war, did you meet up with Petts again? Did that relationship continue?

Yes. The plan was that John, having ended his marriage with Brenda, had decided to go off on his own, with his new partner Kusha, and established the press again in Caernarfonshire, enabled by Lady Lloyd George. How it came about I've no idea, but the promise was if John organised a Lloyd George museum, and painted a portrait of Lloyd George, and established this place, he could have the house above, rent free, and use one room as a workshop. But he did need a partner to work with, and that was where I came in. Kusha also worked, of course, colouring prints and so on. I was very much at the printing end of it; it was a return from war, and an opening for me.

Which brought you into direct creative relationship with the word, and took you to Wales, so it must have been a dream come true for you?

It was, it was very much so, the two together, because the one enabled the other, yes. It was a return to the word, yes.

Then you went to Pigotts, the Eric Gill workshops.

Yes. I'll tell you why. Because the classic press arrangement was very tenuous. How do you re-establish a thing like that after a war when things are very run down? It was an impossible dream, and it very soon became apparent, and I knew that I had to leave, and sooner than be pushed, I jumped. And I'm sure John was grateful. I knew if I could cut letters in stone, I could earn a living. And I was right. But how do you do that? I had no money, I was married to marvellous Judith, who was heroic in those circumstances. We were in an old ruined farmhouse. I knew if I could get a spell in Pigotts I would be able to learn how to carve in stone, and I knew if I had that, there was lots of room for good inscriptions. There were people around who abhorred monumental mason lettering, and wanted something classical, dignified and beautiful, because an inscription can be a work of art, or it can be a horror. And I knew that was an opening for me, if I could get into Pigotts. While I saw Joseph Thorp, he took me to see Doctor Thomas Jones, and that was when a small scholarship was arranged, some

thirty five pounds. It was quite a bit of money in those days, and I went to Pigotts, and met Laurie Cribb, Gill was dead, of course. I started from there and learnt to cut letters in stone.

What was happening at Pigotts? You said that Gill was dead, but it had the Gill pedigree, didn't it? Was it simply a place where letters were carved?

No. It was a whole way of life, dedicated to the Third Order of St. Dominic, a Dominican working lay order, Catholic Order.

But you weren't Catholic?

No. I was very much animated by Gill himself. I have an idea that Denis Tegetmeier, his son-in-law, was less animated by it, and Rene Hague, the other son-in-law, but they carried on when he died. Denis Tegetmeier, who was married to Petra, the eldest daughter, ran the stone shop. And when I say ran, his training was really as an architect, a draftsman, so he'd do all the designing, whereas Cribb, Gill's favourite assistant did the cutting. On the other side of the quadrangle of Pigotts, which was very much a Monastic lay-out, was the press. Rene Hague ran it as a private press. But financially it was in great trouble and didn't last very long. But it printed some fine works. I have an idea that the first edition of *In Parenthesis* came from there. But David Jones, of course, was there some time.

Did you meet Jones?

No I didn't, alas. No, I never met him, and I never got in touch with him. I feared to intrude on his privacy. But I was welcomed into Mary Gill's house, and when she took me to my bedroom she said, "This was David's bedroom." And there on the chest of drawers were a couple of little carved wood blocks that had been engraving blocks, and once the printing was finished, he then carved a little Byzantine Madonna mother and child. So the only link was that I followed him into his room.

You felt you were joining, partaking of the heritage, if not actually meeting the man. But by that stage he had become very reclusive anyway, hadn't he?

He had, and I knew that, and never sought to get to know him by writing or anything; although I was very interested, especially in his devotion to the word, and those marvellous demotic inscriptions of his were a great influence on me. I spent about six weeks at Pigotts, if I remember, didn't require any more. I knew about my lettering, but I didn't know how to use the tool, it was a great mystery; how do you carve letters in stone? It looks such a beautiful thing. I was soon taught. It was the simplest method, plain chisel, plain mallet.

And plain talent! I'm sure I couldn't do it. As I said before we started recording, I've just seen a film from the late Seventies by John Ormond, which shows you cutting the Dylan Thomas inscription, and you make it look easy. I'm sure if I picked up a chisel I'd turn it into something very abstract! You speak at some point of Laurie Cribb having this metronomic regularity of hitting...

He had a wonderful stroke, in a batsman's sense. It was beautifully timed, always.

JONAH JONES

You compare him to the great batsman Gary Sobers at one point.

Ah, did I? I don't know where that comes from, but it sounds right, yes. Laurie was very meditative at stone, he would sit and tap away, tap away, it was a wonderful sound, and many people say he was a better letter cutter than Gill and I think Gill might have agreed, because Gill was more interested, really, in carving statues, and writing, it was preaching a gospel, whereas Laurie was a simple workman, in the best sense of the word, making his letters, and to hear him was a marvellous sound, yes. And he was a good old mate. There was no edge to Laurie.

How old was he, then?

Well, he was a First World War soldier, so…

So he was old enough to be your father?

Old enough to be my father, but we were always such good mates. And later when Pigotts more or less folded, he wrote to me and said was there any chance of getting back to Wales, did I know of anywhere; I found him a little smallholding near Dolbenmaen, which was a battlefield in the *Mabinogi*, which would have interested David very much, and he settled there, his family alongside. And then he came to work in my workshop, so we were mates again. I owe everything to Laurie, really, because he was another enabler. He not only taught me to cut letters, but how to establish a workshop and all that. Being in a workshop is a great help. It's better, in a way, than art school, it's got a different purpose I think, but that's how I started.

It was an intensive apprenticeship but as you say there was no conventional art school for you, and it wasn't what you wanted anyway.

No, it wasn't, really. I wanted to be a workman, and that's how I went about it. And of course in all things it needs luck, or whatever you want to call it, an opportunity to take something up; you must have the opportunity. Where it comes from is I suppose a matter of luck, but in every case I've taken my luck and made the best I could of it. And out of very deprived circumstances, the Depression and so on, Judith and I have made a life together, and had a marvellous family, and it's all on the word, if you like.

What was your first commission? Where did the first money come from?

I can tell you that because Joseph Thorp, or Peter Thorp as we knew him, took me to see Dr. Thomas Jones, who had been Cabinet Secretary to Ramsay MacDonald, Baldwin and all that lot, and he was still active in various things, very much in touch with the Astors of Cliveden who owned *The Observer*. And when I was taken along by Peter Thorp, to a pub near Llandinam, I remember Thomas Jones asked very briefly, "What can I do to help you?" "Well, I would like to go to Pigotts but I'm penniless, and I would require a month or six weeks training, I'm sure that would be enough." I was being very modest. I might have asked for three months, but I wanted to get into work as soon as possible, and earn a living, and so he arranged this thing from the York Trust, and it was only many years

later that I realised it had been established by David Astor, I believe, for just such purposes as to help out lame ducks like me, and that was it. So I went to Pigotts and started from there.

But the first commission to work?

The first commission to work was from Dr. Thomas Jones, who had been Lloyd George's Private Secretary. He wrote to me and said, "We would like to have an inscription in the Principal's House in Aberystwyth and these are the words, just get on with it." And I did, and sent a bill in for thirty-five pounds, or whatever it was.

Which was a lot of money then.

It was, yes, and I was pleased to get the first cheque. I suppose it's still in the Principal's House; how it was established, by whom it was funded and so on and so forth, and that was the first commemorative plaque that I made. From then on a number of people heard about me, particularly Clough Williams-Ellis, and of course Peter Thorp, who put me in the way of people requiring just that sort of work. Lloyd George's grave needed inscriptions, and in fact Clough was so keen on not getting it wrong, he left blanks, there was nothing to mark the grave. The plaques were all there, everything was there, and he was delighted when I came along, and he gave that job to me. And it grew from there. Another thing that Clough did was, again, he'd been unable to find anybody to carve an inscription in a little church on the Llyn peninsula, where his parents had lived and his father was commemorated, being a canon in the Church, I think, and there was a great oak plaque in the church, which had been painted because Clough

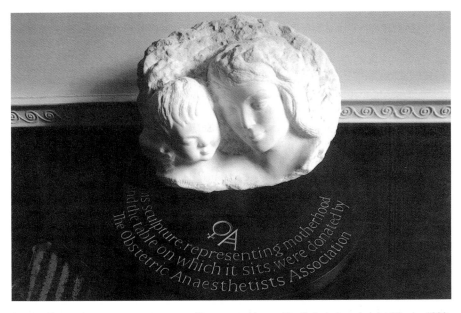

Cloud Nine Carrara marble on Aberllefeni slate, height 38 cm, 1980,
 Association of Obstetric Anaesthetists

couldn't find anybody to carve it, and he very much regretted it, that the paint would fade and so on, and he asked me to do it. That was my third commission. I went into that church daily, and carved in wood. Peter Thorp, incidentally, had taught me how to carve in wood. It's quite a different technique, to carve letters in wood. You've got to split the letter in the middle, then carve out each side, otherwise the grain runs away with you, and you've got no letters. That's how I began, and it grew from there.

The inscription on Lloyd George's grave was a high profile early commission.

Yes, it was. And it wasn't very long before Clough himself was commissioned to design a plaque for Westminster Abbey, and of course, who was to do the cutting? It was me. So I've got two inscriptions in Westminster Abbey; one near Churchill, which was to Lloyd George, and another one in poet's corner, to Dylan.

So this was an auspicious start for someone who was, strictly speaking, unqualified – tutored well, but unqualified – coming out from a very interesting and colourful, but strange set of experiences in the war, and here you were at the centre of something really quite important.

That's right, yes. I've had a great deal of luck in my life. I had one bit of bad luck. Not long after the war, I was struck down with tuberculosis, which was appalling – where had this come from? There was never any in the family, I was living a healthy life, but I really went down very badly, and I had to be rushed into the hospital in Llangefni, under the old Welsh King Edward Trust, before the Health Service of course, and got the best care there, very quickly. Both lungs were damaged, but again I had great luck; my lungs were big enough to take artificial pneumothorax, both of them, which I endured for five years, and the new drugs were coming in, and here I am, eighty-one nearly. So there was a hiatus in my career, and that was when my wife was heroic, because she had by then our first child. I was behind bars, so to speak, my little son could only see me through glass, and Judith was a one-parent family for eighteen months..

Of course, there was that whole isolation…

Yes. That was a ghastly period in my life, and I think that came from Germany. I've always been convinced.

It was rife, wasn't it? As a result of the persecution.

Well, we dealt with some awful cases. Awful to see. People suffering: could we help? This was in the sweep across Germany. It was awful, it was unthinkable. Man's inhumanity to man.

So you reached a point, then, after the war, where despite the very serious setback of the TB, you were on your way, to establish yourself as an artist, a craftsman, as someone who could deliver a commission.

That's right. that was very important. I was able to deliver a commission within a price I thought fair on both sides. Probably too low. But always with work, and I regard that as very important. And I found that sometimes a student has a tendency to immediately charge too high and then wonder

why he doesn't get work. But we've managed. I can't say we lived in poverty, we managed well enough, and all that on the word.

So the word has been your life, in its various manifestations, and it's paid the rent.

That's right, yes.

Which is remarkable in itself, isn't it? You've been a professional maker of things since the war.

That's right. That was where there was a certain wisdom, looking back, in my choice of letter-cutting. It's pretty much a hard craft, which only a few individuals can do really well, and it depends very much on a sort of apostolic succession. Somebody good has to teach you good lettering.

And you were taught by the best.

And I was taught by the best. And there are a number of mates, like David Kindersley and his wife Leda, who still runs a workshop. There are people I met. John Skelton, Gill's nephew, who died the other day. And they'd all come from that workshop, and they'd all taught people in their turn, so I've got pupils, like Ieuan Rees, and Michael Watts, and Michael Morgan in Llantrisant. I've taught them either lettering itself – not in the case of Ieuan Rees, he already had that, he came to me to learn how to cut – but to learn how to design and cut letters and, in turn, to earn a living from it. So this apostolic succession goes on, and I'm sure that they in turn will teach somebody. So we've got a return in Wales to good lettering. It used to happen in the eighteenth century, the early nineteenth, and then became debased in the nineteenth century, for some reason.

I wanted to quote back at you a poem by Vernon Watkins that you quote, 'The Turning of the Stars', in The Gallipoli Diary. *"His mind being in its silence fixed on truth, unrest in calm, calm in unrest he sought". You say that sums up for you the important qualities of Brancusi, and I wanted to lead into an invitation for you to talk about him as he comes up time and again. Clearly, a very important model for you?*

Yes, he was. I was very inadequate, when it came to the battle with stone, but yes, he was the greatest for me. Gill was good in a way, but I didn't like the piety of his figures, and the constant address to piety, or his accent on beautifully formed flesh, so he didn't altogether appeal to me there. But when it came to picking up a piece of stone, something lying in the workshop which was more or less peripheral to your craft of carving letters in stone, you would think about it and what to do with it, because inevitably, using tools, like letter-cutting tools and a dummy mallet, you'd want to extend your skills into the round, sculpture in other words, and I did that. I never thought of myself as a very great sculptor, but I had aspirations, if you like, to be something like Brancusi. I failed miserably, of course. Brancusi was a religious sculptor. More so than Gill. It seems very odd to put them side by side; the only thing they have in common is that they both loved and carved stone, and used it lovingly. Brancusi's forms are abstrac-

tion, and appeal to me much more. I would have given a lot to have the sort of talent that he had.

Would it be fair to characterise him as less self-indulgent than Gill?

Yes he was. Brancusi was much more disciplined in his address to ideas. He was nearer to the definition of poem, 'Poiema', the thing made. Each one was a poem, because the stone was almost going back to the word, and the word to the stone. It was neither abstract nor figurative. I think anybody who carves in stone will be thrilled by him. I certainly was. I never got to his workshop in Paris. I wished to.

Which is now reconstructed in that museum in Paris, isn't it?

I'll have to go there. I travel very little, but I've never been there. On the other hand, I did travel three or four years ago to Venice, and was in a hotel very near the Peggy Guggenheim Museum, and was thrilled to see a couple of beautiful things by him. To see them in the flesh, it was marvellous.

As the war receded, as the Fifties went on and into the Sixties, were you aware of Moore and Hepworth? People who are now the giants of sculpture in stone.

Yes, yes, you've got a lineage there. Hepworth very much so. I liked her work. Trying to be a sculptor and failing, I did some modelling and was successful and I've just written a letter this morning about something that irritates me, that I'm regarded as dead, really. I'm posthumous. My very first model bust, portrait bust, was John Cowper Powys, whom I met through Raymond Garlick, and it was successful in a very odd way; I don't know why, I had only one sitting. He was a bit like Dylan, he wouldn't stop. He would move and talk and talk and talk, and then got very tired and of course was very old and I had to leave him. So I went out with my clay – it was all done in his little cottage in Ffestiniog – and so I came out with this model head, it was really like a human head, and in fact when I got it home, I thought, "I'm never going to be able to improve on this, it'd better go as it is." So I cast it in plaster, and I think it was fifty pounds then to have it bronzed. I didn't have fifty pounds, but I borrowed. I made an overdraft of fifty pounds in order to do it. I was on the carpet in the bank. And I exhibited it at an Eisteddfod, I think, in Llangefni. Nineteen fifty-six, about then. And it sold for one hundred and fifty pounds. I've just had news that in fact it sold recently for an immense sum at Sotheby's. I haven't had the figure yet.

And of course the new law about the percentages isn't in place yet.

That's right. I'm going to write to the Chancellor and the Prime Minister about that, what the French call 'droit de suite'. I feel I've got the authority as a posthumous artist to write from the grave, about how I've been cheated.

So you would obviously support that and here's something that you did all those years ago, which has increased in value many times.

Yes. Not at the rate of inflation, but way beyond that, because I'm dead! So there we are. Yes, I'm going to fight that one. My neighbour is Dafydd

Wigley, I'm going to write to him, and the Chancellor, and the Prime Minister, because I can't understand anybody who would delay such a thing. What's the matter with this philistine lot!

When you went to do the bust of Cowper Powys, that wasn't a commission as such, was it?

No it wasn't. This was a gamble again. Always extending myself beyond what I was capable of.

So you went along with your lump of clay, and you really didn't know quite what you were about.

No. I never had any training in that. But it's always been admired for some reason, and I've never improved on it. I've done a lot of busts since then.

Yes, I was going to say. The bit of Wales that you returned to after the war, seemed to have been peopled with a remarkable array of characters and significant people. Russell, obviously, and you met him, and...

Oh yes. Bertie was just a few fields away. I wouldn't say he was neighbourly, but he knew you. And he once had a party there, I remember, where we met some of the illustrious and some of the infamous. And I've always remembered Micky Burn, who was also a poet, at that party. I've always had a whippet, as you know, and the whippet came to the party too, and she was sniffing around the lawn, and Micky made the most unusual remark: "We do miss something, don't we?" As if the capacity to smell would give us that bit more in life. It's about the only thing I remember of Bertie's party.

Sir Huw Wheldon
Bronze, height 36 cm, 1974
BBC Collection

John Cowper Powys
Bronze, height 36 cm, 1956
National Library of Wales

JONAH JONES

You also did a bust of Huw Wheldon, a very significant post-war Welshman indeed.

Yes, he was indeed, and I think a very significant broadcaster. There are a lot of things I'd like to see back that he initiated and perpetuated.

Like quality programmes on the BBC, more often than not.

Yes. He was in the Royal Ulster Rifles, which was one of the companies in our brigade, the 3rd Parachute Brigade. So we'd been through the war, the same experience, although I didn't know him then. But he became a very, very warm friend, to all of us; our children and theirs were very close, and he used to come to Cricieth. And even when we went to Ireland he came over there to stay with us.

I remember those Fifties programmes because although I was born and grew up in a council house in Carmarthen, my dad was always keen on radio and television. We had one for the Coronation, which was quite rare, actually, in a council house. But I grew up with Huw Wheldon as well through the Fifties and into the Sixties, with the programmes he did.

Oh yes, one of the great initiators. The art of interviewing, and grabbing the listener's attention.

Yes. And also it was good to have that voice. It was a posh voice, but it had that distinct Welshness about it and it was good to hear an authoritative Welsh voice over the TV.

That's right. I thought he was a marvellous broadcaster. He could be difficult sometimes, but it was a great friendship and I missed him sorely when he died.

Was that a commissioned bust?

It was. He commissioned it himself. I don't know why, but when I went to stay with them in Richmond, he would always talk Welsh, and we had a few 'fragrant moments', as he called it, an hour modelling his head. It wasn't easy, actually, but there it is. It's now in Broadcasting House, somewhere.

And a bust like that, how many casts would you take of that? Would it be an edition or would it be a solitary work?

It was unique. You're allowed to take six.

That's the convention?

Yes, but the only one I duplicated was Powys. There's another cast in the National Library of Wales, as well as this private one. The one that's just turned up in Sotheby's.

Did you ever meet Dylan?

No.

Different part of Wales.

That's right, very much so.

But you read the work?

He's the one who put me in touch with Petts, so to speak, that drawing, that story. Very odd life, that way. Very odd indeed. I remember that distinctly.

I wish I had that bit of *The Listener*. I'd just lost a very dear aunt as I was called up, and the Army was good enough to say, "we'll give you another week, so you can go to the obsequies", and so on, and then I had to leave in a hurry, and *The Listener* that week had this story, and this illustration on the top. I knew I wanted both, the illustration and the story by Dylan. And I tore it out, and put it in my bag, and then it was rammed into my kit bag and ages later pulled it out.

And that changed your life.

Yes it did, very much so.

Later on in the Fifties, I think in the Sixties, you were seduced to Ireland. You were called in as a sort of trouble-shooter.

Yes. Well, one of the odd things about my career as an uneducated brat, you might say, who'd had this brief training in Pigotts, I was more or less called up for National Service, to a committee in London, which was called the National Council for Diplomas in Art and Design. Its brief was to raise the level of studies in art schools to degree equivalence, and to weed out those who were incapable of it, and for some odd reason I became chairman of its fine arts category. There was a chairman for graphics, textiles and fashion, and so on and so forth. And we would go around the whole country, validating schools or rejecting them. Some of it was very arbitrary. Swansea, for instance, didn't make the grade at first, but Newport did. I think they've all made it now, they knew what was required. I mean, there's no reason for artists to be ignorant and illiterate idiots. They had to have some complementary studies as well as the craft.

So I was called into Belfast, and I had a connection with Ireland. And when in the Seventies, because of this experience, Dublin was in such a mess, the principal of Belfast School wrote to me and asked if I would care to come along, because there was a lot of trouble in Dublin, where he was the adviser. I went to Dublin at his behest. It was a nice trip, of course, and it was well paid, and when I looked at the place, with this experience of looking at art schools for the last three or four years, I realised how appalling it was. And I found that it was under the aegis of the Ministry of Agriculture, obviously a relic of the days of the Raj, so to speak. This was an easy job. There were umpteen things I had to do which would cost and I told them that, otherwise forget it. I advised on the staff structure, and the course structure and so forth. And they adopted most of them, especially the appointments. They got a good Professor of Sculpture, a good Professor of Fine Art, and a good Assistant Director. But they couldn't get a director. There was nobody who was capable of it. And in the end they asked me if I would consider it. That was how it started. It was an idiotic thing for me to do, and an even more idiotic thing for them to ask. But the place was, well, it was on strike, that was the trouble.

So best to have someone to come in from outside and arbitrate and advise.

Yes. So when I went later to take up this position, I found the place was

picketed. I kept one of the placards. Those were the three members...
Well, well, well. Three striking members of the faculty, as we call them now.
Frightened of being thrown out of the college, that's why, and the students
were with them. I was met at the gates by a deputation, brandishing this
poster which I've kept –

> October seventh, nineteen seventy four. So this was a real crisis of
> mismanagement and misdirection. Mr Jones took part in informal
> discussions with the students last June, while he was conducting
> assessments in the college. The students were very impressed with
> his progressive educational ideas. For this reason we hope the college
> will use the time available before his appointment to put a satisfac-
> tory end to the ATGW strike is achieved.

So you were the people's choice?
Yes. Oh, and it was hard.
They really wanted you to come in and wave a magic wand. And you did that.
I did that actually, yes. I got a great welcome. The press was there – had a
great profile, half a page, which I haven't kept. Oh yes, I was very popu-
lar. I've never known anything like it! Why? I've no idea why.
*One thing led to another. You were co-opted into this board on the mainland,
and then a contact in Belfast gets you to Dublin, and you were the right man
in the right place for the job...*
That's my life. It's like Exmoor again. Whom I met, and the consequence.
*That speaks a lot for your essential creativity and imagination, that finding
yourself in that context, seeing that opportunity, you had the ability to take it,
to make something of it.*
Yes, very much so I would claim, yes. You talk about pushing your luck. I
believe in grasping your luck. We're all granted a bit in life, make the most
of it. My bad luck, I made the best of it and came through, and then the
chance comes and you don't think very hard, you just take it, very much
so.
*The war brought you to John Petts, it brought you into direct contact with print-
ing, it brought you Judith, your wife, who you met in Palestine. So, though
nobody has a good war, you not only survived, but you came through that gath-
ering things unto you in a way, and so it has continued.*
Interestingly enough, there's a little story there about the Palestine issue.
Judith was in the British forces. Not many people realise that but she was
in the ATS, and very much a lynchpin. As the Latin goes, *parva sed apta*,
small but apt. Quite a character. And we both arrived at Mount Carmel col-
lege, which was an army education centre, in this new corps, the
Educational Corps, and we met up with Huw Wheldon again, he was there.
And in the Mess, Judith was talking to another ATS friend, and they were
both speaking Hebrew, of course, which was their native tongue. And Huw

said, "Why you talking like that? Why can't you speak English?" And she said, "Well, I'm speaking my native tongue, why shouldn't I?" All the pips in the world did not impress Judith. So Huw turned to Alun Williams, who I've never met again, and started speaking in Welsh. "What's that?" "My native tongue," says Huw.

She was very much involved in the new Israel, wasn't she?

She was, yes. In a civilian sense. She was never in any illicit, gun-running clique. But she loved her upbringing, which had been in Haifa, and she loved her language, she loved the whole thing. It was a marvellous upbringing and it was a marvellous country, and she would hear no criticism of it. As soon as she was demobilised (she was demobilised before I was) she was more or less cast outside. She became a civilian in this hostile situation.

And a foreigner, as far as the British army was concerned.

Yes, that's right, and hostile in the sense that the civilian population at that time was hostile to the British forces, who were preventing immigration, of course, the sad cases coming across in sinking ships from Germany, survivors from the camps.

And you had been to Belsen before Palestine.

It was ironical. So Judith and I married across the divide, and thank God. It was a marvellous marriage. We had to keep it secret, very much so. It was forbidden. It got so bad, the feeling, almost like Northern Ireland, so bad that we were forbidden to fraternise with the civilian population, which meant the end of several good friendships, because you had an amount of intelligentsia there, and Carmel College was a centre itself. Michael Walker, a future cabinet minister, Huw Wheldon, Alan Champion, who became the principal of a further education college, all these sort of figures were there. Nobody used to go out in this marvellous community, it was forbidden. Well that's fine, I still got out. I arranged a wedding with the District Commissioner who said, "Well, it's no business of mine." I said, "You don't need permission from the army, it's nothing to do with them." So we got married by the District Commissioner, who represented the Crown, and had a marvellous marriage, in secret, climbing through the barbed wire. I arranged with an Arab taxi, and so on.

The stuff from which novels are made! And of course you and your wife are both novelists as well, aren't you?

Yes that's right. Well, she is. I have written two novels.

You're a novelist. If you do it more than once, you're a novelist. That again is a commitment to the word, perhaps a very natural one. You're cutting methodically and skilfully and slowly short inscriptions and the novel then, presumably, was the place where you could be expansive.

Very much so, yes. That's it exactly. I sit down and scribble my thoughts. And, as you know as a poet, there's this magic of the word. Writing it out, even, what a marvellous thing. And the concentration camp horror came out in my second novel *Zorn*.

JONAH JONES

You're even using a word processor now, which is another sort of tactile engagement with the word, and a very useful one.

Yes. I'll allow that, but I haven't a clue.

You're still a typewriter man, are you?

Yes I am. It's there, the processor, my son has given it to me, and it's under wraps. There was a marvellous article the other day about the typewriter keyboard, why it became 'twerpy': the first five letters on the top row are t-w-e-r-p-y. And this was laid out by a man.

The next thing, apparently, it's going to be the hand-held access to the Web, that you can walk around and basically access anything in the world, and purchase anything, just straight out of your hand. Scary. What you do when you take that chisel and that mallet, that is about the most basic, profound thing you can do, is go to stone – inanimate, lumps of stone, and make the stone speak, and that is so removed from, it is so much more tactile than the terrifically powerful but very cool and distant new technology, isn't it? It's the old technology that you're dealing with.

Very much so. I'm dealing with stone-age stuff, leaving my scratch. Or I used to. I have arthritis in my shoulders now, it's impossible.

One of the more recent things of yours that I've seen and enjoyed greatly is of course in my beloved Tenby, and the museum there with the mosaic. How do you approach a commission like that? How did that happen?

Well, I had had very little to do with mosaic, but one of the things about a career like mine is that you're very reluctant to turn a job away. The mosaic was in fact the result of a competition, and I don't know why I was one of those invited to submit ideas, but I thought a mosaic would be the best thing for an exterior wall, that paint wouldn't last, so I submitted this idea.

And the actual making of the mosaic – you designed it, you made it as well, or with help?

I made it on my own. Again, this chance – it's amazing how chance has affected my life – Judith and I lived in north Wales. We had long journeys travelling, and I was getting old, and so at the end it was the matter of better jump rather than be pushed, and we decided to come to south Wales. I had a hernia at the time. We found this marvellous flat which would just do for us. We came down, but I was saddled with one thing. I'd got this commission, the hernia had intervened, and I was saddled with this and had to get on with it. My daughter, at that time, had some rooms in the Model House in Llantrisant, where she pursued her film career, and it was she who arranged for me to be a resident artist while I finished this commission. I took a couple of rooms, and a great table which I made of block board, and arranged the mosaic there in pieces. It's a difficult process to describe. It was all done in reverse.

But you'd never done a mosaic before, or rarely?

I can't remember... yes I had. I'd made a small one in Ratcliffe College, which is a major work of mine. Not the mosaic, but the chapel, in the early

Sixties. It was a public school in Leicestershire, I think. The head was a priest, who came on holiday to north Wales. He'd seen a little statue of mine in a local church in Cricieth, and contacted me. He was a very forceful character, a bit like Huw Wheldon, very trenchant, down the line, active and positive. He said, "We're building an entire chapel, a new chapel, and we need everything; altar, organ grilles, candlesticks, statues, stained glass, all sorts of things. I've seen your little figure in the church and it's just the sort of work I want. I don't want pious repository art." And that was a very large commission. It begin in the Fifties.

It sounds as if on many occasions someone has seen something, or heard of you, and you have been approached.

That's right, yes. All my life.

You do what you do, and people come to you and want what you do.

That's right. I did all the statues, I can't remember how many there were, I painted the baldichino above the altar, huge thing, candlesticks even, the great inscription on the war memorial, a great carving outside in relief, all sorts of jobs. But this same character, Father Leetham said, "Well, that's fine, now what do you do about stained glass? Got all these gaping holes, they have to be filled with stained glass." "Oh," I said, "I know just the man." John Petts had turned to stained glass by then, so I wrote to John and said I'd got a big commission for him, and dear old John, I could kick him, he never even answered. That was like John. He would put things aside.

Really? Because there's a good window in the church in Fishguard by Petts. He didn't even reply?

He didn't even reply, and it went on and on, and the next time I went back to carve another something or other, Father Leetham came along and said, "What about the stained glass? What about your man?" "Oh, well he hasn't answered." "Well, then, you must do it," said the priest.

You did the whole chapel then, didn't you? Jonah's chapel, in Leicestershire

That's right, yes. It's all my work. So I had to do the stained glass. I'd never done anything like that, but I did know Keith New, who did quite a few of the Coventry Cathedral windows, and asked again if I could spend a little time with Keith, and that started it off.

Which was both practical and humble on your part – never too old to learn.

I'm very hot on humility! And then when it came to a kiln it was a problem, because it's a very special kiln for stained glass, it has to be specific. But I knew somebody from the Gas Board who had given me some commissions for some reason. Merfyn the Gas he was always known as. The big boss, and again a character. Merfyn the Gas was well known. And I said to Merfyn, "I need the kiln." "Right," he said, "we'll make your kiln provided we can film you and use it for advertising." And that's how I got the kiln.

This is the artist in the real world, isn't it? Very practical, very realistic.

And taking opportunities, without being a prima donna. If the work is there, you must have a go.

You've been in Wales off and on since the war. What about the state of Welsh art? What about Wales as a place where the artist can function? I mean you have been successful and you've made a living, but at the end of the war, most of Britain, never mind Wales, must have seemed a pretty unprepossessing place for someone who wanted to make his way as an artist. You must have seen great changes in that time.

Yes. It was very unpromising after the war, there's no question. I think Petts himself was heroic to take it up again, but what choice did he have? That's what he left, and why shouldn't he go back? We were both mad. But you had to be mad, you had to be. Like an art student I met in the Glynn Vivian the other day, when I was opening an exhibition: he was talking in a glib sort of student way, abstract thoughts about doing it, and I couldn't understand it, and I said, "Being an artist is just doing it. Do it." And that's what it's about, really. Do it.

On an individual basis yes, one does it, whether the vision precedes doing it or whether the vision comes through doing it, is something that one has to discover for oneself. But in terms of the overall context of living and working in Wales, things have become much more organised, structured and supportive, haven't they? And you've been part of that, haven't you?

Yes of course. I should go back to your initial question. Yes, it was most unpromising. It was interesting that John failed at this. He didn't fail, but he knew – again, jumping before being pushed. The Arts Council was just coming into being.

So if the Arts Council had been around a couple of years earlier, that could have been a helpful crutch to him.

Instead, he joined the Arts Council as the first Director for Art, or some such title. The Arts Council was one of the great initiatives of the government at the time, the Labour government, dispersing funds where they were needed, and establishing a structure in which that could happen. So what was initially unpromising grew, and it's been a marvellous thing to see, because Welsh society, if it wasn't hostile to art, it certainly wasn't promising. It wasn't exactly Chelsea. Although you know people like Augustus and Gwen John had come from Tenby, and Nina Hamnett. Nevertheless, they were exceptions to a rule, which was iconoclastic, really, to the image. There wasn't much room for art and artists at the time.

Certainly not before the war.

No. And so it's one of those post-war things that have grown up in society in general and particularly in Wales. Artists have emerged, out of the muck and poverty and deprivations of war, and the decline of the native industries. Art has become accepted, and is quite a large industry in Wales. I mean, the Arts Council has recently issued an analysis as an industry in Wales the number of people whom it supports, whom art supports. Art and

craft is very much a living for people in Wales now, and I was able to help a bit in this because I was appointed to the Arts Council earlier on, and all told, although I've been lucky, and I know I've been lucky, and I've made my living, I've tried to put something back. I was reckoning the other day I've done thirty-one continuous years of public service in the arts, either on the Crafts Council, or on the Arts Council, or the British School at Rome, and so on. There has been quite a bit of enabling, so now the Arts Council will lend a limited sum to a young artist starting off, or will even award a bursary, if they're sure of their talent.

Something which you could have done with straight after the war, really. Scraping around to do that Powys bust.

Yes, yes. It didn't exist then, and it was very much needed, and fair play, the Government established the Arts Council, and that's done its job ever since. And people grumble a lot at the Arts Council, but I know the difficulties of dispersing public money. You're never right, never, in the public eye. And even artists will groan about it, but it does a job.

We've reached the end of the century, counted in Christian terms, anyway, and things are in pretty good shape in Wales. There's no room for complacency, but you and I come across each other in somewhere like Martin Tinney's, a commercial gallery in Cardiff, and people are exhibiting, and people are buying art, it seems to me in this area, like there's no tomorrow.

I'm astonished at that, and that is a sign of the times, and it delights me. It's almost a completely different society. The core is still there, there's still something about being Welsh that is special, and that outrageous *Guardian* journalist, Julie Burchill, in one of her outrageous essays, said that she longed to be Welsh. She explained what she meant. There is an identity, an enthusiasm, which stretches across a lot of activities, not just rugby, which is now very much the arts, and it's marvellous to see especially young people starting up now, earning a living. It's not always easy, but there's some marvellous work being done. And there's the patronage of course. You go into a gallery now for an opening, and the red spots soon appear.

Yes, it's true. I'm very enthusiastic about this young painter James Donovan from Hirwaun, and it's not ridiculous for someone like James, straight out of college in his mid-twenties, to at least be aiming for professional status. To make his living as a serious painter.

It isn't easy.

It isn't easy. It wasn't easy for you coming out of the war, but in a sense everything was thrown up in the air after the war and if you could spot things coming down you could at least take advantage of that.

The chances were there, yes.

There's a lot of official support and patronage now, and that's only to be applauded, I think.

Yes, and of course there's some very good work being done. I'm still irritated by a notion that is English, really. They moan a bit about devolution,

and they want to be devolved themselves – I'm still irritated by the idea of Cardiff as a blob at the end of the M4, and Wales as a land of sheep. That still goes on, and I find that very irritating. There's still no idea beyond Offa's Dyke that in fact this society is as vibrant as it is in the arts, you know, of writing, music – one of my grandsons has just been appointed to the National Youth Orchestra of Great Britain, and he's now in Birmingham rehearsing for the Proms this year.

The Wales you came to first in the late Forties and Fifties. As you said, there was Bertrand Russell down the road, there was Huw Wheldon, Clough Williams-Ellis, John Cowper Powys, this was a kind of Welsh renaissance you came into. It wasn't just peopled by sheep by any means.

No, it never has been. It's just one of those idle generalisations that the English like to make about the un-English.

But your life has been partly, and maybe centrally at times, about locating yourself in every sense; spiritually, artistically, physically, in Wales. You must feel as if your life has been about coming home, and rearranging what you find here and making it your home.

You've got a very central point of my life there. I do feel that. But I also feel that I'm still a Durham boy. The other day I bought a new car, and I went in and I was talking as I'm talking to you to the salesman, and at the end of it, "Do you mind if I ask you, Mr Jones, you don't happen to come from the North?" "Yes,' I said, "I come from Durham." He said, "So do I. I spotted something."

Oh, it's still there. The accent is still there.

It is, very much so. But the odd thing is it's not alien to Wales. There are some vowels that are the same, and some accents that are the same, in south Wales in particular.

So in a sense, would it be useful to characterise you as having dual nationality?

Yes.

You're a Welsh Geordie. A Geordie Welshman.

Yes. Very much so. Who speaks Wenglish! But I do feel sometimes 'deraciné'.

Well, identity is something we opt into and out of. My accent always gets a lot stronger when I get on a plane, I find. I become a real Taffy at that point. The last thing I'd like to talk about is religion. You're involved with the legacy of Gill, although you felt resistant to some of those things. You've undertaken what was clearly a major commission in terms of Ratcliffe College, which was a Catholic school. You are obsessed with the vision of Jacob, the figure of Jacob, as someone wrestling with God. It is a central image, the idea of wrestling with, physically engaging with one's identity and existence, and that is what carving and sculpting is. Have you also been wrestling with God?

Yes, all my life. Brought up a Congregationalist. A Sunday School lad, my Grandfather saw to that. My father was ruined by the war in his eyes. Came back, he drank beer, which was awful. My grandfather once caught him in

Pilkington's Billiards Saloon, saw the smoke coming out of the window, and shouted up, "Norman, come thee down. Thou art in the midst of Hell." That was the sort of thing I was brought up with, and it never leaves you. Yes, I've wrestled, like Jacob, I suppose. I would say I'm agnostic, basically. Agnostic is the basis now, which seems odd late in life, but that's how I stand.

And yet some of your principal work has been religious – Westminster Abbey, Ratcliffe College. For someone who carves the word and carves images, the church is a natural repository and a benefactor.

Very much so. I owe a lot to the Church. I belonged to it for a long while, as a Roman Catholic, which of course my father would never have countenanced.

Oh, you converted to Catholicism? When was that?

Way back. Late Fifties, mid Fifties. And of course the Old Testament figured largely, especially with my grandfather. When I did carve a stone, quite often it was about the Old Testament, and I think I've written somewhere about an old friend who said that he'd forgotten so much – his memory was going – that he only had five books left, really, and when he'd finished the fifth he went back to the first and had forgotten it. The same thing is going to happen to me, soon.

But two of those would be the Bible *and the* Mabinogion.

Yes, and the third would be Thomas Mann, *Joseph and his Brethren*, which is about Jacob. Oh, what a story. It's just a narrative, in Mann's own language. It's wonderful. That would be one of them, yes. Daft thing, really, Jacob. Why is that an obsession? I think you've got to be daft to be an artist, anyway.

The Sea, the Sea Portland stone, 1978, collection: Mr David Lewis

DAVID NASH

I visited David Nash in March 1999, after meeting him in the Le Long Gallery in New York the previous October. He lives in a converted chapel, Capel Rhiw, in the slate town of Blaenau Ffestiniog in north Wales. The body of the chapel is full of his work, monumental pieces and groups on both ground and balcony levels. We visited his modern factory unit in the town, and had this conversation on his wooded hillside a few miles away by the stream in which his 'Wooden Boulder' lies.

Back in October we first met when an elevator opened on the top floor of the Le Long Gallery in New York and there you were in your boiler suit setting up a new exhibition of work. One of those pieces 'Cut Corners Square' is back here in the chapel, Capel Rhiw, where you live and store your work in Blaenau Ffestiniog. I have this vision of David Nash sculptures, with a life of their own, in transit around the world. You must have works in ships and planes somewhere for a fair proportion of each year. Does that sheer weight of studio and exhibition management get in the way of the creative process?

Well, this interview is part of the 'management': you've been fitted in and I've given you the time. This is an aspect of my life that accesses my work to a more general public. I have a policy for doing that, because if I don't do it the evolution of the work slips out of general evolution; if an artist only shows his work through private galleries it's only really clients and a small art world that sees the work. I've noticed artists just disappearing and I thought they had stopped working, but they hadn't; it's because they are selling their work directly and they don't need a public show or to do interviews. They have peace of mind and a lot of studio time, but that often leads to a disconnection with the larger human community. Fortunately, I work very quickly, being a very choleric and sanguine person, can handle a lot of things at any one time. I am quick in making the work, as long as the preparation is sound. So a lot of my preparation is in administrative work, making sure that when I get to where I'm going to work, or where the show is to be put up all is clear. It's like getting all that work up in the Le Long Gallery on the fifth floor in a passenger elevator, they don't have a freight elevator. So the whole thing was an elevator-designed exhibition, just like the Royal Tournament, dismantling a gun carriage to carry it across a chasm. That show was made here from accumulated work plus some new pieces and I made sure that it could all be slid in and out of that elevator. Even these immensely heavy pieces of wood had to go in at a certain angle, had to be put into the container the right way so that when they came out they were facing the right way to go into the elevator. I actually love all that – I love the engineering and the practicalities, the finances, they are all part of the cultural and social experience of making art. It's all one. I like to think that I'm clear and that all these things are in balance with one another. I can't let the art completely take over, so that everything else seems a drag;

or let the social aspect take over – meeting people and giving interviews; and I mustn't let the economic factors completely take over. You have to have the three spheres overlapping and in balance. And that is partly, maybe even largely what my work is about – how does an individual interface with nature, the environment and fellow human beings.

So what starts on this hillside, what you are making and tending here in Maentwrog, is not in conflict with the New York gallery?

The difference is that what you saw in the New York gallery was a controlled indoor experience, inside a building. Human beings make buildings and indoor spaces to neutralise and calm the elements down so we can live without the constant battle with them.

That's the basis of our civilisation. Once you make your hut you can make nonutile, art objects.

The hut is more necessary in a northern or temperate zone than in an intemperate zone, or the equatorial zones. 'The Cracking Box' is for indoors, and it can only happen inside where it's dry. The dry air sucks the water out of the wood and it cracks. Experiencing objects and physicality in an indoor environment can be like a temple experience, very calm. What you see here in Maentwrog and the 'Wooden Boulder' is all to do with being outside. But the concept is still that of making a geometric form with an aspect of its material nature which will challenge the geometric form I have imposed on it, so that it answers me back, and breaks out of square. Outside where the elements are active we experience physicality in a different way, more connected with time. On this land my sixteen birches leaning out of square are an 'outdoor' way of dealing with the same concept as the cracking box, expressing an idea with a material that answers me back, reacts to what I do to it.

But that's one of the problems of the art world, that people, ordinary people, find very intimidating some of those indoor spaces, even publicly owned galleries – the Tate, the National Gallery. And they find the commercial gallery particularly intimidating.

Yes, but the commercial galleries don't particularly want a general public, they're there to sell the work. They have a love for the art, but they have large overheads. There's a huge difference between the commercial show and the public exhibition. The second is sustained by public money; so for a public show I will bend over backwards to make the work accessible. I want their first sight, the first thing they see, to be very welcoming, I want them to smile and come in. I don't want to threaten them. And I'll include special drawings to help them – like the map drawing, and the family tree drawing – to make the work accessible in an education sense. Commercial galleries don't want those things. A French gallery asked me, "Are these drawings obligatory?" They didn't want them, or the explanation for their specialist audience.

You still do some teaching, don't you? You're still, in a sense, an educator.

DAVID NASH

Yes. Both Andy Goldsworthy and I supported ourselves as artists by doing residencies, artists in schools, museum shows; neither of us was picked up by a gallery for some time. We handled our own business and were teaching – very social, in fact. It's in the fabric of the work to have this wish to communicate to an unknown human being, whereas in the commercial world the gallery is directing it to the known human being, often specific clients. They'll do a show and they will make sure that specific clients know about it.

At the Le Long show in New York quite a few works were sold, and they were substantial works. When we asked the front desk, they indicated that most were going to private collections. That is impressive, and it also says something about America, I think. Some of those works were very large, they wouldn't fit in my house!

Some of those clients have several houses in different parts of the States and Europe.

How does that feel? You make the work, it's put into a container, goes across the Atlantic and into someone's collection, becoming part of their property. Do you have any rights to see it again? Or is it that in a sense once work goes into a private collection you simply move on to the next work?

I have photographs of all the work and the artist retains copyright by law. It remains part of the opus. Because the piece is known to be part of my work it is an example of the ethos of the work. The buyer is taking in this idea and it mixes in with work by other artists that they have. Because they are paying for it, it is very likely that piece is going to be looked after. I've noticed that when I give a work away it often isn't properly looked after; there hasn't been an exchange of value.

But let's take the pieces that went into private collections after the Le Long show, you don't know how that piece is going to be kept, or positioned. That's gone out of your control, hasn't it?

Yes, but legally they now own that piece: they can put it in store, they can paint it blue!

You have to be like Sutherland – once the Churchills took the portrait of Sir Winston, it was at their disposal.

Well, that should have gone to the National Portrait Gallery. It was a curious idea of a gift to someone of such conservative taste.

But any artist who makes a living has to very rapidly come to terms with these orphans leaving you, and only maybe keeping in touch with them.

You have to feel confident that the galleries you work with will handle the work responsibly. My work has seldom appeared in auction or for re-sale – which means that the collectors are buying the work to keep, to live with.

So even if someone dies, the work is valued and kept by the family. That's especially important with site-specific work, of course.

Often I meet the clients and make the work on their property with their wood, so a personal relationship is established, and many have continued

to support me.

You are happy to do that, but presumably there are occasions when you are approached and find that the project doesn't appeal to you, and you turn it down?

You have to go through a clear process at the beginning to understand what the approach is. Where is the motivation coming from? One is always working in partnership with the gallery. They have sold work to these people before, they know them; people come to the gallery because they trust the gallery. What interests me about working in other countries is that every place in the world has unique circumstances, and my ideas for the work come out of those unique circumstances. Those ideas will then be unique to that particular place; I would not be able to find that idea in my own studio.

So your galleries in London, Japan and New York would act as an agency, pass on enquiries about commissions and, to an extent, vet them at that stage?

And to a certain extent they would take part in the administrative aspects and the seeing through of the project. Sometimes it's better that I completely take it over; sometimes the client feels more comfortable if everything is done through the gallery.

Before committing yourself to working on the other side of the world, there would be a lot of correspondence, quite often slides or video of locations etc. that sort of research?

While I'm in America making a work I will take the time to look at another project or two or three projects, to determine whether there's a future in any of them. But I have to personally be in the place. That's for outdoor work, but I really love doing work for a domestic space, family homes. That's the place for them: they contribute to the ambience, to family life.

And they're not furniture in any way.

There's a piece of mine in Belgium that an osteopath has; his wife is blind, and this 'Vessel' is in their play-room with the young two children and their toys. The kids love it, and the wife likes to feel it.

You don't mind people – not just sheep, but people – rubbing up against your work?

It's a very warm, instinctive material for the human being. Every culture in the world has had wood as part of its life – shelter, heat, containment, instruments, furniture, doors.

Yes, when you were talking in the Le Long Gallery with Simon Schama's students I saw that you were touching the work and showing them that it was alright to do that. Which presumably galleries don't like.

The problem is that if I have burnt work in a show, and people touch that, they then wipe their hands on unburnt work or on the walls.

When did you first start burning, or rather charring the wood?

The first was a Christmas Day piece in 1972; I didn't do anything with it for a while. I charred its surface and began to understand more. The emotional response to a charred piece of wood is very different from natural wood.

DAVID NASH

So you began, in a sense, to paint with woods – you've used north American redwoods, you've got the natural variations in the wood itself, and the black of the charring.

Yes, and with indoor work you've got the white of the walls. You've got red wood – red, burnt wood – black, walls – white. As an experience, wood is kind, it's warm. If you see a wood sculpture, first of all you see wood, you 'feel' wood, and then you see the form. If it's black, it's not a wood experience, it's carbon, you see the form before the material.

And it doesn't welcome in the same way, it's more confrontational, isn't it?

You see form before you see the material: there's a different sense of time, it's deeper in time, also further away from you, emotionally. Being black, it's psychologically in a different kind of space.

Earlier we looked at some black crosses – the big redwood cross and also there was one outside of your 'production unit' in Blaenau. The cross does have complicated and worrying connotations, doesn't it?

I first made crosses by marking an egg form I had carved. I marked it with a saw and made a pattern in the integral form of the egg. I pressed beyond the surface into the egg; there were various shapes I used – a square and slices to penetrate beyond the familiarity of this perfect ovoid egg form, to take the space further into it. The cross made with the saw was a very easy way of getting into it. Then I got interested in the cube, sphere and pyramid which, I learned from Plato, are universals. They have this complete

Descending Vessel
oak, 1993
Margam, South Wales

Two Charred Eggs redwood, 1998, private collection

openness to them, they remain a 'universal'. The cross does not have that 'universal' sense. When it's appropriated it is lost to that appropriation.

'X' marks the spot, in one sense.

In its purest sense it is two lines crossing to mark a spot otherwise invisible. Yes, in every culture it has different connotations. The Japanese have no religious problems at all with it.

In Japan you did those two cross pieces packed with snow and then burnt.

With the right hand one the cross was carved deeply into the wood, you look into the wood to the blackness. With the left hand one the cross was cut right through, you look through the cross to the light. Black and light crosses.

You had two in the Disclosure(s) *show in Newport, I remember.*

Yes, there I was interested in working with the Celtic cross. In Germany it's a strong mythic form.

But with political associations.

With what happened with the Fascists. In New York the gallery didn't really want the crosses because of their Jewish clientele. Though we did include them because they are some of the forms I am working with at the present. The most successful crosses have been when I've had a volume of cross, a thickness to them, so you see volume before the symbol. What you have with a cross is the crossing of a point with above and below, left and right. Successful in losing connections to historical associations.

DAVID NASH

At the same time there is the cultural weight of the tree – the cross, the Anglo-Saxon rood, it's the life force, but it is also perhaps the place of death. Simon Schama's 'Landscape and Memory' is so insightful in that respect and it's clear why he is attracted to your work. It's about locating a place, a time, and you in relation to it.

But I can't insist on this interpretation by other people, so I'm feeling overwhelmed by it, the emotional reaction.

I love the range of your work. For example, 'The Striders', are so funny. You are a very serious and profound artist and yet it is refreshingly human, and 'The Striders' are so jokey.

There is a big difference between wit and humour. I like to think that those pieces are humorous. Humour is the oil for the human being. We couldn't cope with life without it. The early Seventies British sculpture was very humourless; Minimalism was very humourless – I loved the philosophy, hated the objects – so I followed Minimalist philosophy, but I tried to bring more human warmth into it: I prefer Rothko to Donald Judd. Rothko I feel has a profound, human, moral quality; in Donald Judd's work I admire the proportions, the design, the materials, but I don't feel anything and my spirit can't go anywhere with it. Rothko is a real minimalist, like Brancusi.

You visited Brancusi's studio, and that was important for you, wasn't it?

Yes, the first reproduction of it in the old modern art museum in Paris. Because it was all put together like a jumble, it was a revelation of what it meant to live in your studio.

And the way the pieces strike off each other. Going into Capel Rhiw is quite an experience. In one sense it's an enormous warehouse; and in another sense it is a wonderfully confused gallery space.

But what animates it and keeps it fresh is a bit like that stream of water which keeps the wooden 'Boulder' alive. And the stream is myself and my wife and children and friends and visitors who come through, walk through, walk down the aisle to get to our home. It is a huge entrance hall to our house.

They get to you through the work and you can't access any other way. And then there are the neighbours watching you in. How do they regard you? Is there dialogue?

You don't know what people think. When I first came here I was very self-conscious. And then I overheard two women talking about me: they said I was the son of a millionaire, I was red-cheeked and always smiling because I was on opium! None of that was true but it was very liberating – why be self-conscious when what people are thinking of you isn't true anyway?

These fictions liven up the community. You are an international artist and you are away from Wales a lot.

I'm never away for more than three weeks at a time. It comes to about three months away each year.

But there is a considerable amount of organisation involved in supporting what

you do as an artist.

Yes, and I've unfortunately lost the services of my assistant recently through illness. So I'm getting up at six and working through to eight thirty to do the office work and then get to work making art.

What relationship do you have with other artists in Wales?

I have had very little to do with any artists from anywhere: that was partly to do with my coming here, to be out of it. I wanted to find my own life, to be free, to be able to live here, somehow. I felt that in London, and the other art communities I knew of, that everybody knew far too much about each other, and wanted the same bit of cake. I'm not competitive. I didn't read art magazines – a lot of the artspeak is laughable, written for a small number of people. I can imagine the writer writing it just for three or four people he respects.

That sounds like a poet – you might as well post the things to a handful of people. But what about your experience of formal education?

I got in the habit of not seeking other artists to spark off. I was lecturing in art schools around Britain and met a lot of other artists within the professional practice of teaching. I still value that experience. I've just taken up a professorship at the University of Northumbria and have groups here, four students at a time. They come partly to explore the area and do one and a half days helping with whatever I'm doing, and we have seminars in the evening.

You've mentioned the influence of Brancusi, but who else was important to you?

Rothko, Ashil Gorky, the Expressionists, the Blue Rider group, mostly painters, philosophies – the Tao, the *Tao Te Ching* of Lao Tsu was an important text.

I can see that the elementals of red and blacks in some of the wood pieces are creating effects that aren't too far away from Rothko. What of your contemporaries?

My immediate contemporary is Richard Long. We're the same age but it's as if he's from another generation because he appeared so quickly. He had a show in the Guggenheim in his early twenties.

Your own international reputation came in the 1980s didn't it?

Yes, it's been a very gradual growth, like a tree, and that's the way I think it should be. Fortunately, the galleries with which I work don't burn their artists out.

As we sit here in the midst of your growing trees it seems obvious that they will have to be patient. I saw a drawing by Long in the Bristol City Gallery which was created with Mississippi mud. It was wonderful.

Yes, he's an important artist. He stepped over the barriers which had been built by the Anthony Caro school of welding. Gilbert and George did, the two evil archangels as it were, and Barry Flanagan did.

And Andy Goldsworthy, who has covered rocks with leaves and shares your sense of the temporal.

I met Andy Goldsworthy, who is ten years younger than me, when he was

still at college; we have been very supportive of each other; we show in the same galleries. There was an assumption when I was at art college that sculpture was to last for ever. A lot of the techniques you were taught were based on that assumption. It's part of the impulse of our time to question that longevity. When you take that out of the equation a lot becomes possible which wouldn't have occurred before.

As I was walking up the hill I asked you about photography, which is the way that a lot of people will experience your art. There's an ambiguity here: viewing and entering the growing dome one has to trample up this hill, and you don't want a lot of people doing that, do you?

No. Well, I'm glad it's not a disappointment, because often after seeing the photograph, seeing the real thing can be a disappointment.

The 'Wooden Boulder' was a disappointment for me – I wanted it wet!

Most people want it to be bigger.

But the photography is part of your process; it's a necessary compromise. You do take many of them yourself, anyway. But people come to those works having seen a very good photograph, shot often from what seems the perfect angle.

The photographs build up the total story of the 'Wooden 'Boulder'. You have only seen it at one moment of time; another time you might have seen snow on it, and another time with water pouring down on it. But that is all part of the point of the piece – it is continually changing. It works in a different way from 'The Angel of the North', or a Rodin's 'Balzac'.

It is potentially in motion, and that's another thing about sculpture; it's true of the three forms that you've been dealing with – the cube, the pyramid, the sphere – I love the way that you can show them with the three drawn forms behind them, the playing of that trick with two and three dimensions.

That's almost a scientific piece of observation about the way we perceive the physical world through our body scale which is one experience and images in two dimensions, which is another, different experience. The perception of a two-dimensional image and a three dimensional object, the actual mechanics of perceiving, are very different. That's why the forms are so simple; I wanted to reduce the subject as much as possible and focus on the experience happening simultaneously.

The charcoal drawings are more threatening than the actual objects. In that kind of Rothko sense of being pulled into the dark. It's more reassuring to walk around the pieces themselves. There's an interesting tension created.

They feed into each other and enhance each other – it's like in architecture when you have two spaces that lead into each other, so both spaces lend extra feeling to each other.

And especially in church architecture. Are you religious?

I was born, educated and raised in a Christian culture. Morality is fundamental to Christians and although I've found, along with most creative people that the Church is unbelievably sick, I never closed the door entirely on it: the spiritual life and, essentially, Christ. The possibly heretical

understanding of the Christ impulse described by Rudolph Steiner has real-
ly interested me.

*Which brings us to the Steiner school. You and your wife, Claire, set that up, a
remarkable thing.*

We were part of a group of people. We were not especially sociable, but we
found our kids needed a more inspired education, certainly a more artistic
one, we found that the Steiner curriculum interested us very much. We
could see their success in the kids who'd been to a Steiner school. That led
us to research a lot more into Rudolph Steiner; to teach in a Steiner school
you need to have that understanding of Anthroposophy. You don't teach
Anthroposophy, but it will give you an understanding of the developing
child. It's patently obvious that it works. The child is given the appropriate
subject-matter at the right time; so that they can be properly six, and prop-
erly seven in their way, to take the essence of being seven into their own
full future life.

Without a government inspector coming along with a measuring tape.

The Steiner schools are highly regarded by the Department of Education.
We were financially involved at the beginning and we put all that we had
in terms of time to spare. We helped to fill the gap.

How many children does the school have?

Forty. There is a kindergarten and junior school. We've had in up to a hun-
dred and ten when we tried to also have an upper school.

*It not only connects with the central place that creativity has in your lives, but
also underlines the essential practicality of you as a person. It strikes me that you
want to see if things work, how they work, and you will be very flexible in
adjusting approaches, philosophies to what will work.*

The philosophies that I found myself reading at school and as a student
were dead. They had no practical application into real living. Tao
Buddhism though made sense to me; that is practical. What I met in
Anthroposophy was an understanding that everything in the material world
has a spiritual connection, good and bad, and that you have to observe what
works and what doesn't work. It's a philosophy which says you should try
out these approaches, particularly working together as a group: under-
standing that a problem is a gift. If you observe it properly the solution is
always within the problem. If you have a group of people observing the
problem without opinion; if you objectively say, "This is the problem as I
observe it", then together you can build a picture of the problem. There is
a lot of discipline involved in listening. What most people do in any group
situation is immediately say what they think the solution is without seeing
the whole picture. That's one of the ways that the management in a Steiner
school works; it takes quite a long time but you get much more accurate
results and much more accurate assessment of problems.

*So the logical step from there is to see you as an artist who will be open to the
feelings of others.*

DAVID NASH

The best example of that is when I go on a project for a museum show. I will meet the people of the museum and then check that the budget for the project is a reality; I will first experience the space, all the practicalities – width of doors to bring in large objects – floor weight loadings. Then I will see what wood is becoming available locally, wind blown, died, or if it's being felled for social reasons, perhaps a tree is threatening to fall on a house, or parks, always have to take out big, windblown trees.

You need that moral justification; you don't want to go in and spoil anything, do you?

No, because that would have disastrous consequences. There was a French village where the mayor got very excited about my doing a project and offered a huge oak in the middle of the square, a tree that was obviously a crucial character in the village. I couldn't possibly work with that. However the village got to hear that I was being offered this tree, interpreted that as my wanting it, and they thought they would fight me off from that. They never helped me at any point of the project, because of that misunderstanding at the beginning.

Wood becoming available from natural sources is part of the indeterminate aspect of the work. I have to work with what is being given: the space is given, the finance is given, and the material is given and I add them up to create a public exhibition. Part of this is that I will go to a local art college and give a talk; I'll meet local woodsmen – this is usually on the second visit to the location. And then some students will volunteer to come and help me, so I have a little team of people. I need this group of local knowledge; and I need help. We become a little community over a three-week period. The group-social aspect of it is something I have to work at very carefully at the beginning; I have to ensure that everyone is working right and that there's a natural sense of good will. If something goes wrong and the good will goes, then the whole creativity is gone. On one project a young video team had been hired by a private client, and they were a bloody nuisance. The project crew were young and they loved the video team being there; I was giving the video team a hard time and my crew supported the video team. The group creative will dropped to zero. It was awful.

You've just taken me to see the wooden 'Boulder', which is working its way to the sea. It won't make it, will it?

I doubt it because of the tides and the way that the estuary works. It's poised at that point in the little stream where it joins the bigger river. It's like at that point on a tree where the branch is going into the trunk.

The two principles are at work again here: in the sense that the work emerged almost as if it wanted to from the large trunk of a felled tree nearby. And it told you that it wanted to be a boulder. It's been transformed but is still in its natural context, left for those forces to work on it. It's almost the reverse of a gallery piece.

It's very much a story-attached art work, because I've kept a narrative going of it, and it's been documented, there are drawings of it, I've written about what I've observed through it. For me it's a stepping-stone into the reality of that particular stream. I hadn't realised how much the amount of water changes, and in autumn what happens when the leaves come down. I think that work says something of my temperament, how I am in the world; I need to see what is being asked of me, whereas another artist might will their idea into the world. The idea is born in them and they will force that to happen.

I'm more inclined to see what is possible physically in any given situation, and see what is appropriate socially

Many landscape painters, it might be argued, do that: they take their idea of the landscape into the landscape and actualise it there, rather than going into landscape and experiencing it without preconceptions.

Some will produce a portrait of the landscape, which will be then seen inside. At what point did the wood become 'boulder', named in your imagination? When did you say, "I know now this is what it's going to be"?

Pretty much right away when we put it in the stream. I hadn't imagined it staying in the stream. Just as I hadn't imagined staying here in Blaenau. The geography, the nature of the place was my initial welcome as a child, and this unpredictable weather – another indeterminate – and the investment of time and experience involvement here.

You have known this area since your childhood, then?

The connection goes back to my grandparents; my grandfather was from Shropshire, just over the border. He started in Newtown as a pharmacist. My father was born in Newtown and they moved to Aberdovey where he went to school. My grandfather was a very wild entrepreneur and moved to London to start a department store on the assets he'd achieved as a businessman and as a pharmaceutical inventor. He made cure-all oils, he made ginger beer, he made a mail-order toothpaste. He bought all the British Army boots after the First World War and sold them to the Turkish Army. And he did it a second time but they all rotted in the ships because there was a docks strike. He made and lost huge amounts of money. My father understood himself to be Welsh, born in Wales but of English parents. I can't claim to be a Celt, though I've had a long association with this area. I have Anglo-Saxon blood, which leads to Anglo-Saxon thinking, which is more materialistic, unfortunately, than the Celtic.

My grandparents after the war still spent most of their lives in Wales. They bought a big house just outside Blaenau Ffestiniog for their old age. By that time they were paupers really; my father and his four brothers kept them, sustained them in that big house which they'd got used to. All my summers were spent here from the age of three, and it was the only place I really wanted to be. I wasn't happy living in a suburb of Weybridge. I went to art school in Kingston after going to an English public school,

DAVID NASH

Brighton College, where my father had gone. He had a marvellous time, but I hated all that English middle class phenomena. It feels like you're being punished, but you haven't committed a crime. However, there was an amazing art master there – it always intrigued me why he was in such a place – but perhaps he needed somewhere to be subversive. I owe him a great deal.

As an art student, initially a painter, but soon becoming a sculptor, where could you set yourself up? For financial and sentimental reasons north Wales must have seemed the natural, obvious place for you.

There was an economic reason, because while I was a student I could buy two small houses with a beautiful position and an amazing view, and a bit of land I could work in, for three hundred pounds. That was after my two years at Kingston. Then, before I went to do post-grad at Chelsea, I sold the first place and bought the chapel for two hundred pounds. I would have got it for fifty pounds but some man wanted to strip it of the scrap iron and raised the bid. I got a bit of part-time teaching around the country to make a living. Up here I did a bit of building work, decorating and I planted trees for the economic forestry group.

Did your tree labouring give you clues about what you wanted to do?

Later, but I knew I didn't want to plant trees in rows. I wanted to re-plant this piece of woodland which had been cut down before I acquired it. I didn't want to plant in rows; I wanted to plant deciduous trees: when you plant one tree, where do you put the next? It's an immediate question, the space between the trees. That led me into this idea of growing spaces over a long period of time.

Sculpture is about excluding space, enclosing space, defining space. And even this hillside has something of the principle of garden about it. It is an arrangement, a re-arrangement, an improvement of nature.

People talk about topiary, the English Garden – Capability Brown – but I'm coming from a sculptural discipline, I'm still bringing a sculptural concept to what I'm doing.

You committed yourself to Wales at a time when there was a lot of political activity, even violence. Houses were burned, road signs were all being painted and there were certain Welsh nationalists fighting back against English incursions. Was that a problem for you?

Yes, for both of us and particularly for our children, though they were at a Welsh school and learning Welsh. We had planned to move away when they were teenagers because we could see what the problems were going to be. Then we got involved with the Steiner school, which had the basic principles of what we wanted for their schooling.

So your children went there?

Yes, the younger one particularly benefited, but the older boy, who was very bright, just had two years. But for that time he had an excellent teacher who managed to connect his head to his heart.

WELSH ARTISTS TALKING

Claire and I are part of an ethnic minority here; the Welsh, like the Irish have justifiable grievances. We knew when we came here that it would take twenty-five years to be accepted. There have been some very positive programmes on BBC Wales and HTV which have helped and local people have been extremely warm.

But you're not coming here as a coloniser; you're dealing with the landscape and maybe you're showing people what is here around them.

I don't draw any attention to my work here; I learnt that very early on. You are doing this very odd thing and your neighbours have to take a position about it, because they are having to live with it. And it's probably going to be negative. Though I did have some support and interest. I thought that I was coming here as a hermit to do my own thing, where there were no contemporary artists, and I didn't think anyone would be interested. I did not think that I'd be travelling the world and having people wanting to write about me. I didn't know what the work was going to be then.

You've got your chapel, your buildings, your hillside, and a factory unit. You are an employer.

Yes, we put fifty or sixty thousand pounds into the local economy each year.

It's not just that your boulder is in the stream, your trees are being bent artistically just outside the town. You are reflecting their landscape back at them, if they want to see it. And you are a presence in the town. When I asked for directions you told me just to drive into Blaenau and ask at the filling station. You are a landmark.

A presence without anything being forced on anybody: these outdoor works have a very low visibility.

Yes, I was thinking I must have driven past here many times without realising it was your wood.

I keep it deliberately anonymous. Though the bent larch trees are starting to show themselves. Blaenau Ffestiniog has a very rich cultural history, I hope the chapel with the work in it can become part of that cultural history. But it will need the community sympathy and support; I hope they can be proud of it.

On the other hand, you don't want a brown heritage road sign saying, "This way to Capel Rhiw and the David Nash Sculpture Park", do you?

No, if there's anything left, a trust or something, it will have to be practical, it will have to be working, educational, it would have to sustain itself economically. If it can then it will be a benefit to the town.

When we get into our sixth decade we start thinking about such things, don't we?

Yes, one becomes more aware of being finite.

This is slate country, and you have made a slate stove on that series of stoves in various countries, utilising various indigenous materials. But you have chosen to work almost exclusively in wood.

DAVID NASH

There's a Scottish artist, Andrew Mylas, who works in steel but lives in a hundred acres of wood. Richard Long has been here and taken slate and in due course I've seen that work in a gallery. Whatever I would do is already there in the slate tips. But I've learned from what happens to the slate: the fact of its indeterminate positioning on the waste tips. Letting the material, the wood speak for itself. I want to do a book at some point with pictures of my work and the slate in Blaenau Ffestiniog to show where the inspiration comes from.

At the back of your chapel-house you have this giant heap of slate. It looms over you. Every time I come to north Wales I take a piece of slate home with me. Slate becomes different when you bring it indoors. It's the contrast of wet and dry again.

Your bit of slate is the classic example of the object that has been touched many times by human beings for it to become available for you to pick up and take back. It has a presence of the human being, that is the essence of my work: the presence of the human being on the earth. I love those museums where they have artifacts containing the sensibility of the human being. I once saw a little Chinese jade carving of a horse drinking and something sparked in me. Across four thousand years.

In such a way you began to work on the theme of vessels, which you are still exploring, some more of which I've seen you working on today. Something sparked in you when you saw those shapes on the trees in Australia worked on

Silver Steps redwood, 1987, private collection

by the Aboriginals – it's a vessel, a vagina, an eye...

It's male and female: from the front it's a vagina, from the side it's a big penis. The mark of the Australian Aborigine making that boat is typical of the hunter-gatherer, they know they won't kill the tree. They don't ring it. There are also hunter-gatherers who extract thread from the bark to make cloth, but don't kill the tree.

And that's an informing principle for you, obviously. You want to take, you want to mark, to bend, but you also want to respect nature.

I'd like to think that I've been humbled by the experience of planting trees and growing forms. The ash dome, knowing what I know now, I wouldn't have started. The trees are all having to grow into one light source, when what they want to do is spread into a larger light source. I've learnt that and I'm making other planting works which are based on that very simple and obvious realisation. I didn't know that until I worked with the trees and they told me. I chose to work with wood because it leads me. It teaches me. The wood and the tree and the elements have continually led me.

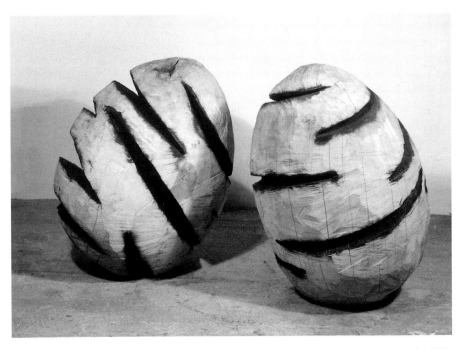

The Whirling Eggs lime, beech, 100 x 70 x 80 cm approx each, 1990

LOIS WILLIAMS

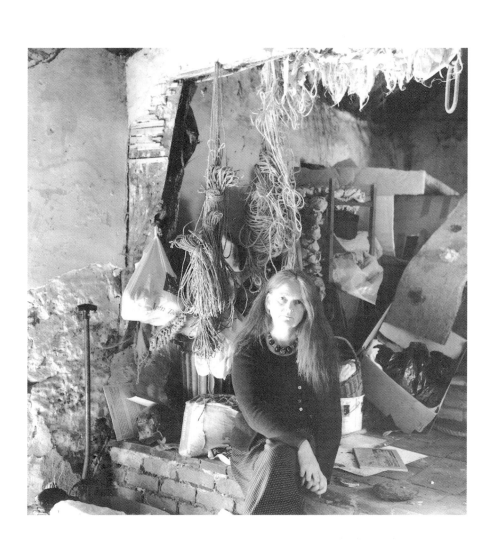

Lois Williams has a studio in an old cottage within sight of St. Asaph cathedral and half a mile from her parents' farm. We met in the summer of 1998 and corresponded at length.

Lois, we are in your studio near St. Asaph. It's an old cottage in some state of disrepair, but, I think, is a place that's important to you. You've been here since 1976 after all. Does this place with its messy stuff have an effect on your work?
I work here and in Sheffield where I teach. But this is my main space and place of work despite having the other studio there. The work certainly becomes part of the building once it's been made – it's like one big environment – but that isn't my intention.

But does the building become part of the work?
I have struggled with the fact that the place can impose itself on the work; this space has a strong presence of its own. My space in Sheffield is completely different – it's just a white box, but that too has its own history in the city. It is a former industrial space as opposed to a domestic space. Often within this studio in Cefn it has been hard to go beyond the dimensions of the house, such as against this wall. It measures thirteen feet and it's hard to go beyond that length here. Quite a few pieces are the height of the floor to the top of the wall, others follow the dimensions of the floor. The walls and this space still have the marks from work long ago – bits of white paint, measurements, scribbles. I never rub them out. This particular wall, for example, is one against which many works have been made and its dimensions have been particularly significant in making a variety of works.

It's got building patina and it's not flat. You've reached the point in your career as an artist that whatever you do will be shown somewhere, so do you have that pristine white gallery space in your mind constantly?
I think that in the early part of my career the works were part of this place, but later it became important to get them out. Their size has now taken them out of this building.

Of course, as a sculptor what you are dealing with above all else is space and volume. are there occasions when you are asked to contribute to a show and you decide that the space is not for you, or that being juxtapositioned in that group is not what you want?
Well, yes, I've been asked to make works for outdoors and I've found that very difficult, because my work tends to be for inside spaces. Obviously spaces are important, as is installing my work within those spaces. I have to feel happy with the context of the show and my place in it. My work naturally relates to indoors and is often of a domestic scale – the hearth rug and curtains, for example. They come naturally. My work wouldn't be suitable for some spaces.

But if someone offered you a large commission in terms of money and scope, might you be tempted outdoors?

Well, I would be tempted to do something – it would be a real development and it would be interesting to take the domestic out of doors. But then my work might disappear.

The materials might dissolve, shrink even.

[Laughs.] No, it might disappear in terms of its size. Mine relate to interior spaces. But it's interesting that you immediately assumed that I was talking about the materials. I have done things that I didn't think I would be able to do. I often work very slowly, but in the *SiteAtions* event in Cardiff I made a piece in a week. That was a new challenge for me, to complete the work for the preview at the end of the week. I did work with the familiar, albeit involving a tenuous association. I did choose a small, domestic-looking space similar to a studio I once occupied. Its title was 'A Welsh Invention'. I took the materials from a little derelict dwelling just up the road here in Cefn Meiriadog. At the end of the week I returned those materials.

I must say that I was a little surprised to find here examples of your work intact, because I thought that many of the things you did were site-specific and, by their nature, temporary, would naturally fall apart – which goes against one of the justifications or principles of art, which is that it shapes and preserves the world, brings order to chaos. That's what poetry does, it seems to me, a sort of pickling process. But it didn't worry you that you collected stuff from a derelict cottage down the road, which had a lot of associations for you, narrative pegs, and could take it down to the other end of Wales and then bring it back and return the objects and materials to the cottage at the end of the show. Why did you bring it back? Would it have been dishonourable not to do that?

Probably because I took it. Some things were made in Cardiff, but from those materials I took. It was important to return the stuff in terms of the way I'd thought about the work: I used it to evoke a memory and it then seemed natural to return it. The used materials remained within the work, of course. There were bits of wood from the cottage walls, fragments of china and debris from the garden.

That's one of the principles of your art, isn't it – to take something and change its context and so change its text. Also, changing its substance by covering it with something, like the wadding or the wax objects.

I am interested in transformation as a device with which to play about with ideas. The objects are rarely what they seem, neither is the material, come to that. Many of them are quite tough and not as fragile as they look. Hanging up there is one of the pieces I did at college over twenty-five years ago – a 'mattress' made of paper. You would have thought it would have disintegrated by now. I mean how long is a 'work of art' supposed to last?

If I buy a work I want it to last.

But you might be buying an idea.

In which case I wouldn't need to buy it; I'd view it and take away the idea.

But some of the objects will change and develop over the years. They will change colour. They will age and often I find that an interesting part of the

process. I like the silvery colour and quality of certain newspaper and its subtle change as one works with it.

When you've used paper, it's been newspaper, certainly not a fine art paper, so you'd expect it to change, that's implicit in what you're doing.

It was interesting to see all the work brought together in the two shows at Wrexham Arts Centre and Oriel Mostyn in 1995. It was work made over a thirteen year period. The first thing you noticed when you went into the Mostyn was the colour, a rich glowing light. The original colour had slowly developed over the years into this wonderfully natural, warm colour. The other thing was the sense of touch embodied in the work. I realised again the sense of my hands on the work. How I had made everything and it had passed through my hands. I hadn't been aware of these things until then.

The recent wax pieces are very much a hands-on intervention aren't they? They are hand-shaped.

Yes, there is no moulding; most are made of wool dipped in the wax and built up by the hands in one go. I certainly had no preconceived ideas about the first five objects and what they were going to look like. Once I'd made those, then I started thinking about the others differently; how they were going to work together on the wall. How I would arrange them.

When you decided to stop in the process, you must have felt that it was finished.

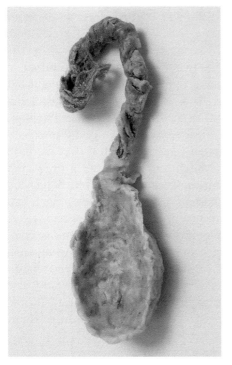

Objects and Ashes (detail) felt, wool, wax, mixed media
 dimensions variable, 1995, artist's collection

Yes, the whole thing about my work is that each piece has a presence about it. When I feel it's got that presence, I stop. It's become itself.

For me there are suggestions of fossils, a bird, a fish. Do you overhear people at your exhibitions making those sorts of interpretations, and does it matter what they are getting?

Some are obvious. Some are concealed.

That one's a spoon. But it could be a noose.

Or a shepherd's crook. That one could be an ear. But it could be a snail.

It could be a cord and placenta.

It's not that.

So there are some interpretations that you will resist – it's not an open-ended thing.

I'm not resisting your interpretation; it's simply that it's incorrect. The piece over there is like a lamb's head, or that's what arose out of the material when I was making it. There's the ear, the horn, and a flap of wax like skin. Lots of people have thought about that other one as a bird on a wire. I hadn't ever seen it as that. For me it's like a bag, a small container; that's a recurring theme.

Like a gamekeeper's gibbet?

I'm not sure whether you are referring to the bag or the whole work 'Objects and Ashes'. Certainly the work contains images I have played with before. Some are plucked from the lexicon of images that I might use, other are not. I am interested in memory and the way it cuts across all sense of time. When I was seventeen I was staying with a relative and drew some cloths hanging in a row at the back of her kitchen door; the memory has remained with me ever since and it is one that shows through a number of works. This particular piece is shaped like an egg; it's hollow inside and out of it pours this long plait, sealed in wax. As a child I had a long plait. I still have that length of hair wrapped in a chiffon scarf. I also still have long hair.

And how did 'Slip' evolve?

I made it for an exhibition called *Conceptual Clothing* which was at the Ikon Gallery, Birmingham in 1986 and which then toured. It's not a dress, but looks like a dress. Its 'back' used the image of a mirror, its title suggested an ethereal garment, like a best dress/wedding dress. The whole image had slipped. It looks old, but was made from new materials – sacks with lettering on. I worked on them to make them look worn. Three years ago at Oriel Mostyn was the first time that I'd hung it in a corner, or fixed in a place, because it had always been fixed in a central point hung from the ceiling.

It has the quality of a relic.

Also, at that Llandudno show I had 'Robe' in which I used hessian. 'Robe' again uses the idea of a dress – it was constructed around a wardrobe door, and then I took the door away.

Your school days were spent in Wales – did everything start there?

Yes I did A level art at Abergele Grammar School. I had a good teacher who had an interesting way of teaching. I learnt more about artists from

LOIS WILLIAMS

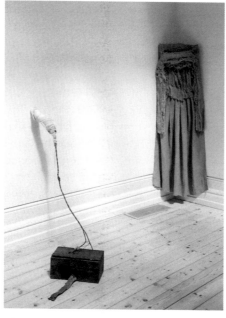

Sore Finger 1983
wire, twine, wool and mixed media, 1983
Slip
sacking, 1986
artist's collection

him, with no formal teaching and being encouraged to find out things, developing ideas, discovering for yourself. It was a great basis for the future.
Which artists excited you? And how did you find out about them in north Wales at that time? Was there any art to see?
The first major gallery I visited was the Walker Art Gallery in Liverpool. I remember seeing a Turner, which still hangs there now. It was magnificent to see that painting in the flesh.
But three dimensional work you really need to be in the presence of, don't you?
Although I had consistently seen exhibitions after that, during the summer of 1973 I went to Paris and saw the work of the Surrealist sculptors as well as that of Nikki de St. Phalle, Annette Messager and Joseph Beuys. Now I travel around to exhibitions all the time.
You were born and brought up as an only child on your parents' farm here, so doing and making practically were things that were part of your life from the beginning?
I also think that a very strong part of that life is a sense of routine. There's always the pressure of work and that infiltrates. I still help out when I'm here.
So you went to do the foundation course at Wrexham. Was that a traditional course then – life class and so on? And was there a moment when you became a sculptor?
It was very much a course of its time – five weeks of painting, five weeks of sculpture, and life drawing. I went from there to Manchester wanting to be an expressionist painter and painted for a while, but during the first year I found my own way of working; I was interested in clothes and during that

time made a costume, a private garment. The headdress was made from scrim, woven and transformed with a needle. I made work which really wasn't too different from what I do now. In the second year a different set of tutors thought I'd make a good expressionist painter! But I began to develop my work in other ways and wove that mattress out of newspapers. In many ways my work remained an extension of painting and I did not see myself as making sculpture until six years after leaving college.

I went on to London and Goldsmiths for the teaching year. I had a studio space there and I was struggling to make new work, but a tutor who came from Rhyl encouraged me to stick to my roots. I came back and collected some materials to take to London. Then I altered my approach to making. I had a big review of my work and decided that I was going no-where; I began to focus on and improve aspects of my work. That was the time that I actually made something and thought of myself as making sculpture. Actually, 'Keepsake', an earlier piece, made in 1981, was the first time I ever used wool in my work and decided to use the material as it was without changing anything. But the piece I am talking about here is 'Sea of a Thousand Creases' which was a carpet. I brought it back here and put it on a plinth, that slab of slate. It took a year to make – a long time. It was great to work bigger and focus my attention. I made it for the exhibition *Art and the Sea*. I'd sent in a proposal and it was accepted. It did all kinds of things. It's related to the floor, though the exhibition had to show it on a plinth because people would have stood on it. It had no colour, but had fantastic colour at the same time; it kind of moved as you went round it – it was silvery one side and dark the other. It was an unbelievable chore to make, but it led to a lot of new work. Carpets interest me, either as a formal shape as in 'Sea of a Thousand Creases', or fragmented as in both versions of 'Hearth', or as a device to suggest life's journey, as in 'Journey' and 'A Living Position'. Some are made quickly as in 'One Room Living', others such as 'Sea of a Thousand Creases' have taken a year to make.

To take a year to make something out of paper seems an astonishing thing to do. The paradigm would be of women through the centuries living in this house quilting and doing very labour-intensive work.

That year was important. It helped me focus on what I wanted to do and what I needed to do. It concentrated my mind and allowed me to take my work in a different direction.

By that time, in the early 1980s, American feminism had swept over here. Was that a factor?

Yes, I had read Lucy Lippard's book on Eva Hesse and subsequently other books too. Through showing work I had been in contact with and had seen a vast amount of work by women. I began to be involved with lots of other women. I was in a number of shows – for example with Cornelia Parker at the Ikon. Work was being reviewed and was included in a lot of exhibitions. In 1984 I had work with other women artists at The Showroom in London,

later Mike Tooby wrote about me and I became noticed in England.

You say, "noticed in England", but were you noticed in Wales? You have a clear sense of your national identity and you've always touched base back here in north Wales.

Well, I was noticed in Wales, but the shows were different. Outside Wales my work tended to be included in shows which essentially dealt with issues. 'The Simplest Aid to Looking at Wales', for example, was shown in the exhibition *City Life, Political Life* at Cornerhouse, Manchester. I used the image of a horn book, a device we used to use for teaching children the alphabet. I modelled those shapes over a long period of time here and each one depicts different letters of the Welsh alphabet and the possibilities of change: some are left out and some left blank.

But you've never worked as a teacher in Wales, have you? In 1976 you went straight from training at Goldsmiths to Sheffield and the school where you have taught ever since. Was that a matter of chance, or choice?

By chance and choice. I wanted a job in the North, I thought Sheffield was close to Manchester, my old college city, but on arriving there I found that they were culturally very different. I was in Sheffield a long time without taking a studio, basically working in my flat and returning to work here in my north Wales studio. But eventually I took a room, in 1980, I think. I was there for six years; a tiny attic room, a sky-light, but no windows, half the size of this one. It was a very productive time for me. I didn't know any artists in Sheffield, but I got to know other people through showing work. Eventually, after a short time in another studio in a domestic space, I got a studio in Yorkshire Artspace in the centre of Sheffield and I've been there since then. It's been important as a complement to this building in Wales: I need the isolation of a studio to work in with no distractions. I can't work at home.

So, though the pieces are aimed at that outside world of a neutral gallery space, they need to attach themselves to that wall or that room – I'm trying to avoid the obvious womb image, with all these umbilical cords around us here.

It's you who's seeing umbilical cords. Most of the works are attached to the walls, but so are paintings. Some pieces are located on the floor, but so are many of the objects in our living spaces. A very few are attached in some way to the ceiling. From where you are sitting you've got a restricted view of materials here. Because I store all my stuff here, rather than Sheffield.

We both have to balance our professional teaching lives with our creative time. How comfortable are you with that? Would you like to be given time to concentrate on the work exclusively?

I suppose that in my early career as an artist I kept my teaching career hidden – as if people would not take me seriously as an artist. It is extremely hard work: when you are an art teacher you can see up to a hundred children every day. At school they have been very supportive of my work. They allow me leave for meetings and some foreign trips. They appreciate that

what I do in the art world is of significance. And I have managed to bring
several artists to the school. The children don't see me as an artist though;
they see me as an art teacher. After work I usually go to my studio, but that
doesn't mean I haven't been thinking about the work during the day. That
studio time is a quiet period when I can focus.

*Has it not been suggested to you that you should move into the college or uni-
versity sector in Wales?*

It has been suggested many times but it hasn't happened. I have never been
offered a job in Wales. Virtually all the visiting lectures and tutorials I have
been invited to give have been outside Wales.

Do you work in the evenings or weekends?

I try to complete my school work in the school day and then try to go to
work in the studio in the weekday evenings. When I'm here in the cottage
I tend to play around with materials and collect things; I don't do that in
Sheffield, I have to be focussed and use the time constructively. There I
usually place the objects within the space and arrive at a sense of the work's
presence.

*Michael Tooby talks about the sense of journey in your work. Does the
Sheffield/St. Asaph axis work in that way for you?*

It's 110 miles to school and I can do it in a couple of hours on a Monday
morning. I need the contrast of the two spaces, in the city and out here in
the country.

*Let's talk about his piece 'Journey'. This is a soft floor arrangement with objects
and string that is arranged, presumably, in a slightly different way each time it's
shown. It hasn't got an unchangeable integrity, is arranged on a plinth and can
be transported.*

No, it's fixed. I find it odd that you use the term 'soft floor arrangement' –
it sounds like a piece of furnishing! It's made from wadding and is off-
white. Perhaps it's because it's quite dark in here that I have a desire to
make things which are white. I also think that I'm a messy person and find
it hard to make white things. I thought of it as life's journey with this bowl
and this stuff spilling out, this lovely silky cord. Some of the objects are
domestic and can be easily recognised, and some are things I've changed in
some way – that's like a sheaf of arrows – it's an old camera case, and the
food and the iron, and the ball-cock and the bottle. When I first made this
work it was meant to be touched. It was in an exhibition chosen for visu-
ally-impaired and blind people. I changed it after the show and decided to
have it raised onto a base. It didn't hold the space as well on the floor. But
the important thing here is this space, my travelling space between the two
places, a mental space where I can think about things on the journey to
work or back home.

*But because it's softened, there is a tension created by its insubstantiality – these
are no longer useful objects, it's almost as if they had been covered by some vol-
canic deposit.*

LOIS WILLIAMS

Often it's mistaken for sheep's wool, but it's wadding to be used in furniture: I've used that quite lot since. It goes back to my interest in making clothes as a student and also in disguising an object.

What you've created is not an object: it's a space that's about objects and the negation of objects. If I bend down and move the strings, have I contributed to the piece?

No, I don't want it touched now. After the original show I think that it would have been destroyed if it had continued to be touched. It's fixed and I would send it to an exhibition with a photograph. Every aspect is carefully considered.

Can we talk about 'Sore Finger', which I find a disturbing work?

That was originally shown with a group of small works at The Showroom in London in 1984. It really hasn't been seen much after that. It was made in my first little studio in Sheffield from found objects – an old box, wire, wool and scrim. I bound the wire tightly and with wool and cloth bound this great big lump at the end which I attached to the wall. Looking at it now I am conscious of the space between the object on the floor and the piece attached to the wall. I also find it interesting that the bound lump resembles a horse's foot.

What about 'A Very Easy Death'? Where does that come from?

The title is taken from a memoir by Simone de Beauvoir about her mother's death. It was an incredibly moving book and "the easy way of death", as the doctors called it, concerned me. There is no easy death and if you live on a

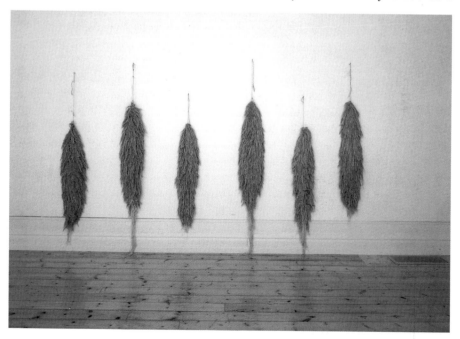

A Very Easy Death hessian, scrim, cord and nails, dimensions variable, 1986, artist's collection

farm lots of things die. I started working here with the idea of a fox's brush. Somebody had given my father a chair from the local pub – I think they called it a Huntsman's Chair. There's a lot of fox hunting around here. On this day there was a fox hunt going on out in the fields and I looked out to see a fox escaping the hunt completely. I pinned the six brushes made of scrim and silk cord on the wall with rusty nails and they took up thirteen feet in length. Exploring and combining these ideas and experiences brought the images together as a whole to create a piece about loss and death.

I made 'Curtain' about the same time. It was important to have the space here, a huge room to myself. It was important to see the work in big spaces; before that the work had been constrained. The space around it was as important as the space it occupied on the walls.

It would be easy to characterise 'A Very Easy Death' as a series of happy accidents – the reading, the fox-hunt, the interest in the material.

No, the idea of the work had been going on for ten years, but eventually it all came together. It wasn't about animals; it was about the fact that there is no easy way to die.

As we get older we start to think about such things. There is no easy death because you will miss all the things that come after. There is definitely a literary aspect to what you do – the Yeats poem, and the de Beauvoir book – where the title came before the work.

But I don't see that 'A Very Easy Death' is about "missing the things that come after". Sometimes a title might be there before the work. 'Sea of a Thousand Creases', for example, but again I'd had the work in mind for several years before I actually made it. An interest in literature is an aspect of my life.

We viewers need a title, we need help and direction when we enter a gallery. As in 'Journey' where we are challenged to see a kind of archeological dig where a civilization has left behind these traces which we have to make sense of. I heard Anthony Gormley on the radio last week and he was arguing that sculpture was the most natural thing. He read Anthropology at Cambridge and that informed his view. In the crudest of civilizations raising a stone to the upright is saying "We were here." Changing the context and configuration of an object. 'Journey' is raised on a plinth and framed by it. There is a sense of remembrancing in this piece of yours which connects for me with 'A Very Easy Death'. Both poetry and art preserve that fact of being here. Which artists do you admire and which have influenced you?

I enjoy the work of many artists and like to see as much as possible. Eva Hesse, Magdalena Abakanowicz, Jackie Winsor, Liz Magor, Susan Solano and many others. I enjoyed seeing the work of Pipilotti Rist at the 1997 Venice Biennale. Miroslav Balka's earlier works based around his family home I find particularly interesting.

Do you draw, or do these works start as objects?

LOIS WILLIAMS

I often start with small sketches, a title, a thought; they then start to shape as a three-dimensional object. I often make lots of objects then select. Recently I have begun doing more drawing, presenting ideas which haven't materialised as sculpture. But essentially my main practice is concentrated on the found and made object.

You could always sell the drawings – because you can't sell these works easily, except to public collections.

I have sold some smaller works and large pieces. The larger works are in collections, but some pieces have been bought for domestic spaces. On the whole, though, the works are made for galleries.

Yes, your work is meant for public space – many involve banal domestic objects which become objectified and can never return to their original context.

I'm not sure that I would refer to the objects as banal; they are chosen because they have particular qualities. They are often imbued with personal significance, but that isn't always so.

There are the references to personal details, such as 'My Grandmothers' Hair'.

I made 'My Grandmothers' Hair' for the space at Wrexham Arts Centre. It was an idea that had lain dormant for a number of years. I am interested in the fact that families often keep a lock of hair. I still have the hair of one of my grandmothers. In the work I hung fine silk fibre which resembled hair in a curtain from the ceiling. The work is about keeping and containing. It was like my grandmothers' hair. All my grandmothers.

What are these panels?

That is a work I made some time ago; 'The Grey on the Outside', a set of nine panels with objects embedded in them or attached to the surface. The image of the flower form isn't too dissimilar from the ear shape in 'Objects and Ashes'.

They're not exactly kept in cotton-wool, are they? My notion of venerating the art object is changed by seeing your work loosely laid around this cottage.

Well, they have been unpacked for a studio visit, but I find it important to have works around the studio. The title was taken from a horse racing commentary I was listening to at the time I did them!

You have work here in the cottage from some years back. Which of your earlier works still please you?

'White Box Arc', 'Sore Finger' and 'One Room Living' are among the works I often think about. 'One Room Living', made in 1985, uses found and made objects arranged apparently randomly on a square. I have always liked this work, it has a rawness in its making.

So work may spring from unlikely sources. How important was the commission which came from the National Museums & Galleries for the Disclosure(s) *exhibition? It seemed to me that here was an example of the way in which a public body could actively encourage new work.*

Yes, I made three pieces for that, including 'A Reconstructed Thing', 'Standing Silent' was also for the *Disclosure(s)* exhibition, though I think that

it was less successful. The title was good – a lot of my work is about standing silent.

Hendre'r-ywydd Uchaf is a reconstructed house from near Denbigh which stands at St. Fagan's. I had heard the name often as a child; my father's family had farmed near Hendre'r-wydd and this conjured up many images. I used the box, the bowl, the cloth and the forms which echoed the house. The bowl had been used as a domestic object and was contained within felt and velvet. 'A Reconstructed Thing' is made from one thread of spun wool. I simply intertwined yards and yards of it and hung it in layers on my Sheffield studio wall.

Can one classify certain types of work made in Sheffield as opposed to work made here, or is it more haphazard than that?

No, it's haphazard. With that piece it was a question of scale. There would have been too little room here in the cottage, whereas in Sheffield the walls are white and bare; with the one thread unravelling to make this piece I could concentrate better there.

How did that satisfy the commission which was to be in response to work in the National Museums & Galleries holdings?

Because it embodied the whole idea of preservation, reconstruction, presentation.

Can we talk about a recent piece 'Red' – the work with the teapot?

'Red' was made in response to war, both specific and in general. A visit to

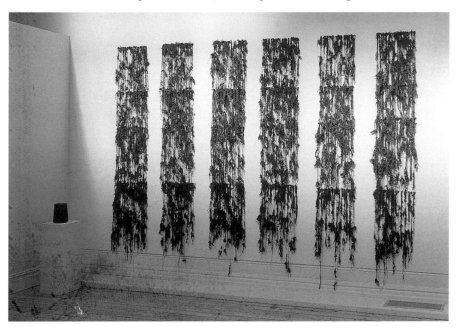

A Reconstructed Thing wool, dimensions variable, 1994, Derek Williams Trust
(Loan, National Museums and Galleries of Wales)

Zagreb prompted that. They were still at war and I didn't like being there, because I felt like an outsider and a voyeur. When I came back I made this work.

Did you shape the teapot, or is it one which you found?

The teapot was one we had used at home at Tan y Bryn. I showed the work in Croatia in 1997 in the *Borders* exhibition organised by the Artists' Project. When I went back for that I also visited in their village some people I'd met in Zagreb on that previous journey. I also went to Bosnia. In both countries villages are wrecked and abandoned. You see things left behind in destroyed homes, like a child's school exercise book, a teapot, torn scraps of traditional weaving.

So the teapot, the most domestic item, is here on the wall and pouring blood.

Not blood.

Well, that which appears to be blood.

I called it 'Red'. The word 'red' has many associations.

You have another recent work called 'Acid'.

Yes, I made it after 'My Grandmothers' Hair'. I decided to attach one long strand to the brush and bind them together with acid. I have always been interested in making domestic objects which can imply danger, either through the material or the title.

Is it also ironic, in that women's hair has connotations of sexuality, power and that painting someone's hair, the hair coming out of a brush like paint, is a cosmetic trick?

That's interesting, I shall have to think about it. [Laughs.]

Acid
used paint brush, synthetic hair,
2 x 40 x 110 cm, 1998
artist's collection

BIOGRAPHICAL OUTLINES

ALFRED JANES

Born, 1911 Swansea. Died 1999

Training
Royal Academy Schools, London

One Person Exhibitions
1935	Everyman Cinema, Hampstead
1949	GVS
1967	Towards a Concrete Art, Architectural Association, London
1974	Retrospective, Oriel, Cardiff and touring
1999	Glynn Vivian Art Gallery, Swansea

Group Exhibitions (selected)
1935	*Past Students of Swansea Art School*, GVS
1937	Mayor Gallery, London
1947	St George's Gallery, London
1948	*Welsh Vision* James Howell, Cardiff
	Redfern Gallery, London
	Welsh Artists Heals Gallery, London
1952	*Artists in Wales* NLW/WAC
1957	*Nine Swansea Artists* GVS
1961	with George Fairley, Ronald Court, GVS
	Artists of Swansea & West Wales Howard Roberts Gallery, Cardiff
1961-62	*Artists of Fame and Promise* Leicester Galleries, London
1962	with Will Roberts, WAC/RNE
1963	Clare College, London
1964	Stoke College of Art
	Archer Gallery, London
1966	*Metamorphosis* Herbert Gallery, Coventry
1968	*Art in Wales* WAC/GVS
1971	Dylan Thomas Country, Upper Grosvenor Galleries, London
1973	South London Art Gallery

Awards
1935	Royal Academy Bronze Medal

Collections
Glynn Vivian Art Gallery, Swansea; National Museums and Galleries of Wales; Cyfarthfa Castle, Merthyr Tydfil; Cheltenham and Gloucester plc; Constitutional Club, London; Newport Museum and Art Gallery; Norwich City Art Gallery; Masonic Temple, Swansea; St Mary's Church, Swansea; University of Texas; numerous private collections

Publications
The Artist in Wales, David Bell, 1957
'The Art of Alfred Janes' *Anglo-Welsh Review* 1958
Alfred Janes 1911-1999, Glynn Vivian Art Gallery, 1999

BIOGRAPHICAL OUTLINES

CHRISTINE JONES

Born 1955, South Wales

Training
1980-1983 West Surrey College of Art and Design

One Person Exhibitions
1985	*Clay Circles* Swansea Arts Workshop Gallery, Swansea
1987	*New Ceramics* The Blenheim Gallery, London
1991	*Form: coiled and carved* Wilson and Gough, London
1996-97	*Still Horizons* Swansea Arts Workshop Gallery; Oriel Myrddin, Carmarthenshire; Llantarnam Grange Arts Centre, Cwmbran
1998	Crafts Council Cafe Gallery, London
1999	*Silent Voices* Black Swan Gallery, Frome

Group Exhibitions
1986	*Presented and Purchased* Glynn Vivian Art Gallery, Swansea
1988	*Createurs Contemporians*, Paris
1988-99	*Contemporary Ceramics* Bonharns, London
1988	Chelsea Crafts Fair, London
1989	Chelsea Crafts Fair, London
1990	Beaux Arts, Bath
	In the First Place Aberystwyth Arts Centre, Dyfed
	Lucie Rie, Hans Coper and their Pupils Sainsbury Centre, Norwich
	Blue Coat Display Centre, Liverpool
	The Discerning Eye Mall Galleries, London
1995	Contemporary Art Gallery Gilbert, Dorset
	National Eisteddfod of Wales
1997	*Ceramic Series* Oriel, Cardiff
1998	*Beyond Material: new craft of the 90s* Oriel Mostyn, Llandudno
	Worcester City Museum and Art Gallery; Mission Gallery, Swansea; Brighton Museum and Art Gallery, Brighton
1999	Howard Gardens Gallery, Cardiff
	Cleveland Crafts Centre, Middlesbrough
1999	*Clay into Art* Metropolitan Museum of Art, New York
	Interior Design Xu Limited, Leamington Spa, Warwickshire
	Objects of Desire Roger Billcliffe Gallery, Glasgow
	Phillips Contemporary Ceramics London & New York
	Welsh Artists Martin Tinney, Cork Street, London

Awards
1989	Special Award, Craft Council, Wales
1996	Prize Winner, National Eisteddfod of Wales
1998	Craft Bursary, Arts Council of Wales
1999	Crafts Council Selected Maker, Crafts Council, London
2000	Gold Medal for Craft, National Eisteddfod of Wales

Publications
'Living Art at Auction', Cyril Frankel, *Arts Review Yearbook*, 1990

WELSH ARTISTS TALKING

'Contemporary British Ceramics', Christopher Finch, *Architectural Digest* USA, 1995
Coiled Pottery, Betty Blandino, A&C Black, 1996
Colour In Clay, Jane Waller, The Crowood Press, 1998

Collections
Sainsbury's Collection, Norwich; Glynn Vivian Art Gallery, Swansea; Metropolitan Museum of Art, New York; National Museum of Wales, Cardiff; York City Art Gallery, York; Fitzwilliam Museum, Cambridge; Los Angeles County Museum of Art, California. Private collections nationally and internationally.

Studio
Swansea

TERRY SETCH

Born 1936, Lewisham, London

Training
1950-54	Sutton and Cheam School of Art
1956-60	Slade School of Art, University College, London

One Person Exhibitions (selected)
1965, 67, 68, 70, 73	Grabowski Gallery, London
1972	University College, Cathays Park, Cardiff
	Chapter Arts Centre, Cardiff
1976	Oriel, Cardiff
1977	Faculty of Art and Design Gallery, Cardiff Institute, Cardiff
1979	Chapter Arts Centre, Cardiff
1980	*Summer Show III* Serpentine Gallery, London
1981	Frans Wynan Gallery, Vancouver, Canada
1982	Nigel Greenwood Gallery, London
	Once Upon a Time There Was Oil Arnolfini, Bristol
1983	Christine Abrahams Gallery, Melbourne, Australia
1985, 87	Nigel Greenwood Gallery, London
1987	St Pauls Contemporary Art Gallery, Leeds
1989	*The Bay* Andrew Knight Gallery, Cardiff
1990	*Sailing in the Bay* Conservation Management, London
1992	*New Work* Oriel, Cardiff; Turner House, National Museum of Wales, Penarth; Camden Arts Centre, London
1993	*New Work* Talbot Rice Arts Centre, Edinburgh
1995	*Paintings 1993-95* Raw Gallery, London
1995	West Wales Arts Centre, Fishguard, Wales
1997	Washington Gallery, Penarth

Group Exhibitions (selected)
	Numerous tours and exhibitions with *56 Group Wales*
1956/7/8	*Young Contemporaries*, London
1959	*Tomorrow's Artists* Grabowski Gallery, London

BIOGRAPHICAL OUTLINES

1962	*Visual adventure* Drian Galleries, London
1964	*Trends and Trendsetters* Howard Roberts Gallery, Cardiff
1966	*Structure 66* Welsh Arts Council, Cardiff
1967	*Young Britain* ICA exhibition, toured New York and Los Angeles
1968	National Eisteddfod of Wales, Barry (Prizewinner)
1969	*Play Orbit* ICA, London
1970	*Celtic Triangle* toured Wales, Northern Ireland and Eire
1971	*Art Spectrum Wales* National Museum of Wales, Cardiff and tour
1972	*John Moores 8*, Walker Art Gallery, Liverpool
1974	*British Painting 1974 Hayward Annual*, Hayward Gallery, London
1978	*Giardelli, Jones & Setch*, UCW Cardiff; St Catherine's, Oxford
1980	*Hayward Annual* Hayward Gallery, London
1980-82	*The Probity of Art* touring exhibition, Spain, Portugal and Turkey
1981	*XIII Festival International de la Peinture* Cagnes-sur-Mer, France
1981/2	*Cardiff Artists* Galerie der Stadt, Stuttgart, Germany
1982	*13 British Artists, An Exhibition about Painting* Neue Galerie-Sammlung, Ludwig Aachen; Mannheim; Braunschweig, Germany
	The 4th Biennale of Sydney, Art Gallery of New South Wales, Sydney
1983	*Alive to it All* Arts Council of Great Britain exhibition, toured
	New Art selected by Michael Compton, Tate Gallery, London
1984	*English Expressionism* Warwick Arts Trust, London
1985	*John Moores 14*, Walker Art Gallery, Liverpool (Prizewinner)
1986	*Summer Exhibition* Royal Academy, London (Invited Artist)
1987	*Which Side of the Fence* Imperial War Museum, London
1987	*Small is Beautiful part 5 - Landscapes* Flowers Gallery, London
1987-88	*The Experience of Landscape* ACGB touring exhibition
1988	*Artists in National Parks* V&A, London; UK and USA tour
1989	*Tree of Life* South Bank Centre, London and tour
	Twentieth Century Welsh Art touring exhibition to Japan
1990	Contemporary Art Society Art Market, Smiths Gallery, London
1991	*The Boat Show* Smiths Gallery, London
1992	*The Man, the Form and the Spirit* Connaught Brown, London
	The National Eisteddfod of Wales, Aberystwyth
1993	*Innovation and Tradition: Recent Painting in Britain* Tate, London
1994	*This Sceptred Isle*, Burlington New Gallery, London
1994/5	*Disclosure(s)*, Oriel Mostyn, Llandudno; Newport Museum; Caixa de Terrassa. Spain; National Museum of Wales, Cardiff
1995	Laing Art Competition, Old Library Art Centre, Cardiff and The Mall Galleries, London
1996	*Art 96*: London Contemporary Art Fair, Raw Gallery, London
	Frankfurt Art Fair, Germany, Raw Gallery, London
1996/7	*The contemporary collection*, National Museum and Galleries of Wales, Cathays Park, Cardiff
1997	*Art 97*, Mina Renton Fine Art, Business Design Centre, London
1998	*Absolut Secret*, Royal College of Art, London and McKee Gallery, New York, USA
1999	Artists Project, Millennium Centre, Cardiff
2000	*Oil, Water*, Centre for the Visual Arts, Cardiff
	Painting the Dragon, National Museum and Gallery, Cardiff

Awards

1968	National Eisteddfod of Wales main prizewinner
1971	Welsh Arts Council Painting Award
1972	John Moores 8 Prizewinner
	Welsh Arts Council commission award for Coleg Harlech
1978	Welsh Arts Council Major Artist Award
	Print Commission, National Eisteddfod of Wales
1985	John Moores 14 prizewinner
1988	Athena Award, shortlist prizewinner

Collections

Tate Gallery; National Museum and Galleries of Wales; Victoria & Albert Museum; Arts Council of Wales; British Council; Glynn Vivian Art Gallery, Swansea; Arts Council of Great Britain; Contemporary Arts Society of Wales; Wakefield City Art Gallery; Coleg Harlech; Contemporary Arts Society; Northampton Art Gallery; University College London; University College of Wales, Aberystwyth; Rugby Borough Council; University College of Wales, Swansea; Leicestershire Education Authority; Museum of Modern Art, Lodz, Poland; South Glamorgan County Council; Normal College, Bangor; Glamorgan Education Authority

Publications

Terry Setch Oriel, Cardiff, 1976

Hayward Annual Arts Council of Great Britain, London, 1980

Summer Show III (sel. Stephen Cox), Arts Council of Great Britain, 1980

Contemporary Arts Society of Wales 20th Anniversary Exhibition W B Cleaver & David Fraser Jenkins, National Museum of Wales, 1987

Artists in National Parks Department of the Environment & Victoria and Albert Museum, London, 1988

Athena Art Awards 1988 Athena/Pentos, London, 1988

The Tree of Life, New Images of an Ancient Symbol South Bank Centre, London, 1989

Images of Paradise Christies, London, 1989

Shared Earth a Contemporary Exhibition of Anglo-Soviet Landscape Sister Wendy Beckett and Edinaya Zemlya, Greenwoods Art Foundation, Peterborough, 1991

Royal Academy Illustrated 1991 Royal Academy, London, 1991

New Work by Terry Setch Welsh Arts Council/ National Museum of Wales/ Camden Arts Centre London, 1992

Disclosure(s) Oriel Mostyn & Newport Museum and Art Gallery, 1994

Harlech Biennale Harlech International Biennale, Harlech, Gwynedd, 1994

Contemporary British Landscape Flowers East, London, 1999

Studio

Penarth, Vale of Glamorgan

DAVID GARNER

Born 1958, Ebbw Vale

Training

1977-78	Foundation, Newport Art College

BIOGRAPHICAL OUTLINES

1978-81 BA (Hons), Cardiff Art College
1981-84 MA Fine Art, Royal College Of Art, London
1983 Paris Studio Scholarship, (RCA)

One Person Exhibitions
1996 *Political Games* Oriel, Cardiff

Group Exhibitions (Selected)
1993 *Welsh Sculpture* Margam Sculpture Park, Port Talbot
1994 *Changing Views, The Welsh Group* The Old Library, Cardiff
1995 National Eisteddfod of Wales, Colwyn Bay
1996 *The Welsh Group* Brecon Museum
 National Eisteddfod of Wales, Llandeilo
 The Protest Of Discipline Taff Bargoed Drift Mine, Glamorgan
 (collaboration with poet Patrick Jones)
1997 National Eisteddfod of Wales, Bala
 Detritus Newport Museum & Art Gallery, Gwent
 (collaboration with poet Patrick Jones)
1998 *Landmarks* National Museum, Cardiff
1999 *The Last Shift* St. David's Hall, Cardiff.
 Creating An Art Community – 50 Years Of The Welsh Group National Museum of Wales, Cardiff
 National Eisteddfod of Wales, Anglesey
2000 *Contemporary Art Society For Wales, Distribution Exhibition* Turner House, Penarth
 Certain Welsh Artists touring National Museum of Wales, Cardiff, Glynn Vivian Gallery, Swansea

Publications
Political Games Dai Smith, David Briers, David Adamson, 1996
The Protest Of Discipline Patrick Jones, 1996
Detritus Clare Rendell, Carol-Anne Davies, 1997
Sounds Of The Suburbs! S.Wales John Peel, Channel 4 TV, 1999
Creating An Art Community Peter Wakelin, 1999
Certain Welsh Artists Iwan Bala, Seren, Bridgend, 1999
Painting The Dragon Anthony Jones, BBC Wales TV, 2000

BRENDAN STUART BURNS

Born 1963, Nakuru, Kenya.

Training
1982-85 Fine Art degree course, Faculty of Art and Design, Cardiff.
1985-87 Slade School of Art, University College London.

One Person Exhibitions
1991 *The Florentine Experience* Powerhouse Gallery, Laugharne, Dyfed.
1992 Llantarnam Grange Arts Centre, Cwmbran

1995	Wyeside Arts Centre, Builth Wells
1996	Oriel Contemporary Art, London
1999	Y Tabernacl, Museum of Modern Art Wales, Machynlleth
1999	National Museum & Galleries of Wales, Turner House

Group Exhibitions

1983	Viriamu Jones Gallery, UCC
1987	Hatton Gallery, Newcastle
	Solomon Gallery, London
	Contemporary Art Society, Smith's Gallery, London
1988	Wales Open, Aberystwyth Arts Centre
	Oriel Gallery, Cardiff. William Feaver Selection
	Contemporary Art Society, Smith's Gallery, London
1989	Howard Gardens Gallery, Cardiff
	Contemporary Art Society, Smith's Gallery, London
1991	*Welsh Contemporaries*, Red Square Gallery, London
	National Eisteddfod of Wales, Bro Delyn
	Contemporary Art Society, Smith's Gallery, London
	Wales Art Fair, The Old Library, Cardiff
1992	National Eisteddfod of Wales, Aberystwyth
	Whitleys, London
	The Welsh Gallery, Bond Street, London
	Towner Art Gallery, Eastbourne
1993	Hay on Wye Festival of Literature and the Arts
	The Royal College of Art, London
1994	*Art '94* The Business Design Centre, London
	National Eisteddfod of Wales, Neath
	The Kilvert Gallery, Hay on Wye
1995	*Welsh Contemporaries* Oriel Contemporary Art, London
	Two man Show St David's Hall, Cardiff
	56 Group Wales Exhibition Old Library, Cardiff
1995-96	*WYSIWYG Contemporary Abstract Painting* touring exhibition, Aberystwyth and Wrexham.
1996	*Welsh Contemporaries* Oriel Contemporary Art, London
	Art of the Possible 56 Group Wales touring exhibition National Eisteddfod of Wales, Llandeilo, National Museum and Galleries of Wales, Turner House
1997	*Welsh Contemporaries* Oriel Contemporary Art, London
	University of Glamorgan Purchase Prize 1997 Exhibition
	56 Group Wales, Worcester City Art Gallery
	Derek Williams Collection, New Purchases National Museum and Gallery of Wales
1998	*Welsh Contemporaries* The Riverside Studios, London
	University of Glamorgan Purchase Prize 1998 Exhibition
	Chatton Gallery, Northumberland
	Painting – Ysbryd / Spirit – Wales Howard Gardens Gallery, UWIC
	Landmarks National Gallery and Museum of Wales
	Washington Gallery, Penarth.
1999	*Art 1999* London Contemporary Art Fair, Gordon Hepworth Fine Art

BIOGRAPHICAL OUTLINES

Welsh Contemporaries, The Riverside Studios, London
Visualize Gallery, Cardiff.
National Eisteddfod of Wales, Anglesey
Reading Images St David's Hall, Cardiff
Painting – Ysbryd / Spirit – Wales Llantarnam Grange Art Centre, Cwmbran, Oriel Clwyd, Mold, Flintshire.
New Work 56 Group Wales, Howard Gardens Gallery, UWIC

2000 *Oil and Water* with Terry Setch, Iwan Parry, Centre for Visual Arts, Cardiff
Welsh Artist of the Year, St David's Hall, Cardiff.

Collections

South Glamorgan County Council Collection; Leicestershire Education Authority; Associated Newspapers for Museums Collection; National Museum and Galleries of Wales, (Derek Williams Collection); Contemporary Art Society of Wales; University of Glamorgan; Celtic Manor Hotel & Conference Centre, Newport; Private Collections United Kingdom, USA and Australia.

Awards and Prizes

1989	Welsh Arts Council Travel Scholarship, Florence, Italy
1991	Artist in Residence, Llanfrechfa Grange Mental Health Unit, Cwmbran
1992	Welsh Arts Council Travel Scholarship, New York, USA
1993	Gold Medal in Fine Art, National Eisteddfod of Wales, Llanelwedd, Powys
1997	The Friedrich Konekamp Award for Painting
1998	Gold Medal in Fine Art, National Eisteddfod of Wales, Bro Ogwr
1999	First Prize, University of Glamorgan Purchase Prize
2000	Welsh Artist of the Year

Membership

56 Group Wales
Co-initiated and co-ordinated the publication *Painting - Ysbryd / Spirit - Wales*

Studio

Cardiff

ROBERT HARDING

Born 1954, Southport, Lancashire

Training

1973-1974	Coventry (Lanchester) Polytechnic
1974-1977	Exeter College of Art & Design
1977-1981	University of Lancaster

One Person Exhibitions

1979	NUS/SUN, installation using mirrors and sunlight (for Students Union), University of Lancaster

1982	Scott Gallery, University of Lancaster
1982	Swansea Arts Workshop Gallery
1984	Swansea Arts Workshop Gallery
1994	Pennsylvania Academy of Fine Arts, Philadelphia, U.S.A
1995	Old Library Gallery, Cardiff

Group Exhibitions (selected)

1979-80	*Singleton Sculpture Show* South Eastern Arts touring exhibition
1980	*Art into Landscape 3* Serpentine Gallery, London
1981	*UK Sculptour U.S.A.* exhibition sponsored by British Council: Decker Gallery, Maryland Institute of Art, Baltimore; Museum of Art, University of Oklahoma; United Artists Gallery, Albuquerque, New Mexico; Laumeir International Sculpture Park, St. Louis, Missouri
	Art into the Open North West Arts Association
1982	*Sculpture for a Garden* Tatton Park, nr Manchester
1983	*Exposed to the Elements* Rochdale Art Gallery & Charlotte Mason College, Ambleside
	New Heritage Oriel, Cardiff
	Open Air Sculpture St. Donats Arts Centre, Vale of Glamorgan
	"... those who can't..." Scott Gallery, University of Lancaster
1985	Clifftop Sculpture, Tout Quarries, Portland, Dorset
	Co-curated Sculpture and Architecture - Restoring the Partnership The Building Centre, London and subsequently touring Wales
	Larger than Life, Chapter, Cardiff
1986	*Seven Sculptors Working in Wales* Glynn Vivian Art Gallery, Swansea
	Vision 8 Coity Castle and Church, nr Bridgend
1987	*Sculpture in the Park* Rufford Country Park, Nottinghamshire
	Welsh Sculpture Oxford Gallery, Oxford
1988	*The Art of Lego* international touring exhibition
	Sculpture in a Garden Cricieth Festival Exhibition
1991	National Eisteddfod of Wales (also 1993, 1996 and 1999)
	Insight (exhibition for the visually impaired), Glynn Vivian Art Gallery, Swansea & Educational Resource Centre, Chepstow
1992	*Testimony Garden* Garden Festival Wales, Ebbw Vale
1993	*The Welsh Sculpture Exhibition* Margam Park
1994	*On and Off the Level* (with Neil Evans) Glynn Vivian Art Gallery, Swansea
	On and Off The Wall (with Neil Evans), Henry Thomas Gallery, Carmarthen
1997	*Sculpture in the Park* Festival Park, Ebbw Vale
	The Gateway (Yr Adwy) Project Coed Hills, St. Hilary, nr Cowbridge
1999	*Ironwill* Crescent Arts Workshop, Scarborough

Also numerous other A.A.D.W. (1982-89) and annual Welsh Group (since 1990) and 56 Group (since 1997) exhibitions in all parts of Wales and beyond.

Awards

1977	Phillip Andrews Memorial Studentship
1977-1979	Major State Studentship
1980	Art Into Landscape Prizewinner
1981	Art into the Open Prizewinner

BIOGRAPHICAL OUTLINES

1982 & 1984	Young Artist Grants from Welsh Arts Council.
1987	West Glamorgan Craft Fellowship (Afan College, Port Talbot)
	British Council Travel Award to Romania
1994	Artist in Residence, Pennsylvania Academy of Fine Arts, Philadelphia, U.S.A.
1997	Arts Council of Wales Award
2000	Wakelin Award, Glynn Vivian Art Gallery

Collections

Works in St. Davids Hall, Cardiff; Glynn Vivian Art Gallery, Swansea; West Glamorgan Education Authority; Presidents Collection, M.I.A. Baltimore and in private collections in Europe and U.S.A.

Studio

Llantrisant

IVOR DAVIES

Born 1935

Training

1952-56	Cardiff College of Art
1956-57	Swansea College of Art - Art Teacher's Diploma
1959-61	University of Lausanne
1975	University of Edinburgh

One Person Exhibitions (selected)

1965	Outlook Tower, Edinburgh
1968	Traverse Theatre, Edinburgh
1973	McRobert Centre, University of Stirling
1974	Oriel, Cardiff
1975	Education Gallery, City Art Gallery, Leeds
1972/73/74/77	Talbot Rice Art Centre, University of Edinburgh
1980/81	Holsworthy Gallery, London
1986	Palacio Municipal de Exposiciones, Corunna, Spain
1986	Palacio Municipal de Exposiciones, El Ferrol, Spain
1986	Llanover Hall Arts Centre, Cardiff
1987	Newport Museum and Art Gallery
1987	Davies Memorial Gallery, Newtown
1987	Loughborough College of Art
1989	Janus Avivson Gallery, London
	Max Rutherston - Jane Roberts, London
	Windsor Arts Centre, London
	Al Sharaf Halkin Arcade, London
1990	Jedda, Saudi Arabia
1991	West Wharf Gallery, Cardiff
	Wrexham Library Arts Centre
1992	Bangor Arts Centre

University of Nottingham
1993 Glynn Vivian Museum & Art Gallery, Swansea
Gateway Arts Centre, Shrewsbury
Victoria Art Gallery, Bath
1992 Mandarin Fine Arts, Hong Kong
1993 Bruton Gallery, Bath
1994 Martin Tinney Gallery, Cardiff
1995 *Delwedd Cymru – Natives*, Brecknock Museum, Brecon
1998 Royal Cambrian Academy touring exhibition
Museum of Modern Art Wales, Machynlleth
Turner House, Penarth
Wolseley Fine Art, London
2000 Bruton Gallery, Leeds

Group Exhibitions (selected)
1953 National Museum of Wales, Cardiff
1955 Contemporary Welsh Painting and Sculpture, National Museum of Wales
1953-59 *Young Contemporaries*, RBA Galleries, London
1959 Gallery One, London
1959 Kettles Yard Art Gallery, Cambridge
1960 Galerie Theater, Bern, Switzerland
Galerie Kasper, Lausanne, Switzerland
Galerie Bridel, Lausanne, Switzerland
1963 Dillwyn Gallery, Swansea
1966 *Signals* London
1968 *Wales Now* Welsh Arts Council Travelling Exhibition
1973 *The Artist-Craftsman in Architecture* Edinburgh Art Centre
1973 *Wales and the Modern Movement* University College, Aberystwyth
1970s - 2000 National Eisteddfod Exhibitions
1970s *Original Print* the Edinburgh Printmakers Working Travelling Exhibitions
1981-82 *The Final Proof* travelling exhibition
1980-81 *Art and the Sea* Glasgow; Llandudno; ICA, London
1981 *Cardiff Artists* Stuttgart
1982 *Artists in Focus* photographs by artists, Morley Gallery, London
1983 Welsh Group touring exhibitions
1986-87 *Celtic Vision* Madrid, Cocunna, Cork, Dublin, Glasgow, Cardiff, Nantes
1986 *New Vision* Warwick Arts Trust
1987 Beca group exhibition on tour with SEWA
1987 Chalk Farm Gallery, London
1988 *Celtic Vision II* Dublin
1989 Oriel 31, Welshpool
1992 New Academy Gallery, London Richmond Gallery, Cork Street
1993 Beca group exhibition *Fire and Flood* Oriel Bangor
1994 *Flowers in a Room* Oriel Myrddin, Carmarthen; Glynn Vivian, Swansea
1995 Royal Academy Summer Exhibition
Intimate Portraits Glynn Vivian, Swansea
The Discerning Eye Mall Galleries, London

BIOGRAPHICAL OUTLINES

	Bruton St. Gallery, London
1996	Royal Academy Summer Exhibition
1997	*Celtic Landscapes* Wolseley Fine Arts, London
	Welsh Group exhibition, European Parliament, Strasbourg
	Nine Welsh Artists Rotunda, Hong Kong

Publications (selected)

Red Art 1917-1971 *Art and Artists* Vol 6 April 1971
Irrational Work *Art History* March 1979
Modern Art *Aspects* No 14
De Chirico *Artscribe* No 37
Editor *Link* 1985-1987
Diego Rivera *Studio International* November 1987
Notes Towards the Definition of the Artist: Ivor Davies *Planet* 106

Collections

Arts Council of Wales; Scottish Arts Council; University of Edinburgh; University of Stirling; University College, Aberystwyth; University College, Swansea; Education Gallery, City Art Gallery, Leeds; National Museum of Wales; The Robert Colquhoun Memorial Special Award of Merit; Arts Council of Great Britain; Newport Museum and Art Gallery; The Deal collection of drawings, Dallas
Private collections all over the world

JONAH JONES

Born 1919, Laverick Hall near Washington, Co. Durham

Training

1936-39	Part-time studies King Edward School of Art, Newcastle
1949	Worked in Eric Gill Workshops, Pigotts, Bucks

One Person Exhibitions

1967	Tegfryn Gallery
1973	Oriel Bangor
1974	Magdalen Street Gallery, Cambridge
1980	Hatton Gallery, Newcastle
1982	Gregynog
1989-90	Retrospective touring, Mostyn Gallery; National Library of Wales; Turner Gallery National Museum of Wales, Penarth

Group Exhibitions

1961	WAC show touring, with John Petts and Kyffin Williams
1963	WAC drawings
1966	Two-man show with Keith Vaughan, Oriel Bangor
1968	*Art in Vales Today*
1973	*Wales and the Modern Movement*, UCW Aberystwyth

WELSH ARTISTS TALKING

Numerous shows of Contemporary Art Society of Wales, National Eisteddfod of Wales, and Arts Council of Wales

Commissions
1956	Welch Fusilier Memorial Hall, Wrexham
1959	Ratcliffe College Chapel – stained glass, sculpture, inscriptions
1960	Ampleforth College – stained glass, sculpture and inscriptions
1960	Coleg Harlech wall sculpture
1971	Wall sculpture at Law Courts, Mold
1973	Wall sculpture, North Wales Police HQ, Colwyn Bay
1983	Sculpture in Carrara Marble for National Association of Obstetric Anaesthetists, Bedford Square, London
1984	Welsh-American Portfolio (14 Welsh poems in Welsh and English painted for screenprinting for Western Illinois University)

Publications
Autobiographical essay in *Artists in Wales* ed Meic Stephens, 1971
Essay in *John Cowper Powys*, ed Belinda Humfrey, 1972
Essay in *Readings in Art and Design Education* ed Warren Piper, 1975
A Tree May Fall (novel) Bodley Head, 1980
The Lakes of North Wales Wildwood House & Whittet Books, 1983
Zorn (novel) Heinemann 1986, and Penguin 1987
Afterword to Brenda Chamberlain's *Tide-race* Seren, 1987
The Gallipoli Diary Seren, 1990

Films
Cwmpas, BBC, 1963
Look at Life – The Living Stone, Rank Films, 1965
Canvas: Gregynog Collection, BBC2, 1967
Look Stranger: A man works where he must, BBC1, 1972
Cedric Morris, BBC Wales, 1986

Educational Activity
National Council for Diplomas in Art and Design 1961-71
Faculty Member, British School at Rome 1961-71
Adviser, Ulster College 1968-71
Director, National College of Art and Design, Dublin 1974-78
Director, Kilkenny Design Workshops 1974-78
External Assessor at Art Colleges: Liverpool, Manchester, Wolverhampton, Sheffield, Newcastle University etc.
Welsh Arts Council Art Committee 1980-83 and 1986-90
Fellow at Newcastle University 1980-81
Gregynog Arts Fellow, 1981-82
Queen's Jubilee Medal for service in the Arts 1983

DAVID NASH

Born 1945, Esher

BIOGRAPHICAL OUTLINES

Training

1963-67 Kingston College of Art

One Person Exhibitions (selected)

1973 *Briefly Cooked Apples* Queen Elizabeth Hall, York; Oriel, Bangor

1976 *Loosely Held Grain* Arnolfini Gallery, Bristol

1978 *Fletched Over Ash* Air Gallery, London

1979 Arnolfini Gallery, Bristol

1980 *Wood Quarry* Elise Meyer Gallery, New York

 Mixed Wood Southampton University Gallery; Galleria Cavallino, Venice

1981 *Pyramids and Catapults* St. Paul's Gallery, Leeds

1982 *Two Views of Nature* Elise Meyer Gallery; Oriel, Bangor

 Wood Quarry Rijksmuseum Kroller-Muller, Otterlo

 Kilkenny Art Gallery, Kilkenny Castle, Ireland

1983 *Sixty Seasons* travelling exhibition

1984-85 Travelling exhibition, Japan

1985 Bixby Gallery, Washington University, St. Louis

 Rijksmuseum Kroller-Muller, Otterlo

 Elm, Wattle, Gum Heide Park and Art Gallery, Melbourne

 Aveago Gallery, Sydney

 Galerij 565, Aalst

1986 *Tree to Vessel* Juda Rowan Gallery, London

1987 L.A. Louver Gallery, Los Angeles

1988 *Ardennes Project* Galerij 565, Aalst

 Drawings Nishimura Gallery, Tokyo

1989 Ek'ymose Bordeaux

 Mosaic Egg Annely Juda Fine Art, London

 Oak and Birch Galleria Sculptor, Helsinki

1990 *Chene et Frene* Musée des Beaux-Arts, Calais

 Louver Gallery, New York

1991-2 *Sculpture 1971-90* travelling exhibition

1992 *Sculpture and Drawings* Gerald Peters Gallery, Dallas

 The Planted Projects 1977-1992, Louver Gallery, New York

1993 *At the Edge of the Forest* Oriel, Cardiff

1994 *Voyages and Vessels* travelling exhibition

 Otoineppu – Spirit of Three Seasons travelling exhibition, Japan; US

1995 Gianni Giacobbi Fine Art, Palma de Mallorca

 Bat in the Box, Lizard in the Glove Refusalon Gallery, San Francisco

1996 Art Affairs, Amsterdam

 Croesau, Wyan, Llestr, Pasg 1996 Oriel Y Ddraig, Blaenau Ffestiniog

 Green Fuse, Mead Gallery, Warwick Arts Centre, Coventry

 Forms into Time 1971-96 Museum van Hedengaase Kunst,

1997 *David Nash,* travelling exhibition

 Red and Black, L.A. Louver Gallery, Los Angeles

 Stoves, Atlantic Centre for the Arts

1999 *Engaging with Primary Elements* Artists' Gardens, Weimar

Selected Group Exhibitions

1975	*The Condition of Sculpture* Hayward Gallery, London
1977	*From Wales* Fruit Market Gallery, Edinburgh
1980	*British Art Now: An American Perspective* Guggenheim Museum, New York (and subsequent tour of USA)
1981	*Art and the Sea* Third Eye Centre, Glasgow
1982	*Aspects of British Art Today* Tokyo Metropolitan Art Museum (and subsequent tour of Japan)
1983	*Tongue and Groove* Coracle Press, London
1984	*Survey of Recent International Painting and Sculpture,* Museum of Modern Art, New York
1986	*Overland* Ikon Gallery, Birmingham
1988-89	*Artists in National Parks* Victoria and Albert Museum, London
1989	*Tree of Life* Cornerhouse, Manchester (and subsequent tour)
1991	*Charred Sculptures* Museum Folkwang, Essen
1992	*David Nash, Therese Oulton, John Virtue* Louver Gallery, Los Angeles
1993	*Differentes Natures* Espace Art Defense, Paris
1995	*British Abstract Art, Part 2: Sculpture* Flowers East, London
1996	*Endangered Spaces* Christie's, London
1997	*6th International Shoe-Box Sculpture Exhibition* Hawaii Art Gallery
1997	*Ecce Ubu,* La Maison du Spectacle -La Bellone, Brussels
1998	*Twenty Five Year Celebrations* Butler Gallery, Eire
1999	*tweede natur -belden en installaties* Halle-Zoersel, Belgium,

Publications (selected)

Briefly Cooked Apples, York, 1973
Loosely Held Grain, Arnolfini Gallery, Bristol, 1976
Fletched over Ash, AIR Gallery, London, 1978
David Nash, *Aspects,* (summer 79), 1979
David Nash, *Aspects,* (spring 80), 1980
Wood Quarry, Elise Meyer, New York, 1980
Stoves and Hearths, Duke Street Gallery, London, 1982
Fellowship, Yorkshire Sculpture Park 1981-82, 1982
Wood Quarry Otterlo, Kroller Muller Museum, The Netherlands, 1982
Sixty Seasons, Third Eye Centre, Glasgow, 1983
David Nash – Japan, Ki No Inochi, Japan, 1984
Elm Wattle Gum, Heide Art Gallery, Melbourne, 1985
Hoge Veluwe Otterlo, Kroller-Muller Museum, The Netherlands, 1985
Tree to Vessel, Juda Rowan Gallery, London, 1986
Wood Primer, Bedford Press, San Francisco, 1987
Chene et Frene, Musée Greuze, France, 1988
Mosaic Egg, Annely Juda Fine Art, London, 1989
David Nash, Sculpture 1971-90, Serpentine Gallery, London, 1990
Wality: Smoke and Turpentine with Leon Tarasewicz, Warsaw, 1991
David Nash: Phillipville and Wality Projects 565 Gallery, Aalst, 1991
At the Edge of the Forest Annely Juda Fine Art, London, 1993
Braendt Eg, Kunsthallen Braendts Klaedefabrik, Odense, Denmark, 1993
Voyages and Vessels, Joslyn Art Museum, Omaha, 1994
Otoineppu – Spirit of Three Seasons Hokkaido pp. 8-98, 1994

BIOGRAPHICAL OUTLINES

Collections (selected)

Stedelijk Museum, Aalst; Aberdeen Art Gallery; Museum van Hedengaase Kunst, Antwerp; Ayr Art Gallery; Bristol Museum and Art Gallery; Palais des Beaux-Arts, Brussels; Musee des Beaux-Arts, Calais; Museum of Modern Art, Caracas; National Museum of Wales, Cardiff; Welsh Contemporary Art Society, Cardiff; Fonds Regional d'Art Contemporain, Corsica; National Museum, Dublin; Towner Art Gallery, Eastbourne; Scottish National Gallery of Modern Art, Edinburgh; Uffizi Gallery, Florence; Fukuoka City Art Museum; Frans Hals Museum, Haarlem; McMaster Museum of Art, Hamilton, Ontario; Espoo Karhusaari, Helsinki; Hiroshima Fine Art Museum; Asahikawa Museum of Art, Hokkaido; The Contemporary Museum, Honolulu; Honolulu Airport, Hawaii; Louisiana Museum, Humlebaek; Ichikawa Museum of Art; Indianapolis Museum of Art; Iwaki City Museum; Kamakura Museum of Art; Abbot Hall Art Gallery & Museum, Kendal, Cumbria; Tichon Environmental Sculpture Park, Langeland, Denmark; Leeds City Art Gallery; Leicester Museum and Art Gallery; Fonds Regional d'Art Contemporain, Limousin; Arts Council of Great Britain, London; British Council, London; Contemporary Art Society, London; Government Art Collection, London; Tate Gallery, London; Victoria and Albert Museum, London; Museum of Contemporary Art, Los Angeles; L'Ecomusee de Pierre de Bresse, Macon; Madison Art Center, Wisconsin; Manchester City Council; Heide Art Gallery, Melbourne; Walker Art Center, Minneapolis; Nagoya City Museum; Margam Sculpture Park, Port Talbot, Wales; Metropolitan Museum of Art, New York; Guggenheim Museum, New York; Joslyn Museum of Art, Omaha; Rijksmuseum Kroller-Muller, Otterlo; Art Gallery of Western Australia, Perth; Portsmouth City Museums; Kunsthalle Recklinghausen; Rouen City Metrobus de l'Agglomeration Rouennaise; San Diego Museum of Art, California; San Jose Museum of Art, California; Hoam Museum, Seoul; National Museum of Contemporary Art, Seoul; Mappin Art Gallery, Sheffield; Southampton City Art Gallery; Laumeier Sculpture Park, St. Louis; St. Louis Art Museum; Tochigi Prefectural Museum of Fine Arts, Utsunomiya; Tokyo Metropolitan Art Museum; Setagaya Art Museum, Tokyo; Musee Greuze, Tournus; Centre d'Art Contemporain, Ile de Vassiviere; Yorkshire Sculpture Park; Ujazdowski Castle, Warsaw

Films and Documentaries

1978	*Woodman* directed by Peter Francis Browne, Arts Council of Great Britain
1982	*Wooden Boulder* made by the artist, Welsh Arts Council
1984	*Sunday Museum Programme* NHK TV Tokyo
1988	*Stoves and Hearths* Alter Image, Channel 4 Television
1993	*David Nash at the Edge of the Forest* directed by Richard Traylor Smith, BBC Wales TV
1996	*From Capel Rhiw to the World* Peter Telfer, HTV

Studio

Capel Rhiw, Blaenau Ffestiniog

LOIS WILLIAMS

Born 1953, North Wales

Training

| 1971-72 | Wrexham Technical College |
| 1972-75 | Manchester Polytechnic |

WELSH ARTISTS TALKING

1975-76 University of London, Goldsmith's College

One Person Exhibitions

1983 Wrexham Library Arts Centre and Oriel, Theatr Clwyd, Mold

1986 *Lois Williams, Recent Sculptures* Mappin Art Gallery, Sheffield

1987 *Lois Williams, Sculpture* St. Paul's Gallery, Leeds

1995 *From the Interior. Lois Williams Selected Sculpture 1983-1995* Oriel
 Mostyn Gallery, Llandudno/Wrexham Arts Centre

1999 *A Living Position* Rich Women of Zurich, London

2000 *Objects and Ashes* Djanogly Art Gallery, Nottingham

Group Exhibitions (Selected)

1975 *Northern Young Contemporaries* Whitworth Art Gallery, Manchester

1979 *Sculpture by Young Artists Living or Working in Wales* Aberystwyth Arts
 Centre (and tour)

1981 *Art and the Sea* Oriel Mostyn Gallery, Llandudno/ICA, London

1983 *Sculpture by Women* Ikon Gallery, Birmingham

1984 *Pandora's Box* Arnolfini, Bristol

1985 *Women's Art in Wales* Oriel Mostyn Gallery, Llandudno (and tour)
 Beyond Appearances Nottingham Castle Museum (and tour)

1986 *Off the Shelf* Rochdale Art Gallery
 City Life, Political Life Cornerhouse, Manchester
 Conceptual Clothing Ikon Gallery, Birmingham (and tour)

1987 *Paper and Thread* Milton Keynes Exhibition Gallery

1988 *Along the Lines of Resistance* Cooper Art Gallery, Barnsley (and tour)

1989 *Ways of Telling* Oriel Mostyn Gallery, Llandudno
 Animal Liberation – The Centre of the Circle Rochdale Art Gallery.
 The Natural Element Oriel, Cardiff
 It Makes Sense! Artworks to Touch, Smell, See and Hear Greenwich
 Citizens Gallery, London

1990 *New North. New Art from the North of Britain* Tate Gallery, Liverpool
 (and tour)
 Art at your Fingertips Museum of Garden History, London
 The Paper Show Oriel Mostyn Gallery, Llandudno (and tour)

1992 *BP re-Vision. New Challenges in Contemporary Art* Greenwich Citizens
 Gallery, London (and tour)
 *2nd Coming. Outstanding Contemporary Art from Ten Years of Major
 Exhibitions 1980-1990* South London Art Gallery
 On the Brink? Leeds University Art Gallery
 Journeys Southern Arts Touring

1993 *Celtic Landscape* Gallery of Modern Art, London

1994 *Disclosure(s)* Oriel Mostyn Gallery, Llandudno/Newport Museum and
 Art Gallery (and touring)
 Into the Elements Aberystwyth Arts Centre (and tour)

1995 *Intimate Portraits* Glyn Vivian Gallery, Swansea (and tour)

1996 *Harlech Biennale* Harlech
 Grave Goods Crawford Arts Centre, St. Andrew's (and tour)

1997 *Wax Works* Collins Gallery, Glasgow
 Borders Moderna Galerija, Zagreb (and tour)

BIOGRAPHICAL OUTLINES

	Contemporary Art Society for Wales 60th Anniversary Exhibition National Library of Wales, Aberystwyth
1998	*Landmarks* National Museum of Wales
1999	*Harlech Biennale* Harlech
	Cameo Rich Women of Zurich, London
	National Eisteddfod of Wales, Winner: Gold Medal in Fine Art
2000	*Artworkers* Newlyn Art Gallery/Oriel Mostyn Gallery, Llandudno (and tour)
	Luminaries Aberystwyth Arts Centre (and tour)

Selected Projects On-Line Exhibitions

1994	*Site-Ations* Cardiff Artist's Project. Various venues
1995	*World's Women on Line* UN Fourth World Conference on Women. Beijing and Arizona State University
199 7	*Axis Web Exhibition* Cardiff Bay Arts Trust Selection
1999	*Axis Web Exhibition* selected by Jill Morgan
	Cyfuniad International Artist's Workshop, Triangle Arts Trust

Public Collections

Arts Council Collection, Contemporary Art Society for Wales

INDEX

INDEX

INDEX